MW01056612

The Warsaw Ghetto in

American Art and Culture

The Pennsylvania State University Press

University Park, Pennsylvania

Samantha Baskind

The Warsaw Ghetto in American Art and Culture

Library of Congress Cataloging-in-
Publication Data

Names: Baskind, Samantha, author.
Title: The Warsaw Ghetto in American art and
 culture / Samantha Baskind.
Description: University Park, Pennsylvania : The
 Pennsylvania State University Press, [2018]
 | Includes bibliographical references and
 index.
Summary: "An interdisciplinary study examining
 the diverse meanings of the Warsaw Ghetto
 in American culture. Looks at how the
 ghetto has been represented in fine art, book
 illustrations, film, television, radio, theater,
 fiction, poetry, and comics"—Provided by
 publisher.
Identifiers: LCCN 2017031182 | ISBN
 9780271078700 (cloth : alk. paper)
Subjects: LCSH: Getto warszawskie (Warsaw,
 Poland)—In popular culture. | Jews in popu-
 lar culture—United States.
Classification: LCC NX652.J48 B28 2018 | DDC
 700/.43529924—dc23
LC record available at https://lccn.loc
 .gov/2017031182

Copyright © 2018 Samantha Baskind
All rights reserved
Printed in China
Published by The Pennsylvania
State University Press,
University Park, PA 16802-1003

The Pennsylvania State University Press is
a member of the Association of American
University Presses.

It is the policy of The Pennsylvania State
University Press to use acid-free paper.
Publications on uncoated stock satisfy the
minimum requirements of American National
Standard for Information Sciences—Permanence
of Paper for Printed Library Material,
ANSI Z39.48–1992.

In memory of Mary D. Sheriff,

mentor, shining example, and friend

Contents

Illustrations

Acknowledgments

Every reserve I have as a scholar and a person was tapped to write about this history. The invigoration of discovery and my love of crafting words and arguments remained, but the challenges of the subject matter often left me crushed and questioning my choice to write about the Holocaust. Throughout, I felt nourished by my wondrous children, Asher Solomon Baskind and Naomi Margalit Baskind, who inspire me to reach higher in all areas. Yet they also served to remind me of the devastating loss of life, families, and the unfathomable pain of mothers who watched their children suffer and die. On days that I felt the weight of my subject matter most heavily, I pondered my motives. Eventually I came to understand why I felt compelled to write about the Warsaw Ghetto: I wrote this book for readers, so that they might better understand how vividly culture, politics, and Jewish history intersect; for me, as a scholar and a Jew; and for Asher and Naomi, who will someday learn about the tragic history of our people, and the family lost to us, unknown forever.

A number of institutions and individuals made it possible for me to research and write this manuscript, and it is a pleasure to acknowledge their support. I offer sincerest thanks to Motl Didner of the YIVO Institute for Jewish Research for providing me with his unpublished translation of *Der Nes in Geto*. Jane Klain at the Paley Center for Media could not have been more generous during my visits to study and transcribe Serling's *In the Presence of Mine Enemies*. I recognize Ellie Kellman for introducing me to the magazine *World Over*. Sherri Long at Bowling Green State University came through in a pinch with two key illustrations. The Joe Kubert Estate, Joanne Wilson Jaffe of the Ben and Evelyn Wilson Foundation, Jon Bogdanove, Judy Chicago, Bernice Eisenstein, Audrey Flack, Trina Robbins, Donald Woodman, George Krevsky Gallery, and Pucker Gallery were especially considerate with illustrations and permissions. Tina Sell's assistance with grant writing was, as always, unsurpassed.

Gracious colleagues read drafts of chapters at various stages, helping me to navigate thorny issues. For their insightful comments I gratefully acknowledge the expertise of Stephen Bergson and Natasha Goldman. Jeff Karem's keen eye made the Uris chapter immeasurably stronger. Laura Levitt's careful attention to my discussion

of children in the ghetto was crucial to the ultimate shape of those chapters. Ellen Landau, Ranen Omer-Sherman, Andrea Pappas, and Larry Silver have been steady intellectual companions on this project and many others over the years. I thank them profusely for their constructive advice on prose and argument, and for many years of rewarding friendship. To Sean Martin I extend my warmest appreciation for countless conversations about Polish Jewry and his genuine excitement for my work. Richard Romaniuk, I thank you for walking with me along the border of the former Warsaw Ghetto and through its confines.

I am very fortunate to have received vital institutional funding from external sources. A fellowship from the Holocaust Educational Foundation to study at Northwestern University with like-minded colleagues proved invaluable in the early stages. Special mention goes to Paul Jaskot, Michael Rotenberg-Schwartz, and David Dennis for their collegiality. Just as essential was a Curt C. and Else Silberman Seminar fellowship at the United States Holocaust Memorial Museum. I am grateful to have received the Edwin Gale Fellowship from the Harry Ransom Center in Austin, Texas, to examine Leon Uris's archive. Closer to home, Cleveland State University provided financial support, enabling me to visit the Wisconsin Center for Film and Theater Research, where I consulted the Rod Serling Papers and Millard Lampell Papers. The reproductions in this book were made possible by the Faculty Scholarship Initiative Fund and the Dean's Office in the College of Liberal Arts and Social Sciences at Cleveland State University.

How lucky I am to work with the Pennsylvania State University Press. I thank Jennifer Norton, Patty Mitchell, and Laura Reed-Morrisson for their behind-the-scenes stewardship. Ellie Goodman's ongoing enthusiasm for my work and sharp editorial eye, and dynamic press director Patrick Alexander's professional camaraderie, mean so much to me. I would also like to single out Rachel Arzuaga, Jessica Ritsko, and Elizabeth Sisley, students extraordinaire. Scott Simon's friendship and grammatical prowess are unparalleled. I recognize the tremendous support of my mother, Julie Baskind, who cares for my children when I travel for long periods to archives and abroad.

Portions of chapters first appeared in "A Warsaw Ghetto TV Drama from Mr. Twilight Zone," *Forward*, April 19, 2016; "Leon Uris's *Mila 18*, Muscular Judaism, and the Warsaw Ghetto Uprising in American Culture," in *Absorbing Encounters: Constructing American Jewry in the Post-Holocaust Decades*, ed. Eliyana Adler and Sheila Jelen (Detroit: Wayne State University Press, 2017), 215–43; and "Picturing 'The Holiest Thing': Joe Kubert's Children of the Warsaw Ghetto," in *Visualizing Jewish Narrative: Jewish Comics and Graphic Novels*, ed. Derek Parker Royal (London: Bloomsbury Academic, 2016), 171–84.

Finally, I dedicate this book to Mary D. Sheriff. It is with a heavy heart that the last sentences I write as I finish this project's journey to publication are for her. Without Mary, my book would have never existed. No books I wrote in the past or will write in the future would exist. Words are meager to convey her generosity of time and spirit, inexhaustible encouragement and devotion to her students, and intellectual rigor. And so with all my love and admiration and gratitude, I remember Mary.

It is impossible to put into words what we have been through. One thing is clear, what happened exceeded our boldest dreams. . . . *I feel that great things are happening and what we dared to do is of great, enormous importance.*

—Mordecai Anielewicz (1919–1943), commander of the Jewish Combat Organization, April 23, 1943

If you could lick my heart, it would poison you.

—Antek Zuckerman (1915–1981), deputy commander of the Jewish Combat Organization, late 1970s

Introduction

On Passover eve, April 19, 1943, Jews in the Warsaw Ghetto mounted the now-legendary revolt against their Nazi oppressors. Modest numbers and meager weapons notwithstanding, a small group of Jewish militants held off two thousand well-armed SS men for twenty-eight days, even though the entire Polish Army had fallen to the Nazis in a comparable amount of time after the blitzkrieg invasion of September 1, 1939. From that fateful day until the current moment, the courageous actions of the partisans who resisted during the Warsaw Ghetto uprising—along with the preceding deprivation and despair of ghetto life—have captured the American imagination. To be sure, this central locale and its seminal culminating affair have metamorphosed into a potent emblem of the war and Jewish life in Europe that is nearly as prominent as Auschwitz. If the Holocaust is known as unqualified evil, with Auschwitz serving as a synecdoche, then the Warsaw Ghetto serves simultaneously as the epitome of courage and the ultimate in squalor. This book explores these two leitmotifs, among others, inherent in many projects about the Warsaw Ghetto. The range of evocative material newly exposed measures more precisely than before

exactly how, over generations, the ghetto has been staged by American artists. Paying close attention to the ghetto's varied meanings in American life, I investigate how its story has been told, retold, and remembered across creative boundaries, including fine art, book illustration, film, television, radio, theater, fiction, poetry, and comics.

The structure of this study is mostly chronological, arranged also for thematic coherence. Five chapters examine different artistic "versions" of the Warsaw Ghetto, stressing the various ways representations, cutting across seven decades, have conveyed the agenda of a particular moment, in part by interrogating how we know and depict the past. While analyzing what diverse cultural conceptions reveal about how Americans remember the ghetto, and by extension the Holocaust, I unpack the interests of each creator, noting especially the maker's proximity to the events (e.g., as survivor, resident of America during the Holocaust, child of a survivor). Tracing the vicissitudes of the Warsaw Ghetto's deployment in culture, my goal is to offer an index to the concerns of American Jews and their attitudes about the Holocaust. To that end I pursue the following questions: What is the creative imprint of the ghetto and its catastrophic history? How are artistic representations of the ghetto linked to shifting conceptions of Jewish American identity and life in the Diaspora? How does art enter social and political consciousness? How is art politicized, or even depoliticized, and interpreted by a diverse viewing public? Why has this seminal moment and place in European history, thousands of miles away, been claimed by Americans, and so persistently, for more than half a century? Throughout, I consider how creation and interpretation are affected when memory, politics, and aesthetic concerns intertwine in the making of art. Thus, my project sheds new light on the importance of the Warsaw Ghetto as a site of memory, trauma, and creative struggle and illuminates its underappreciated role as a litmus test of postwar Jewish American identity. For readers who do not know about the Warsaw Ghetto and the insurrection that took place there, this book will not only apprise them of it but will place it for them in time and in art.

To set the stage for what is to come, I begin with a historical profile of the Warsaw Ghetto and initial details about the uprising. At the outbreak of World War II, Jews made up around one-tenth of Poland's population and one-third of Warsaw's, the largest Jewish community in Europe. Numbering approximately 400,000, Jews lived, worked, and contributed to the thriving city. Before the ghetto's assault on Jewish dignity, Warsaw was a tranquil place where Jews could mark their days by their worldly engagements as much as by age-old tradition. With the onset of war, initiated by the Nazi blitzkrieg invasion and Poland's rapid fall and surrender in late September 1939, Jews were immediately persecuted.[1] The Germans slowly introduced a growing number of unnerving restrictions: Jewish bank accounts were frozen, businesses publicly marked, and identifying armbands mandated. On November

15, 1940, Warsaw's Jews were quarantined in a ghetto three and a half miles square, comprising only 2 percent of the city's space, with all entrances sealed the next day. Soon they were more strongly isolated behind red brick walls more than ten feet high and reinforced with barbed wire. Living in a mere one hundred square blocks and in only 27,000 tiny apartments, Jews were confined in startling numbers: 240,000 in September, 360,000 by November, and over 470,000 by the summer of 1941.[2] Everyday life in the overcrowded ghetto consisted of begging and destitution. Dead bodies lay in the teeming streets, along with starvation and widespread disease, not to mention fear of an unprovoked attack or deportation.

Any Jew caught outside the congested ghetto without a pass was subject to death. Trapped within their walled prison, Jews suffered from insufficient clothing and nourishment; in 1940 the daily food ration was 413 calories and the following year only 253.[3] Deteriorating conditions and inadequate sanitation led to rampant disease, especially typhus. The Judenrat (Jewish council), headed by Adam Czerniakow, ruled the ghetto and was compelled to impose Nazi decrees on their coreligionists, including the excruciating order that they choose who would be deported to death camps. By spring 1942, liquidation had begun as the Final Solution gained currency; from July to September 1942, 265,000 Jews were deported to Treblinka, where most suffered a brutal, genocidal death, and thousands of others were sent to slave-labor camps. In January 1943, only 60,000 Jews remained in the ghetto when a second series of mass deportations began. Realizing that the noose had tightened and they had little left to lose, a number of Jews mounted a small resistance, allowing some deportees to escape. Heartened by this success, even as one thousand Jews died fighting and desperation swept through the ghetto, the rebels united factions and organized the larger revolt, now known as the Warsaw Ghetto uprising.

When German troops entered the ghetto for the final liquidation on April 19, approximately 50,000 remaining residents were in hiding. With scant weapons, many homemade, the Jewish insurgents surprised the Germans, who retreated after a dozen men were wounded or killed. To force out the Jews, the SS set fire to the ghetto on the third day of fighting. Stubbornly clinging to a desire to die with honor, about 750 partisans staved off the Nazi juggernaut until May 16. Twenty-three-year-old uprising commander Mordecai Anielewicz perished in a bunker at Mila 18, either after a German gas attack or by his own hand. A few survivors managed to escape to the "Aryan" side through sewers, including deputy commander Antek Zuckerman, but most either died in the ghetto or soon after their transport to Treblinka. As a capstone to the Germans' hard-earned victory, General Jürgen Stroop ordered his troops to destroy the Great Synagogue, on Tłomackie Street, with the commander managing the detonator himself. The uprising, a final effort to save the heart of

eastern European Jewry, has since come to stand as the Holocaust's archetypal act of resistance, not only in the United States but also throughout the world.[4]

While versions of the Warsaw Ghetto have been constructed in America differently at different times, it is not quite so in Israel, which privileges the uprising and airbrushes the ghetto experience. Evidence of the uprising's importance to the self-conception of post-Holocaust Israeli Jewry is manifest in the date and name proposed to commemorate the largest genocide in history: April 19, the start of the ghetto's rebellion. Israelis rejected that date for several reasons, not least of which is its proximity to Passover. Originators in Israel felt that Passover, a joyous holiday that celebrates Jewish emancipation, and Yom Hashoah (Hashoah means "the catastrophe" or "utter destruction"), a solemn day that memorializes the destruction of European Jewry, should remain separate. Held annually on the twenty-seventh day of Nissan (April or May), Yom Hashoah shifts in the American calendar because of the lunar nature of the Hebrew year. Although the event was separated from the date of the uprising, the opening ceremony in Israel takes place in Warsaw Ghetto Square, located at Yad Vashem, Israel's Holocaust museum and official site of commemoration. The day's full name, Yom HaZikaron laShoah Ve-laG'vurah, translates as "Day of Remembrance of the Holocaust and the Heroism," thereby recollecting devastation and valor equally, even though the latter pales in comparison to the former. Yad Vashem's full name also links death and the Jewish fight for life: The Holocaust Martyrs' and Heroes' Remembrance Authority. What I am getting at is that there are some points of connection between American and Israeli interests in the ghetto, notably the heroics of the fight. American responses, though, are driven by diverse goals and ideals, whereas the Israeli response to the uprising has been mostly homogeneous—stressing the uprising to the exclusion of ghetto life. More fixed, local concerns guide Israelis. From the start—and especially during the founding years with Israel under siege—Zionist ideology depended on the negation of the so-called weak, diasporic, old Jew and the exaltation of the sabra: the bold, pioneering, new Jew. The Warsaw Ghetto uprising suitably supported that cause. In contrast, the United Nations has no connection with, or need for, the uprising and thus in 2005 established January 27 as International Holocaust Remembrance Day, a date coinciding with the Soviets' liberation of Auschwitz-Birkenau.

First lauded by Jews in multiple publications, the uprising eventually became mythologized by, and for, a broader American audience. Take the *American Jewish Yearbook*'s coverage just months after it occurred, which in four short paragraphs self-consciously used the word "heroic" twice. With little information yet known, the author reports on the "heroic leaders of the ghetto uprising" and characterizes the battle as "a daring, if futile thing for the Jews to undertake against the overwhelming

superiority of the enemy. But even from the garbled and clouded reports received so far, we can piece together a heroic story that will forever light up the dark and sordid tale of the Nazi-built Warsaw ghetto. . . . If, after achieving their 'victory,' the Nazis proceeded to liquidate the ghetto, it must have caused ironical laughter somewhere—but it was not the Nazis who laughed."[5] Soon thereafter an article in the *Evening Star*, then the premier newspaper in Washington D.C., printed an article histrionically titled "Homage to the Christian Poles and the Maccabean Jews of Warsaw!" The title itself exalts Jewish heroism by invoking fighting Jews of yore, complemented by the author's melodramatic prose: "In the heart of Warsaw the most unmartial of peoples, the most helpless and lost, had turned their prison into a fortress and were prepared to the last child to make their tormentors pay dearly for every life. The wailing walls had become stockades. . . . The battle represents one of the most extraordinary episodes in the history of religious and racial strife . . . the Jews, by their battle, sent out a call to all men: ENDURE NO LONGER! FIGHT!"[6] The Jewish periodical *Menorah Journal,* heartened by this outside report, reprinted the article before the table of contents of the summer issue.[7]

Whereas the *New York Times* dispassionately accounted for the insurrection as it occurred, the paper a year later printed an editorial lauding the fight with awe and respect: "It is not only Jews who, this week, observe the first anniversary of the Battle of the Warsaw Ghetto. All faiths and creeds thrill at the heroic story. All the free world stands uncovered in profound respect for those brave men, women and children who, almost barehanded, fought the tanks and the guns of the Nazi beast through thirty-five days of horror and died rather than yield. . . . Warsaw will be a beacon for humanity for centuries to come."[8] Chapter 1 looks at related early cultural manifestations of the uprising, wherein the valor and self-determination of the partisans were eagerly eulogized to several ends. As depicted in radio plays, stage plays, and even fine art, the revolt was used as a vehicle to spur America to further action, its portrayers hoping to bolster support for trapped Jews in Europe by demonstrating that Jews took "heroic" responsibility for themselves and were not impotent, helpless sheep led to slaughter. A compelling tool of propaganda, the ghetto also offered an opportunity to demonstrate—*to prove*—Jewish suffering and therefore Nazi crimes.

Unsurprisingly, American cultural producers have over the years paid close attention to the ghetto's idealized muscular Jews, but the ghetto has served as much more than a platform to instill pride and extol courage in the face of overwhelming victimization. As an opportunity to call attention to the Jewish experience outside the concentration camps, the Warsaw Ghetto provided artists with malleable material for their work. While artist Arthur Szyk, author Leon Uris, and others made the resistance and the heroic fighting Jew their primary focus—the subjects of chapters 1

and 3—survivor Samuel Bak, in a series of paintings based on the iconic photograph from the *Stroop Report* of a little boy in the Warsaw Ghetto with his hands held up (whom for ease of reference I call throughout this book the Warsaw Ghetto boy, as he is commonly named elsewhere), does not address the uprising at all. As described in chapter 4, Bak's paintings speak to issues of innocence, memorialization, and mercilessness and likewise stand as creative expositions of the permanent breach in his life—one of a number of examples that reveal how children fit into the ghetto's story. Chapter 5 continues this theme by examining how the Warsaw Ghetto figures into comics, chiefly those that feature the survival of children to demonstrate, however feebly, that a vestige of hope survives even if few Jews do. The writers discussed in chapter 2—Rod Serling, Millard Lampell, and John Hersey—set their sights on family relationships, with the uprising as mostly a footnote in their conceptions. None of this trio was interested in tidy narratives; they crafted layers and contradictions for which the general American public, accustomed to Anne Frank's naïve idealism and simplified characterizations, was somewhat unprepared.

Films like Roman Polanski's Academy Award–winning historical drama *The Pianist* make especially evident the severe deprivation in the insular ghetto, but the disease-ridden ghetto finds prominence in almost all of the projects herein. Some representations aim explicitly to shock and overwhelm in their barbarity, like Charles Reznikoff's sweeping poem *Holocaust* and Joe Kubert's graphic novel *Yossel: April 19, 1943*, both unrelenting in detail and devoid of any catharsis. As further considered in chapter 5, expressly in an extended discussion of *Yossel*, some artists exploit the emotional power of the Holocaust by depicting children. Whether confronted with children's suffering and death or with their unlikely survival—and thus the fleeting glimmer of hope that survival stirs—readers and viewers are reminded of all that was lost. My claim, which I hope this study demonstrates, is that the Warsaw Ghetto cannot be simplified as only *the* example of Jewish resistance during the Holocaust, and that many other stories inhere in the history of the largest ghetto under Nazi dominion.

Examining artistic representations suggests an all-too-often-parsed debate on the acceptability of such representations, across media, about the Holocaust. I hesitate to rehash this overwrought conversation, but the focus of my book demands that I at least offer a few words, however repetitive they may be, about what art can or cannot do, should or should not do, and what limits, if any, should be put on representations of the Holocaust.[9] Discourse on this topic most often begins with German philosopher Theodor Adorno's dictum "To write poetry after Auschwitz is barbaric."[10] Pronounced only six years following the full disclosure of human suffering and torture, and the accompanying shock at the barbarity of humanity, Adorno's

declaration makes sense for that moment. Forgotten by some, Adorno amended his oft-repeated pronouncement in 1966: "Perennial suffering has as much right to expression as a tortured man has to scream; hence it may have been wrong to say that after Auschwitz you could no longer write poems."[11] Literary critic George Steiner still persisted, "The world of Auschwitz lies outside speech as it lies outside reason," as did survivor and Nobel Prize winner Elie Wiesel, who asserted that the Holocaust "defeated culture; later, it defeated art, because just as no one could imagine Auschwitz before Auschwitz, no one could now retell Auschwitz after Auschwitz."[12]

Less adamantly proscriptive but still with a caveat, historian Saul Friedlander introduced his seminal edited volume *Probing the Limits of Representation* by warning that the "record should not be distorted or banalized by grossly inadequate representations. . . . There are limits to representations *which should not be but can easily be transgressed.*"[13] Yet Friedlander acknowledges that those limits are highly subjective and vaguely ascribed. All of the cultural productions in this book are by secondary witnesses, save Samuel Bak's paintings, and certainly art by those removed from the events presents the Holocaust to the reader, viewer, and listener in a mediated and invented form—understandably causing discomfort to some, of which much has been written. But the debate on appropriateness of form and subject, once necessary and valuable, is not particularly relevant to my analysis, and therefore, for the most part, I sidestep it. Conversely, I take seriously the cautions of contemporaneous critics who pointed out the limitations of the work investigated here and consider the meaning of their responses, which are inextricably linked to the issues I explore.

To put it bluntly, I remain nonjudgmental about the "aesthetic of postmemory," to co-opt Marianne Hirsch's compelling phraseology.[14] I am interested in why such representations *exist,* the variety of *forms* they take, what they *meant* to audiences in their own day, and how they *function* in the continuum of American responses to the Holocaust vis-à-vis the Warsaw Ghetto. Accordingly, this book contributes to previous discussions of the Americanization of the Holocaust, a term used to denote the persistence, appropriation, and transformation of the Holocaust in American culture. As Hilene Flanzbaum aptly opines: "If the Holocaust, as image and symbol, seems to have sprung loose from its origins, it does not mean we should decry Americanization; rather, the pervasive presence of representations of the Holocaust in our culture demands responsible evaluation and interpretation."[15] My study adds new dimensions to these previous evaluations by concentrating on creative treatments of the Warsaw Ghetto in diverse media, from its establishment to the present, aiming to widen our understanding of the ghetto's legacy in American consciousness. As I show, artistic interpretations of the Warsaw Ghetto over time

reveal much about identity, memory, and values in American Jewish life. Further, I aim to assess the roles that culture plays in disseminating information about the Holocaust to an American audience via the Warsaw Ghetto and the varying ways that audiences have responded. At the same time, I look at how cultural projects participate in shaping our understanding of the ghetto and thus also the destruction of European Jewry.

Throughout the period I worked on this book, the Warsaw Ghetto entered the news more often than even I expected. When I first started my research, a documentary that reexamined Nazi propaganda footage of the ghetto soon before its liquidation reached theaters. Titled *A Film Unfinished* (2010), the movie attracted an extended story and front-page coverage in the Arts section of the *New York Times*. In May 2011, an hour after landing in Poland, President Barack Obama laid a wreath at the foot of Nathan Rapoport's Warsaw Ghetto Monument, erected on the very spot the uprising took place. Other American dignitaries, including Jimmy Carter in 1977, had preceded Obama. Unveiled on the fifth anniversary of the day the revolt began, this thirty-one-foot-tall commemorative figural sculpture bears a dedication at the bottom in Yiddish, Hebrew, and Polish: "To the Jewish people—its heroes and its martyrs." When two ghetto partisans died, Vladka Meed (2012) and Boruch Spiegel (2013), both received prominent coverage in the press. Meed, for example—a Jew who could pass as a gentile and thereby capitalized on her appearance to work as a courier smuggling weapons into the ghetto in preparation for the revolt—was lauded in lengthy obituaries in the *New York Times* and the *Washington Post*. In late 2015, soon after a mass shooting at a Portland community college that left thirteen dead, presidential hopeful Ben Carson argued in support of gun ownership by invoking the Holocaust. Carson asserted that if Jews and others in the general population had had access to guns, then Hitler and the Nazi genocide might have been thwarted. The Anti-Defamation League, citing the uprising, swiftly issued a statement denouncing Carson: "The small number of personal firearms available to Germany's Jews in 1938 could in no way have stopped the totalitarian power of the Nazi German state. When they had weapons, Jews could symbolically resist, as they did in the 1943 Warsaw Ghetto Uprising and elsewhere, but they could not stop the Nazi genocide machine."[16]

Although appearing a few years before I began my book, it is worthwhile to mention a satire on the Internet that capitalized on the prominence of the Warsaw Ghetto's rebellion to make a larger point about liberal politics and went viral in 2006. Appropriating the recognizable Warsaw Ghetto boy photograph, the subject of chapter 4 and the image that so influenced artists Samuel Bak, Judy Chicago, and others, the left-wing website ThePeoplesCube.com ridiculed the political correctness of the *New York Times* (fig. 1) with a fake *Times* front page dated May

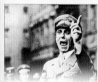

If today's New York Times editors were in charge in 1943...

Fig. 1 Oleg Atbashian, "Warsaw Ghetto Uprising an Over-Reaction: European Leaders Blame Jews for Disproportionate Response," 2006. *New York Times* satire posted on ThePeoplesCube.com. Reproduced by permission.

10, 1943, that includes the headline "Warsaw Ghetto Uprising an Over-Reaction: European Leaders Blame Jews for Disproportionate Response." Ironically playing on an all-too-familiar and deadly phrase, the title above the reproduced photograph reads, "Jewish Resistance Shatters Hopes for a Peaceful Final Solution." Taking the satire further, two shorter articles receive similarly provocative titles: "Jewish Over-Reaction May Cause Grave Humanitarian Crisis" and "Peace Vigil Calls for Jewish Cease-Fire."[17]

As I wrote the body of this book, the seventieth anniversary of the uprising (2013) attracted keen attention. Articles ran in the *New York Times,* the *Huffington Post,* and other leading publications, including *Tablet,* a popular daily online magazine of Jewish culture and news that reported from Warsaw for a week. Commemorations were held in communities across the United States; the Cleveland Jewish community, for instance, brought in the chief rabbi of Poland to speak at several venues about current Jewish life in his country. The United States Holocaust Memorial Museum resurrected a play commissioned in honor of the tenth anniversary of the museum's opening, *Time Capsule in a Milk Can: Emanuel Ringelblum and the Secret Archives of the Warsaw Ghetto.* This forty-minute one-man show, about the remarkable archive found hidden in milk cans beneath the ghetto's rubble, was performed at that year's regional events in New York, Chicago, Boca Raton, Los Angeles, and Washington, D.C., preceded by introductory remarks about the uprising's anniversary. Ringelblum, played by actor Marc Spiegel since the play's premiere, read excerpts from diaries accompanied by original dialogue, spoken to the audience in character. In this second incarnation, PowerPoint slides featuring actual photographs from the ghetto showed on a screen behind the performance.

Emanuel Ringelblum's Oneg Shabbos archive, established after the Nazis sealed the ghetto, receives attention at various times in the following chapters. A teacher and historian with a Ph.D. on medieval Polish Jewry, Ringelblum organized a clandestine group composed of historians, educators, and writers to collect ephemera and record details about ghetto life, Polish Jewry, existence under the Nazi regime, and ultimately the extermination of his coreligionists. Called Oneg Shabbos (Joy of Shabbat) because the organization's board met on Saturday afternoons, the group systematically collected in-depth documentation, including journals, letters, photographs, poetry, and essays—invaluable testaments about Jewish life in the ghetto—alongside documentation of German crimes. A trove of ephemera comprises materials from the underground press, German posters declaring the deportation, theater posters, drawings, and ration cards, along with commissioned essays on topics like "the girl couriers of the underground movement" (smuggling was big business) and "processes of the adaptation of the Jewish artisan to wartime conditions." Ringelblum began his own eyewitness documentation of the events, published as *Notes from the Warsaw Ghetto,* in January 1940, soon after the start of the war.[18] The archives were buried in three separate locations in the ghetto; two of the stashes were recovered from the ghetto's rubble in 1946 and 1950, while the third archive, buried on the eve of the uprising, remains unfound. These precious documents hidden in metal boxes and two subterranean milk cans, along with many prominent diaries written by denizens of the ghetto (e.g., Mary Berg, Chaim Kaplan, and Janusz Korczak), supply

vital sources for some of the cultural conceptions described here. Hersey, Lampell, and Uris all read portions of the archive, diaries, and other primary documents as part of their research, as did I.[19]

I should mention one final commemoration of note from the seventieth anniversary of the uprising. Particularly affecting was a new statement written in honor of the ghetto fighters, circulated on the Internet, to be read during that year's Passover Seders:

On this night of the Passover Seder, when God redeemed the Jewish people from slavery and oppression in Egypt, we recall that night, 70 years ago, the first night of Passover 1943, when the Germans assaulted the Warsaw Ghetto. On that Seder night the remnants of the Ghetto, the remnants of the Jews of Warsaw, the remnants of the 1,000-year-old Polish-Jewish community rose up against evil and the enemy. Imbued with the call of Moses, they too declared, "Let my people go!" They took up arms, though no one gave them arms. They fought, though no ally fought with them. On this night of Passover, the Jewish birthday of freedom from oppression and slavery, they restored self-defense and power to the Jewish people. Thus, on this night of Leyl Shimurim when God watched over us millennia ago, we honor the memory of the young men and women of the Jewish Fighting Organization of the Warsaw Ghetto with a pledge that we will never forget the gift of revolt against tyranny that they bequeathed to us and to all humanity.[20]

This reading serves as a successor to one written by Rufus Learsi, penned near the tenth anniversary of the uprising and meant to be read at Passover Seders. Distributed nationally to synagogues and other Jewish organizations, Learsi's statement also connected Passover with the revolt that took place on the first night of the holiday a mere decade earlier, as well as with a larger history of Jewish oppression. Titled "Lest We Forget," it was dedicated in memory of "our brothers [killed] at the hands of a tyrant more wicked than the Pharaoh who enslaved our forefathers in the land of Egypt."[21]

Even into the twenty-first century, new creative incursions are being made. Two recent novels are set in the ghetto, neither about the uprising: Richard Zimler's *Warsaw Anagrams* (2011), a mystery filled with descriptions of daily life in the ghetto, and Jim Shepard's *Book of Aron* (2015), a work of historical fiction that explores the plight of children within the ghetto's walls. As I am putting the final touches on this manuscript, a musical about the ghetto, *Warsaw: A Musical Drama,* has been playing at a number of venues, with press attention suggesting a possible Broadway run. Only three years before, another musical set in the ghetto, *The People in the Picture* (2011), ran on Broadway at Studio 54 for a little over two months as a limited engagement.

With the book and lyrics by Iris Rainer Dart, author of the best-selling novel *Beaches*, *The People in the Picture* takes place in 1970s New York. The plot revolves around an aging survivor of the Warsaw Ghetto and her memories of her time as the star of a Yiddish theater troupe amid the struggles of living under the Nazi regime. Just a few years earlier, yet one more musical tried to make the Warsaw Ghetto popular material for the stage, *Imagine This* (2008), concerning a family of actors staging a play about Masada amid revelations of Treblinka and rumblings of a resistance. Produced and performed on London's West End for six weeks, the play reached a large U.S. audience in 2010 when PBS aired a filmed version of it in more than forty markets. That same year, a smaller Off-Broadway musical, *To Paint the Earth*, addressed the ghetto experience from its best-known vantage point: the struggle and hope of the uprising.

What may someday be the most prominent of Warsaw Ghetto projects has yet to be produced but has already garnered media attention: Miramax Films cochairman Harvey Weinstein aspires to produce a movie adaptation of Leon Uris's best-selling epic *Mila 18,* heretofore the most public and celebratory cultural production about the uprising and the subject of chapter 3.[22] There I delve deeply into Uris's novel about the Warsaw Ghetto and a number of interrelated endeavors, investigating how Uris dogmatically aimed to change the standard Holocaust narrative, illuminate anti-Semitism, and empower Jews—in regard to imagined Jewish cowardliness and physical deficiency, and misrepresentations of disloyalty to one's country—during a period when the Holocaust was no longer on the margins. Just as the actual uprising raised Jewish morale in 1943, Uris raised Jewish morale with his exhaustively researched fictional retelling of it in 1961.

I began this introduction with two epigraphs quoting the primary commanders of the Warsaw Ghetto uprising: Mordecai Anielewicz, who succumbed during the battle, and Antek Zuckerman, who survived, along with his future wife, Zivia Lubetkin. I chose to open with these binary statements because the first, exalting Jewish courage and self-reliance, has supplied the raison d'être for many creations about the revolt, while the second, much lesser known and about the aftermath, starkly contrasts with the optimism of its predecessor. Zuckerman's retrospective account, told to Claude Lanzmann in an undated interview conducted for the director's award-winning nine-and-a-half-hour documentary *Shoah* (1985), achingly conveys unmitigated suffering. As I have indicated, although the ghetto's suffering receives as much prominent attention in creatively inspired Warsaw Ghetto narratives as the uprising does, audiences expect and favor the overdetermined revolt. Indeed, the ghetto's quotidian suffering obviously less dramatic and more somber though it has received attention in scholarly accounts, has not been as readily acknowledged

in cultural representations, in part because we want to forget the calamitous and depressing when faced with something at least a little bit better, and especially when that very something has been turned into an unlikely spectacle. Far from monolithic, the position of the Warsaw Ghetto in American art is much vaster, less predictable, and more polyphonic than expected.

The desire to fashion works of art about the Warsaw Ghetto suggests a meta-awareness on the part of the makers discussed here; the drama is not only the heroic actions of the Jewish Combat Organization but also the struggles to record, preserve, and remember, which are always heroic imperatives in their own right in the penumbra of the Holocaust. Uris and others were interested in muscular Judaism in the physical sense but also in muscular archivism—compiling, collating, and creating "texts." Those "texts," in various media, may reenact the past to comment on its importance in the present, to revise the historical record, to influence the historical moment, to bear witness, or to work through the trauma ensuing from the Holocaust's despair—however futile that may be. In this light, a symbolic link connects the artistic "combat" work of the cultural producers in this book to the physical "combat" of the predecessors that inspired them. At their best, works of art orchestrate a variety of discourses and voices to produce robust cultural and social debate, rather than the unified nationalist narration of, say, an epic poem. Certainly some American artists are nationalists, but their works are inclusive of diverse stories and voices. Offering a fusion of hope and despair, dignity and degradation, faith and nihilism, and of course heroism, empowerment, and fortitude, the Warsaw Ghetto narrative has been more prominent in American culture than any other account from the Holocaust but the story of Anne Frank.

This study, by examining the Warsaw Ghetto's influence and multifold appearances in American culture, reveals the ways in which the festering city within a city has served as a recurrent tool for fashioning and refashioning Jewish identity. Even as my story captures one faraway locale from the mid-twentieth century that has taken on mythic status, it also reveals something about an enduring American fascination with the underdog and rebellion. To name but one example that surfaced during the conception of my project, *Time* magazine's Person of the Year in 2011 was "The Protestor." By integrating cultural, social, and political history, I consider the ways in which representations of the Warsaw Ghetto—a lasting symbol of eastern European Jewry—have been influenced and shaped by the Jewish American experience. Parsing how the Warsaw Ghetto has been depicted, commemorated, and transformed over time—while exploring connections between different art forms and themes—yields important insights about how Americans, Jews and non-Jews, use and make sense of the ever-present tragedy of the Holocaust.

1

We are like rams and sheep bound for sacrifice, except that it is hard to determine the exact instant at which one will be out upon the altar. The sword has already been removed from its sheath, but we haven't yet stretched out our necks for the slaughter.

—Chaim Kaplan, resident of the Warsaw Ghetto, July 31, 1942

The dream of my life has risen to become fact. Self-defense in the ghetto will have been a reality. Jewish armed resistance and revenge are facts. I have been a witness to the magnificent, heroic fighting of Jewish men of battle.

—Mordecai Anielewicz, commander of the Jewish Combat Organization, April 23, 1943

"You Must Be Prepared to Resist, Not Give Yourselves Up like Sheep to Slaughter"

Heroism, the Muscular Jew, and the Warsaw Ghetto, 1943–1950

While American Jews were not yet aware of Mordecai Anielewicz's characterization of the Warsaw Ghetto uprising as "the magnificent, heroic fighting of Jewish men of battle"—dubbed so in his last known letter to his deputy commander Antek Zuckerman—the idea of resistance in the ghetto as heroic, empowering, and epic immediately took hold in the American Jewish psyche, and from 1943 until the end of the decade the revolt resonated through the arts. Indeed, the partisans provided a grand final stand against the Nazis, fighting until death. This remarkable affair offered a potent symbol of a so-called "different type" of Jew: one of valor and self-determination. Subsequently, in varied media the uprising has been appropriated to subvert the unfortunate but common canard that Jews went to the gas chambers like sheep to slaughter.[1] The Jewish Combat Organization's call to resistance, from January 1943, even adopted this regularly repeated phrase as a rouse to rebellion: "Jews in your masses, the hour is near. You must be prepared to resist, not give yourselves up like sheep to slaughter."[2] Just before this call for action, in late 1942, historian Emanuel Ringelblum similarly wrote:

Most of the populace is set on resistance. It seems to me that people will no longer go to the slaughter like lambs. They want the enemy to pay dearly for their lives. . . . They calculate now that going to the slaughter peaceably has not diminished the misfortune, but increased it. . . . Now we are ashamed of ourselves, disgraced in our own eyes, and in the eyes of the world, where our docility earned us nothing. This must not be repeated now. We must put up resistance, defend ourselves against the enemy, man and child.[3]

Progenitors of American culture, whether in art, radio, theater, or literature—although also unaware of these rallying calls, issued directly from participants in the insurrection—employed the rebellion in various ways even in this early period to reveal that Jews were anything but passive, anything but sheep giving themselves up; from the onset, the revolt became a symbol of Jewish pride. This chapter examines such representations of "muscular Judaism," or the "tough Jew," across the arts, paying special attention to how the makers capitalized on the heroism of the Warsaw Ghetto uprising's rebels in the first seven years after it took place.

Radio Dramas as Propaganda to Awaken Hearts and Thwart Indifference

On June 14, 1943, with the Nazis having barely announced their victory in the ghetto, a short radio drama titled *The Second Battle of the Warsaw Ghetto* aired on NBC's Blue Network. One of a series of twenty radio plays written for and "dedicated to the war effort," *The Second Battle of the Warsaw Ghetto* was sponsored by the Free World Theatre.[4] Called *The Free World Series*, these productions, joint ventures of the Office of War Information, the Hollywood Victory Committee, and the left-wing Hollywood Writers Mobilization, aired on Sundays to five million listeners.[5] The plays were based on statements or suggestions by influential figures, including Pearl Buck, Adolf Hitler, Franklin D. Roosevelt, and Walt Whitman. A lost statement by Lillian Hellman inspired *The Second Battle of the Warsaw Ghetto,* the eighteenth installment of the series. Among the notable actors who performed the plays were Jackie Cooper, Dinah Shore (born Frances Rose Shore to Jewish immigrants from Russia), Lena Horne, James Cagney, Judy Garland, and Claudette Colbert. German Nobel Laureate Thomas Mann, living in Los Angeles at the time, was actively involved with the project. Mann's statement about a young soldier's return home after the war served as the impetus for the drama *Tomorrow,* and he penned the introduction that accompanied a published compilation of the series, which appeared in print in 1944.[6] He explained that the performances were

propaganda in the best and purest sense of the word. Propaganda—not for war. . . . At most it is propaganda for a war to which we were not in the least inclined but which was forced upon us in order to prevent evil from gaining sole mastery on earth, and which we must wage to the end for the sake of mankind's honor and for the preservation of our own free human lives. . . . It is good propaganda insofar as it awakes our hearts which are so much inclined to drowse in indifference, and summon them to hate evil and to believe in a better world as the fruit of victory.[7]

Written by Irving Ravetch, the son of a rabbi and later an acclaimed screenwriter, and performed by John Garfield (born Jacob Garfinkle to Russian Jewish immigrants on New York's Lower East Side) and Anne Baxter, *The Second Battle of the Warsaw Ghetto* tells the story of the Herzog family: Dovid (grandfather), Chaim (father), Zelbel (son), and Leah (daughter). Explicitly proclaiming the validity and currency of the events, the play begins with a voice announcing, "This we bring you now is the truth. Remember that, you who listen—this is the truth! It happened in your time! It happened—and is happening."[8] The action starts with the characters preparing for Shabbat and talking about the oppressions and restrictions in their community, such as the closure of Jewish businesses. Ravetch portrays the family as loving and tender; Zelbel offers to rub his grandfather's back as they distribute their paltry food rationing of bread. As the Sabbath candles are lit, a Nazi arrives at their door, inquiring about their status. Chaim informs the Nazi that his wife has died; he does not provide a reason, but one could infer that she may not have held up well under the restrictions imposed by the SS regime. After the Nazi departs, the family resumes their Shabbat prayers, only to be interrupted again, this time by a figure dubbed in the script as X, who describes himself as "a patriot" (225). This shadowy figure explains that he comes as a friend, with news of a planned revolt in the ghetto: "This is a moment for action. . . . You have friends, Herzog—an army of friends . . . we offer weapons." Confused, Zelbel asks, "Weapons—for what use—for what purpose?" X responds that the weapons are meant to fight the Nazis. Zelbel counters, "We are four, we are nothing!" adding, "What hope can there be in such madness?" (225, 226).

Zelbel's father, Chaim, warms up to the idea of fighting and possible escape, reiterating the oft-repeated shibboleth that informs the title for this chapter: "To stay and be slaughtered like animals, to cower here behind our doors and be cut down—no! We have had enough of that" (226). Dovid takes the position of much of the older generation, explaining that he is too elderly for a journey beyond the ghetto walls even if there could be a victory and subsequent escape. Still hesitant, Zelbel echoes his earlier refrain—"No-no hope!"—while X believes "there is always

17

The Muscular Jew

hope" (228), much like the protagonists in the stageplay *The Miracle of the Warsaw Ghetto* (described below). Before the conversation turns, Zelbel submits an argument adducing a stereotype that non-Jews have long held about Jews. Evoking the ancient example of Rabbi Akiva, he places his coreligionists in a position of passivity and bookishness: "The great Rav Akiba showed us, didn't he, Zaida [grandfather in Yiddish]? To accept death calmly, with nobility. . . . To sit like him, in ecstasy, chanting aloud from holy books while the Romans stripped his flesh with iron combs. There is our example. To die with our books in our hands" (228).

Leah, the sole female character, suggests that the family commit suicide rather than let the Nazis "defile our bodies" (228). Surprisingly, the grandfather, Dovid, first comes around to the idea of resistance:

We are Polish citizens, and this is our home. And here we shall stay—and here we shall die. But there is only one way for free men to die. And that is in defense of their freedom. . . . [turning to X] We shall take your weapons—and fight for what is ours. . . . We prepare the lesson—we teach the world. . . . We do our part. To those other millions in darkness like us, we say: See the Herzogs! See how free men and women hold their homes, fight for it from room to room! See the Herzogs, lying in their blood on the bedroom floor, holding their weapons! Awake, Herzogs throughout the world! To arms! (228, 229)

Once Chaim fully embraces Dovid's point of view, he echoes the fervor Anielewicz voiced in his final letter to Zuckerman: "This day the ghetto will see undreamed-of sights" (230). While the play mostly focuses on the family's musings about fighting and then the actual battle, a brief interlude conveys a sense of the life, and its typical events, that they will not be able to experience simply because they are Jews. About three-quarters of the way through the drama, Chaim asks his son if he would like to visit with a girl named Selma, who he matter-of-factly notes "would have been a good wife." Zelbel wistfully muses with one simple word, knowing he will never get married, "Wife . . ." (231; ellipsis in original).

The family readies as the uprising begins, with Dovid exultantly proclaiming: "I lived for this! Jews in arms! . . . Jews in battle! . . . Oh, God, you are indeed good, and omnipotent, and all-merciful!" (231, ellipses in original). In the midst of gunfire, ricocheting bullets, and screaming, the fight ensues. Shooting from their apartment's windows, the family members begin to fall. First Chaim dies, smiling, and then Dovid quietly passes. The young siblings continue fighting, and soon Leah is shot. Still, Zelbel remains convinced that resistance was the correct course, and links his family's conduct no longer to Rabbi Akiva's passivity but to fighting Jews of lore: "Zaida, I remember you used to read us of heroes . . . Bar Kochba in the mountain

gorges, with the Romans falling like leaves around him; Maccabeus, the Hammer on the Plains of Eretz Yisroel; Gideon trumpeting in the night—and now you, Zaida, and my father and my sister in a house in Warsaw. Yes—and myself beside you" (235; ellipsis in original). The production ends amid a thunderstorm, with Zelbel wondering if he, his family, and the Jews will be forgotten and if their fighting spirit will go unacknowledged: "Oh, Zaida, will the world know of us? Will the world know . . . ? Or are we alone here?" (235; ellipsis in original).[9]

On October 11, 1959 (rebroadcast April 1, 1973), the NBC program *The Eternal Light* aired a radio drama by Joseph Mindel about a man who chronicled the uprising. By way of its title and subject matter, this later radio play, titled *The World Will Know,* provided a rejoinder to its predecessor. To ensure that the world know, in fact, was the purpose of the Ringelblum archive—to leave behind tangible evidence of eastern European Jewry before its nightmarish end. This recurrent goal, to prove the veracity of the Holocaust and preserve a history of European Jewish life, resurfaces in Leon Uris's best-selling *Mila 18* (the subject of chapter 3 of this book). That novel's fictional historian, Alexander Brandel, much like Ringelblum, keeps a wartime diary, where he muses: "It seems that everyone is writing diaries these days. There is a terrible fear that we will be forgotten." Later Brandel laments to his wife: "They are going to destroy our entire culture. How can I preserve a few voices to show the world who we were and what we have given them? Who will be left?"[10]

Morton Wishengrad's wartime radio drama *The Battle of the Warsaw Ghetto,* approximately twenty-five minutes long and with themes analogous to those of Ravetch's play, aired on the eve of Yom Kippur 1943 on NBC-Red; rebroadcasts began that same year and have continued to the present. Starring Arnold Moss, the radio play won an award from the Writer's War Board as the War Script of the Month. The dramatization re-aired on December 12, 1943, in celebration of Hanukkah, thereby connecting it with the grand Jewish victory of the Maccabean Jews over the Syrian Greeks in ancient times. To leave no doubt about this analogy, the original script for this second airing includes a brief announcement to be read before the docudrama starts: "The National Broadcasting Company in cooperation with the American Jewish Committee brings you a special Jewish holiday broadcast commemorating the eight-day festival of Hanukkah, which begins next week. Hanukkah celebrates the heroic Maccabean revolt against the Syrians and symbolizes the triumph of light over darkness. Today you will hear a modern parallel of the Maccabean Revolt, with a dramatization of 'The Battle of the Warsaw Ghetto' written by Morton Wishengrad."[11]

Already an established playwright, Wishengrad was asked by the American Jewish Committee (AJC) to write a play to air on Yom Kippur, and he suggested the

subject of the uprising. Enthusiastic about this idea, AJC attorney Milton Krents immediately sent Wishengrad materials on the subject, including newspaper clippings and diary entries, which proved to be daunting. As Wishengrad remembered: "The more I read, the more inadequate to the task I felt. Several times I asked Krents to get another writer. He refused. I invented all sorts of pretexts. . . . But Krents insisted that I do the job. So I began. The average script takes me from ten to fifteen hours of steady writing. *Warsaw Ghetto* took nearly ten days." His goal, Wishengrad explained in 1945, was "to present the tragedy of the people who gave the world its monotheism, its morality, and its concept of the sacredness of human life. I wanted to present Jews as they are, without self-pity, without anger, and with the terrible conviction that, to paraphrase Theodor Herzl, if you cannot march, you must at least remain standing."[12] Taking Herzl's words to heart, Wishengrad deliberately constructed a story of dignified, strong Jews of whom American Jewry could be proud. Further, by self-consciously portraying Jews as willing to fight against all odds, Wishengrad crafted a plea to the larger American community, who might finally understand that this much-maligned people were deserving of assistance. At the same time, he revealed the family at the heart of the story as a family like any other (Ravetch did this as well), and thus the average person (i.e., Christian) could relate to their loyalty, love, and sorrow.

The docudrama was produced with a different cast on January 28, 1945 (with Raymond Massey as Isaac Davidson, the narrator), during the second year of the Jewish Theological Seminary's radio series *The Eternal Light,* and then to commemorate anniversaries of the uprising on April 19, 1959, and April 9, 1961.[13] It aired again on *The Eternal Light,* in relation to Hanukkah, on December 15, 1968, and December 11, 1977. The three original performances, between 1943 and 1945, widely heard, generated more than twelve thousand letters, and the War Department sent transcriptions abroad for the troops. Hundreds of amateur enactments, in Sunday schools, high schools, and colleges, were produced by 1945, in addition to an overseas broadcast on Armed Forces Radio.[14] On the seventieth anniversary of the rebellion, in 2013, the drama found life anew on the Internet, via *The Chosen Radio,* a series airing on BlogTalk Radio every other week. The contemporary announcer introduced the play by noting the epic fight as well as the vast loss of life afterward: "Today's program . . . commemorates . . . that heroic fight for freedom from the Nazis. Nearly 445,000 people were cramped into an area that previously had held one-tenth of that number. 13,000 Jews were killed in the ghetto during the uprising. Of the remaining 50,000 residents, most were captured and shipped to concentration and extermination camps."[15]

The Battle of the Warsaw Ghetto opens with the chanting of El Moleh Rachamim, a memorial prayer. Preceding the dialogue, a voice foreshadows the eventual outcome while offering praise for Jewish might: "It is a prayer for the dead . . . 'Ayl Maw-lay Rah-chah-meem' [*sic*]. Hear him with reverence, for it is no ordinary prayer and they are not the ordinary dead. They are the dead of the Warsaw Ghetto—the scapegoats of the centuries. . . . for them in the Ghetto of Warsaw there was no release . . . there was only the abyss. In the Ghetto thirty-five thousand stood their ground against an army of the Third Reich—and twenty-five thousand fell. They sleep in their common graves but they have vindicated their birthright" (33). The story proper commences with Isaac Davidson relating how he, his wife, Dvora, and their son, Samuel, were transferred into the Warsaw Ghetto by Nazis and issued food cards that entitled them each to a pound of bread a week. A female neighbor fills them in on the grim situation, a ploy to communicate salient facts to the listener, like the population explosion. She delivers the disturbing information that fifty thousand people lived in the ghetto before the walls went up and now five hundred thousand Jews are trapped within their prison fortress (35).

Importantly, this early segment underscores the spiritual resistance of those enclosed within the ghetto. Before her death, Dvora Davidson, for example, plants a few sprigs of grass on her windowsill to brighten their days: "Now our house has a garden. . . . There is no land where the sun doesn't shine. Now let it shine here on something green in the Ghetto" (35). The narrator emphasizes this optimistic perspective: "Green grass in the Warsaw Ghetto . . . a few pathetic blades of green in the scrabbled earth. But a sign of living spirit and a proof that where the spirit lives there can be no degradation. There in this place of death, shut-off, walled-in, foredoomed, there were things of the spirit done by men and women like Dvora. In the Ghetto of Warsaw there was beauty and comradeship and learning" (35). Later scenes impart details about children's secretly learning, with the narrator stressing this activity along with a description of the ghetto symphony, four ghetto theaters, and other life-affirming endeavors:

The Ghetto waited for tomorrow. It tried to do so with dignity and self-respect. . . . In the cellars of the tenements the children went to classes; and wherever there was a patch of dirt the older boys studied agriculture; carpenters taught their trade to clerks with thin chests; the watchmakers and the leather workers opened trade schools; the artists taught their art. And all of this was free. Whoever wanted to learn was welcome. It was a somber, grim, melancholy place, heavy with the foreboding of death, but we encouraged each other to work and to study and to laugh. (37)

Davidson reports more than fifteen thousand deaths from typhus, including his wife, Dvora, with their son sobbing over her dead body. He then pragmatically does the unthinkable: Davidson takes Dvora's body to the street and leaves her there, naked and nameless, so that he and Samuel can still collect her bread, which Davidson calls Samuel's "inheritance" (39). The Mourner's Kaddish, a prayer recited as a part of mourning rituals, and the sound of young Samuel crying, quickly follow. At this point, midway into the broadcast, the listener has been privy to one family's degradation and deprivation and their attempt to stay strong amid this desolation. Next come more historical particulars. The narrator relates that on June 22, 1942, trucks entered the ghetto to begin the liquidation, "and each day thereafter the black trucks came. And each day when they left, there was weeping in the Ghetto. . . . Listen, 275,954 fewer bread cards in the Ghetto! Swift, accurate, final. Quicker than typhus, surer than hunger" (40, 41). The story takes a turn here, with Davidson explaining the ghetto residents' appeal, through the Polish underground, for weapons from the United States, England, and Russia: "We waited for weapons that did not come. Five hundred thousand waited. (*Pause*) Three hundred thousand waited. (*Pause*) One hundred thousand waited. And finally thirty-five thousand who didn't know where to look . . . but the answer came from under their feet—from the sewer under the Warsaw Ghetto" (41).

The next four pages of the script, almost a third of the entire play, convey the uprising in dramatic fashion, punctuated by sounds of gunfire and screams of pain, portraying Jews at battle with meager weapons yet achieving small victories. Davidson narrates: "April 19, 1943. Thirty-five thousand men, women, children stood ready. It was the day. Trenches were dug during the night. Every house, every room, every cellar, every roof was prepared. At 4 a.m. a detachment of Storm Troopers in light tanks escorted the black trucks to the walls of the Ghetto. They came as usual on their daily errand. We waited until the vehicles were within range. . . . The entire detachment was wiped out. In a few hours they came again. SS troops. Our snipers manned the Ghetto Wall itself. We were ready" (42, 43). Days have passed, the fight almost over, when Davidson encounters a fallen comrade whose right arm was blown off at the elbow. He refuses a bandage, asking instead about the battle. Davidson replies, "We're still fighting," and then melodramatically paints the picture of his friend's final minutes: "The blood ran from the shattered stump and soaked the ground. But he smiled. . . . The smile lingered on his lips even as his eyes began to glaze—and he spoke an epitaph for the Warsaw Ghetto" (44).[16] That "epitaph," Wishengrad explained a few years later, was inspired by his reading of the teachings in *Pirkei Avot,* or *Ethics of the Fathers* (early third century C.E.), a compilation of Jewish thought from generations of rabbis; in the often-cited *Pirkei Avot,* Wishengrad

first encountered the words he placed in the mouth of the dying man near the end of *The Battle of the Warsaw Ghetto*.[17] To be sure, the fallen ghetto Jew's penultimate utterance adopts the words of a Jewish sage of yore: "It is not for thee to complete the work, but neither art thou free to desist from it." Overdramatically, but still powerfully, the dying man adds, "Tell them to mark that on my grave" (44–45). A haunting rendition, once again, of El Moleh Rachamim filled the airwaves, fading under the voice that began the broadcast:

Hear him [the cantor] with reverence. For he sings a prayer for the dead—twenty-five thousand dead. It is no ordinary prayer and they are no ordinary dead. For they are the dead of the Warsaw Ghetto—in the year nineteen hundred and forty-three. Tonight they sleep in their last trench, their choirs dispersed in ashes, their holy books sodden in the seventh-month rain, the rubble deep on the thresholds of their houses. They were Jews with guns! Understand that—and hear him with reverence as he chants the prayer. For on the page of their agony they wrote a sentence that shall be an atonement, and it is this: Give me grace and give me dignity and teach me to die; and let my prison be a fortress and my wailing wall a stockade, for I have been to Egypt and I am not departed. (45)

Wishengrad's play imparts a story about both spiritual and physical resistance. By the end, he has unequivocally shown that the Jewish dead, martyrs who died by fire, had risen to the occasion (had offered spiritual resistance, "stood their ground," and "vindicated their birthright") and should be celebrated. Moreover, "they were Jews with guns," emphasized with an exclamation point in the script, which demonstrates that Jews are in fact willing to fight when supplied with weapons, a counter to stereotypes of weak, bookish Jews who shy from battle, as claimed by Zelbel in *The Second Battle of the Warsaw Ghetto*. This accounting of ghetto life frames the doomed Jews in the best possible light for Jewish and non-Jewish listeners; Wishengrad was well aware of the large Christian audience for NBC–Red, and, later *The Eternal Light*. As such, he depicts Jews as strong in their resolve, human, and deserving of rescue, and hence the script ably meets the goals of the play's sponsor, the American Jewish Committee—a long-standing group dedicated to contesting anti-Semitism.

Fine Artists Respond

Soon after the uprising, artist William Gropper, who had already made a name for himself as a biting satirist contributing prints to a number of journals, published a series of eight drawings collectively titled *Your Brother's Blood Cries Out*

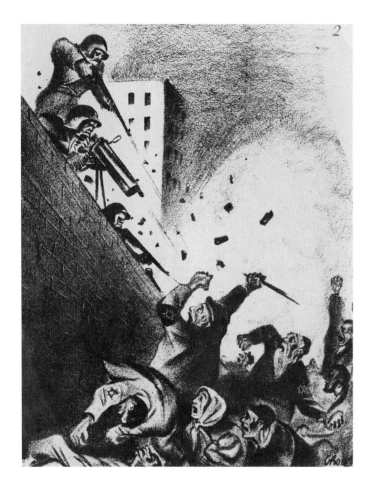

Fig. 2 William Gropper, opening page of *Your Brother's Blood Cries Out: Eight Drawings by William Gropper* (n.p., 1943). Lithograph, 8 ⅝ × 12 ½ in. Sheet, 10 ½ in. × 14 in. William Gropper Papers, 1916–1983, bulk. Archives of American Art, Smithsonian Institution, Washington, D.C.

(1943). This title, based on Genesis 4:10, adopts God's words to Cain after he murdered his brother, Abel. Gropper explains, "Hitler and fascism made me aware that I was a Jew. I think all intellectuals who were never concerned with their faith were thrown into an awareness by these atrocities. I put out a portfolio, *Your Brother's Blood Cries Out,* lithographs of the Nazi atrocities against Jews."[18] Most of the images depict the subjugation of Jews and particularly ruthless treatment at that. The cover portrays a bleak landscape with two Nazis standing next to a pile of bodies, and Jews digging a mass grave for their coreligionists. In one drawing, four Jews have been hung on a crossbar, their bodies limp and dangling above four laughing Nazis. The opening page of the small portfolio, though, features Jews fighting from behind the ghetto's wall (fig. 2). Combatants wield their meager weapons, and the SS looms over them with large rifles, but their defiant struggle continues. *New Currents* magazine, a New York–based periodical published for two years under the auspices of the Jewish Survey Corporation, reproduced the entire portfolio in its pages and offered a nine-by-twelve-inch reproduction of any of Gropper's eight drawings to one-year subscribers. Gropper's print depicting Jews rising up against their oppressors accompanied William Shirer's review of John Hersey's Warsaw Ghetto novel *The Wall* (discussed in some depth in the following chapters). Above the reproduction, the review's subheading accentuated the broader strokes of *The Wall* in terms akin to those outlined in this chapter: "It is a monumental epic of the Jews who lived and died there—and of all men facing death."[19]

Three years later, at the third anniversary of the uprising, Gropper repurposed the eight drawings from *Your Brother's Blood Cries Out* for a collaboration with the author Howard Fast. The result was a small book titled *Never to Forget: The Battle of the Warsaw Ghetto,* published by the Book League of Jewish Peoples Fraternal Order. Gropper drew one additional image for the collaboration: a cross section

of Jews, one an elderly bearded figure with his arms raised toward the heavens, standing before a firing squad. Although all but one of the drawings emphasize the brutality of the Nazis and Jewish suffering rather than fighting, Fast's narrative, written in the form of a poem, mostly tells the story of the uprising. Running through the poem are the themes of remembrance, heroism, courage, and hope (themes that recur throughout this book). Fast opens the poem as follows:

> We Pledge never to forget the page
> of heroism and courage written by the
> Jews of Poland in the Battle of the Warsaw
> Ghetto. With their blood and anguish they
> inscribed the hope for a bright new world.[20]

It is worth pointing out that Gropper visited the ruins of the Warsaw Ghetto in the late 1940s. The trip made a strong impression on him; at the time, he vowed to make one painting annually in memory of those who died in the Holocaust. He did not scrupulously follow through on this lofty goal of remembrance, but on a few occasions he painted a single elderly Jew lamenting to the heavens. One canvas in this vein, painted in 1966 but now lost, bore the inscription "Dedicated to the memory of the victims of the Warsaw Ghetto."[21]

At roughly the same time as the two radio dramas and publication of Gropper's portfolio of drawings, artist Ben Wilson painted a canvas of the revolt titled *Uprising in the Polish Ghetto* (ca. 1943; fig. 3). Nine multigenerational figures rendered in vigorous movement dominate the scene, with several displaying extreme anguish; the girl on the far right, perhaps a daughter, clutches at the large man holding a knife, pulling at his clothes in an effort to restrain him, while what might be a young son clings to his father's leg. In contrast, the figures on the left maintain a different purpose; they seem to be encouraging the dominant figure on his mission. All of the figures' eyes gaze in different directions. Thus does Wilson communicate the hopelessness of the situation, whether or not the figures are family members who know that their loved one embarks on a suicide mission. The fighter's compatriots on the left, however, are confident of the justness of their purpose, though they demonstrate different mind-sets in the face of this untenable venture. Complemented by somber shades of green, brown, and blue, evoking Picasso's austere palette during his Blue Period, the painting expresses the relentless despair that Wilson felt during the Great Depression and World War II, particularly the Holocaust. His dramatic painting captures the discordant objectives of the figures and at the same time accentuates the mission of the principal figure in the painting. To underscore the figures' importance, only a sparse tree hints at the

Fig. 3 Ben Wilson, *Uprising in the Polish Ghetto*, ca. 1943. Oil on canvas, 32 × 41 ⅞ in. William Benton Museum of Art, University of Connecticut, Storrs. Reproduced by permission of the Ben Wilson Estate. Photo courtesy of the William Benton Museum of Art.

unspecific landscape, and the figures themselves are pressed against the picture plane as evidence of the artist's main focus: the ensuing battle and reaction to it. Gripping a handheld weapon, the principal figure surges resolutely forward. That a highlight of red lines the edge of his knife, hinting at future combat or past rebellion, deftly suggests Wilson's aim to communicate the individual goals of the men and women populating *Uprising in the Polish Ghetto*. For the chief figure, his purpose was to fight.

It is no surprise that Wilson turned to the subject of the uprising, considering that his work from that time was concerned with social issues and he had previously painted canvases in response to Nazi tyranny. *Flight* (ca. 1935) addresses analogous matter about Jews under siege. While not about an impending battle, *Flight* portrays another tightly packed cross-generational group that attempts to escape oppression. *Deportation*, painted the same year as the uprising, depicts five expressionistic figures in an ambiguous circumstance; two women sit in a boat, and three other figures on

land quietly stand by. Rendered in subdued colors, this vertically oriented canvas tells a story of Jewish dislocation. Exposing the injustices of his age provided a compelling raison d'être for Wilson through the 1930s and 1940s. As he explained: "The implicit aim of all art is the extension of the consciousness of one to many, of the now to the hereafter."[22] Like the two radio shows previously discussed, Wilson's painting about the ghetto's insurrection—although it would have reached a much more limited audience—carried a broader point about Jewish fortitude and worthiness for rescue.

Almost concurrently, Shlomo Mendelsohn, a public leader in prewar Warsaw and a member of the executive board of the Yiddish Scientific Institute, presented a paper in Yiddish titled "The Battle of the Warsaw Ghetto." Soon thereafter it was published in Yiddish in the January–February issue of *Yivo Bleter* (1944) and reprinted in its entirety in the spring 1944 issue of the *Menorah Journal.*[23] A pamphlet with the same name and containing this material, written for a general audience, was translated into English and widely distributed in the United States. As Max Weinreich stated in a brief preface to the twenty-eight-page publication: "In view of the contemporary and historical interest of the subject, the Executive Board of the Institute resolved to issue this material in English translation and thus have its contents brought to the attention of the American public opinion."[24] That opinion, the Yiddish Scientific Institute hoped, was again that the Jews had suffered greatly—and enough; had fought hard and long; and were deserving of American intervention. Mendelsohn drives this point home by introducing data gathered about the uprising via underground reports, the Polish government, the Polish underground press, and witnesses who escaped. In addition to submitting as many possible details about the battles in the ghetto, along with a map illustrating where they occurred, Mendelsohn describes the atrocities to which the Jews were subjected, the appalling position of the Judenrat, and Adam Czerniakow's suicide, as well as the ghetto residents' starvation and subsequent deportation. Mendelsohn ends his report with the following summary, worth quoting at length (and take note of his careful use of words echoed throughout this chapter: "heroism," "resistance," and "sacrifice"):

I have tried to be as cool as possible in my account of the revolt. I have tried to stifle the pain, the admiration and the feeling of guilt that is ours. When the day of reckoning dawns and the tribunal of the world will pass judgment on the deeds of heroism in the struggle against the forces of evil, Jewish resistance in Poland will be part of the evidence submitted. Will there be one among us capable and worthy enough to present this miraculous evidence to the world? I hope that there will still be a Jewish people in Europe and they will be the ones to tell humanity of the moral summits attained by the Warsaw Ghetto fighters in their unequalled sacrifice.[25]

Theater and the Elusive Miracle

Barely a year and a half after the courageous exploits of the Warsaw Ghetto fighters, on October 10, 1944, the New Jewish Folk Theatre (formerly the Yiddish Art Theatre) debuted its inaugural production, also highlighting the epic fight: a Yiddish-language play by H. Leivick (pen name of Leyvick Halpern) boldly titled *The Miracle of the Warsaw Ghetto* (*Der Nes in Geto*). Leivick was a poet who had gained renown for *Der Goylem,* first performed in Hebrew by the Habima Theater in Moscow in 1925 and later in Yiddish. His ghetto drama was billed on the play's poster as a "great artistic production . . . about heroic resistance in Warsaw" that "must be seen by every Jew" (fig. 4). The play, considering the language spoken by the actors, was written for a Jewish audience, and so its message—one of inspiration and optimism—must be interpreted as geared to Jews and not of a wider purview. *The Miracle of the Warsaw Ghetto* ran in New York for twenty weeks and then traveled to venues in Milwaukee, Chicago, and Montreal, Canada. The show centers around a group of disparate characters who unite to fight for a common cause; these characters comprise, among others, a Zionist, a Bundist, a Breslever rabbi, the daughter of a reviled convert, and a warrior from Eretz Israel. One critical running storyline concerns the character Israel, who initially opposes violence; in act 1, scene 1, Israel invokes the ubiquitous canard that fighting is "not the Jewish path," while Rabbi Itzik calls this mentality a "disgrace" and counters, "I do not give my permission for weakness!"[26] Following the death of Rachel, the girl Israel loves, during an underground mission, he reconsiders his passive stance and joins the rebellion.

Heinz A. Condell, a German Jewish refugee who arrived in the United States in 1938, created the stage designs, with the climactic uprising captured in a photograph on the play's poster (fig. 5). In the photograph, more than a dozen militants aim guns and prepare to throw homemade grenades amid the debris of the ghetto—replete with a tattered Zionist flag flying above the tumult and wreckage. Hanging above the detritus of battle, a banner reads, "Gevalt yidn zayt zikh nit meyaesh," or "For heaven's sake, Jews, don't despair," repeating a comparably sanguine sentiment from *The Second Battle of the Warsaw Ghetto* voiced by the character X when urging the Herzog family to fight and not give up hope. As the play opens, this same mantra appears on a somewhat incongruous sign hanging over the Torah ark in the synagogue; one character, Leybush, sings, "For heaven's sake, Jews, don't despair," as his voice trembles (fig. 6). Leybush incants this refrain anew in the second act when the rebellion begins—and it serves as a theme running through the production. Seeing not only the melodrama in Leivick's play, the producers characterize the staging as "optimistic in tone" and the play itself as "a heroic drama rather than a tragedy."[27]

Indeed, the miracle in the play is the Jews' triumph in battle against the odds, however fleeting, even as they die fighting.

Starring eminent Yiddish actor and director Jacob Ben-Ami, the play unfolds in three acts. The play starts on the eve of Passover "in a very poor synagogue," per the stage direction, with the trapped Jews preparing for the holiday and simultaneously for the resistance, noting their lack of weapons.[28] As one character puts it early on, employing crucial words from the Passover Seder as a preface, and with a touch of humor: "Why is this night different from all other nights? On all other nights we let ourselves be led like calves into the gas chambers. But on this Passover night we will not let that happen. We will shoot. What will we shoot, ha? Now that is a question."[29] Scene 2 of act 1 finds the Jews at their meager Seder, eating smuggled food and anticipating the Nazis arrival while waiting for weapons. The would-be insurgents mobilize themselves in this talky scene, and the audience gets to know the characters' individual personalities and their commitment to family. The scene closes with the start of gunfire and the call to arms.

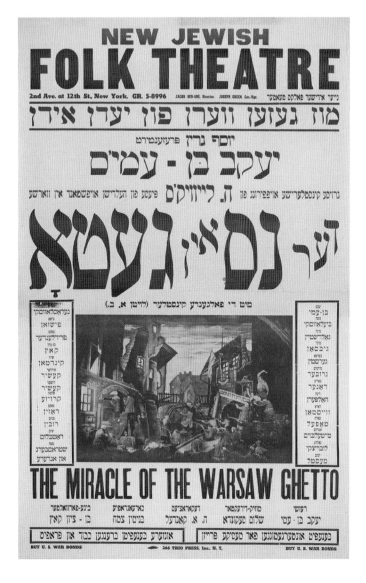

Fig. 4 *The Miracle of the Warsaw Ghetto*, 1944. Poster. American Jewish Historical Society, New York, N.Y., and Boston, Mass.

Acts 2 and 3 comprise the battle. Act 2 commences two weeks into the uprising, with the synagogue serving as a hospital for the wounded. Rabbi Itzik, who has been shot in the leg, calls the Jews "heroes of Israel," and Rachel deems them "very brave" and "heroic," which the rabbi seconds. The warrior from Eretz Israel, Joseph—who keeps a journal (prescient on Leivick's part, considering how important wartime journals became in future assessments of the Warsaw Ghetto)—comments that "to die as a proud Jew, one must live differently," meaning a Jew must fight.[30] To no avail, the comrades wait for weapons to arrive from the Polish underground, and so Rachel volunteers to leave the ghetto to procure new arms. She does not return (we soon

Fig. 5 *The Miracle of the Warsaw Ghetto*, 1944. Theater still. Ivan Busatt / Museum of the City of New York, 69.133.1.

Fig. 6 *The Miracle of the Warsaw Ghetto*, 1944. Theater still. Ivan Busatt / Museum of the City of New York, X2012.7.356.

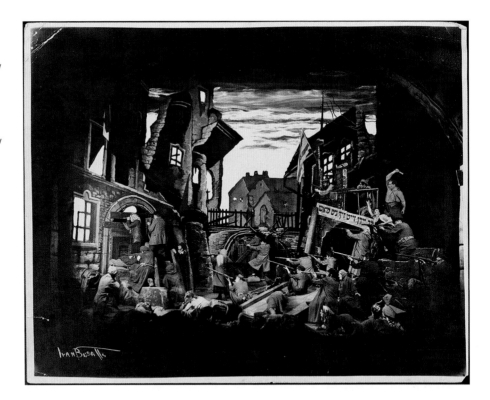

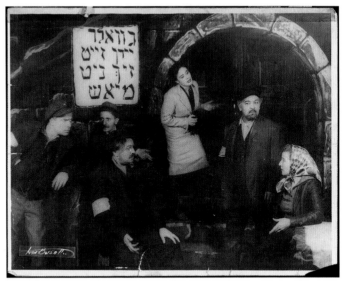

find out she has been killed), but after a long period a representative from the Polish underground arrives, proclaims the uprising "miraculous," and compliments the comrades' "remarkable heroism."[31] Guilty over Rachel's death because he did not volunteer for the mission instead of her, Israel finally joins the fight. As act 2 closes, Israel leaves the ghetto in search of additional weapons.

The third act begins with the synagogue defiled by bullets and the stage littered with the rubble of buildings destroyed by bombs. Yet the banner with the mantra "For heaven's sake, Jews, don't despair" still hangs, as does the Jewish flag. Throughout, the sounds of fired bullets pepper the action. Reb Itzik remarks that God has shown the comrades "miracles" even as the group has suffered thirst, the holy ark and one Torah scroll have been destroyed, and Israel has not returned after three days.[32] Finally, Israel comes back with some dynamite, and Nazi tanks enter the ghetto. Israel, on a suicide mission, runs into the courtyard with the dynamite and blows up the first tank. The remaining Jews acknowledge that the victory is in dying proud and vow to fight on, which they do. Act 3 offered, according to a reviewer in the *Montreal Gazette,* a "highly dramatic" recounting of the daring of the Jewish defenders, staged across "a striking tableau" of barricades, and photographs of the production confirm this appraisal.[33] In short, a Jewish fighting spirit, Jewish honor, and the bravery of the comrades, as the characters call themselves, pervade the play. Jewish militancy is even featured in a promotional photograph of Ben-Ami, which portrays him resolutely staring forward and purposefully grasping a large rifle (fig. 7). At different points the characters lament the murders of their brethren and vow not to be similarly slaughtered, a word used frequently in different conversations. God's mercy and at times his absence are also invoked, as is the belief of some of the characters that God will protect them in battle.

Of course there was no miracle, as the title seems to suggest initially, if a miracle meant that the Jews survived. No, even they knew that their fate was sealed. Still, coverage in the *Day,* a Yiddish daily newspaper, used the same term. Samuel Margoshes, who wrote the column News and Views, did not address the uprising until May 12, several weeks after it took place, because he doubted the veracity of the events. When Margoshes did finally write an appreciation of the fight, "miracle" was the word he found most apt (akin to Mendelsohn, who in his paper dubbed the battle "miraculous"). As Margoshes put it:

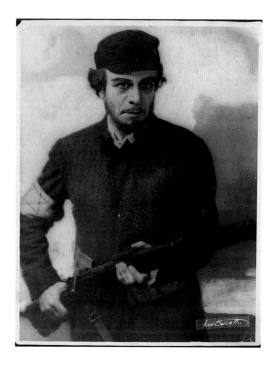

Fig. 7 Jacob Ben-Ami, promotional photo for *The Miracle of the Warsaw Ghetto,* 1944. Ivan Busatt / Museum of the City of New York, 69.133.2.

I did not write about the heroic resistance of the Jews in the Warsaw ghetto immediately after the strange news broke, for the simple reason that I distrusted the information. Frankly, it seemed unbelievable to me. For how is it possible, I queried, for unarmed people to stand up, even for ever so short a time, against the greatest military machine the world has ever seen. . . . I confess now that I took the reports . . . [as] Nazi propaganda designed to afford a pretext for Nazi atrocities. . . . However, I see now that I was mistaken. There was an upflare of Jewish resistance in the Warsaw ghetto, and it was one of the miracles of our age.[34]

Subsequently, the few surviving ghetto insurgents did not repeat the refrain of a "miracle" in their postwar recollections but instead stressed the goal of dying with honor—which meant, matter-of-factly, fighting even with the foregone conclusion of death. Years later Marek Edelman, cofounder of the Jewish Combat Organization and the only uprising leader to remain in Poland after the war, explained that on the second day of the uprising, April 20, the Nazis "called out that if we'd agree to a ceasefire, they would send us to a special camp. We shot at them. . . . By the way, we missed, but it doesn't matter. . . . The important thing was just that we were shooting."[35] True to reality, in the final act of Leivick's play most of the cast fights, and instead of showing their deaths, the play has the rebels vow to fight until their end. The play was so well received as a symbol of courage and hopeful affirmation that soon after the war's end Leivick was sent—along with opera soprano and folk singer Emma Lazaroff-Shaver and a delegate from the International Red Cross—by the World Jewish Congress to Europe "to help sustain the morale of the thousands of Jews in the displaced persons camps whose physical and mental condition has been endangered by the long series of trials to which they have been subjected," as the Jewish Telegraphic Agency euphemistically and mildly reported.[36] Leivick left the United States in early January for a two-month visit in Germany.

Arthur Szyk's Fighting Jews: An Artistic Call to Action

Artist Arthur Szyk, born in Lodz, Poland, who immigrated to the United States in 1940, also explicitly foregrounds heroism and Jewish strength in several images. This theme forcefully surfaces before the war in a frequently reproduced gouache-and-watercolor work, *Joseph Trumpeldor's Defense of Tel Hai* (1936; fig. 8), which was completed when Szyk still lived in Poland but which ultimately and repeatedly engaged an American audience. The painting depicts the brave actions of Jewish settlers, led by Joseph Trumpeldor, at Tel Hai in 1920. A Russian-born Zionist activist who immigrated

Fig. 8 Arthur Szyk, *Joseph Trumpeldor's Defense of Tel Hai,* 1936. Watercolor and gouache, 9 ⅛ × 7 ⅝ in. Reproduced with the cooperation of The Arthur Szyk Society, Burlingame, Calif., www.szyk.org.

to Palestine, Trumpeldor died while defending Tel Hai—a village in the northern Galilee—against an Arab siege. Legend has it that a wounded Trumpeldor uttered his triumphal assessment—"Never mind, it is good to die for our country"—as he perished. Whether true or not, Trumpeldor's feats and courageous perspective stirred fellow Zionists, who extolled him as an exemplar of the armed and bellicose Jew.[37] Summoning the triumphal and pyramidal scheme of Eugène Delacroix's monumental canvas *Liberty Leading the People* (1830), with its charging mass of militants from the July Revolution, the meticulously detailed *Joseph Trumpeldor's Defense of Tel Hai* shows its protagonist at the apex of a group of male and female fighters, gun held aloft. To ensure that his viewers understood the identities of the fighting Jews, Szyk labeled

33

The Muscular Jew

the painting "Tel Hai" in gold-hued Hebrew surrounded by painstakingly rendered decorative components inspired by medieval manuscript illuminations. Underneath, Szyk added another layer by quoting a portion of the ancient Jewish sage Hillel's famous aphorism "If I am not for myself, then who will be for me?" By adopting the figure of Trumpeldor, Szyk offers viewers a confident twentieth-century Jew fighting against would-be oppressors while, as Joseph Ansell astutely observes, associating him with an ancient and often-quoted source of wisdom.[38]

The eventual "reinterpretations" of Szyk's painting first link it to calls for Jews to fight and then to the definitive and most visible battle in which they did fight: the Warsaw Ghetto uprising. *Joseph Trumpeldor's Defense of Tel Hai* initially appeared in the United States on the cover of the periodical *American Hebrew* in May 1941. With the United States still holding steadfastly to their international policy of isolation and nonintervention, the painting was meant to spur American Jews to action. That is to say, it was used to urge the U.S. government to increase its military response to Nazi aggression, especially in light of the revised title that the magazine appended to the painting: *May I Perish with the Enemy*.[39] Under its original title, the painting was reproduced again, the following year, in *American Hebrew*. That the magazine's readership would have beeen almost exclusively Jews further indicates that Szyk aimed to empower his coreligionists as both fighters and advisors to the larger Jewish community, encouraging them to act on behalf of European Jewry. In 1944, *Joseph Trumpeldor's Defense of Tel Hai* served as the cover image for Rufus Learsi's slim book *The Jew in Battle,* published by the American Zionist Youth Commission. (Near the uprising's tenth anniversary, as noted in the introduction, Learsi created a reading focused on remembrance of those who died in the ghetto to be read during the Passover Seder.) *The Jew in Battle* describes the rebellion in laudatory prose; Learsi characterizes the events in the ghetto as ones of "indomitable death-defying courage." He also furnishes background about Jews as "a fighting people," reaching as far back as biblical times and recalling Bar Kochba—a legendary Jewish revolt against the Romans (132 C.E.)—among other armed encounters, including the episode at Tel Hai.[40]

Likely inspired by news of the unexpected insurrection in the ghetto, and surely with fascism on his mind, Szyk conceived *Modern Moses* (1943; fig. 9), a work reproduced and circulated by the Emergency Committee to Save the Jewish People of Europe. A defiant and muscular Moses stands at the center, arms upraised, flanked by a youthful Aaron to the left and Hur on the right. While typical of the long-bearded incarnation of Moses found in art's history, Szyk's Moses deviates from precedent with his rebellious and resolute gaze and strong hands fitting of a fighter rather than the familiar pensive older patriarch found in, for example, Rembrandt's *Moses with the Tablets of the Law* (1659; fig. 10). Michelangelo's *Moses* (ca. 1513–15; fig. 11) does

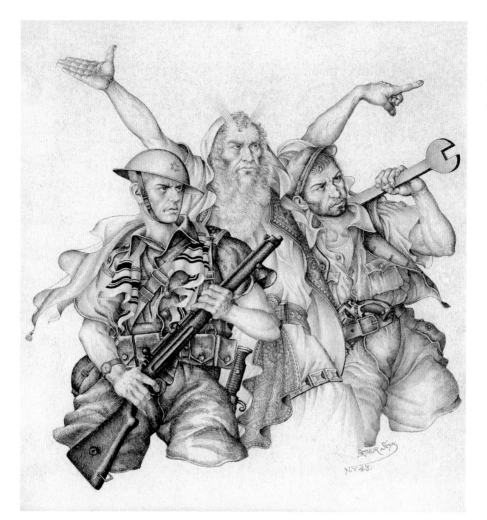

Fig. 9 Arthur Szyk, *Modern Moses*, 1943. Pen and ink and pencil, 10 × 7 ½ in. Reproduced with the cooperation of The Arthur Szyk Society, Burlingame, Calif., www.szyk.org.

possess a well-defined physique and intense stare, but the artist did not sculpt him as such to make a comment on the Jewish body, readiness for battle, and physical fitness. Michelangelo consistently explored human musculature and sculpted idealized figures regardless of the subject (e.g., *David*, 1501–4). In the case of his *Moses*, the dichotomy between the figure's advanced age and his physique may be jarring for some, although his deep concentration coincides with the tension in his veins and muscles as he clutches the Tablets of the Law, an accoutrement that does not capitalize on his taut anatomy as much as the weapon-toting figures flanking Szyk's Moses.

Szyk took inspiration from the biblical story of the Jews defeating Amalek on the way to Israel, in Exodus 17:8–13. Specifically, Exodus 17:11 states, "And it came to pass, when Moses held up his hand, that Israel prevailed; and when he let down his

Fig. 10 Rembrandt, *Moses with the Tablets of the Law,* 1659. Oil on canvas, 66 ½ × 54 in. Gemäldegalerie der Staatlichen Museen, Berlin.

Fig. 11 Michelangelo, *Moses,* ca. 1513–15. Marble, height 92 ½ in. San Pietro in Vincoli, Rome. Photo: Wikimedia Commons (Jörg Bittner Unna).

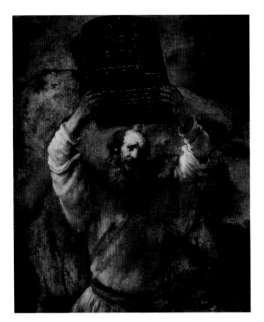
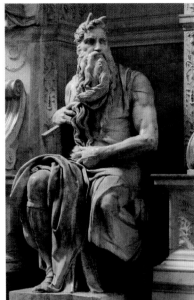

hand, Amalek prevailed." Naturally Moses's hands must then remain upraised, but of course they grew tired; in support, Aaron and Hur placed a rock on the ground as a seat for Moses and helped him keep his arms aloft (Exodus 17:12). This scene is not unprecedented in art, but by no means was it popular. American painter William Page, for instance, painted *Moses, Aaron, and Hur on Mount Horeb* (1857; fig. 12), fashioning Moses as an older man so tired that as Aaron and Hur assist him, he closes his weary eyes and his body slouches. Szyk's bellicose and brawny Moses deviates substantially from this image and others in the history of art.

A configuration comparable to that in *Modern Moses* surfaced earlier, in Szyk's renowned *Haggadah* (1935; fig. 13), urging Jewish might but without the blatant connection to the present.[41] In this version of the biblical trio, Moses possesses even more defined musculature, with each sinew visible (notably, Moses is not mentioned once in the Haggadah's text, but that did not deter Szyk from making his point). Markedly, Aaron and Hur remain in the biblical realm, wearing ancient costumes, and are closer to Moses's advanced age. The scene takes on a metaphorical cast in both versions, representing powerful Jews defeating a generic enemy. *Modern Moses,* though, stands out in its self-proclaimed modernity because its Aaron and Hur are depicted as contemporary young militants. This trio embodies resistance at its finest, rooted in both the biblical past and the modern day. Obviously a Jewish soldier, Aaron wears a *tallit* (Jewish prayer shawl), combat helmet decorated with a Star of David, and army fatigues while carrying a gun; early Zionists favored the Star of David as a the symbol for Zionism, Gershom

Scholem explains, because "it lacked any clear connection with religious conceptions and associations."[42] Hur appears as a makeshift ghetto fighter with a pistol tucked into his belt and an improvised weapon, an oversized wrench, casually sitting on his shoulder. The metaphorical Aaron, a trained fighter with a gun, joins with Hur, who knows that as a Jew already marked for death he has nothing to lose in battle and at least his honor to gain. Standing with Moses, who wears a long flowing robe, discernibly ensconced in the biblical era, this younger duo cannot help but gain confidence; Moses, a mortal certainly, but one with connections to God, may just be the most potent weapon of all. The threesome in *Modern Moses* gaze ahead with determination toward a common purpose, while the *Haggadah*'s Moses, Aaron, and Hur—who are rendered in color and fine details—face in different directions. Certainly the *Haggadah*'s figures inspire assurance, but they serve as a generic Zionist statement (a theme running through the *Haggadah*) rather than as war commentary addressing the then-current struggle. The simplicity of line and hue with which Szyk renders *Modern Moses* contributes to the print's effectiveness as a visual pronouncement of Jewish courageousness across time.

Fig. 12 William Page, *Moses, Aaron, and Hur on Mount Horeb*, 1857. Oil on canvas, 118 × 82 in. Smithsonian American Art Museum, Washington, D.C. Gift of Donald E. Kastner, 1977.98.

In *Modern Moses*, Szyk has interpreted a Jewish text, the Bible, and made it relevant to modern times: his visual critique, citing the importance of Jewish strength and warfare, has been reworked in accord with the methods of the Jewish sages. Szyk employs a variation of the two-thousand-year-old tradition of Midrash. Written commentary on the biblical text that engages in exegesis but is more *"concerned with the creation of meaning,"* Midrash, in part, attempts to make the Bible's stories relevant to modern life.[43] It is the job of the Jewish sage—and in the twentieth century such a sage can be understood as a rabbi or a scholar (or an artist, as I am arguing here)—to find within the Bible answers for the current time. Accordingly, scholar

Fig. 13 Arthur Szyk, *The First Battle with Amalek,* from *The Haggadah,* 1935. Watercolor and gouache, 11 ¹⁄₁₆ × 9 ¹¹⁄₁₆ in. The Robbins Family Collection. Reproduced with the cooperation of The Arthur Szyk Society, Burlingame, Calif., www.szyk.org.

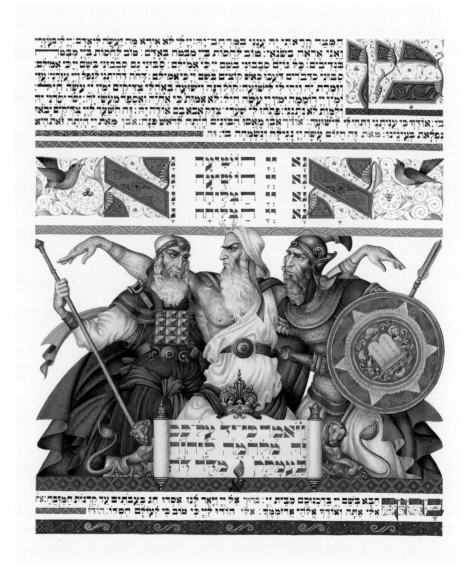

David Roskies contends that at times of catastrophe Jews link the biblical past to the unthinkable, often secular, present: "The greater the catastrophe, the more the Jews have recalled the ancient archetypes."[44] This "Jewish pattern of response" has been articulated since the destruction of the First Temple (587 B.C.E.), in Jerusalem, when the Jew sought a means of comparison and understanding for that cataclysm.[45] Roskies explains that the recapitulation of Jewish liturgical thinking is so ingrained in the Jewish psyche that "at that moment of crisis, individuals have the ability and the freedom to reinterpret and radicalize the tradition."[46] Szyk's Midrash,

or interpretation, has been made through artistic figuration, not words. For Szyk, the biblical story of the Amalekites was the perfect prototype to illustrate a Jewish military mind-set during the Holocaust, the greatest catastrophe the Jews had ever known.[47]

After the war a compilation of Szyk's satirical anti-Axis political cartoons reached publication under one cover.[48] Titled *Ink and Blood: A Book of Drawings* (1946), this book of political material was released in a limited print run of one thousand copies, each inscribed by Szyk. Several images previously published elsewhere are accompanied by new material; in all there are seventy-five illustrations with seven in color. In the introductory material Struthers Burt characterizes the volume as a book about the forthcoming years of reconciliation: "This is NOT A WAR-BOOK, although most of the cartoons were drawn in time of war. This is a PEACE-BOOK; a book for the parlous years that follow upon war."[49] Burt's assertion does not always accord with the imagery, a mixture of biting satire and fervent pro-Jewish material, providing Szyk's personal response to German chancellor Otto von Bismarck's oft-referenced *Blut und Eisen* speech (Blood and Iron; 1862), which advocated increased military power and the budget to make that possible.[50]

The book's frontispiece, the first of five opening color images, offers a self-portrait of Szyk sitting at his desk completing a portrait of Hitler, who contorts uncomfortably under the artist's mighty pen (1944; fig. 14). From left to right, Benito Mussolini, Pierre Laval (a prominent French politician and member of the Vichy regime), and Henri Pétain (chief of state in Vichy France), have been tossed in the trashcan, all overthrown officials who collaborated with the Nazis and whose regimes fell to the Allies. A drawn portrait of a tiny Joseph Goebbels, Hitler's minister of propaganda, emerges from a sheet of paper atop the table, holding a German News Bureau microphone, and forced, it would seem, to broadcast the destruction of fascism, not the Jews. In front of the desk stands Hideki Tojo, prime minister of Japan;

Fig. 14 Arthur Szyk, *Ink and Blood (Self-Portrait)*, 1944. Watercolor and gouache, 11 × 8 in. United States Holocaust Memorial Museum Collection, Washington, D.C. Gift of Joseph and Alexandra Braciejowski. Reproduced with the cooperation of The Arthur Szyk Society, Burlingame, Calif., www.szyk.org.

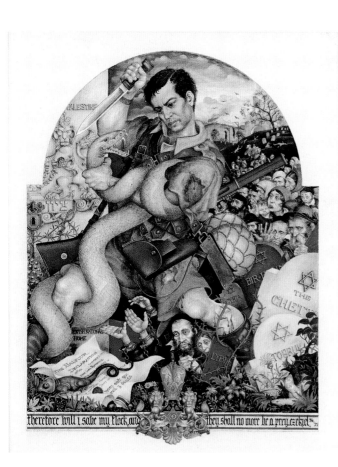

Fig. 15 Arthur Szyk,
The White Paper, 1943.
Watercolor and gouache,
8 ¾ × 7 in. Reproduced
with the cooperation of
The Arthur Szyk Society,
Burlingame, Calif., www
.szyk.org.

Hermann Goering, head of the German Air Force, crawls on all fours; and Heinrich Himmler, head of the Nazi SS, is squashed on the ground, his hand futilely grasping a bloody dagger. Spanish dictator Francisco Franco also lies underneath Szyk's desk, fittingly tossed aside with the other Axis leaders. Three arrows, symbolizing the Allied victory of the United States, Great Britain, and the Soviet Union, skewer the Nazi eagle flying above Szyk's head. Four plates follow this vitriolic initial image, symbolically depicting England, France, Russia, and America. Later, the Germans, Japanese, and Mussolini are lampooned in black and white. Among the most searing black-and-white images (published in other venues even more effectively in color) is plate 6 in the book: a close-up portrait of a wild-eyed Hitler, provocatively titled *Anti-Christ* (1942), with skulls for pupils. Hitler's oversized head, with the Latin words *vae victus*, "woe to the vanquished," scratched into his hair, is superimposed on a background of skulls, Nazi soldiers, despondent Jewish prisoners, and an oversized black swastika outlined in white.

Of the remaining seventy-two illustrations, only two are reproduced in color, telling of their importance. Plate 53, *The White Paper* (1943; fig. 15), carries several scathing commentaries. First, it refers to British limitations on Jewish immigration to Palestine in 1939, as delineated initially by the title and then by the iconography. At the base of the painting, on the left, the abandoned Balfour Declaration of 1917 lies ignored in a heap with a rodent crawling across it. The consequence of the British reneging on their support for a Jewish homeland in Palestine has been death—as indicated by the headstones strewn throughout. Some headstones denote locations where Jews perished, and others, in the far back, mark a mass grave, lit by a pogrom fire in the farthest distance. Distraught, homeless Jews, some in shackles, populate the image as well. A small, invidious serpent, decorated with swastikas and symbolizing Nazism, watches from the lower right corner. In the midst of this tale of woe, Szyk finds a way to celebrate Jewish might. The largest figure, a Jewish soldier with

a gun over his shoulder and adeptly wielding a knife, slays "The White Paper," signified by an outsized white snake. A passage from the Bible inscribed at the bottom reinforces Szyk's assertion of Jewish strength and action: "Therefore will I save My flock, and they shall no more be a prey" (Ezek. 34:22).

Carefully placed at the end of the portfolio to accentuate its significance and message, the final color plate, *Battle of the Warsaw Ghetto,* also proclaims Jewish grit, specifically, as the title suggests, in reference to the Warsaw Ghetto (fig. 16). Painted in watercolor and gouache in April 1945, the second anniversary of the uprising, the image portrays male and female fighters, young and old, conquering a representative SS officer lying on the ground with his helmet and gun strewn uselessly around him. One of the Jews mockingly holds up a sign with Himmler's order that reads, "Eastern District, Order to the Troops: All Jews must be killed." Other armed Jews populate the background, which includes a glimpse of the ghetto's infamous wall, and one proudly holds aloft a Zionist flag. To augment his point, Szyk has inscribed words on all four highly decorated borders of the image, inspired by Persian-style miniatures. At the bottom is a dedication to "Samson in the ghetto," referring to the biblical figure in Judges, which explicitly links Warsaw's Jews with this strongman who kills his Philistine oppressors even while knowing that he will die too. Szyk proudly divides this short phrase with two words—"MY PEOPLE"—in all capitals and overlying a Star of David. A phrase around the border bears Szyk's sentiments toward the Nazis, also biblical in nature: "To the German people, sons of Cain, be ye damned for ever and ever amen."

Szyk's comparison of the Nazis to a biblical foil, Cain—who in a fit of jealousy killed his brother, Abel, perpetrating the world's first murder (Gen. 4:8)—was used in other art about the Holocaust, including the aforementioned portfolio of drawings *Your Brother's Blood Cries Out* by William Gropper. In *The Miracle of the Warsaw Ghetto,* Israel observes, "Abel must overcome Cain, even if Cain has more dynamite," and then again, "I must do something to overcome Cain!"[51] George Grosz, a German satirist who was not Jewish, employed Cain as a metaphor for Hitler in a 1944 canvas titled *Cain, or Hitler in Hell,* which portrays a distraught, sweating Hitler sitting in a burning landscape. In a lithograph from 1969, *Cain and Abel II* (fig. 17), Jack Levine, an admirer of Grosz, also connected the Holocaust to Cain. Published by the Anti-Defamation League, to whom Levine donated the print to assist with fund-raising, the lithograph purposefully submits the story of the Bible's first siblings, the sons of Adam and Eve, as an allegory for the Holocaust. Levine configures the fighting brothers' legs to intertwine in the form of a Nazi swastika, and the brothers' arms form yet another powerful symbol recognizable to the lay viewer, whether Christian, Jewish, or Muslim: the sign of a cross. Further, the face of the murderer

Fig. 16 Arthur Szyk, *Battle of the Warsaw Ghetto,* 1945. Watercolor and gouache, 8 ⅝ × 6 ¾ in. Reproduced with the cooperation of The Arthur Szyk Society, Burlingame, Calif., www .szyk.org.

gazes at his faceless victim, his brother. Levine's Cain and Abel metaphorically enact the Nazi view of Jews as faceless impositions, although in this case on the "Aryan" race, even if the Nazis too were brothers of the Jews insofar as the human race is one people. Before and after this print, Levine composed conventional interpretations on canvas (1961 and 1983) of the moment when Cain, a farmer, and Abel, a herdsman, clash over God's rebuff of Cain's sacrifice to him.

A Cain analogy appears in Szyk's art on another occasion, in a graphite-and-ink drawing titled *De Profundis* (fig. 18), made the year of the uprising. The drawing's name derives from Psalm 130, which serves as a prayer of mourning and whose first two verses read: "Out of the depths have I called Thee, O Lord. Lord, hearken unto my voice; let Thine ears be attentive to the voice of my supplications." Below Szyk's intricately illuminated rendition of the psalm's Latin opening is God's question to Cain from Genesis 4:9: "Where is Abel thy brother?" Bodies of men, women, and children are piled underneath these plaintive words, in particular an elderly Jew holding an ornate Torah, and Jesus, with a crown of thorns, cradling the Ten Commandments, representing the martyred Jew—a recurring trope in modern Jewish art, chiefly in relation to the Holocaust. More corpses extend into the background, lining the horizon. A destroyed building bookends these far corpses on the left; a leafless weeping willow hangs over the Jewish dead on the right. They are most likely the ghetto's dead, considering the broken wall on the far left, probably an allusion to the recent destruction in Warsaw.

Fig. 17 Jack Levine, *Cain and Abel II*, 1969. Lithograph, 18 ¾ × 16 ¾ in. Art © Estate of Jack Levine / Licensed by VAGA, New York. Photo courtesy of the Estate of Jack Levine and George Krevsky Gallery, San Francisco.

Rarely does Jewish history accentuate Jewish valor and strength (though some biblical history does) as depicted in Szyk's *Battle of the Warsaw Ghetto* and other works that have been discussed in this chapter. One particularly notable exception can be found at the heart of Masada lore, a frequently told history that has been, to a degree, constructed to demonstrate Jewish grit and a determination not to stand idle under the thumb of oppressors. As chronicled by the first-century historian Flavius Josephus in Aramaic and then Greek in *The Jewish War* (ca. 75 C.E.), during the First Jewish-Roman War a number of Jews revolted against the Romans to thwart an attempt to capture them in 70 C.E. Members of a group known as the Sicarii took flight from Jerusalem to Masada, a fortress near the Dead Sea. They lived on the mountaintop for three years, but when the Romans were close to finding and destroying them, the community—sometimes numbered at 960—committed mass suicide, dying by their own hand instead of the enemy's. According to Josephus, the commander, Eleazar Ben Yair, convinced his coreligionists to kill each other rather than be captured, arguing that then they could "die nobly and as free men": "It is evident that daybreak will end our resistance, but we are free to choose an honourable death with our loved ones. . . . So let us deny the enemy their hoped-for pleasure at our expense, and without more ado leave them to be dumbfounded by our death and

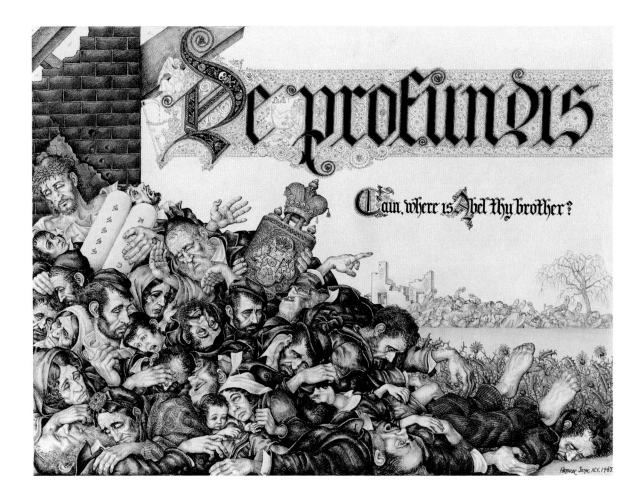

Fig. 18 Arthur Szyk, *De Profundis: Cain, Where Is Abel Thy Brother?*, 1943. Pen and ink and pencil, 15 × 20 in. Reproduced with the cooperation of The Arthur Szyk Society, Burlingame, Calif., www.szyk.org.

awed by our courage."[52] Comparable resolve surfaced in a strikingly similar fashion in the January 1943 call to resistance by the Jewish Combat Organization in the Warsaw Ghetto: "Let everyone be ready to die like a man!"[53]

This ancient story has since become a national symbol well known to Israelis and disseminated to tourists who find a trip to Masada at sunrise a compulsory part of a pilgrimage to the Israeli homeland. The struggle of the Jews on Masada has been embellished and wrapped in hyperbole, and they themselves have been deemed freedom fighters, resisters, and warriors who retained their freedom against all odds.[54] In 1981, ABC made those mythologized events recognizable to the wider American population with the broadcast of a well-watched television miniseries starring Peter O'Toole that dramatized the story. Some historians even couple the thwarted capture of Masada with the Warsaw Ghetto uprising. Citing Zionist Isaac Lamdan's 1926 poem *Masada*, about this earlier Jewish conflict, David Roskies asserts

that it, "more than any other text, later inspired the uprising in the Warsaw ghetto."[55] No doubt *Masada* was influential, but Roskies's observation remains in the realm of speculation, considering the equally influential poetry of Hayim Bialik, whose prose more insistently calls for passionate resistance.

Hayim Bialik, Max Nordau, and Emma Lazarus on Jewish Passivity and Physicality

Before the early canonization of the ghetto's insurrection in Jewish American culture, heroism and the taking up of arms served as contrasts to what had long been viewed as Jewish passivity.[56] Israel's national poet, Hayim Nahman Bialik, wrote an early twentieth-century lament on the meekness of Jews. A biting indictment, "In the City of Slaughter" ("Be'ir ha-Haregah," originally published in Hebrew and sometimes also called "The City of Slaughter") was penned shortly after Bialik visited Kishinev following pogroms there in April 1903 that left around fifty dead, hundreds injured, and more than one thousand Jewish homes and businesses plundered. Sent to Kishinev by the Jewish Historical Commission of Odessa to interview survivors and submit a report, a distraught Bialik was shocked by what he saw and also angry that those who died did not rise up against their murderers. The result was a lengthy poem vivid in details and searing in tone (Bialik's poems written from 1903 to 1906, especially, were prompted by anti-Semitic incidents). Not only does Bialik describe the devastation and brutalization of the Kishinev massacre, but he also chastises those who died for turning to God and meekly waiting for a miracle. That same elusive miracle is not falsely touted in the title of Leivick's play, because for him the miracle was not survival but the wondrous success of Jews who kept the Nazis at bay for so long, even if the partisans ultimately perished. As Bialik writes:

> Watching from the darkness and its mesh
> The lecherous rabble portioning for booty
> Their kindred and their flesh!
> Crushed in their shame, they saw it all;
> They did not stir nor move;
> They did not pluck their eyes out; they
> Beat not their brains against the wall!
> Perhaps, perhaps each watcher had it in his heart to pray:
> *A miracle, O Lord—and spare my skin this day!*[57]

Bialik's poem mobilized and became a rallying point for Russian Jews. The younger generation, many of whom were Zionists, took Bialik's words about cowardice to heart and were encouraged to defend themselves and their rights. Energetic and angry, motivated Jews organized self-defense groups. Two years later, during the 1905 pogroms, Jews protected themselves, their families, and their honor.

Bialik was surely aware of Max Nordau, a Hungarian physician and fervent Zionist who called for the creation of a "New Jew" in 1898, at the Second Zionist Congress, and then in publications after the turn of the century. For Nordau, "Muscle Jews," or *Muskeljuden*—manly and dignified—would counter the weak, intellectual Jew who had been feminized by anti-Semites. These New Jews were "deep-chested, sturdy, sharp-eyed men," as Nordau put it, regenerated figures forming a Zionist body that would epitomize a strong and militaristic Jewish nation and "take up our oldest traditions." Those old traditions, Nordau elaborates, were ones of valorous heroism and physical fortitude, qualities lost in exile: "[T]he fear of constant persecution turned our powerful voices into frightened whispers, which rose in a crescendo only when our martyrs on the stakes cried out their dying prayers in the face of their executioners."[58] Nordau felt that the small stature typical of Jews contributed to their persecution and that a fit body, achieved through disciplined exercise, would help to ensure survival. He envisioned the New Jew as bodily superior and assisted in founding the Bar Kochba gymnastic club in Berlin in 1898 to promote physical fitness, with additional clubs soon established in other parts of Europe.[59] Nordau cited Bar Kochba in an effort to associate modern Jewry with the figure he saw as "a hero who refused to know defeat. . . . Bar Kochba was the last embodiment in world history of a bellicose, militant Jewry."[60] Bar Kochba was the leader of a celebrated eponymous rebellion against the Romans, and for a brief three years he established and led an autonomous Jewish state of Israel before the Roman legions conquered the Jews yet again. Much like Masada, the Bar Kochba revolt is repeatedly extolled and resurrected as a historical example of Jewish strength by many in addition to Nordau.[61]

Szyk's aforementioned *Tel Hai* painting was coupled with Bar Kochba when it was reproduced on a 1943 cover of the Zionist magazine *Answer*. There the image was edited to attach the iconography to this earlier revolt; the golden label "Tel Hai" was removed, and instead a caption designated the painting "Descendants of Bar Kochba." A description in the magazine's table of contents connected Bar Kochba with the very recent actions in the Warsaw Ghetto: "The Artist expressed in this striking drawing the indomitable spirit of the Hebrew soul. In the Warsaw ghetto this spirit inspired Jewish heroes to desperate fight with the Nazis, and thus vindicated the honor of a people and the death of the martyrs."[62] The prior year, in 1942, this Zelig-like painting was temporarily renamed *The Modern Maccabees* and allied with calls for Jewish

resistance by evoking the Maccabean revolt celebrated annually during Hanukkah. Szyk himself averred that the work now titled *The Modern Maccabees* "symbol-ize[d] physical resistance of Jewish people in modern times" when it was printed in Brooklyn's *Jewish Examiner*.[63] Seemingly ever present, the painting was published as the cover of the summer 1942 issue of the *Menorah Journal,* supplied courtesy of the Committee for a Jewish Army of Stateless and Palestinian Jews, housed in New York, to whom Szyk had just offered the painting,[64] and also in the *Jewish Spectator* that year. One additional appearance followed in the *Jewish Forum* in January 1944. In this final reproduction the painting was no longer coupled with Tel Hai, Bar Kochba, or the Maccabees, but with the newest example of Jewish valor as indicated by its most recent revamped title: *Self Defense in Warsaw.*

Ideas about Jewish manhood, physical proficiency, and its regeneration also held currency in America. Emma Lazarus, a writer best known for her poem "The New Colossus" (1883), engraved on a plaque at the base of the Statue of Liberty, elaborated similar principles nearly two decades before Max Nordau (she also made a case for a Jewish homeland, anticipating Theodor Herzl by over a decade).[65] Spurring Lazarus's thinking on the matter was a lengthy article in the *Century* by a Russian who con-doned pogroms in her homeland. The writer, Madame Zinaida Ragozin, condemned Jews for exploiting their host country, characterizing them as a "parasitical race" whose "ways are crooked, their manner abject,—because they will not stand up for themselves and manly resent an insult or oppose vexation, but will take any amount of it if they can thereby turn a penny."[66] Ragozin's taunt that Jews are unmanly was prompted by her interest in masculinity and obviously also her virulent anti-Semitism (she wrote a children's book on "Aryan heroes"). She later collaborated on the earliest American edition of the infamously anti-Semitic *Protocols of the Elders of Zion.*

By invitation from the magazine's editor, Lazarus dismantled Ragozin's argu-ments in the next issue of the *Century* with a commanding response titled "Russian Christianity Versus Modern Judaism," and she deliberately concentrated on the issue of manliness and strength several months later in *American Hebrew,* the peri-odical that later published Szyk's *Joseph Trumpeldor's Defense of Tel Hai.* Running from November 3, 1882, to February 23, 1883, in fifteen weekly installments, the column "An Epistle to the Hebrews" outlined Lazarus's thoughts on assimilation, anti-Semitism, and the importance of a Jewish homeland in Palestine. In reference to masculinity, Lazarus begins with a caveat about contemporary Jews by fram-ing their plight historically as a victimized nation, "paralyzed by the tyranny of Christian legislation": "If I speak with occasional severity of the weakness or the degeneracy in certain points of my people, I promise that I do so with full appre-ciation of the heroic martyrdom of ages that has in great part engendered their

national defects."[67] Further, she laments the current condition of eastern European Jews as "a race of soft-handed, soft-muscled men," comparing them to their valiant forebears, a "race of the Maccabees and of Bar-Kochba, in whose army no soldier was admitted who could not uproot a tree as he rode, the splendid race of scholars, warriors, artists and artisans dwindled into the pale and stunted pariahs of [the] Ghetto and Judenstrasse."[68] Belaboring this point for her mostly Jewish readership, Lazarus continues while once again complimenting ancestral Hebrews: "We read of the Jews who attempted to rebuild the Temple using the trowel with one hand, while with the other they warded off the blows of the molesting enemy. Where are the warrior-mechanics to-day equal to either feat?" Lazarus answers her own question by explaining that while Jews are clearly a rigorous people, considering they have survived deprivation, confinement, and anguish in the Diaspora, their bodies still have been depleted and are "undeniably stunted and debilitated . . . emaciated past recognition, bearing no likeness to [their former selves]."[69] To rectify this situation, Lazarus suggests that Jews put away books and instead focus on labor, particularly agriculture, so that they can redress their inadequacies. In sum, she exhorts her coreligionists to refashion themselves "in an instant and earnest return to the avocations of our ancestors in the days when our ancestors were a truly great and admirable people."[70]

Lazarus's most forceful point calls for Jews to build up their strength and to protect themselves: "It depends upon us alone, whether we pick up and wield the keen and cunning weapon of defence that was snatched from our hands, and that now lies rusty at our feet. . . . Let us live, let us develop to their highest possible limit the physical and productive capacities of our people. Let us strengthen the root, sap and stock of the tree." Pursuing this notion, Lazarus repeats the argument on other occasions, originally as the final words of epistle 4: "We should adapt ourselves to the practical requirements of the hour, and make our race the fittest to survive, a paragon to all the nations of the earth." Epistle 5 ends on the same note: "Let our first care to-day be the re-establishment of our physical strength, the reconstruction of our national organism, so that in the future, where the respect due to us cannot be won by entreaty, it may be commanded, and where it cannot be commanded, it may be enforced."[71]

A turn-of-the-century publication from the Educational Alliance, a settlement house on the Lower East Side of New York City where Jewish newcomers learned American manners and customs, corroborates Lazarus's perceptions and coincides with Nordau's idea that gymnastics instruction would increase Jewish physicality: "The importance of physical training for our down-town brethren cannot be overestimated. Our co-religionists are often charged with lack of physical courage. . . .

Nothing will more effectively remove this than athletic training."[72] Such attitudes continued as the war drew near. In a foreword to *The Jew in Sports* (1936), author Stanley Frank aimed to illuminate and tout Jewish athletic accomplishments, urge increased athletic participation, and argue against anti-Semitism (published by a mainstream press, this book had the potential to reach a large and diverse audience): "No privileges are asked for the Jew merely because he is a Jew. It is sufficient to consider him as a normal person and accord to him the same treatment enjoyed by his fellow men. The realization that the Jewish athlete has played so prominent a part in sports activities will no doubt come as a surprise to the Jew himself. If this book has the effect of rousing him from his physical lethargy it will have served a worthy purpose."[73] Clearly the Warsaw Ghetto uprising offered an opportunity to undermine the stereotypes delineated in Nordau's and Lazarus's writings and elsewhere. Strength, bravery, and heroism pervade most retellings, especially in the early phase discussed in this chapter.

The Fighting Jew in Print

Much as *The Battle of the Warsaw Ghetto* made a timely appearance on the radio, and *The Miracle of the Warsaw Ghetto* on the stage (as well as other cultural responses described here), a book by Ralph Nunberg titled *The Fighting Jew* (1945) was rushed to print to capitalize on the recent historical example of Jewish strength and bravery. A blurb describing the volume in the *Menorah Journal* advertised it as "the thrilling story of the thousands of Jewish fighting heroes," including, of course, Bar Kochba and "culminating in the epic stand in the Warsaw Ghetto."[74] A succinct summary of the volume by *Kirkus Reviews* perceptively explains its necessity: "A book which dispels the fallacy of Jewish cowardice at a time when anti-semitism is on the increase, and which—through historical example—proves the heroism of the race. . . . The facts speak for themselves, receive no unnecessary emphasis, and form a record which—unfortunately—is needed (but may not be read) in these times."[75]

The Fighting Jew, which can be aligned with the ambitions of Learsi's previously mentioned *Jew in Battle* but in a longer form, intended to neutralize the "prejudice against Jews as cowards [that] has been alive for centuries" by proffering historical and statistical proof against the erroneous perception of Jewish meekness. Curt Reiss, a refugee from Nazi Germany and journalist who introduces the book, wisely argues: "If Jews were cowards there would not be a single Jew today. The fact that Jews have survived to our time proves that they are willing to fight back against those who have wanted to do away with them. This fight has been fought over many centuries."

Loyalty and patriotism serve as a related theme, asserted initially in the introduction with an exclamation point: "Jewish membership in the armed forces of our country is 40 per cent higher than that of the non-Jews!"[76]

Also dedicated to broadly dispelling myths about a Jewish lack of courage, loyalty, and patriotism, and published at the same time as Nunberg's and Learsi's books, is Mac Davis's *Jews Fight Too!* (1945). Written in story-like form and enhanced by inked illustrations, *Jews Fight Too!* comprises thirty-five short chapters on Jewish participation in World War II. The book opens with the reprint of a speech delivered on March 30, 1944, by Congressman James M. Curley from Massachusetts. A non-Jew, Curley urged Congress to aid Europe's persecuted Jews and to temper anti-Semitism by pointing out Jewish involvement in American war efforts from the Civil War to the Mexican War to the battles of his own time. Armed with impressive statistics, he refuted the unjust charge by propagandists that Jews in the military largely worked in noncombat services.[77] Davis's author's note follows, a brief one-page but forceful account: "The anti-Semite's scurrilous sport has been to spread the whispered lie that 'Jews don't fight.' Fascist propaganda everywhere has used this slander to gain its evil ends. . . . Yes, Jews fight too! Perhaps they do not fight any better, nor more heroically than other people—but certainly no less bravely do they fight. One million Jews are fighting in the Allied armies of the United Nations, and countless thousands of Jews without uniforms have been at the same time fighting against the common enemy of the world."[78]

Jews Fight Too! came out shortly before war's end, and among its ambitions was to press the United States to recognize the contributions of American Jews and by extension the country's responsibility to Jews abroad. Following the narrative accounts, a chapter titled "They Were the First" details over fifty military "firsts" by Jews, across borders. For example: "Master Gunner Sergeant Lou Diamond was first to be voted 'ideal Marine.'. . . The first fighting Yank from Union City, New Jersey, to die in World War II was Private Joseph Guttman. His father lost his life in World War I. . . . Five hundred Jewish refugees from Poland enlisted with the Chinese Army. Of them said Generalissimo Chiang Kai-shek: 'They've proved capable and energetic in fighting the Japanese. I am highly pleased with the morale of my Hebrew warriors.'"[79] The final section, nearly a third of the book, titled "They Fought! They Bled! They Died!," comprises a list of more than twelve hundred Jewish soldiers who served in the U.S. military, compiled by the Bureau of War Records of the Jewish Welfare Board, through October 1944.

What makes *The Fighting Jew* and *Jews Fight Too!* distinctive is the rapidity with which they appeared on the market and, accordingly, their close connections to World War II. Published soon after the war ended, *The Fighting Jew*

unequivocally takes up the challenge to lift up Jewish morale and combat the view, held by American Jews and non-Jews alike, that European Jews did not try to defend themselves. Unexpected is the author's organization of the text; the uprising's narrative appears in both the first and last chapters, with standard accountings of well-known battles—the Maccabees, Masada, Bar Kochba, and others—sandwiched in between. (*Jews Fight Too!* also begins with a chapter on the ghetto, "The Epic Battle of the Warsaw Ghetto," and follows with other World War II stories, mostly about the military.) By bracketing the body of the text with the events in Warsaw, *The Fighting Jew* self-consciously makes the uprising the raison d'être of the book—not just the culmination and most current example of centuries of Jewish fighting.

In this narrative recounting, historical but also written in a story-like fashion, Nunberg first relates the partisans' realization that they must fight. The final chapter, titled "To the Last Man," which chronicles the days leading up to that fight and the actual battle, concludes as melodramatically as the play *The Miracle of the Warsaw Ghetto*.[80] Nunberg describes a young man on a roof, "the last Jew in the ghetto, posted beside the blue and white [Zionist] flag. When he saw the Nazis, he tore the flag from the pole and wound it around his arm"—an allusion to the wrapping of phylacteries (black leather boxes containing scrolls worn around the arms of observant Jews during morning prayers). In the end he dies dramatically and as a proud Jew: "Nazis leaped toward him and tried to grab him . . . he got away and jumped down. He had guarded the flag through forty-two days and forty-two nights. Now he took it with him to his death."[81] The shorter account of the uprising in *Jews Fight Too!,* which seems slightly out of place considering the book is really about American military achievement, is still understandably included because of its then-current relevance. Davis presents the facts as well as they were known (he does not mention Anielewicz) and praises "the rebellious Jews for refusing to submit meekly to slaughter." Once again, dramatic prose paints a picture of the rebellion, with recurrent themes such as fighting for dignity, the heroism of the partisans, and the symbolism of a Zionist flag. As Davis theatrically writes toward the end of his recounting: "A Jewish girl wrapped a torn flag of Zion around her wounded body and began to sing the 'Hatikvah.'"[82]

Commemorating the First and Second Anniversaries of the Uprising

The first anniversary of the uprising, with the war raging on, engendered tributes to Warsaw's fallen Jews, intertwined with reflections on the rebels' heroism. On April 13,

six days before the actual anniversary, the American Representation of the General Jewish Workers' Union of Poland arranged a meeting at the Capitol Hotel in New York City to commemorate the event. A message sent from the State Department extolled the partisans' deeds: "No finer page has been written in the long history of the Jews than the battle waged by unarmed men, women and children against the brutal Nazi murderers. They have provided an inspiring example to all who, believing in liberty and the dignity of the human soul, prefer an honorable death to slavery. Their sacrifice shall not have been in vain. For the heroic defenders of the Warsaw ghetto have strengthened the spirit of free peoples resolved upon the extinction of Nazi tyranny and the liberation of all oppressed peoples." Judge Joseph M. Proskauer, president of the American Jewish Committee, issued a statement echoing these sentiments:

Though resistance was futile, though it spelled inevitable death, these heroic Jews chose to die fighting. . . . In all the heroism of this worldwide war, no single act compares with the valor of the starving, downtrodden Jews of the Warsaw Ghetto. . . . The battle of the Warsaw Jews, their hopeless battle, must ever be an inspiration to us all. It is appropriate that we who live commemorate their valor on the anniversary of their battle to the death. It is fitting that the traditional Hebrew prayer for the dead, El Mole Rachamin [repeated twice in *The Battle of the Warsaw Ghetto*], be said for those who died that freedom may live.[83]

On April 19, dubbed a day of "Prayer and Sorrow" by the Synagogue Council of America, thousands went to synagogues to pray (originally scheduled for April 16, the event was changed to coincide directly with the uprising's anniversary).[84] More than five thousand Jews visited New York City's Warsaw Synagogue, on the Lower East Side, alone. The Jewish Labor Committee, formed in 1933 and comprising several socialist and Yiddishist groups, including the Workman's Circle, helped organize a ten-minute work stoppage, to be held starting at eleven in the morning, "to commemorate the heroic death of the Ghetto fighters," as Executive Secretary Jacob Pat wrote in letters meant to encourage participation.[85] A one-page leaflet further explaining the purpose of the demonstrations accompanied the letters, describing Nazi oppression and itemizing the numbers of deaths in Europe as a whole and in Warsaw specifically. The uprising was called "a most inspiring battle" and "a glorious symbol of man's resistance to tyranny and slavery. Instead of submission, [the Jews] chose resistance, and gave a most inspiring account of themselves."[86] Tens of thousands of Jews stopped work and other activities, and thousands of Jewish stores closed. More than thirty thousand Jews assembled at city hall, from rabbis to artists—including Arthur Szyk— to businessmen. There Mayor Fiorello LaGuardia publicly praised the partisans.

The day concluded with a large meeting at Carnegie Hall arranged by the American Jewish Committee but encompassing many different Jewish groups, with members of the Jewish Labor Committee, Federation of Polish Jews, and the World Jewish Congress, among others, in attendance. An aggressive publicity campaign began in the days immediately preceding the opening: press releases and letters to newspapers were sent out, touting the goals of the show, giving a sneak peek at some of the "tributes" in the catalogue, and pointing out the notable speakers who would be appearing at the initial event.[87] On April 12 the Jewish Labor Committee sent out to scores of recipients a letter—tinged with words to inspire guilt—with an accompanying ticket for this mass meeting. Signed by Jacob Pat, the letter said, in part: "We are sure that you will find it your sacred duty to come and pay your respects to the fallen Jewish martyrs. However, [if] it is absolutely impossible for you to attend this meeting of tribute, we ask you to please be kind enough and return the ticket to us, for you surely realize that it would be sacrilege to have empty seats at that time. Empty seats will signify a lack of thought for our fallen brethren."[88]

At this sizeable commemoration and memorial service, attended by Rabbi Stephen Wise and additional dignitaries, the feats of Warsaw's Jews were likened to those of ancient Jewish heroes (a ploy seen several times in this chapter already). A resolution adopted by the group allowed an opportunity for additional pleas of help for European Jewry as well as entry into Palestine. Rabbi Israel Goldstein supplied a statement touching on many of the themes previously explored here: the ghetto fighters' heroics, of course, and also their connection to courageous Jews of old; the choice between going to slaughter like sheep and meeting a brave end head on; and the willingness to enter battle knowing that death would most likely be the result: "The men, the women and the youth who resisted Nazi tanks, guns and incendiaries are to be remembered as the Maccabees and the Bar Cochbas [sic] of our tragic time. Unlike their forbears [sic] of ancient days they went into a battle where they did not have even a fraction of a chance of success. The only chance they had was being slaughtered like cattle or dying like heroes. They decided to put a high price on their own lives. They died defiant, resisting and heroic." Nahum Goldmann, chairman of the administrative committee of the World Jewish Congress, unequivocally invoked the new Jew in his address: "The fight of the Warsaw ghetto characterizes a new type of Jew who is growing in Europe as a result of the unimaginable suffering of European Jewry. Jews of a heroic type who are ready to give their lives in defending [a] Jewish future and Jewish ideals."[89]

The featured entertainment of the evening, if you can call it that, was a reading of "The Story of the Warsaw Ghetto," written for the occasion by Pierre van Paassen,

a Unitarian minister. Sam Jaffe (born Shalom Jaffe), who had roles in several films and would later appear in a classic American film about anti-Semitism, *Gentleman's Agreement* (1947), read the story (Luise Rainer was originally slated to read it but fell ill). A highly dramatic, laudatory, and at times histrionic account of an event for which not all facts were yet clear, the tale unfolds as one might expect. It opens with a report of "the last Jewish bullet" fired, a young girl wrapping "the flag of Zion around her body," and the singing of Hatikvah, after which it declares: "In letters of fire the name of Warsaw's ghetto will stand in the annals of history beside those of Thermopylae and Masada, with Verdun and Stalingrad." The following day an article in the *New York Times* reporting on the occasion and bearing the headline "Jews Here Acclaim Heroes of Warsaw" deemed the rebellion an "epochal battle."[90] To be sure, representations and discussions of this lauded epochal battle were ever-mindful of its implications for Jewish heroism. At the same time, by depicting or calling to mind the presence of a Zionist flag, the Jews' "heroic" actions were coupled with a possible and well-earned future homeland. A Zionist flag featured prominently at this commemoration; similarly, in *The Miracle of the Warsaw Ghetto* the characters at one point voice their concern that the flag should stand in a central place for the ensuing battle. Recall too that in Nunberg's book *The Fighting Jew,* a partisan grabs the flag and dies wrapped in it, and in Szyk's image *Battle of the Warsaw Ghetto,* the same flag appears in the background. While all of these works are most intent on presenting the uprising as an essential moment of Jewish resistance, they also stress the Zionist hopes of their protagonists.

On the second anniversary of the uprising, the Jewish Labor Committee organized an exhibition at the Valentine Gallery in New York City called *Martyrs and Heroes of the Ghettos,* which ran from April 19 to May 25, 1945. Twenty-five panels measuring four by eight feet each, four large tables, and a memorial to the dead formed the structure of the show. The exhibit began with a brief description of the Jewish contribution "to culture and civilization" by, somewhat oddly, reproducing on the first panel a sculpture by a non-Jew: Michelangelo's *Moses*.[91] In addition to picturing the plight of European Jews, the catalogue "presented a review of important contributions of the Jewish people to world culture and world progress . . . [which] climaxed with the heroic resistance of the Warsaw Ghetto."[92] To that end, panels depicted famous Jewish scientists and philosophers through the centuries and Jewish Nobel Prize winners, along with photographs of Jews in different professions, to prove that Jews work in, and contribute to, the same areas as non-Jews.

Subsequent sections chronicled overt anti-Semitism, and Nazi persecutions, while others depicted the worldwide response to Nazism and Hitler's plan to annihilate European Jewry. Then several panels bore photographic witness to the

genocide. With this summation of German oppression and Jewish misery complete, seven panels in the next unit focused exclusively on the Warsaw Ghetto, picturing the walls around the ghetto and the area where the resistance occurred and including underground documents, a series of maps, and "a description taken from an authentic record of the fighting" (notice the crucial assertion of the word "authentic"). This portion of the show described camps where other revolts occurred, and offered pictures of twenty leading figures fighting against the Nazis. Placed at the center of the exhibition was "a memorial for the Unknown Jewish underground fighter," with a quotation in Yiddish and English accompanied by a message (unspecified) from the fighters.[93] The back of the memorial presented a few haunting statistics; the first panel showed the Jewish population in Europe before Hitler rose to power and then the paltry numbers in 1945, grimly observing that two out of every three Jews had been exterminated. The second panel once again elucidated Nazi means of killing and delivered another devastating statistic: five Jews were killed every minute.

At that time, a chief objective of the committee and of other involved American Jews was to concentrate on war relief for those remaining coreligionists in Nazi Germany, including rescue and relocation efforts. Among the sponsors of the exhibition, with names listed on the second page of the short accompanying catalogue, were Eleanor Roosevelt, Albert Einstein, and Thomas Dewey (then governor of New York, who gave the opening address), Robert F. Wagner (senator from New York), and Mayor LaGuardia. Eleanor Roosevelt sent a "tribute," as the notes appearing in the back of the catalogue are termed, suiting the premise of the exhibit: "The unspeakable atrocities perpetrated by the Nazis against the Jews, and their suffering, has horrified the whole civilized world. Their courage, under terror and enslavement has won the admiration of the world, and all civilized people will lend every effort in the future to prevent any recurrence of such evil." Roosevelt's tribute accompanies words from other luminaries (like Thomas Mann, who earlier participated in *The Free World Series*), including a universal assertion from Albert Einstein, which partially reads:

Millions of our brothers were systematically murdered only because they were Jews. They died as members of a people—the Jewish people. Are there still any of us who do not realize that we Jews have remained a people who, in spite of suffering and persecution throughout the centuries, have, again and again, become united? I hope not. . . . The silent appeal to the conscience of the world which your exhibition aims to make will, let us hope, not be in vain. Let this appeal call forth from each visitor the conviction that a great effort must be made to give protection to the minorities and all persecuted groups, and provide them with security against local outbreaks of mass-hysteria.[94]

It bears mentioning that the United States Holocaust Memorial Museum's establishment in 1993 was partly created to this end: to ensure that the lessons of the Holocaust would be heeded and other genocides thereby thwarted. This sentiment appears on much literature from the museum; one fund-raising brochure from 2013 explains, apropos "the persistent threat of genocide" and anti-Semitism: "Never again starts here. The world needs the lessons of the Holocaust, now more than ever."[95]

The organizers of the 1945 show had a clear agenda. They invited many dignitaries to the opening, including the prime minister of Denmark, the ambassador of the Union of Soviet Socialist Republics, and the Peruvian embassy ambassador (none of them attended), to lend credence and importance to life and death in the Warsaw Ghetto and to the truth of the war, which was emphasized not only in the catalogue but in official written statements and speeches made at the event. Planning documents detailing the objectives of the exhibition confirm this truth. One document explains the "aim of impressing on the American public at large the brutality and ruthlessness with which the Nazis have undertaken to exterminate the Jews, the heroism with which the Jews have attempted to resist, and the necessity for prompt and effective aid to those who survived."[96] The insistence on truth and the authenticity of the inconceivable—systematic destruction of a people in death camps and gas chambers—pervades many of the early accounts already described. To name but one previous instance: recall the narrator of *The Second Battle of the Warsaw Ghetto,* who announces at the beginning of the play, "This we bring you now is the truth. Remember that, you who listen—this is the truth! It happened in your time! It happened—and is happening" (221).

At the exhibition's premiere, Oscar-winning actor Paul Muni (born Meshilem Meier Weisenfreund in Galicia, who earlier performed on the Yiddish stage) read the "Last Manifesto of the Jewish Armed Resistance Organization of the Warsaw Ghetto" and the last testament of Samuel Zygelbaum.[97] Zygelbaum, an exiled Jewish representative of the Polish government, committed suicide in protest of Nazi brutality and the oppression of Warsaw's Jews. His suicide letter, addressed to General Wladyslaw Sikorski, prime minister of the Polish government-in-exile, was published broadly, including in the *New York Times,* and became a rallying cry for American intervention. The letter reads, in part:

My companions in the Warsaw Ghetto fell in a last heroic battle with their weapons in their hands. I did not have the honor to die with them but I belong with them and to their common grave. Let my death be an energetic cry of protest against the indifference of the world which witnesses the extermination of the Jewish people without taking any steps to prevent it. . . . Having failed to achieve success in my life, I hope that my death may jolt the indifference

of those who, perhaps even in this extreme moment, could save the Jews who are still alive in Poland.[98]

In death, Zygelbaum served as another Polish Jewish martyr—although not in battle but as an educated man rendered impotent by the Nazis—his martyrdom meant to awaken Americans from their indifference. On June 4, 1943, nearly three weeks after he died, on May 12, the *New York Times* reported, in a terse paragraph following a reprint of his suicide letter: "That was the letter. It suggests that possibly Szmul Zygielbojm will have accomplished as much in dying as he did in living."[99] By featuring a reading of the letter alongside the bellicose manifesto of Jewish armed resistance, the Jewish Labor Committee meant to demonstrate a different form of resistance, one without arms; to exhort Americans to save Europe's Jews; and once again to tout the heroics of the partisans, which Zygelbaum praised.

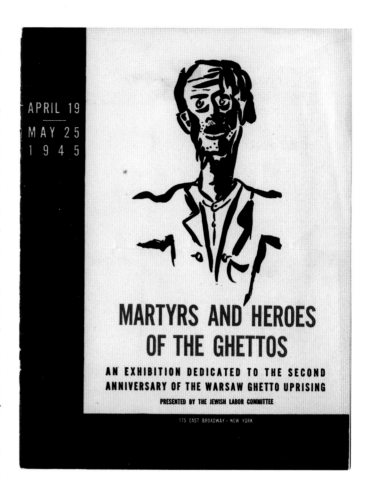

APRIL 19
MAY 25
1 9 4 5

MARTYRS AND HEROES OF THE GHETTOS

AN EXHIBITION DEDICATED TO THE SECOND ANNIVERSARY OF THE WARSAW GHETTO UPRISING

PRESENTED BY THE JEWISH LABOR COMMITTEE

175 EAST BROADWAY · NEW YORK

Fig. 19 Catalogue cover of *Martyrs and Heroes of the Ghettos*, 1945. Exhibition catalogue. Courtesy YIVO Institute, New York.

The fifteen-page catalogue accompanying the exhibition included an unfortunate black-and-white drawing of a gaunt-faced, emaciated figure on the cover (fig. 19) and the title of the show printed in blood-red oversized capital letters, neither of which accorded with the image of Jewish strength that the organizers were trying to convey (as the catalogue states, "This pictorial exhibit aims to pay tribute to the heroes of the Warsaw Ghetto"). A two-page introduction bears the specifics of what was then known as five million dead, first tortured and then killed in the gas chambers, and editorializes, in an attempt to convince naysayers of the Nazi genocide: "This is hard to believe. There are still millions of people who refuse to give credence to these horrifying facts." The introduction continues by laying out Hitler's agenda and pointedly states, in terms repeated throughout this chapter: "The Jews in the ghettos did not go silently to the slaughter. Forgotten by the world, left alone to their fate by all the nations, unprotected, unarmed, the Jews of the ghettos launched an open battle against the mighty Nazi arms." This essay closes with an appeal for

justice: "The exhibition presented by the Jewish Labor Committee is dedicated to the heroes and martyrs of the ghettos. Let us pay them honor. They have not perished in vain. The blood of 5,000,000 victims cries for vengeance; demands justice! The world, humanity, owes a great debt to the old and suffering people of Israel."[100]

Five following pages of captioned photographs, "the most eloquent authentic data," evince a "story of torture and horror," as a short description puts it. The catalogue images do not illustrate what would be revealed later as unthinkable, gruesome wartime conduct, but instead concentrate on the subjugation of Jews; for instance, Nazis rounding up Jews, troops forcing Jews to push their coreligionists in carts through the streets for the soldiers' amusement, hanged Jews, and Nazi troops in the Warsaw Ghetto. On the last page of this material, a map of the Warsaw Ghetto appears alongside the longest caption, which explains that the battle in the ghetto was not an isolated instance of resistance but rather "the most spectacular of scores of battles in ghettoes throughout conquered Europe." Then, in a culmination of the language and representations already quoted, the caption further reads: "Doomed though it was, it continued valiantly for 40 terrified days and nights, a people's uprising of the 40,000 Warsaw Jews. That it ended in defeat and death for the out-numbered, out-armed Jews is not as important as that it typified the heroic dignity and courage of the human spirit."[101] In the Valentine Gallery catalogue and elsewhere, the uprising functions as the apex of most representations of the ghetto from the 1940s: to name a few, the final color image in Szyk's *Ink and Blood* portfolio, Ralph Nunberg's book *The Fighting Jew*, and, perhaps most forcefully, in the section immediately before a description of the Holocaust's aftermath in a vast, 560-page book from 1946 that carefully elaborates the debasement and destruction of the Jews: *The Black Book*. Subtitled *The Nazi Crime Against the Jewish People*, it was published in New York under the joint auspices of the World Jewish Congress (New York), the Jewish Anti-Fascist Committee (Moscow), Vaad Leumi (the Jewish National Council of Palestine, Jerusalem), and the American Committee of Jewish Writers, Artists and Scientists (New York).

An Early Indictment: *The Black Book: The Nazi Crime Against the Jewish People*

The Black Book, as summarized by the *Saturday Review of Literature*, offers a "stirring indictment . . . and evidence of the crimes committed by the Nazis against the Jewish people throughout Europe. Its pages horrify the reader."[102] Aimed to prove all charges against the Nazis and to encourage punishment, as well as to quash fascism as a whole, the mostly chronological text is methodically laid out in seven chapters, some imparting particulars country by country: "Indictment," "Conspiracy," "The Law," "Strategy of Decimation," "Annihilation," "Resistance," "Justice." Because of

the massive loss in Poland and the large ghettos there, Warsaw receives prominent attention at various times. The chapter "Strategy of Decimation" discusses Poland as a whole and the Warsaw Ghetto in some depth, providing details about Jewish removal from the general population and incarceration in the ghetto; about the death rate; about hunger and abuse, as told through long testimony from a young boy in the ghetto; and about many other appalling matters.[103]

The introductory eight-page indictment declares: "The blood of Hitler's victims cries from the ground. The purpose of our bill [of indictment] is to make the cry articulate. . . . No crime against humanity, formerly known, quite reaches this depth of loathsomeness."[104] Begun in 1942, this exhaustively researched document incorporates copious evidence of Nazi crimes in the ghetto—from newspaper clippings, anti-Jewish legislation, quotations from speeches and declarations by Hitler, Goebbels, and others, to grisly photographs. One page features a photograph of a pile of dead children, captioned, "this is what the Nazis did to children all over Europe."[105] The book also documents population and death statistics and has visual aids charting food rations. Running through the book are especially detailed accounts of Hitler's tactics: scapegoating of Jews (e.g., the rise of Communism was blamed on the Jews), degradation, pogroms, asphyxiation, starvation, and so forth. Amid all of this misery, the authors still subtly accentuate Jewish resistance during the Holocaust as well as military contributions before World War II. For example, in the introductory indictment the authors describe Jewish assimilation, noting that European Jews fought "wholeheartedly" during World War II in their adopted countries, as per books like Mac Davis's *Jews Fight Too!*[106] That same early section calls attention to the fact that Hitler's war was against "unarmed men,"[107] implying that Jews had no means to defend themselves, words aimed toward those who blamed Jews themselves for their near extinction (Wishengrad's *Battle of the Warsaw Ghetto* more subtly makes this point when the narrator points out that the characters were "Jews with guns" who succeeded in battle).

The second-to-last chapter of the book, structured by country (France, Belgium, Holland, and so on) and preceding the chapter on justice, surveys Jewish resistance throughout Europe; of note, this is the only chapter told from the victims' perspective. Not unexpectedly, the authors point out that the "story of the revolts of the doomed in the ghettos and death camps of eastern Europe is one of great heroism in the face of great odds. Too frequently there was no hope or possibility of survival. Resistance could end neither in escape to freedom nor in victory on the spot, but only in death."[108] Within the section on Warsaw, that inevitable death is linked to strong Jews of yore, the rise of muscular Judaism, and a desire to die with dignity: "A new kind of soldier developed in the ghetto. . . . The fighting organization which developed this new man

revived the ancient of the Maccabeans. . . . The revolt of the ghetto found expression in the slogan on the banners and the placards that appeared on the walls of the ghetto during the first days of the revolt: 'Polish Jews, to Arms! Defend the Honor of Our People!' It was a fight for the dignity and honor of the Jewish people."[109]

These initial projects, related to early Holocaust revelations, used the uprising to make a point about both Jewish grit and action (an attempt to counter the erroneous belief that the Jews were passive and compliant) and Jewish suffering (a word used aptly and repeatedly in descriptions of the Nazi's oppression of the Jews) and thereby illuminate the dire situation in Warsaw, hoping to mobilize and strengthen American support on behalf of European Jewry. Indeed, the heroism and fighting spirit of the Jews serve as a refrain in the works described here, as does the sacrifice of the European Jews as martyrs. These twinned themes provide the basis for the inscription on a square stone in New York City's Riverside Park, set at the planned location for the first American Holocaust memorial: "This is the site for the American memorial to the heroes of the Warsaw Ghetto battle April–May 1943 and to the six million Jews of Europe martyred in the cause of human liberty."[110] Laid in 1947, four and a half years to the day after the battle's start, the stone slab remains in place, essentially forgotten, and the memorial unrealized.

Significantly, there was a lacuna in the representation of muscular Judaism following this initial period. After the war's end and these initial explorations of the uprising, cultural producers in the 1950s were quieter on the subject, and on the Holocaust in its entirety, although not nearly as reticent as some scholars previously claimed.[111] The early surge of pride at Jewish rebellion ebbed in light of the reality of six million Jews brutally murdered and the need to rehabilitate and find homes for survivors. Some commemorations were staged, and *Zog nit keyn mol* (1943)—translated as "Never say" and otherwise known as the "The Partisans' Song" or "Song of the Warsaw Ghetto"—was frequently sung at these occasions, but Holocaust remembrance did not pervade American Jewish life as ubiquitously as it does now. The theme of heroism gained ground again, slowly, when Israel emerged as an independent Jewish state and when the shock of the German genocide lost its immediate sting. At that time, in the 1960s, as detailed in chapter 3, the ideal of the muscular Jew developed beyond even Nordau's and Lazarus's earlier formulations.

The imprint left by the uprising was unprecedented and immediate. American Jews were quick to use the events in the ghetto, even before the facts were fully known, to shape a new Jewish identity—one of heroic resolve that deserved respect and an American response. An attempt to come to terms with the cataclysm and the deaths of six million Jews would be left to the next generation. But first, in the

decade immediately following the works discussed in this chapter, representations of the ghetto became more nuanced. While the fight still received attention, writers, artists, and critics in the late 1950s and early 1960s began to take a wider look at life behind the unyielding eight-foot-high walls of the ghetto, especially complex familial relationships. By examining Millard Lampell's theatrical adaptations of a celebrated novel by John Hersey, and a prominent teleplay by Rod Serling, among other compelling renditions, chapter 2 explores how stories about the Warsaw Ghetto, and by extension the Holocaust, were framed and represented over time and according to medium.

2

As a writer it behooves me to write of those major tragedies which involve the wholesale destruction of masses of people. In the case of the Nazis, it was the wholesale destruction and mass genocide of over 6 million human beings. . . . As a point of interest, I lost 33 relatives between the years of 1933–1942 all at the hands of the Nazis. So you can understand my personal association with the problem.

—Rod Serling, June 22, 1960

I was responsible to the people who had played out that terrible hour in history.

—Millard Lampell, autumn 1960

"I Was Responsible to the People Who Had Played Out That Terrible Hour in History"

Rod Serling, Millard Lampell, and Familial Conflict Behind the Walls

In 1960, two major shows about the Warsaw Ghetto confronted American audiences with new narratives. The first, a teleplay by Rod Serling titled *In the Presence of Mine Enemies*, appeared as part of the *Playhouse 90* drama anthology series. Five months later saw the premiere on Broadway of *The Wall*, Millard Lampell's theatrical adaptation of John Hersey's acclaimed historical novel of the same name (1950). Unlike the portrayals of the Warsaw Ghetto in chapter 1, neither of the 1960 productions made the uprising—the watershed event that symbolized Jewish resistance during the Holocaust and heretofore superseded most other aspects of ghetto life—the predominant theme. The critical and popular reactions to these two productions and the foci of the stories, with surprising emotional involvements and complicated familial relations taking center stage over the uprising, bear striking parallels. This chapter examines those parallels and also interrogates how these plays, largely overlooked by scholars, were maligned in their time. Serling's play was censured for not showing enough Jewish suffering and for daring to introduce nuanced gentile and Jewish characters, while Lampell was conversely criticized for portraying too much

suffering and similarly for creating characters that demonstrate a range of responses to their confinement in the ghetto. Both Serling and Lampell were further criticized by the Jewish and mainstream press for unrealistic and verbose dialogue; for many, the dialogue undermined easy recognition of the characters, thereby undercutting audience identification. I argue, however, that these two productions drew fire primarily because they disrupted a burgeoning postwar Holocaust narrative: a convention largely set by the stage and movie adaptations of the best-selling *Diary of Anne Frank*. Serling's teleplay receives additional attention because of its nationwide audience and the writer's prominence as an outspoken commentator on the social condition, as well as his role as the creator and host of the celebrated CBS fantasy series *The Twilight Zone*. I also intend to show how Serling's research for *In the Presence of Mine Enemies* primed him, even compelled him, to write more forceful stories about fascism and Nazism, influencing subsequent episodes of *The Twilight Zone* and other later projects.

Serling's Early Life, First Teleplays, and *The Twilight Zone*

Serling's interest in World War II predated his specific attention to the genocide of Europe's Jews, no doubt because of his three years in the U.S. Army during the war, which troubled him throughout his life, and his own experiences with anti-Semitism as a young man. Raised in Binghamton, New York, Serling fondly remembered the city of his youth in his work even though he faced some anti-Semitism when living there. According to Anne Serling, whose moving memoir about her father includes some insights into his Jewish identity, during his childhood Serling, his older brother, and his first-generation American parents worshipped at a Reform synagogue, although Serling's mother, Esther, had been raised Orthodox. Samuel, Serling's father, served as vice president of the family's synagogue. The youngest Serling also frequented the Binghamton Jewish Community Center and attended Sunday school until confirmation, and the family went to synagogue on the High Holy Days but did not attend regularly the rest of the year.[1] Serling married a non-Jew, Carol Kramer, who had been raised a Unitarian; Carol's father objected to the union because Serling was Jewish, calling him "that black-eyed Jew."[2] The couple sent their children to a Unitarian church on Sunday mornings, in part because, Anne Serling explained, her father saw Unitarianism as "intellectually open-minded" and a "liberal religion" with ideals similar to those in Judaism. Serling himself did not go to church services, and he retained "many Jewish values and traditions." Among them, he annually lit *yahrzeit* candles for his parents. He taught his daughter the bedtime prayer he had said as a child, which

included a request that God help the supplicant to be "a good Jew."[3] Serling's wife, in fact, called her husband Elyan, derived from his Hebrew name: Rowelyan Ben Shmuel.[4] When in the army, Serling wrote home about Shabbat services on Friday night.[5] Anne Serling characterized her father as "fiercely proud of his heritage."[6]

Serling enlisted in the U.S. Army the day after he graduated from high school and subsequently served as a paratrooper and fought in the Battle of Leyte. Many members of his first squad died at war, and Serling, wounded by mortar shells, was subsequently awarded a Purple Heart for his injury and a Bronze Star for bravery. Among his many early shows devoted to war, *The Sergeant,* an *Armstrong Circle Theatre* episode (April 29, 1952) and Serling's first produced story (a different writer penned the screenplay), dramatizes the role of honor and blame in war through the reactions of four injured soldiers recovering in a hospital ward during the Korean War. *The Rack,* which appeared on the *United States Steel Hour* anthology series (April 12, 1955), depicts the lasting trauma of an American prisoner of war tortured in North Korea (a cinematic adaptation, by another writer and starring Paul Newman, reached theaters the next year). *The Time Element,* presented on *Westinghouse Desilu Playhouse* (November 24, 1958), enacts a tale about a man at Pearl Harbor right before the Japanese bombing. With one exception—*To Wake at Midnight* on *Climax!* (June 1955), which conveys the doubt of a German soldier about the merit of the Third Reich's philosophy—these initial considerations of war explored various battles, including those of World War II, but focused on the strain of combat and the necessary choices made in battle as opposed to the perspective of Jews and the actions of the Nazis.

Initially produced live from Hollywood, *Playhouse 90* premiered on October 4, 1956, with Serling's adaptation of Pat Frank's novel *Forbidden Area.* It fittingly ended, during a shortened fourth season of eight shows that aired irregularly, with a contribution by its most prolific writer: Serling's drama about the Warsaw Ghetto. *Playhouse 90* televised one hundred plays on CBS, weekly and then, as the series waned, biweekly, garnering an Emmy for best new series in 1957, along with eleven other wins and forty-three nominations through its acclaimed full run. Major names acted in the perennially popular series, including Johnny Carson in the comedy *Three Men on a Horse,* Jason Robards and Eli Wallach in a two-part adaptation of Hemingway's *For Whom the Bell Tolls,* and a youthful Burt Reynolds in an adaptation of Pat Frank's novel *Alas, Babylon.* In all, Serling wrote ten scripts for the series, including the highly regarded, Emmy Award–winning *Requiem for a Heavyweight,* the second *Playhouse 90* telecast (October 11, 1956).[7] Serling's *In the Presence of Mine Enemies* aired on May 18, 1960, the final installment of *Playhouse 90*'s ambitious, high-budget, original plays.

The major themes of *In the Presence of Mine Enemies* run through some of Serling's earlier teleplays. Interested in complicated issues that plague humanity, including prejudice in its many forms, Serling wrote a number of dramas that probe the human psychology of discrimination and the related struggle between good and evil. *Noon on Doomsday,* produced by the Theatre Guild on the *United States Steel Hour* (April 25, 1956), provides an apt example. Conceived soon after Emmett Till's kidnapping and lynching in Mississippi and the subsequent trial of two white men and their eventual acquittal by a white jury, Serling's script drew suspicion from sponsors worried about the story's parallel to the Till events. While still attempting to comment on that egregious case of racism and subsequent injustice, Serling downplayed the comparison in a revised script that called for the murder victim to be an elderly Jewish man who owned a pawnshop. Sponsors, though, still saw Till's likeness in the prospective teleplay even as it explored the obligations of society to mete out justice. After numerous meetings with interested parties who dissected the script, Serling conceded: "My victim could no longer be anyone as specific as an old Jew. He was to be called an unnamed foreigner, and even this was a concession to me, since the agency felt that there should not really be a suggestion of a minority at all; this was too close to the Till case. Further, it was suggested that the killer in the case was not a psychopathic malcontent—just a good, decent, American boy momentarily gone wrong."[8]

In the revision of *Noon on Doomsday,* the hour-long dramatization was refined ambiguously, not focused on black-white relations or anti-Semitism but, as Serling put it, "on the evils and ramifications of mass prejudice. . . . It stated basically that the extension of prejudice must of necessity be overt violence. What begins as a thought will soon deteriorate into a deed."[9] In essence, Serling still points a finger toward Till's murderers and the Nazis' genocide, however indirectly. Looking back at *Noon on Doomsday,* Serling offered his experience as a warning to would-be television writers that they might be limited to noncontroversial and socially innocuous storylines.[10] Dissatisfied with the final product, his third draft, Serling described the censored *Noon on Doomsday* as diluted and vague—indicative of the author's surrender "to the ritual of track covering so characteristic of the medium he wrote for" and of "the impossible task of allegorically striking out at a social evil with a feather duster because the available symbols for allegory were too few, too far between, and too totally dissimilar to what was actually needed. In a way it was like trying to tell a Jewish joke with a cast of characters consisting of two leprechauns."[11]

The June 19, 1958, *Playhouse 90* episode *A Town Has Turned to Dust* attempted to address the Till case again. Also subject to sponsor interference, the teleplay, when it ultimately aired, managed to tell of the lynching of a late nineteenth-century Mexican

boy living in a small Southwestern town who loved a white woman only "with his eyes," not a black boy who whistled at a white woman in the twentieth-century deep South, as did Till.[12] Nevertheless, even the script for this altered narrative endured much editing. Among the reasons were sponsors' concerns that Mexicans would be offended by epithets like "enchilada eater" and "Mex"; that the main character's original name, Clemson, would upset the all-white school Clemson University; and that complications might ensue for the Allstate Insurance Company over suicide claims (a suicide figured in the first script). Almost exactly four years, later *In the Presence of Mine Enemies* suffered similarly at the hands of sponsors who interfered with the story. Moreover, that play nearly remained a script, tucked away in a pile of stories that never reached production, because sponsors were reluctant to underwrite such a bold topic.[13] The show only made it on the air because, due to a writer's strike, there was no other play available at the time.

Premiering on October 2, 1959, a year before *In the Presence of Mine Enemies, The Twilight Zone* was, in part, created to explore modern-day social issues like those in *Noon on Doomsday,* albeit through unorthodox stories, a ploy triggered by Serling's frustration at sponsor intrusions. Accordingly, the show, a staple on the CBS network for five years and in wide syndication soon after its cancellation, reached a large audience with less meddling. Serling frankly explained: "There is traditional trick covering that we've been doing for years and on 'The Twilight Zone' we tell it completely in parable. If we do a story about the psychology of mob violence, we tell it as a science-fiction story. But the psychology remains the same."[14] During its five-year run of 156 episodes, of which Serling wrote 92, *The Twilight Zone* successfully subverted taboos in television writing, a subject Serling tackled in an essay for *Writer's Digest Magazine:* "The high hurdle in this mass media is the awareness of touchy subject matter, sensitive areas of thought and conflict—the taboos that label a plot 'controversial.'" He singles out a few "thematic pariahs" in no particular order: "Sex, infidelity, fantasy, suicide, political controversy, racial or religious controversy, and sanguine violence."[15] By using aliens and other elements of the supernatural and science fiction, Serling spoke to controversial societal ills in a fantastical, veiled manner—in contrast to the overt representation of the Holocaust in *In the Presence of Mine Enemies.*

This subterfuge is aptly demonstrated by the classic *Twilight Zone* episode "The Monsters Are Due on Maple Street," from March 4, 1960, about how the average person can turn against one's neighbors and friends when fear takes over. This episode explores how difference can trigger suspicion and subsequently prejudice and scapegoating—at its extreme leading to a mob mentality—in this case at the hands of aliens who laugh as the earthlings become their own worst enemies when they surrender to their basest instincts.[16] The unsettling story shows that even innocuous,

Rod Serling and

Millard Lampell

commonplace individuals—here suburbanites—can perpetuate as much evil as "Others." Serling closes with a chilling narration, one that less obliquely connects to the Holocaust: "The tools of conquest do not necessarily come with bombs and explosions and fall-out. There are weapons that are simply thoughts, attitudes, prejudices—to be found only in the minds of men. For the record, prejudices can kill and suspicion can destroy and a thoughtless, frightened search for a scapegoat has a fall-out all of its own for the children . . . and the children yet unborn. And the pity of it is . . . that these things cannot be confined to . . . The Twilight Zone."[17] CBS saw a Jewish/Holocaust correlation too. The network entered the episode for a 1961 Brotherhood Media Award, given by the National Conference of Christians and Jews, an organization formed in 1928 to address interfaith understanding. CBS's nomination described "The Monsters Are Due on Maple Street" as an exploration of the religious and social divisions that led to the Holocaust: "'The Monsters Are Due on Maple Street' vividly illustrated the consequences of fear of the unknown on the relationships of neighbors in a representative American community. An effective point about brotherhood was delivered by showing the possible consequences of a *lack* of true brotherhood. The drama's depiction of what havoc fear and ignorance can create in a single community constituted a tremendously powerful plea for the end of such fear and ignorance."[18]

In the Presence of Mine Enemies

The leitmotif of "The Monsters Are Due on Maple Street" becomes explicit in *In the Presence of Mine Enemies,* about the Heller family's experience and eventual fate in the sealed Warsaw Ghetto, beginning a week before the uprising, after hundreds of thousands had been transported to the death camps. With tensions increasing, Rabbi Adam Heller (Charles Laughton) and his son, Paul (Arthur Kennedy), who has escaped from a prison camp, are at odds. The rabbi tenaciously believes that faith will see the Jews through the war, but the embittered Paul, whose face has been scarred in the camp and who has seen firsthand the bestiality of which Nazis are capable, is primed for resistance. Thus does Serling introduce the trope of the freedom fighter, and one particularly bent on revenge, versus a man of the book. A few other characters propel the story forward. Rabbi Heller's daughter, Rachel (Susan Kohner), dedicated to her father, to whom she dutifully tends, is raped by a middle-aged Nazi officer a little over halfway into the drama. A younger Nazi, Sergeant Lott, played by "newcomer" Robert Redford in his first major role, offers a study in compassion and a crisis of conscience—a man torn between what he knows is right and the orders

of his commanding officer. A Polish Christian peddler named Josef Chinik (Oskar Homolka) helps the Heller family by bringing them food, books, and wine whenever possible—remaining committed to his friends at the risk of his life. Emmanuel (Sam Jaffe), a terrified carpenter going insane from the ghetto's stifling existence, appears at various times as he attempts to build himself a hideout.

A black screen opens the production, against which a voice-over calls out Jewish names for deportation. A camera pans to a Nazi reciting those names, followed by close-ups of weary, grim Jewish faces of all ages. In the background, a song of Jewish mourning heightens the somber mood. A Nazi derisively comments: "They call them in here to pick out the ones who are to die, and yet they sing. Jews. Who can explain Jews?"[19] The camera moves away from this unsettling scene, and then superimposed on the screen, atop the Jews awaiting their fate, a series of explanatory sentences scroll up, underscored in the background by the SS man continuing his roll call. The sentences, whose words are rendered in emphatic, capitalized letters, provide background to the story:

IN AN EASTERN EUROPEAN COUNTRY BETWEEN 1940 AND 1943, THE CONQUERERS SET ASIDE AN AREA OF ONE HUNDRED SQUARE CITY BLOCKS AND SURROUNDED IT WITH AN EIGHT FOOT WALL. IT WAS CALLED A GHETTO, AND WITHIN ITS CONFINES FIVE HUNDRED THOUSAND HUMAN BEINGS WERE GROUND INTO DUST. THE PEOPLE IN THE STORY ARE FICTIONAL; BUT THEIR TORMENT AND THEIR TRAGEDY IS A MATTER OF RECORD.

Several seconds pass for the viewer to take in this information, with more names called and an anxious crowd of hollow-cheeked faces filling the screen, again accompanied by music of mourning. Then a simple three-word sentence pans up and dramatically stops at center:

THIS IS WARSAW.

As the camera continues to scan the gaunt faces, the audience learns further of their sorrow. A Nazi dismisses those remaining: "Alright, children of Israel. All you not called may go back to your rooms now." The commander departs, and some of the ghetto's residents besiege Rabbi Heller, begging him to help them find their missing loved ones, at which time the dialogue reveals that his son, Paul, is among the missing. Approximately seven minutes of the program have passed when the show's title appears in large capital letters along with brief credits, including Rod Serling as writer, Fielder Cook as director (Cook previously produced and directed Serling's Emmy Award–winning breakthrough play, *Patterns*), and Peter Kortner as producer.

The story recommences with the rabbi returning home, touching the mezuzah on his doorpost, and walking inside his humble abode, adorned with other symbols of piety: a menorah on the piano and a picture of a rabbi on the wall. Rachel, washing dishes, stops to give her father a kiss. With a touch of irony Heller comments to his daughter: "So, Rachel, we live another day." Rabbi Heller and Rachel laugh and reminisce, and engage in an insightful conversation connecting their current plight with a larger Jewish history, one of a number of intriguing dialogues in the teleplay.

Rachel: "It's really incredible, Papa. How we can neutralize horror and adjust it to fit into our schedule."

Rabbi: "This is not a new thing, Rachel. This is a skill developed over three thousand years."

When preparing to go out again, the bearded rabbi, wearing traditionally Orthodox clothes and a *kipah* (yarmulke or skullcap), adjusts his armband and quips: "Of course, how else would anyone know I was Jewish?" Rachel affectionately helps her father shrug on his coat and hugs him as he leaves.

At this point the elaborate choreography that characterizes the play, filmed on video in a CBS studio, begins in earnest; a great deal of the action takes place within, and up and down, the mazelike, stifling confines of the often-crowded stairwell that leads up to the Heller's tiny apartment. On his way down the stairs, Heller sees Emmanuel building his current hideout. At the bottom of the stairs, with El Moleh Rachamim—the song of the dead used in radio plays (discussed in chapter 1)—setting the tone in the background, the rabbi learns that weapons are being collected. Israel, a would-be resister, informs Heller: "We will be using these shortly, Rabbi. The ghetto is raising an army." The young man explains that to this point Jews have died too quietly but now will die under protest. Ever pious, Heller replies, "God be with you." Looking at the makeshift weapon in his hand, Israel responds, "And give us strength." Continuing on to the synagogue, where a stained-glass Star of David window has been broken, Heller meets with his Polish Christian friend, Chinik, who tries to cheer the rabbi and assuage his growing doubts. To ensure his safety in the ghetto, Chinik, ironically, puts on a Star of David armband.

Fifteen minutes into the telecast Paul comes home, worse for wear after escaping from the prison camp but pleased to be reunited with his sister. Soon Heller and Chinik arrive at the apartment, and the overjoyed rabbi pours wine and praises God for bringing his son back alive. A siren disrupts the reunion, and Paul runs out of the apartment, quickly descending the stairs as Sergeant Lott enters, accompanied by an older Nazi, Captain Richter (George Macready). At this spot in the telecast a break

interrupts the tense moment with an utterly inappropriate commercial from one of the three sponsors of the program: a gas company extolling the benefits of "silent gas." When the show resumes, Captain Richter inquires about rumors that the building houses a resistance group, but he is soon taken with the beautiful Rachel. Richter eyes a framed photograph of Paul, asks the rabbi about his whereabouts, and learns that Paul has served in the Polish Army for three years. Back to the unavoidable typecast of Jews and the military, Richter derisively insults: "A race of readers trying to produce a warrior." It is here that Lott experiences his first internal conflict; the captain asks the young soldier to hit Heller, but Lott superficially slaps him, much to the dismay of his superior, who then punches the rabbi. Lott quickly leaves the apartment but pauses a moment, concerned, before departing.

Approximately thirty minutes into the story, Paul and his father engage in their first polarized conversation about how to deal with life in the festering ghetto. As Paul cynically ridicules him: "God can't hear you, Papa. God has left the premises. He has new friends now. . . . So, Papa, I'd hold up any further prayer till I've found a replacement. A God a little more righteous than the one who has moved over to the Germans." Once again, viewers are subjected to a gas commercial, as a comely woman announces: "Today more people than ever are cooking with gas." Fortunately, an innocuous commercial from the Allstate Company airs before the start of act 2, when Rabbi Heller visits the council in an effort to locate some of the missing. The scene again depicts a litany of names being called—a leitmotif cutting though the story like a scar—fading in volume as the camera pans over desperate Jewish faces. Back at his apartment, a weary Heller laments to Paul: "Names and names and names and names. I carry a cemetery in my pocket." Paul irately replies with the common refrain that the Jews are senselessly dying like sheep. Sitting together at their tiny kitchen table, the two verbally spar. Paul venomously spits his words and gets in his father's face; Heller desperately tries to convince a sneering Paul to have faith in God. Paul wants to kill Germans and make them suffer as he has, wishing, with hands clasped together and fingers intertwined in anger yet simultaneously approximating a gesture of prayer, that "for every Jewish baby thrown out of a window, I could do the same to a German baby." The pair discuss anger and vengefulness versus respecting God's laws and praying for salvation. Paul animatedly argues that each person needs to find faith in one's own way; Heller rejoins, "Anger is no faith, and hatred no theology." In reference to Paul's all-consuming rage and murderous desire for revenge, Heller invokes God and likens Paul to a swastika-wearing Nazi: "To put on the trappings of the conqueror, this is no salvation." Looming over his exhausted father, Paul replies that salvation will not be found it in the Bible, because "there are new rules now."

71

Rod Serling and

Millard Lampell

Paul's face, a face of irrationality and anger sullying an apartment of faith, fades away, replaced by a new location and a face of conscience and introspection. The scene moves to Nazi headquarters, where Richter questions Lott's loyalties. In an especially disturbing conversation, with the camera unremittingly cleaving tight to the captain's features so that the viewer can see his malice as well as hear it, he matter-of-factly explains to an uncertain, wide-eyed Lott that if Germans hate Jews, then they are unified. He further reasons that Jews need to be tortured and made to feel pain so they continue to fear their oppressors and remain victims rather than opponents. Lott questions, "How do I reconcile hitting old men and hating starving children with any kind of logic?" Richter asks Lott, who remains unswayed by his commander's distorted logic, to fetch Rachel for him, and hesitatingly, Lott does. To no avail, Lott tries to console Rachel during the car ride to Nazi headquarters.

Having learned on the street that Rachel has been taken away, Paul returns to the apartment, furious with his father. In one of the most searing indictments of the teleplay, Paul excoriates Heller, likening him to a Nazi, albeit from a very different perspective, just as the rabbi had characterized his son in an earlier conversation: "In a strange, unaccountable way you make me understand Nazis. . . . You're a caricature, Papa. A caricature of a Jew. You bury yourself with chants and dirges and prayers while your people are being slaughtered. You may have exceptional faith, Papa, but damn it. You have no honor. . . . The Torah and the Talmud and the literature of two thousand years, is there anything amongst them, anything at all that covers your sister being raped?" Richter surely does rape Rachel; she emerges from his quarters shell-shocked, holding her meager coat closed. Lott takes Rachel home, where she collapses on the apartment's stairs, and Paul carries his sister to her bedroom. Enraged, Paul finds a knife, mocks his father's ineffective faith, and leaves the apartment to exact revenge, further spurred by a wall he passes marked *Jude* in graffiti. Meantime, Heller has become disillusioned in light of his daughter's ordeal. On the stairwell a woman asks him to say a prayer for her dying baby, but he cannot and bemoans to Chinik, who sympathizes with the family's plight: "This mother has been duped by me. She has been bilked, cheated. My life has been an endless prayer and prolonged supplication to a God without ears, to a God without eyes."

Nearing the hour mark, the pace of the story increases. Paul has murdered Captain Richter and an all-out hunt for the killer ensues. Chinik, who has already jeopardized his life for his Jewish friends, and whom Paul has previously taunted despite the man's kindness, says that he will not stand by, because "that is the sin of mankind." The Pole turns himself in as the killer, whereupon a Nazi promptly shoots him dead on the staircase. Rabbi Heller loses his grasp on reality; when he sees the woman whose baby he had been asked to bless, the baby now dead in her arms, he

flatly looks around, unfocused, and delivers a haunting soliloquy: "There is not a dead infant in its mother's arms. Nor is the body of my friend Chinik lying on the stairs. There is nothing."

Act 3 commences with a black screen and the recitation of more names. As the scene comes to life, Jews await their demise, crowding the apartment's staircase. Three months have passed. Rachel has been "ill," obviously pregnant. Paul examines a rifle in anticipation of the uprising, which has been little discussed (Israel soon stops by and hastily tells Paul that it will happen that evening). A delusional Heller wonders why Chinik has not stopped by to play chess with him. Conditions in the ghetto have worsened: water has frozen in the taps, food is scarce, and Jews are dying in large numbers. Lott enters the apartment and reminds Rachel, who sits knitting on her bed, that it was he who brought her to the captain. Knowing that a revolt looms and the ghetto's Jews will perish, Lott, in part to atone for his sins, wants to help Rachel escape through the sewers. He tells Rachel that when he looks in the mirror, "I feel sick, I feel cold. I have to point a finger at the reflection." He begs for a chance to make amends. He professes his love for her, a love that could have blossomed if he was not a German and she not a Jew. In a stirring scene, a vulnerable Lott bows at Heller's feet, asking his forgiveness: "We are not all beasts. We are not all animals. . . . As God is my witness, Rabbi. . . . Some of us have not forgotten how to love. Oh God, Rabbi, forgive us. Please forgive us" (fig. 20). Offering absolution, Heller blesses Lott before a commercial break for Camel cigarettes. Lott's aching submissiveness as he kneels before the rabbi starkly contrasts with the seething, aggressive Paul, who earlier loomed over and manhandled his father (fig. 21).

For Serling, commercials were a necessary evil. In a discourse on the nature of television, when the medium was young and Serling enjoyed his first successes, he bewailed the logistics of the profession (for example, *Kraft Television Theatre,* the first popular one-hour dramatic show, would not allow writers at rehearsals until the day the show aired), the invariable rejections, the lack of recognition, and the challenges of time restraints. Serling singled out rigid time frames that must accommodate commercials; for instance, a half-hour show could only air a twenty-three-minute play because of commercials, which disrupt the story's flow.[20] These disruptions, intrinsic to the medium, were a source of aggravation for Serling, who facetiously chided: "How do you put on a meaningful drama or documentary that is adult, incisive, probing, when every fifteen minutes the proceedings are interrupted by twelve dancing rabbits with toilet paper."[21]

Serling erroneously believed that *Playhouse 90* would free him from these "peculiar interruptions," as he termed commercials, because the longer format "would be moving out of an igloo into a mansion."[22] Nonetheless, *Playhouse 90* relied on several sponsors,

Fig. 20 *In the Presence of Mine Enemies,* 1960. Film still. Columbia Broadcasting System.

Fig. 21 *In the Presence of Mine Enemies,* 1960. Film still. Columbia Broadcasting System.

each of which requested at least two commercials. Thus, the ninety-minute shows were not composed of three acts. Instead, seventy minutes of script was divided into twelve-to-thirteen-minute segments with commercials interspersed. Serling explained that his scenes needed to end at high emotional moments and at logical parts of the storyline, but in the end the overall effect was that of "a chopped-up collection of short dramatic segments torn apart and intruded upon by constantly recurring commercials. . . . the play is forced to become a kissing cousin to an entity totally foreign to it. The audience, during a one-hour viewing of a drama, is forcibly deprived of that drama and in its place is exposed to three minutes of Madison Avenue dynamics."[23] Herein lay a big problem for *In the Presence of Mine Enemies:* the draining show about an ignominious history was presented cheek by jowl with commercial products, egregious in itself, and one of those products was woefully unsuitable to a dramatization of the Holocaust. A viewer of *In the Presence of Mine Enemies* actually wrote to Serling regarding the commercial breaks, calling them "unpalatable" but noting: "[In] one respect [the commercials] have been of value. I vowed to quit smoking on the spot and . . . never[,] if I pick up the habit again[,] to smoke Camels. It may seem silly and irrational but that is my reaction to telling me to enjoy smoking more, while watching a play dealing so effectively with the misery which is a part of us all" (one would think he might have been offended by the gas commercial).[24] Likewise, NBC's watershed nine-plus-hour miniseries *Holocaust: The Story of the Family Weiss* (1978) was also assailed for commercial interruptions. When Steven Spielberg's Oscar-winning film *Schindler's List* (1993) was first televised on NBC, in 1997, the Ford Motor Company's sponsorship allowed it to be shown without commercials. Unmentioned, but likely contributing to Ford's decision to underwrite the movie's broadcast, were the shameful anti-Semitic activities of the company's founder in the 1920s.

When *In the Presence of Mine Enemies* restarts following the commercial, gunshots ring outside the apartment's walls, signaling that the uprising has begun. Heller explains to Paul that Lott will be taking Rachel away in the hope that her life can be saved. Although incensed that his father would let Rachel leave with a Nazi, and only after attacking Lott, Paul lets her go. The revolt has now increased in noise and proportion. Paul picks up a large rifle and prepares to join the battle. As Paul loads his rifle, Heller says: "I am going with you, Paul. Faith is a weapon too. And we have never lacked for faith. Not in this ghetto or in the thousands of ghettos before this. We shall go out together, my son." Paul replies: "I must go out and do this my own way," repeating words he said earlier in anger, but here in a measured way. The rabbi now agrees, responding, "And I in mine." As they walk down the staircase together, one last time, Paul with a gun in hand and the rabbi with a book, deeply mournful cantorial singing mixes with the sound of gunfire.

A few sentences, in capital letters akin to those at the beginning of the broadcast, convey one of Serling's customary ending morals, this time in print rather than by way of his *Twilight Zone* narrations:

BY THE END OF THE UPRISING OF 1944 [an obvious error] THE GHETTO HAD BEEN DESTROYED. OUT OF FIVE HUNDRED THOUSAND HUMAN BEINGS, THERE WERE ONLY A HANDFUL OF SURVIVORS. A CHAPTER IN HUMAN MISERY HAD BEEN WRITTEN IN INDELIBLE SHAME AND COMMITTED TO HISTORY. WARSAW AND ITS GHETTO CANNOT BE FORGOTTEN NOR CAN IT BE FORGIVEN. ALL THAT MANKIND CAN EVER DO IS TO POINT TO THE FEW MOMENTS OF HUMAN NOBILITY PLAYED OUT IN THE ONE HUNDRED SQUARE CITY BLOCKS . . . AND OFFER THEM NOT AS AN EXPLANATION OF THE PAST—BUT AS A REASON FOR THE FUTURE [ellipses in original].

While this written epilogue remains on-screen, at one point, with graffiti marring a wall in the background, bullets continue to be fired, and singing persists. As the shooting eventually fades into silence, the screen goes black and the teleplay ends.

In line with the story and the epilogue, CBS issued a series of press releases prior to the May 18 airdate that concentrated on the human element of the teleplay instead of heroism. A February 1960 release announced the upcoming presentation, noted that it had yet to be cast, and described the play as a "90-minute drama [that] focuses on the searching investigation of a gentle and religious man to find a code of morality by which to survive in a society which has turned its back on religion."[25] In April a second release alluded to the uprising, broadening the description and noting that Charles Laughton had been cast as Rabbi Heller: "'In the Presence of Mine Enemies' is a story of how Rabbi Heller and his flock lived, suffered and fought back against their Nazi oppressors."[26] The May 4 press release did not mention the revolt at all. It disclosed the entire cast, including "newcomer Robert Redford," and characterized Heller as "a rabbi who could have existed, but actually did only in the mind of the writer. The rabbi is a gentle man, trapped with members of his flock in the unspeakable horror of the Warsaw Ghetto during the World War II years between 1940 and 1943."[27] Foreign to the average viewer, Heller's extreme adherence to his faith against all odds is central to the play. His inability to fathom the events around him, however, resonated with an American public still stunned by the scope and cruelty of the Holocaust as it had unfolded in the 1940s, with the release of graphic footage of the camps and news coverage of the Nuremberg trials, which included additional inconceivable visuals.

The week of the show, *TV Guide* featured the teleplay in a half-page feature, which, like the press releases, accurately describes it as a drama concerning faith, not muscular Judaism: "In the midst of this all-too-real nightmare, Rabbi Adam

Heller, the gentle leader of an Orthodox Jewish congregation, strives to hold his flock together and communicate to them his own idealism, strength, courage, and faith."[28] To underscore Heller's role over that of the underground, a sketch of a pious, bearded rabbi accompanies the drama's synopsis and cast list. All of these prerelease announcements pivot on Heller and how he clings to religion despite the most atrocious of circumstances. The title of the play suggests this theme; *In the Presence of Mine Enemies* is lifted from Psalm 23, a psalm extolling God for his infinite care no matter the situation. To quote verses 5 and 6: "Thou preparest a table before me in the presence of mine enemies; Thou hast anointed my head with oil; my cup runneth over. Surely goodness and mercy shall follow me all the days of my life; and I shall dwell in the house of the Lord for ever." The program's turn from muscular Judaism toward faith and family distinguishes the telecast from previous representations of the ghetto. John Hersey's seminal novel on the ghetto, *The Wall* (1959; described below), includes a small subplot about faith, but other plots receive much larger treatment, as does the rebellion. A rabbi in Hersey's novel explains why he remains measured despite knowledge of Treblinka: "It is nonsense to feel humiliated by the Nazis, because we all know that our faith will survive their persecutions: we are better and stronger than they are. . . . therefore we can regard our death as humiliating to them. I am calm because I know that any system that is based on love and respect will outlive any system that is based upon hatred and contempt."[29] The rabbi in *The Wall*, like Heller, encourages illogical beliefs, and in Serling's case this misguided faith contributed to the teleplay's poor reception. The extreme positions of Heller and Paul, not to mention Lott's turn as a principled Nazi, made it impossible for viewers to connect with the story's main characters.

A *New York Times* reviewer, however, described *In the Presence of Mine Enemies* as

a study of members of a Jewish family in the infamous Warsaw ghetto that was exterminated by Nazi bestiality. In ninety minutes Mr. Serling searched beneath the anguish of the Jews who faced the indescribable torture of living death. But more specifically, in a series of brilliant characterizations, he examined the different courses chosen by the victims to preserve their integrity. Whether it took the form of recourse to religion or the gun, the pursuit of honor was an individual decision. . . . The drama captured not only the degradation and despair in the ghetto, but in its conclusion there was also a moving affirmation of the dignity and indestructibility of the human being.[30]

I cite this review first because it is the most positive assessment of Serling's final *Playhouse 90* production. The critic calls attention to the varied responses to life in the ghetto and accurately singles out honor as one of the play's dominant themes;

Rod Serling and
Millard Lampell

he fails, though, to point out that non-Jews achieve the strongest demonstrations of honor—that of the conflicted Sergeant Lott and Chinik's self-sacrifice—with the looming insurrection only a minor element of the story. Paul is fueled by revenge, and Heller is driven by a faith that eventually falters. As Freud contends in *The Future of an Illusion,* the faithful cling to God's existence without tangible evidence—and in Heller's case in the bleakest of conditions—because to believe otherwise would be too painful.[31] Conversely, Lott looks realistically at the events around him and remains consistent throughout. Despite severe external pressures, Lott maintains his conscience and in the end, at great personal risk—the possibility of death—he does the right thing. Similarly, Chinik continually sacrifices for his friends, prolonging their lives by bringing them food and then by giving his life to save Paul.

Essential to an analysis of *In the Presence of Mine Enemies* is the fairy-tale-like ending. The young, attractive German and Jew come together and ostensibly make it to safety, and the once-bickering father and son set out together to die honorably, each in his own way. This ending was not, in fact, what Serling had in mind at all. In the intended version of the script, which was censored by the network to temper its aggressiveness and original shocking denouement, Paul enters the apartment to find Rachel packing to leave with Lott. His anger is much fiercer, as are his objections to the escape of his sister and her German paramour. Practically, Heller exhorts Paul to calm down, reasoning that at least two young people must live. The scene cuts to a sewer, where Rachel and Heller meet up with Lott. Paul has followed them, ready to thwart his sister's escape with a man he perceives as the enemy. He raises a gun that he has procured for the uprising. "You must let your sister go. You must let her have this chance," Heller implores. Unable to stop Paul verbally, the rabbi shoots him with a gun he was given by a rebel. Paul's last words are ones of relief that the revolt has begun and that his coreligionists will finally fight. The distraught rabbi looks at his son, now dead, and supplicates: "God forgive me. For now I've taken a life. I've killed my own flesh. A lifetime spent serving God . . . to end in a sewer. God forgive me, my son." Cradling Paul, Heller kisses him and despondently opines: "I know now, Paul, what is reality. I know. One seed staying alive in a wasteland. This is reality."[32] Lott and Rachel are gone, the rabbi has no children left, and he most certainly will die. What is so remarkable about this original ending is that its powerful and horrific twist, a sensational gambit typical of Serling's work on *The Twilight Zone,* predated *Sophie's Choice* by almost two decades (1979, novel; 1982, film). Heller and Paul do not run off "heroically" into gunfire—an unsatisfying anti-climax, to be sure. Instead, the story ends with a chilling and bleak moral dilemma, an honest and effective example of Serling's work and one that might have garnered more positive reviews.[33]

A remake that aired on Showtime on April 20, 1997, the day after the fifty-fourth anniversary of the battle, adopts the intended ending. Filmed in Montreal, Quebec, not in the confines of a studio, this version conveys the atmosphere of the ghetto beyond the Hellers' claustrophobic apartment building, the deportation center, and the Nazi headquarters featured in the 1960 production. The motif of the congested staircase remains an element of the staging, and significant action still takes place in the Hellers' apartment, but the choreography is not as constrained in the latter version. Out on the street, dead Jews and live Jews are carried or violently dragged away. Nazis round up Jews clinging to their meager possessions and load them for transport to even more appalling conditions. Weather figures as an important factor too, with ferociously cold conditions accentuated from the outset. Jews trudge through snow, rub their hands to keep warm, build small fires in the snow, and breathe clouds of air as they speak. At one point a woman pulls a poster off a wall to cover a corpse lying in the snowy street. Ominous music of mourning along with choral chanting and singing is prevalent, surging and falling at crucial moments, controlling and manipulating the viewers' emotions. Most of the key dialogue remains, as do the main characters, but an additional character, Gina, appears in the cast, adding a new dimension to the story. A friend of Rachel's, Gina provides an example of the deadly and specious temptations of food. Midway into the show, Gina announces that she has been offered a job and will be rewarded with free marmalade if she accepts. When Rachel questions her about the job, Gina, who has pinned her hopes on the promise of food and work, demurs. Rachel begs her not to go, but Gina, who wonders if she will ever "look pretty again," leaves, happily departing with suitcase in hand to what is surely her death. The unexpected finale, with Paul confronting Heller, who tries to spirit away Rachel and Lott, unfolds underground in a damp, shadowy sewer—the location for the ending in the original, which was scrapped because of the impossibility of constructing such a scene in a studio. When Heller shoots Paul, the sound of the bullet echoes, reverberating off the sewer's walls. The rabbi dejectedly climbs out of the sewer, alone, as the play ends.[34]

The *Playhouse 90* version was faulted for its overly talky nature, but that was in part because of the limitations of filming in a studio, where action and atmosphere could not so easily be effected, and also because Serling was forced to end the program with a conciliatory conversation rather than the Greek tragedy planned. *Daily Variety Review* called the characters in the *Playhouse 90* episode "talky symbols" and described the show as a "cerebral recollection of one of history's most inhuman chapters."[35] *Weekly Variety Review* decried the characters' "solo dissertations" and "the philosophy that Serling wished to propound [as] both superficial and pretentious."[36] The remake, however, was praised for the "principles taught by the surprise ending,"

which were "worth thinking about,"[37] although one reviewer felt that the denouement in the sewer was "wisely discarded" by Serling in 1960.[38] A critic for the *Los Angeles Times* lauded "the story's inherent power as a human tragedy and morality tale," an observation that could not be made of the *Playhouse 90* production.[39]

Impassioned Assessments of *In the Presence of Mine Enemies*

In Serling's estimation, the failure of *In the Presence of Mine Enemies* could be attributed not only to interference with his original ending but to poor casting. In late September 1959 correspondence with Joseph Schildkraut, before the first draft was finished on November 6, Serling wrote that he intended to start working on "our project" soon, as Serling had tapped Schildkraut for the role of Heller.[40] Schildkraut declined the role, and Charles Laughton played the part instead. Displeased with Laughton's performance, Serling disparaged him in several letters and other venues. When the play was still in rehearsals, Serling wrote to a friend, "I have been immersed in walking tip toe, hand in hand with that eminent British fag, Charles Laughton, who for the first nine days of rehearsal read every line like Captain Bligh which is not unexciting, but somewhat off beam since he's portraying the role of an Orthodox rabbi in the Warsaw Ghetto."[41] Soon after the play aired, Serling wrote: "I had mixed feelings about the production of In the Presence of Mine Enemies. I thought the casting hurt it irreparably, but that some of it <u>did</u> get through, and God knows I think it's a story that must be told and re-told."[42] Reviewers similarly maligned Laughton's disappointing performance; a critic from the *New York Herald Tribune* unequivocally asserted that Laughton's part as the rabbi "may be set down as one of the most valiant bits of miscasting in Playhouse 90's history," and *Weekly Variety Review* felt "he never quite materialized as either a sufferer in the ghetto, a stricken father or [a person] of primary importance as a rabbi."[43]

Laughton's miscasting was the least of Serling's problems. Responding to a compliment from friends, Serling reiterated his opinion on Laughton's failings while referring to a larger controversy: "I thought Laughton was so incredibly miscast that he all [but] destroyed the total effect. The show has engendered considerable comment both pro and con. I now stand in the middle between two poles of accusation. Either I'm a great and vicious anti-Semite (according to Leon Uris) or I'm a dirty, Jew-loving bastard (from the Steuben Societies of the United States)."[44] Serling refers to Uris's incendiary reaction to the teleplay, a response in keeping with the novelist's perspective on the Holocaust, from which he nearly single-mindedly focused on Jewish heroism and resistance and cringed at signs of weakness (discussed in

depth in the next chapter). Uris voiced his antipathy in a blistering open letter to CBS, wherein he called the show "the most disgusting presentation in the history of American TV. I cannot conceive how you would permit such an insult and defamation of the Jewish people by public mud-slinging on the graves of half a million Jews who were killed in the Warsaw Ghetto. . . . Joseph Goebbels himself could not have produced such a piece of Nazi apologetics. I demand that CBS burn the negative of the film and publicly apologize for the scandal."[45]

Rejoinders to Uris were equally impassioned. Charles Beaumont, who wrote for *The Twilight Zone,* regarded Uris's impeachment as "hysterical, vicious, and wholly irresponsible. As for his demand that CBS burn the film, the author of *Exodus* would do well to remember that that sort of thing was one of Herr Goebbels' specialties."[46] An article in the *Jewish Newsletter,* a biweekly publication self-branded as "Independent Thinking on Jewish Problems," reprinted Uris's "gem of chauvinistic indignation" and chastised its author: "These hysterical cries of 'defamation' and 'insults to the Jewish people' come from the author of a book which describes Arabs as sub-human, the English as Imperialistic brutes and all other 'Goyim' as an inferior breed of people to the Israeli supermen."[47] A personal letter from Ann Landers (signed with her birth name, Eppie) to Serling weighed in on Uris's widely read scourge: "We thought 'In the Presence of Mine Enemies' was one of the best things on television in recent years. This bird Uris must be out of his Jewish mind!"[48] Uris and Serling, however, must have reached some sort of accord; correspondence from mid-June to early July confirms that the two authors agreed to disagree.[49]

After Uris, another public condemnation came from Rabbi Chaim Bookson, who wrote an article about the teleplay for the *Jewish Press.* Calling it "an unforgivable whitewash," Bookson worried that the play obscured reality and that "the naïve would rightly infer from 'In The Presence of Mine Enemies,' that the predominant makeup of the German Army were plagued by pains of guilt, when in reality such Germans, if any, were infinitesimally minute when ranked along the Nazi hordes who devilishly relished the sadistic delights of murder and torture." Bookson accused Serling of "unwittingly serv[ing] up a sickening dish of apoliga [apologia] of an unprecedented nature," described the show "as morally reprehensible, as historically misleading," and sent Serling a clip of the article a few days after its publication.[50] A like-minded response came from the "1939" Club, a nonprofit fraternal organization of American Jews of Polish descent. A letter to Frank Stanton, president of CBS, lays out several points in the group's critique of the teleplay, finding disfavor with, among other things, Chinik's role as a kind, helpful Pole. Acknowledging that *In the Presence of Mine Enemies* derived from Serling's imagination, the group points out: "[I]t tends to distort the truth, as we know it . . . it is our duty to protest the

incorrect presentations of Jewish-Polish relations during that period. . . . As viewers and American citizens we request that the C.B.S. make appropriate amendments, to rectify to the American public the distorted picture of the Warsaw Ghetto Uprising created by your presentation." Representatives from the club offered to supply CBS with "witnesses, documents, and any material that they may deem necessary, to convince the American public of the correctness of our approach."[51]

Several viewers felt like Uris, Bookson, and the "1939" Club, but not quite as emotionally. One letter to Serling begins calmly, "I cannot imagine that it was your intention to write a pro-German play. . . . I am sure your aim was to paint a realistic and humane picture but I believe the result was a distortion of reality." She goes on to say that she was "horror-struck to see a young German portrayed as a savior of a Jewish girl," because it was unimaginable to her that a German soldier would enter the Warsaw Ghetto "for a noble motive." The writer is concerned that this so-called misrepresentation to the larger public would downplay the enormity of the Nazi annihilation of the Jews, and she condones the rabbi's passivity as a real-istic reaction because "who could visualize that even the Nazis would be willing to wipe out millions of defenseless Jews"?[52] Viewer Helen Buck enjoyed the show but believes that while there were isolated cases in which Germans and Poles helped Jews, they were far and few between. She wants to know if, by making Lott and Chinik the heroes in the play, Serling was urging viewers "to forgive what has been done." Buck admits that she has not yet forgiven, because most Nazis tortured and murdered Jews, and Poles looked the other way. She recommends that Serling write a second play to "show how Mrs. Chinik refused to hide a Jew in her cellar, and how after delivering Rachel into safety, Sergeant Lott returned to the German army to murder other not-so-young-and-pretty Jews." In closing, Buck suggests that if his play is not "a plea for forgiving," then its author should "not capitalize on the suf-fering of the Jews."[53] After Serling in 1960 won an Emmy for the *Twilight Zone,* Art Barron, editorial supervisor of creative projects for NBC, wrote to him succinctly: "Congratulations on your richly deserved Emmy for your most imaginative 'Twilight Zone'—but please no more nice Nazis."[54]

Some aggrieved viewers made insightful points. Shirley Simpson was correct in her valuation that Paul "was most certainly the villain as compared to your fresh young German boy." But the opening to her letter goes too far: "It couldn't possibly be due to your ignorance of the horror that was the Ghetto so it must be your lack of courage to portray it—or leave it alone—accurately. Your script was a total insult and blasphemous to the memory of the Jews who died in the Ghetto. To have the audacity to portray a German soldier sympathetically, even if such a one existed, was dishonest and superfluous."[55] Simpson, Barron, and others could not comprehend

Serling's conception, because it did not adhere to standard Holocaust accounts. Earlier cultural responses were largely nonfiction or adapted from documentary evidence, exemplified by the atrocities committed (e.g., as seen in newsreels and photographs), hopefulness amid the devastation (e.g., *The Diary of Anne Frank*), or heroism. Crucially, an American precedent did not exist for the portrayal of a Nazi, and an especially young, handsome one, in a favorable light. To state it plainly, *In the Presence of Mine Enemies* trespassed on what was then a nascent Holocaust narrative, one of devastation, resistance, or hopeful idealism.

Although in the minority, a few viewers were pleased with Lott's character. One viewer appreciated Serling's point that not all Germans were Nazis, and found the relationship between a Jew and a Christian Pole "especially impressive."[56] Not surprisingly, a writer born in Berlin, clearly injured by widespread derogatory generalizations about Germans, wrote, "Thank you, thank you, thank you—for Sergeant Lott!"[57] It is this very reaction that angered some Jewish viewers: the perception that Serling's play was meant to exonerate Nazis when the tenor of the time was still predominantly one of unmediated anger. Many viewers found it unbelievable that a Nazi could be good—the very point the German letter writer endorsed. It bears repeating that *In the Presence of Mine Enemies* presents the Holocaust in a nuanced manner, not in black and white: the teleplay does not portray all Jews as good/victims and Nazis as bad/perpetrators. Most Americans of the early 1960s, Jews and non-Jews alike, were not ready to accept or think about the possibility that some Germans were placed in an untenable position and that not all Germans were Nazis.

The Horizon of Expectations

Literary theorist Hans Robert Jauss's concept of the "horizon of expectations" helps to clarify why many viewers found Serling's teleplay so unsatisfying, aside from the obvious and understandable desire for Nazis to be vilified and the Jews' lot during the Holocaust to be mourned. In other words, at the end of Holocaust stories, viewers in the 1960s expected to be uplifted and/or to cry, to encounter the evil confirmed by well-circulated atrocity footage and photographs, or at the very least not to see Jews behaving badly. Jauss understands the "horizon" as the sum of readers' expectations regarding a text and its cultural material and perceives the role of most authors as playing into or against those expectations or transforming the horizon itself.[58] This historical moment was dominated by one Holocaust account, that of Anne Frank, published in diary form in 1947, which served as a primary horizon. In the fifties, *The Diary of Anne Frank* was adapted into a perennially popular Pulitzer Prize–winning

play (1955) and a movie (1959) recounting Anne's relationship with her family and the friends who were secretly hiding in a cramped annex in Amsterdam, wherein Anne famously retains her faith in humanity despite her plight.[59]

Also widely known was Hersey's *The Wall,* which chronicles the hardships and, all the more, the hope of a makeshift supportive Jewish "family" within the ghetto's confines. The early radio plays *The Second Battle of the Warsaw Ghetto* (Ravetch) and *The Battle of the Warsaw Ghetto* (Wishengrad) similarly feature warmth and mutual support, but among traditional, multigenerational families. A critic lauded Hersey's historical novel for creating a portrait of the Holocaust that inspired a sense of identification, one that "we of the predominantly Christian world of the West can comprehend and feel. . . . For though ostensibly it is about certain men, women and children, almost all of them Jews, in the Warsaw ghetto, and about how they behaved in the hour of their agony—the nobility they showed and the many human weaknesses—it is much more interesting and significant on a higher level as an epic tale of man on this planet, his human condition, his fortitude, his courage, his cowardice, his corruption, his cunning, his humor, his power to love." In brief, Hersey's characters transcend their identities as Jews: "But above and beyond the 'Jewishness' of these persons lies the man and the woman, the human being, the naked child of God on the face of the earth."[60] Audience identification was constructed even more carefully in the stage and film versions of *The Diary of Anne Frank,* where the adapters deliberately omitted Jewish symbols and statements so that Anne's victimization would be universalized and easily recognized by viewers.[61] Shortly before the annex residents' arrest, Anne reflects, unlike the particularized diary entry that specifies Jewish suffering: "We're not the only people that've had to suffer. There've always been people that've had to . . . sometimes one race . . . sometimes another . . . and yet. . . ."[62] In contrast, even as Hersey intentionally created human types to whom the audience could relate, he was simultaneously interested in teaching his readers about the beauty of Jewish ritual and peppered his vast novel with ethnographic details.[63] Frank, Hersey, Serling, and Lampell all focused on family and relationships, but Serling's and Lampell's divergence from recognizable characterizations contributed to their projects' failure.

Several other productions on the Holocaust figured prominently in the 1950s, although they were not nearly as influential as those based on Anne Frank or on Hersey's novel. Reginald Rose, a celebrated television writer often mentioned in the same breath as Serling, wrote the teleplay *The Final Ingredient* (April 19, 1959), concerning spiritual resistance in Bergen-Belsen, which appeared on ABC the day before Passover and, probably coincidentally, the sixteenth anniversary of the uprising. *Judgment at Nuremberg,* a *Playhouse 90* episode from 1959, two years before the

filmic adaptation, employed graphic footage taken upon liberation of the camps (the film used such footage as well). A critic from the *New York Times* praised the acting and production and noted: "The most moving parts of the program, however, were provided by film clips showing actual Nazi outrages. The crimes of Nuremberg, Buchenwald and Belsen were of such enormity that even a brief view of them necessarily made all of the other dramatic elements in this production seem unimportant."[64] The teleplay's documentary evidence of anti-Semitism shows German civilians and Nazi soldiers shoving and rounding up Jews, followed by footage of Nazi rallies. Later, chilling footage from the Allied Army Signal Corps, running almost four minutes, documents the camps, the atrocities committed there, and the liberation. Appallingly, the network—under pressure from the American Gas Company, a sponsor of the show—muted the word "gas" each time it was spoken by the prosecutor with reference to the gas chambers and death camps. By 1978, when the miniseries *Holocaust* aired, times had changed: atrocity photos and extended documentary footage were regularly deployed, unexpurgated, to augment the fictional account.

As early as 1946, Orson Welles's film noir *The Stranger*, about a fugitive, conscienceless Nazi, also used newsreel clips of the camps, which did conform to audience expectations, but this still was not enough to demonstrate the enormity of evil. One critic disliked the film because Welles, who played the title role, "gave no illusion of the sort of depraved and heartless creatures that the Nazi mass-murderers were."[65] *Sealed Verdict* (1948), a problematic feature film with a convoluted plot and forced love story, lays out Nazi war crimes and villainy, as does Samuel Fuller's *Verboten* (1959). Apropos Jauss's discussion of the aesthetics of reception, viewers at the end of the 1950s were influenced by this handful of predecessors—especially Anne Frank's wartime diary and dramas stemming from it—and that shaped their expectations of, and reactions to, greatly different performances about the Holocaust from around the same period. Serling's transgression was his failure to write familiar characters that were easy for his audience to identify with, or even understand; the rabbi was overly pious, Paul too angry, Lott too "good" for a Nazi, and Chinik too "good" for a Pole.[66] Rachel, the dutiful daughter, raped and traumatized, allowed viewers an opportunity to empathize and mourn, but this kernel did not offset the unrecognizability of most of the characters in the teleplay. Nearly as egregious, *In the Presence of Mine Enemies* did not uplift viewers, nor did it make them cry—either by heartening them as witnesses to the nobility of the human spirit or by laying out a litany of crimes against humanity.

Serling's primary political and literary goal was not to renovate Jewish identity in the post-Holocaust period through stories of militancy and courage, to demonstrate

Nazi brutality, to deliver a redemptive drama, or to allow a chance for viewers to mourn the unfathomable loss of life (and innocence, on Rachel's part). No, Serling's Warsaw Ghetto story was not particularly militant, replete with action and honor. Rather, Serling aimed to transform his viewers' horizon of expectations regarding the range of emotional responses during the Nazi genocide. For Serling, it would have been far too simple merely to indulge his viewers' needs. Serling's regular rejoinder to those who denounced his unprecedented take—and he took the time to answer a fair number of his detractors—clarified his goal. As he says in reply to a letter from the youth director at the Forest Hills Jewish Center, who had expressed disappointment in the play:

Neither my Pole nor the German soldier were designed to be representative or symbolic. As a dramatist, I was dealing with individuals—not symbols. As a matter of fact I thought I'd gone to great lengths to make the implication clear that these were the exceptions to the rule. Were I to have handled the theme in any other way, it would have evolved as a documentary not as a drama. The essence of playwriting is conflict and for me to have shown a Jewish point of view in this case would have been simply a restatement of a horror we are already too familiar with. All I was trying to dramatize was that even in a sea of madness, there can be a moment [involving] just a fragment of faith, hope, decency and humanity. Hence, an orthodox rabbi can put his hand on the quaking shoulder of a young German and offer him forgiveness that he cries out for.[67]

Cultural interpretations of the Warsaw Ghetto, focusing on the resistance and the uprising, along with the Holocaust standard, *The Diary of Anne Frank*, formed an authoritative prehistory, and the successor to these representations, *In the Presence of Mine Enemies,* disrupted the familiar "rules" of Holocaust stories produced before 1960. Serling's teleplay, a break with the burgeoning authoritative prehistory—which Jauss would say tested "its aesthetic value in comparison with works already [encountered]"—proved too difficult for a significant and vocal cadre of disappointed contemporary critics and viewers to swallow.[68] With all that said, many viewers did enjoy the show. Serling received dozens of letters, along with some Western Union telegrams, praising the production, the dialogue, and the acting in general terms, and sometimes extravagantly. To submit but two examples, penned on the evening it aired: Mrs. Edith Leonard expressed her appreciation with "I can't tell you how moved I was by your play 'In the Presence of Mine Enemies'—the most brilliant production ever shown on television. It must be shown again and again."[69] Freda Katz wrote: "For the past 90 minutes I have been completely enthralled. . . . Words are inadequate to put into writing the magnificent effort and work you have

done this evening."[70] Serling rightly observed: "The reaction to IN THE PRESENCE OF MINE ENEMIES has been interesting—totally polarized and no middle ground at all."[71]

While *In the Presence of Mine Enemies* sidestepped most day-to-day Nazi aggression and extreme Jewish suffering, Serling the man undeniably acknowledged the Holocaust as vicious and inhumane. A UPI article about Serling and the upcoming broadcast strongly evinced the anger that Serling held for Nazis, even though it was not foregrounded in the teleplay. Serling was quoted: "Human indignation is such a short-lived commodity. We forget the atrocities of the Nazi concentration camps and the lampshades made of human skin for Ilsa Koch at Buchenwald. But how can we forget?"[72] In correspondence about the show, he stressed the savagery of the Holocaust and the imperative that such events not recur. On several occasions Serling answered letters regarding *In the Presence of Mine Enemies* by explaining that he "felt that it was a story that needed be told so that this same kind of horror might not happen again."[73] One letter writer, after reading that Serling's show on the ghetto would soon be televised, was astounded that he would craft a story about Nazism, when what was needed was a play on the current threats from Communist Russia; such a play, the writer told Serling, would be much more of a "service to your country, to your audience, and to yourself."[74] Annoyed, Serling retorted: "I find it equally incredible that you should feel that the wholesale destruction of six million human lives must be relegated to a position of historical obscurity simply because it occurred fifteen years ago. . . . Prejudice and an animal disregard of human dignity did not die in a bunker with Hitler and Goebbels. Every smeared swastika on a building wall is evidence that this prejudice remains with us. . . . No passage of years, fifteen or fifty, can [militate] against the necessity of all this being remembered."[75] At times Serling defended himself by pointing out that *In the Presence of Mine Enemies* explored totalitarianism, which was timely, and mentioned that the first *Playhouse 90* installment dealt with Cold War themes (*Forbidden Area;* October 4, 1956); the next year a *Playhouse 90* presentation attended to the Hungarian anti-Communist revolution (*The Dark Side of the Earth;* September 19, 1957). Understanding the play's broader implications and its current relevance (a few letters indicated the applicability of the play in the shadow of the Cold War), an admirer commended *In the Presence of Mine Enemies* for being "presented at a time as opportune as this, with the downfall of the Summit Conference and the threats and tirades of Mr. K."[76] Another fan grasped the play's even wider, universal applicability, characterizing it "as literally shout[ing] its plea for man's true understanding of his fellow man and his cry for survival and it made me want to grip people like my mother (born in Virginia in 1878 and schooled to despise the Negro) and shout 'Open your eyes and your ears, the whole story is here before you—do something NOW while the whole wide world is spread out at

your feet—your damned superiority and hate will all be leveled in the dust of the grave.'"[77]

The Twilight Zone: "Deaths-Head Revisited" and "He's Alive"

In the Presence of Mine Enemies marked Serling's initial foray into the Holocaust, albeit a failed one in many viewers' eyes. Yet he forcefully retackled the subject of Nazism eighteen months later in an episode of the *Twilight Zone,* "Deaths-Head Revisited," perhaps as an apologia for his maligned *Playhouse 90* telecast. He reached this point only after cautiously exploring loosely related subject matter; two episodes about generic totalitarian leaders aired a little over a year after *In the Presence of Mine Enemies.* "The Obsolete Man" (June 2, 1961) told a story about a formidable chancellor who outlaws religion and books and is sanctioned to liquidate persons deemed obsolete (the state ultimately deems the chancellor obsolete). Several months after, "The Mirror" (October 20, 1961) offered an installment on a paranoid and repressive dictator who unilaterally kills prisoners he deems enemies of the state. However, it was the powerful "Deaths-Head Revisited," which aired on November 10, 1961, that unflinchingly explored the results of dictatorship through the depravity of the death camps.

Written during the Eichmann trial (the manuscript is dated April 28, 1961, sixteen days after the trial began), "Deaths-Head Revisited" centers on Captain Gunther Lutze, a former Nazi commander going by the name of Schmidt, who nostalgically returns to Dachau. Lutze encounters the ghosts of inmates he had murdered, led by Alfred Becker, portrayed by Jewish actor Joseph Schildkraut. Only two years before, Schildkraut had played Anne Frank's father in the filmic adaptation of her diary, and he had performed the same role on stage more than a thousand times. He was the actor Serling had intended to play Rabbi Heller in *In the Presence of Mine Enemies* (he also appeared in another *Twilight Zone* episode, "The Trade-Ins"; April 13, 1962). Although not identified as a Jewish inmate, Becker's Semitic features mark him as such. In an eerie scene, the hollow-eyed ghosts in their striped uniforms trap Captain Lutze in the barracks and inventory his crimes, to which he begs, without an ounce of insight: "Please let me out of here. This is inhuman." Haunted and tortured by those he destroyed, Lutze, instead of escaping with an easy death, loses his mind and is doomed to prolonged misery—a fitting revenge fantasy and poetic justice, to be sure. This kind of revenge fantasy was unusual for American media at the time. It is increasingly seen in twenty-first-century cinema. Quentin Tarantino's *Inglourious Basterds* (2009), for example, takes revenge to a brutal extreme. Its satisfying, even

cathartic, denouement finds Hitler, Goebbels, Goering, and other Nazis burned alive or mercilessly shot multiple times. Less vicious and truer to reality is the resistance film *Defiance* (2009), a factual story of Jewish partisans in the Naliboki forest, led by the Bielski brothers. Many of these antivictims survive, a subtle form of revenge on the Nazis, but more explicitly, the brothers kill those responsible for murdering their parents.

Delivered in his terse speaking style, Serling's opening voiceover introduces "Deaths-Head Revisited":

Mr. Schmidt, recently arrived in a small Bavarian village which lies eight miles northwest of Munich. A picturesque, delightful little spot one time known for its scenery. . . . But more recently related to other events having to do with some of the less positive pursuits of man. Human slaughter, torture, misery and anguish. Mr. Schmidt, as we will soon perceive, has a vested interest in the ruins of a concentration camp. For once . . . some seventeen years ago, his name was Gunther Lutze. He held the rank of a Captain in the S.S. He was a black-uniformed, strutting animal whose function in life was to give pain. And like his colleagues of the time, he shared the one affliction most common amongst that breed known as Nazis . . . he walked the Earth without a heart. And now former S.S. Captain Lutze will revisit his old haunts, satisfied perhaps that all that is awaiting him in the ruins on the hill is an element of nostalgia. What he does not know, of course, is that a place like Dachau cannot exist only in Bavaria. By its nature . . . by its very nature . . . it must be one of the populated areas of . . . the Twilight Zone.[78]

Serling's careful choice of wording makes explicit the viciousness of Nazi actions ("human slaughter, torture, misery, and anguish") and characterizes Lutze and his fellow Nazis as walking the earth without hearts, in contrast to Lott's sensitive character from *In the Presence of Mine Enemies,* whom he portrayed with a very big heart.

Significantly, the closing narration of "Deaths-Head Revisited" does not end, as usual, with the expression "in the Twilight Zone." In lieu of this iconic phrase, Serling's foreboding narration tersely tenders a larger warning that extends further than the Twilight Zone's universe, to the universe of the concentration camp and beyond:

All the Dachaus must remain standing. The Dachaus, the Belsens, the Buchenwalds, the Auschwitzes. All of them . . . they must remain standing because they are a monument to a moment in time when some men decided to turn the earth into a graveyard. Into it they shoveled all of their reason, their logic, their knowledge . . . but worst of all, their conscience. And the moment we forget this . . . the moment we cease to be haunted by its remembrance

Rod Serling and

Millard Lampell

. . . then we become the grave diggers. Something to dwell on and to remember . . . not only in The Twilight Zone, but wherever men walk the earth.[79]

Particularly remarkable, too, is that Serling brings God into this ambitious epilogue. The script reads as quoted above, but in the taped narration Serling added the word "God." That is to say, Serling's parting words in the taped episode deviate from his script: "Something to dwell on and to remember . . . not only in The Twilight Zone, but wherever men walk on God's earth." After immersing himself in Holocaust material, Serling may also have been experiencing a crisis of faith akin to that he constructed for the distraught rabbi Adam Heller. By invoking God's name in "Deaths-Head Revisited," Serling indirectly asks, Where was God during the Holocaust? (In chapter 4 survivor Samuel Bak asks this same question in his paintings.) Serling also rehearses the Jewish admonition "Never forget," as well as the perils of forgetting, when describing the death camps as monuments to the Holocaust that must remain so as to keep the memory of the Nazi genocide alive.

As a side note, at the end of "It's a Good Life," the episode preceding "Deaths-Head Revisited," Serling presents a teaser: "This is the lobby of an inn in a small Bavarian town. And next week we'll enter it with a former SS officer. It's the first stop on his road back to relive the horror that was Nazi Germany. Mr. Joseph Schildkraut and Mr. Oscar Beregi demonstrate what happens to the monster when it is judged by the victim. Our feeling here is that this is as stark and moving a piece of drama as we have ever presented. I very much hope that you're around to make your own judgment." The key here can be found in three words: "monster," "it," and "judgment." Serling deliberately calls the Nazi a monster and does not give that monster the humanizing feature of gender, carefully dubbing the officer "it" instead. He then plays on the word "judgment"; the viewer is invited to render judgment on Serling's assertion that the episode rivals the best The Twilight Zone has presented and also on the actions of the Nazi, which the unnerving inmates themselves do within the episode.

The filming technique in "Deaths-Head Revisited" is particularly inventive. Before Lutze meets up with the ghosts of his past, he enters the detention building, with a smile playing on his lips, remembering that he had "such good times in there." As he stands in front of the desk from which he had issued orders leading to the deaths of thousands, Lutze's pose exactly mirrors that in a portrait of Hitler, hanging behind him (fig. 22). This shot creates an equivalence between the pair and unequivocally acts as an impeachment of all Nazis (which Serling took pains not to do in In the Presence of Mine Enemies), with Lutze serving as a representative of vicious and unrepentant SS men. Later, when Lutze fondly recalls his evil deeds, these memories appear behind him as apparitions, fading in and out on the screen. When

the ghostly inmates finally get Lutze in their grip, he falls to the ground. On his back, he sees the inmates looming over him, in an upside-down triangle, a significant echo and repurposing of the triangles constituting the Star of David on armbands that many Jews were forced to wear (fig. 23). All music is muted, replaced with an eerie silence until Lutze rights himself and the inmates flip so as to be staring him down. This evocative scene was re-created four decades later, in one of eight graphic-novel adaptations from Serling's scripts. Chosen for a cross section of themes, all of the graphic novels include some scenes that were not in the televised episodes but appeared in earlier scripts and were edited out.[80] A story conducive to a marriage of text and image, the graphic-novel rendition of "Deaths-Head Revisited" is enhanced by color and the slow revelation of the story within the frames of each panel. The colors range from black and

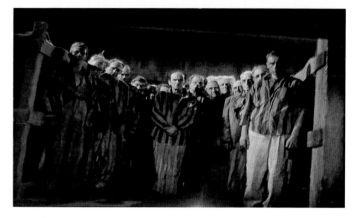

Fig. 22 "Deaths-Head Revisited," 1961. Film still. Columbia Broadcasting System.

Fig. 23 "Deaths-Head Revisited," 1961. Film still. Columbia Broadcasting System.

white in some of the somber barracks scenes to hellfire reds and yellows and oranges in panels where the inmates present their indictments of Lutze.

One other *Twilight Zone* episode written by Serling with a Holocaust theme deserves a word. "He's Alive" (January 24, 1963, from the fourth season, when installments were sixty minutes in length instead of thirty), an uncanny morality tale concerning the endurance of prejudice, features the spectral spirit of Hitler, who returns to earth to mentor an ineffectual neo-Nazi named Peter Vollmer (Dennis Hopper). "Hitler" first coaches Vollmer on how to speak persuasively to the masses and then convinces him to murder one of his supporters in order to create a martyr around whom the followers can rally. Vollmer's influence and following increase, to the dismay of a kind old man who has been a father figure to Vollmer. That man, a Jew named Ernst Ganz who was incarcerated in Dachau for nine years, chastises Vollmer for his preaching of hatred, invoking the millions of people killed by men who espoused such an ideology. Although Vollmer professes his affection for Ganz, he continues his malevolent ways. Later, Ganz interrupts a rally led by Vollmer, calling the younger man "a cheap copy" of Hitler. Hitler reappears to Vollmer, revealing

Rod Serling and

Millard Lampell

his identity as he steps out of the shadows, and exhorts him with twisted logic to kill Ganz: "The old man, the Jew, he'll be back again, tomorrow night, the next night. I know him, I know the type. We sent them into the ovens but always there was a handful left to point a finger [as "Hitler" says this he points his own finger]. His kind, Mr. Vollmer, his kind are dangerous."[81] Vollmer does kill the man who loved him like a son, and soon after, the police arrive on the scene to apprehend Vollmer for his role in the earlier killing. As Vollmer flees, the police shoot him. A profile shot of a shadowy Hitler walks away, ignoring Vollmer, who was merely a pawn, leaving him to die as the one-time führer departs to find a new disciple of hate.[82]

As the episode ends, Serling warns:

Where will he go next, this phantom from another time? This resurrected ghost of a previous nightmare. Chicago. Los Angeles. Miami, Florida. Vincennes, Indiana; Syracuse, New York. Anyplace . . . every place . . . where there's hate. Where there's prejudice, where there's bigotry. He's alive. He's alive so long as these evils exist. Remember that when he comes to your town. Remember it when you hear his voice speaking out through others. Remember it . . . when you hear a name called, a minority attacked. Any blind, unreasoning assault on a people or any human being. He's alive . . . because through these things . . . we keep him alive![83]

As in Serling's closing narration for "Deaths-Head Revisited," his moral in "He's Alive" extends beyond the specific Jewish experience in an obvious attempt to broaden his message, similar to that in some films made during the war and adaptations of *The Diary of Anne Frank* in which Jewish passages were watered down. Anti-Nazi movies like *The Seventh Cross* (1944), about escapees from a concentration camp, included diverse peoples persecuted by the Nazis, not just Jews. "He's Alive" refers generally to twelve million deaths at the hands of the Nazis in lieu of six million Jews. The episode afforded Serling an opportunity to use Nazism to craft a democratized political statement concerning mass prejudice while at the same time tackling the Holocaust, perhaps another attempt to make amends for *In the Presence of Mine Enemies,* which Serling dubbed—in his extended response to Rabbi Chaim Bookson—"a source of humiliation for a number of years to come."[84]

Serling's Other Holocaust and Jewish-Themed Projects

Aside from these *Twilight Zone* episodes, a few other projects by Serling relate to the Holocaust. In 1967 Serling worked on a novel, never completed, with the tentative title "X Number of Days," treating the dilemma of an American Jewish

soldier living in Germany soon after the war. A G.I. under his charge has been accused of killing a German man recognized as a Nazi. That G.I., a bigot the soldier detests, is innocent, whereas a Jewish civilian is in fact guilty of the crime. The soldier faces one of Serling's trademark quandaries—in this case, should the soldier turn in the hated but innocent G.I., or the guilty but justified Jew?—and the novel intended to explore that difficult moral crossroads. After finding no takers for this manuscript, Serling, who always hoped to parlay his scriptwriting skills into success as a novelist, attempted to transform the in-progress novel into a teleplay. NBC did purchase the script, which reached the development stage, but it was shelved before it reached production. During this same period, Serling optioned and adapted a script (titled "Bodo") for Christopher Davis's novel *The Shamir of Dachau* (1966), about Bodo Cohen and a fellow Dachau survivor. The pair attempts to find and exact retribution on a cruel surgeon from the camp, a figure who specialized in experiments on prisoners in the vein of Mengele, known as the "Butcher" (the revenge fantasies in "Deaths-Head Revisited" and in *The Shamir of Dachau* definitively subvert Jewish victimhood). This endeavor, with subject matter and the kind of signature twists that appealed to Serling, also never made it to the screen. A few years later Serling began hosting his most successful follow-up series to the *Twilight Zone:* another fantasy/imagination-based series, titled *Night Gallery* (1970–73), which ran for three seasons after high ratings in a three-part NBC pilot special (November 8, 1969). That first special closed with a macabre Holocaust story titled "The Escape Route."

"The Escape Route" features comeuppance for a former Nazi. Gruppenführer Joseph Strobe, previously known as Helmut Arndt, a murderous Nazi commander at Auschwitz, lives relatively happily as a fugitive in Buenos Aires. Learning of Adolph Eichmann's capture by the Israelis, Strobe now fears for his own life. Emotionally tormented by this turn of events, the Nazi finds serenity in an art museum, looking at a tranquil painting of a fisherman on a lake. Mostly unremorseful for his actions, but fearful of getting caught, Strobe continually revisits the museum, imagining himself as the peaceful fisherman in the boat. A survivor of the camps, Bleum—played by Sam Jaffe, the actor who portrayed Emmanuel, the frightened carpenter, in *In the Presence of Mine Enemies*—recognizes Strobe and alerts the Israeli police. Frantic and murderous, Strobe kills Bleum in a scene accompanied by an emotive rendition of the Mourner's Kaddish in the background. When the Israelis close in on Strobe one night, he escapes to the darkened museum and stands in front of what he believes is the idyllic lakeside painting, desperately pleading with God to let him into the fisherman's haven. His wish is granted; Strobe is subsumed into the canvas for eternity. Unbeknownst to Strobe, the painting of the serene fisherman had been

removed from the wall. In its place hangs an image of a concentration camp with a cross at center. Strobe, nailed to the cross, will forever cry out in agony.[85]

Portions of what appeared in *Night Gallery* were initially written for a motion picture, to star Sammy Davis Jr., who helped conceptualize one of the three stories. When it was clear that a film would not be picked up, those stories were transformed into three novellas, published together in one volume titled *The Season to Be Wary,* and subsequently reworked into episodes for *Night Gallery*.[86] Although it did not sell particularly well, *The Season to Be Wary* still piqued the interest of television executives. "The Escape Route" could obviously be told in greater detail on the written page, and Serling used this opportunity to lay out more gory particulars, in a nearly one-hundred-page story, than could be articulated in the televised adaptation, perhaps indicating still-lingering regret over *In the Presence of Mine Enemies.* Influenced by Eichmann's defense at his trial, where he chillingly explained that he merely performed the job asked of him, Serling wrote of Gruppenführer Strobe's discovery of his comrades: "He had found the bodies of two SS men captured by partisans—their mutilated faces frozen in a last anguished denial of any evil done; torn mouths still open in a protest that they had 'simply followed orders'" (5). Serling highlights the absence of German guilt (which Lott unequivocally felt) by stressing Strobe's nostalgia for the Third Reich, remembered by the Nazi as "the exuberance and energy and vigor of a people, a nation, a purpose" and "mass adulation" of Hitler (4). Strobe admiringly describes his fellow Nazis, with backs "ramrod straight [and] lips thin and hating, their muscles firm and toned from the calisthenics of killing" (6). After his discovery of their bodies, Strobe recalls the unremorseful eyes of SS men, which "rarely showed surrender and never showed guilt" (6)—like Lutze's unrepentant character in "Deaths-Head Revisited" (4).

Serling also lays the torture on thick, elaborating on, for example, "the naked animal expression of unutterable fear and languageless agony" of Strobe's victims (10), the terror "on the face of a Jewish dentist from Berlin when they put the syringe of acid into his testicles" (11), and Mengele's "mangling . . . scarring . . . [and] killing" of thousands during his operations (9). The novella purposefully plays into the conceit of Jewish weakness and the metaphor of helpless sheep, only to subvert it. When thinking about the Israelis in pursuit of him, Strobe calls them "Yids from a comic-opera desert country five thousand miles away. . . . Play actors putting on the trappings of their tormentors. . . . My God, can you fear Jews? Can you fear a breed of sheep?" (9). But then the fearful Nazi pauses, realizing that "*they had taken Eichmann*" (10; emphasis in original) and "the order of the universe had been turned upside down. The hunters had become the hunted; the victims were now dispensing the death" (11). Backhandedly, Strobe concedes, "Some children of Israel had made a

transformation from sheep into hounds," (12) and twice acknowledges that he "may well be a pale pig on the way to a slaughter" (30, 33).

Toward the end of Serling's short life he wrote two final stories about Jews—neither tackling retribution, but concentrating on elderly Jews and children. "The Messiah on Mott Street" (December 15, 1971), from the second season of *Night Gallery,* tells of a young Jewish boy searching for the Messiah on the Lower East Side as a salve for his dying grandfather (Edward G. Robinson). *A Storm in Summer* (February 6, 1970, with an encore presentation in late April 1971; remade in 2000 by *Showtime*), a well-received, Emmy Award–winning ninety-minute drama that aired on the *Hallmark Hall of Fame,* also set aside the recurring subject of vengeance and posthumous justice from this period. Instead, it told of a kindly older Jewish delicatessen owner who spent a summer in upstate New York caring for an African American boy from Harlem. In the summer of 1970 Serling was busy turning *A Storm in Summer* into a musical, with Steve Allen writing the songs.[87] Eventually the musical version was scrapped, and the show opened as a stage drama in California, with Sam Jaffe (a favorite actor of Serling's who appeared as Jewish characters in *In the Presence of Mine Enemies* and "The Escape Route") playing the deli owner. The play received unfavorable reviews and closed after a short run. CBS was interested in a half-hour weekly series based on *A Storm in Summer,* and a pilot was made, but the network's insistence on a laugh track derailed the project. Nonetheless, pleased with this post–*Playhouse 90* and –*Twilight Zone* success in its teleplay form, Serling planned to adapt *A Storm in Summer* into a novel, which, unfortunately, was not finished before his untimely death in 1975, at the age of fifty.

Millard Lampell's Adaptations of John Hersey's *The Wall*

A different conception of the Warsaw Ghetto was produced the same year as *In the Presence of Mine Enemies:* Millard Lampell's adaptation of John Hersey's seminal novel *The Wall,* first as a two-act stage play, which premiered on Broadway at the Billy Rose Theatre on October 11, 1960, and then as a reworked three-act play, which opened at the Arena Stage in Washington, D.C., on January 29, 1964.[88] Nearly two decades later, Lampell again rewrote the script for a three-hour CBS television adaptation (1982). In all of these versions, Lampell strove to retain the integrity of the lengthy novel, which necessarily needed to be condensed. By choice, Hersey stayed out of the making of the play; he neither read the script nor saw it performed before opening night on Broadway. He left responsibility for and creative control over his work to Lampell, director Morton Da Costa, and Kermit Bloomgarden, a seasoned

Rod Serling and
Millard Lampell

producer who had already shepherded *Death of a Salesman* (1949), *The Music Man* (1957), and, notably, *The Diary of Anne Frank* (1955), among others, to Broadway.

Hersey's *The Wall* (1950), the fourth-highest-selling novel the year of its release, with nearly 330,000 copies sold and a Book of the Month Club selection, was the first lengthy novelization on the Warsaw Ghetto and the uprising.[89] A non-Jew and well-respected journalist for *Life* and *Time* magazines, Hersey—who had gained fame for historical novels, including the Pulitzer Prize–winning *Bell for Adano* (1944), about an American soldier in Sicily during World War II—may have been the most objective writer to approach the difficult matter only five years after the liberation of the camps. As early as 1947 Hersey had written a short story for the *New Yorker* about a survivor of the Lodz Ghetto and concentration camps.[90] A "family saga" related like a diary, *The Wall* chronicles ghetto life in detail, from the degradations to the most humane of interactions. The six-part novel, more than six hundred pages long, was partially researched by historian Lucy Dawidowicz, whom Hersey hired as an assistant, as well as Jewish Polish survivor Marc Nowogrodski. *The Wall* encompasses a much wider swath of time than the few months covered by *In the Presence of Mine Enemies*. Hersey's novel spans the period from November 1939 to the rebellion in 1943, when a few survivors escape to the Lomianki Forest (Lampell's play enacts events from spring 1940 to spring 1943). The book was so popular that the Limited Editions Club published an illustrated, oversized volume of *The Wall* in 1957, consisting of fifteen hundred copies. William Sharp, an artist and political cartoonist of Jewish heritage who fled Germany in 1933, contributed twelve full-page aquatints along with dozens of pen-and-ink drawings strewn throughout.[91] A condensed excerpt of the final pages of *The Wall* even appeared in an issue of the widely circulated Jewish children's magazine *World Over* near the uprising's seventh anniversary.[92]

The Wall unfolds through the eyes of historian, archivist, and Judenrat member Noach Levinson, a character based on Emanuel Ringelblum. Levinson's meticulous observations are interspersed with a fictional editor's explanations in a "discovered" manuscript, a clear connection to Ringelblum's *Notes* and the Oneg Shabbos archive (the novel's analogous group is named the Society for the Pleasures of the Sabbath). A man without ties or relatives, Levinson writes in one entry that he is "being caught up in something like family life" (60) and later, paradoxically, remarks that he is "happier in the ghetto than I was before. I have many friends now, and my mind has been opened up to all sorts of new things" (149). Levinson marvels: "I am among my beloved friends, who wanted me to be with them. Noach Levinson: family man" (206). Other key characters include Rachel Apt, the capable daughter of a wealthy, unconscionable jeweler named Mauritzi Apt, who reverses his circumcision and escapes the ghetto with false papers. As such, Apt leaves his motherless children to

dic within the ghetto prison. Strong and assertive, Rachel serves as a "little mother" to those around her, is devoted to her friends—designated as "the family" or "a family" dozens of times in the novel—and eventually helps to lead the uprising. Dolek Berson, a charming but ambivalent individualist who in due course connects with his new "family," matures behind the ghetto's walls, finding compassion and purpose in his newfound relationships and the resistance. Slowly, the appalling conditions are revealed to the reader, but the main characters, "the family" and assorted others, find ways to live as normally as possible amid an ever-growing number of restrictions and increasing squalor. For example, a clandestine school is established to continue the children's education, two weddings are performed, and a child is born. The struggles, joys, and resilience of Polish Jewish life are portrayed over hundreds of pages until the end, when the characters realize that they are doomed and the resistance is formed among previously disharmonious factions. The sixth part of the novel elaborates the battle, ending with a few surviving characters' escape though the sewers.

In a revealing speech delivered by Hersey after winning Yale's Howland Memorial Prize for distinction in literature, he explained why he chose to write about the Warsaw Ghetto:

For a long time, I thought I would write about one of the great concentration camps. . . . I concluded that the people in the concentration camps had been degraded by their experience to a subhuman, animal level; whereas in the ghettos, the people had lived on as families to the very end, and had maintained at least vestiges and symbols of those things we consider civilization—theaters, concerts, readings of poetry, and the rituals of everyday human intercourse. I resolved to try to deal with the ghetto; because of its legendary quality I chose the Warsaw story.[93]

Hersey indeed focused on family; the novel revolves around a handful of families that band together in support and community under the most barbaric of circumstances. As the book jacket's front flap asserts: "On the surface THE WALL is the story of the systematic piecemeal extermination of the Jews of the Warsaw ghetto, and the heroic resistance of defenseless men and women against the full brute force of the Germans. But the real story is the growth in spirit of a group of friends, so that they emerge undismayed and triumphant in the face of physical annihilation."[94]

Supportive of a stage adaptation of his novel, Hersey witnessed a series of stops and starts in the process of developing the play. The first producer and director, Auschwitz survivor Jack Garfein, sat on an early script and tried to write his own. A frustrated Millard Lampell, who wanted to write the play, penned arduous letters

recounting the events that stalled the production of *The Wall*.[95] Finally, Garfein surrendered his rights to produce it in March 1960, with the understanding that Hersey authorized Lampell's script, which was both an adaptation and a reinterpretation (a few years earlier the stage version of *Anne Frank* had fared similarly when a script by Meyer Levin was rejected for one authorized by Anne's father, Otto Frank). Certainly faithful to many incidents in the book, Lampell sometimes combined characters to make points about self-protection versus human connection, while also seeking to understand why it took the ghetto's inhabitants so long to rebel. Levinson does not appear in the play; his copious first-person observations are instead incorporated into action. Another key goal, aligned with Hersey, was to reveal slowly the countless limitations and humiliations—that is, the bureaucracy—that culminated with the death camps. For example, Jews are compelled to build the ghetto's walls, are forbidden to pray, must wear armbands or face arrest, and are subjected to physical abuse at the slightest (or no) provocation—all of which culminate in the deportations. As Rachel eloquently voices in Lampell's play:

It's brilliant the way they do it, the Germans. Bit by bit, here and there. A dozen Jews grabbed in a restaurant and dragged away for forced labor. Ah, here it comes. But no. Quiet again. So, all right, it's not so bad. Bank accounts frozen. Quiet again. Public worship forbidden. Each time it hits a different group. Somebody yells, everybody else cries, shaa!—you'll only make trouble for the rest of us. . . . These little rules and regulations. Little stabs and jabs and pinpricks. Never mind, it's not serious, only a scratch. Nobody seems to realize, from enough pinpricks you can bleed to death.[96]

Lampell, born to immigrant parents from Austria-Hungary, was already an accomplished composer and writer when he undertook to adapt *The Wall* for the stage. Raised in a liberal Jewish home, Lampell in his early twenties helped form the Almanac Singers, a folk group that included future legends Lee Hays and Pete Seeger, and later Woody Guthrie. One of the group's songwriters and vocalists, the left-wing Lampell took existing tunes and transformed the lyrics into topical antiwar and pro-union ballads. "The Ballad of October 16th," from the group's debut album (1941) and set to the tune of "Jesse James," ridiculed President Roosevelt and denounced any intention that he had to go to war. Soon after the song's release, Hitler invaded the USSR, thereby violating the 1939 Hitler-Stalin pact. Subsequent songs from the Almanacs, who performed across the country at union halls, picket lines, and clubs, took a radical turn with the changed political climate. The politically engaged group moved past peace songs to ones that lampooned Hitler. A square-dance number titled "Round and Round Hitler's Grave," an audience favorite sung to the melody of

"Old Joe Clark," began: "I wish I had a bushel, I wish I had a peck, I wish I had a rope to tie around old Hitler's neck." At their height, the Almanacs performed for almost thirty million listeners on the radio program *This Is War,* which aired on all four major networks (February 14, 1942). Unfortunately, the group's previous peace songs came to the attention of the FBI, which felt that the Almanacs' music undermined the war effort, and so the bureau in turn undermined their popularity.[97] Seeger was drafted in June 1942, which also led to the group's demise, and the following year Lampell was drafted too.

During his time with the Almanacs, Lampell began freelance work as a journalist and radio scriptwriter, a skill he parlayed into television writing. He also wrote for the *New Republic* and the left-wing magazine *Friday* and was especially vociferous about his opposition to fascism. In 1940, under the pseudonym Mike Landon, Lampell penned an article titled "Is There a Führer in the House?," which informed readers about American fascists running for seats in the U.S. Congress.[98] Drafted in 1943, Lampell was assigned to the air force radio section in Connecticut, where he wrote and produced for the Army Air Corps radio series *First in the Air.* After finishing his stint with the air force in 1946, Lampell traveled to veterans' hospitals, collecting material for scripts on soldiers. Lampell, who had moved to Hollywood and worked for Warner Brothers, was blacklisted during the McCarthy era; when subpoenaed to testify before the House Un-American Activities Committee, he refused. After a decade in obscurity, he wrote and saw the production of a number of screenplays and television plays in his own name, ultimately garnering an Emmy, a Writers Guild Award, and several Peabody Awards (the miniseries *Holocaust* also won a Peabody Award in addition to eight Emmys).

A month after *The Wall* opened, Lampell authored an article for *Midstream* magazine chronicling the process of writing a script based on Hersey's novel. Lampell explained that he aimed to move beyond the characterization of "man as a helpless victim" to one in which there is "indomitable hope, and the rare, exultant moment when one man finally reaches out to embrace a fellow man."[99] Lampell was daunted by the task of adapting a novel with more than six hundred pages that follows the lives of fifty-odd important characters over four years—on his first attempt as a playwright. He poetically assessed it: "It was as though one had decided to try one's hand at sculpting, and chose the Himalayas for a first chunk of stone."[100] Nevertheless, Lampell forged ahead, conducting his own exhaustive research, independent of Hersey's, including poring over the documents left behind by Oneg Shabbos (a major find was made after Hersey researched his book). Lampell also consulted the official report of the ghetto's destruction, known as the *Stroop Report;* read Yiddish literature; and met and corresponded with ghetto fighters Antek Zuckerman, Zivia Lubetkin,

and Chana Fryshdorf. Subsequently, he dedicated the published two-act script to Zuckerman and Lubetkin.

When Lampell visited with Zuckerman, the two engaged in a conversation that confirmed the heart of Hersey's story and Lampell's subsequent interpretation. Zuckerman stressed the joy still found among his comrades amid their struggle: "'Would you believe that in the worst days, when everything was burning, when we were hiding away in the bunkers, we drank and laughed, argued and sang, kissed in the shadows? You must know that, if you wish to write about the Ghetto.'" Lampell, like Hersey, took this emphasis on companionship to heart. Indeed, Lampell felt the play, most importantly, was about "family": "However much they rebelled against it, history had made them a family. . . . A family. With a family's feuds and hatreds, and a family's fierce loyalties. Perhaps from this it is possible to understand how they could have perpetrated upon each other the most savage cruelties and also the most tender love. They reflected all mankind, a little larger than life."[101] Near the end of this revealing essay, Lampell summarized his goals well: "Out of all the horror of Hitler Europe, it is this that to me emerged as the most significant fact. A handful of Jews exposed the fullest potential of the human race. To resist death. To trust one another. To commit themselves. To endure."[102]

Cracks in *The Wall*

The Broadway version was criticized more often than not, primarily for failing to develop characters that viewers could care about. Walter Kerr singled out Lampell for laying out "one isolated instance of suffering after another," for his stilted dialogue, and for his inability to create characters that "breathe," and opposed his work to the "magnificent" adaptation of *The Diary of Anne Frank*.[103] Robert Coleman of the *New York Mirror* found the play "lacking in emotional punch. . . . we were not moved as much as we felt we should be. . . . It never makes us as angry as it should."[104] John McClain of the *New York Journal American* complimented the opulent and inventive sets, calling the play "a sort of rich man's 'Diary of Anne Frank,'" but also felt that it "encloses a desperate and dreary flashback; there is too much wailing and not enough genuine emotion." He singled out George C. Scott, who played Berson, as miscast.[105] Taking these reviews to heart, Lampell, four days after the opening, lamented in a letter to Hiram Haydn, president of Atheneum Publishers and an author in his own right, that in the following days he would try to reinsert "the human values" that, during rehearsals, were "whittled away bit by bit, [as] the emphasis shifted more and more strongly toward the spectacular, the

surface theatrical effect, the external elements" that obscured and rendered the play "incapable of capturing the inner life."[106]

Lampell did concentrate his energies on instituting some swift changes to improve the play, but the largest changes were made in the second adaptation, premiering in 1964. In production notes dated two weeks after the 1960 opening, Lampell decried the show as overproduced and diminished by elaborate sets and technical details, and felt the characters did not "come first," which from the start was his primary goal. He asked, "How are we to keep from drowning our characters in the external events? By choosing a style of production and direction that focuses on characters and relationships, and letting the atmosphere be evoked by spare hints."[107] Although that goal was not achieved in the original show, the script for the 1964 adaptation includes drawings for two simple sets, revealing a much sparser configuration in an arena-type setting. Natural-sounding, conversational dialogue and fewer monologues in a tightened script, along with a slightly trimmed cast, allowed audience members to better know, and care about, the main characters, who could thus more effectively move the audience. Lampell appeared to be pleased with the second show's cast. As Serling had been unhappy with Laughton, Lampell was unhappy with the original male lead's performance, remarking that George C. Scott "was capable of playing Berson (when his neuroses would let him) but he rarely did."[108] Reviewers almost uniformly commended the latter performance, appreciating the central staging, a form that allowed for the episodic nature of the show to flow freely. Amid other accolades, one critic described it as "among [the Arena Stage's] major achievements," and another as "the most worthwhile Arena has undertaken in theme and artistic development."[109] The latter critic praised the production so lavishly because of the connection it enabled her to make to members of "the family"—a connection that was missing from the Broadway original. She commended the characters as finely realized, appreciating that the story and its people took precedence over the stage effects.[110] A different reviewer praised the Arena production as "leaner, simpler, more powerful . . . less ponderous [and] more persuasive. . . . Never fully satisfied with his original play, Mr. Lampell heeded intelligently the critical comments which pursued it during a Broadway run three seasons ago."[111] The one denunciation that surfaced inevitably invoked comparison of the play to *The Diary of Anne Frank*. In a backhanded compliment, the *Washington Post* praised Lampell for "making his characters identifiable. . . . It would seem that the frankly frustrated playwright did well to take this second chance at shaping Hersey's fictionalized document into stage form. . . . [But it] falls short of the eloquence of 'The Diary of Ann[e] Frank.'"[112]

Three months after the original's opening, facing financial problems and dwindling attendance, *The Wall* was slated to close. Serendipitously, the night that George C. Scott

returned to the stage after the play's end to announce it would be shuttered on January 21, violinist Isaac Stern and his wife, Vera, were in attendance. Vera Stern, who lived in France during the war, had been forced to wear a Star of David armband there and lost her father at Auschwitz. She vowed to raise the necessary money, $20,000, to save the show, which she did. *The Wall* eked out eight extra weeks before permanently closing after a mere five months on Broadway. At this time and after, *The Wall* was staged in London, Amsterdam, Munich, Warsaw, Tel Aviv, and Buenos Aires.

In both productions, Lampell included four especially harsh incidents from Hersey's novel, with some of the strongest dialogue in the play. These are Mauritzi Apt's departure from the ghetto and his biological and surrogate families' reactions; the celebration of the wedding of two young people, Mordecai (Rachel's brother) and Rutka (Rabbi Mazur's daughter), at which the famished "family" eats an emaciated horse—a nonkosher animal—calling the pitiful meal "a feast"; and Stefan Mazur's attempt to turn his father, Rabbi Mazur, over to the Gestapo. The near suffocation of a crying baby to keep him from alerting the Nazis to the survivors' whereabouts occurs in the earlier production, whereas the 1964 version has the baby fully suffocated—and by Rutka, its mother, not a partisan—making the 1960 audience's squeamish response seem almost excessive by comparison.

The first of these incidents depicts an aghast Rabbi Mazur—a beloved rabbi who, like Heller in *In the Presence of Mine Enemies*, relies on his faith—confronting Apt as he tosses aside his religion and his family: "You think your religion is something you can take off like an overcoat?" Apt replies, "You'd be surprised what a plastic surgeon can do." To which the rabbi responds, "And the doctor made you a new heart?"[113] Even more forcefully in the second version, Lampell uses Hersey's words from the novel almost verbatim in a longer exhortation. As the rabbi argues: "What sets us aside from the rest of the world, you cannot change with a document [the false papers]. . . . It is in your fingertips, in the nerves behind your eyeball, in the drumstick of your ear, the membranes of your nostril."[114] Soon thereafter, Mazur rationalizes the family's partaking of nonkosher meat—the slaughtered horse—out of desperation for nourishment: "The sixth commandment says: 'Thou shalt not kill.' If we allow ourselves to die of starvation, we are violating the law! *Therefore,* according to God's will, we should eat the horse!"[115] Toward the end, Stefan—Rabbi Mazur's self-interested and not particularly bright son—makes an unsettling request of his father. Stefan's first act of betrayal comes when he joins the Jewish police, rounding up his coreligionists for transportation to Treblinka and beating them with a club. Perhaps most abhorrent, Stefan asks his father to give himself over to the Nazis in exchange for his own life, reasoning that Rabbi Mazur is old and the young deserve to live. Unable to convince the rabbi of this logic, Stefan chastises his father, irrationally

102

The Warsaw Ghetto

reasoning: "I thought you would want to help me."[116] Stefan instead delivers Berson's typhus-stricken wife, Symka, to the Gestapo.

Just as Serling attended to familial relations—opting not to portray a dramatic and extended uprising but to allude to it and the forming resistance—so did Lampell, who briefly conveyed the joy of fighting back rather than re-create a full-scale battle. Also like Serling, Lampell chose not to write a play that followed a well-worn trajectory or stock figures. Lampell felt that simply causing tears would "be much too cheap. In retelling the story of the Warsaw Ghetto, I hoped to provoke emotions more profound than tears."[117] His conception, as has been described, focuses on the singular will and hope of a cross section of very human Polish Jewish characters. The obvious difference from Serling's play is that Lampell's script does not include any "nice Nazis," as NBC creative supervisor Art Barron put it. Yet, like Paul in *In the Presence of Mine Enemies,* two "bad" Jews feature in *The Wall*: Mauritzi Apt, the aforementioned patriarch who abandons his children, and Stefan Mazur, whose acts of betrayal are even further reaching. Lampell had no interest in romanticizing the ghetto's residents, which he felt would be insulting: "I simply wished to present them as I believed they were—tragic, jealous, warm, frightened, tormented, cruel, courageous—in short, a mirror of the human race with all its failings and all its astonishing potential."[118] Hersey's goal was the same, but his characterizations of the "bad" Jews represent a small component in a vast tome, thereby cushioning their effect, and the revolt receives extended treatment. Apt and Stefan, too, stand out sharply in Lampell's much-condensed play, as do the traumas the characters experience. *Commentary* critic George Ross observed:

The adaptation by Millard Lampell brings to the Broadway stage some of the most terrible incidents in John Hersey's novel, but little of the terror—or the pity. . . . The Broadway play does not succeed, either in creating real people or any urgent sense of their unbearable dilemma. . . . Hersey's novel also says that the decision to resist had to be made anew with each breath, and was unbearably painful, disheartening, and inglorious. The play surely wanted to say something like this, but giving in to the simplicities of melodrama it became a bedtime story.[119]

Hersey's disturbing scenes and characters were gradually developed, but by virtue of the theatrical medium, time constraints, and external factors, Lampell was forced to simplify or edit out much of the detail explaining who, how, and why the characters were forced to behave as they did in unprecedented and unfathomable circumstances.

The responses to Lampell's and Serling's 1960 interpretations of the Warsaw Ghetto suggest a conflicting need simultaneously to remember *and* forget. Such

remembering needed to be purer, less multidimensional than that presented in the two dramas in question, if audiences wanted to remember at all. Apropos Lampell's *The Wall,* the *Jewish Forum* cautioned against the desire to forget, encouraging Jewish organizations to attend the play, which served as "a lesson in memory" and a warning against complacency, "because too many of us have, in this era of good living, forgotten the lesson of World War II. We are too tolerant and unwilling to put out the fire before it becomes a conflagration.... The meek as well as the strong should flock to see this wonderful production."[120] An article about *The Wall* in *Reconstructionist* magazine addressed the middling attendance. The author points out that the play had not attracted large audiences even though much of the audience for theater in New York was Jewish, and reasons that Jews avoided seeing *The Wall* because they did not want to be reminded of Nazi atrocities. Rumor had it, the author reports, that the Philadelphia Jewish community tried to boycott the show when it opened there, because of unfavorable depictions of Jews. Conversely, he suggests, *The Diary of Anne Frank* was well received on Broadway because it centered on goodness within an identifiable family, less on violence, and—I would add—no "bad" Jew appeared in the drama, or any Nazis, for that matter, considering that Anne and the other annex residents were distanced from the camps and Nazi sadism.[121] A critic at *American Judaism* also speaks to the quandary of *The Wall.* He observes that a good part of the house was empty a few days after opening night, and wonders if the audience response was tepid because of the play's limitations or because "people resent being pulled out of their affluent drowsiness and hurled into the apocalyptic pit of twenty years ago?"[122] Once again, the writer assesses *The Diary of Anne Frank* as palatable because it evaded disturbing particulars, in contrast to *The Wall,* whose "suffering . . . is too huge, too naked, too lacerating."[123]

A few months after *The Wall* closed, Lampell himself addressed the play's poor attendance in an article written for the *ADL Bulletin.* Audiences, he points out, anticipated "a grim, unrelieved tale of horror . . . a bleak tale of victims" and as such avoided seeing it. Lampell was blindsided by this reaction, having "unwittingly fashioned a mirror for certain painful, conflicting and half-hidden emotions in many Americans, and particularly American Jews." As he does elsewhere, Lampell asserts that the play was about life and not death, "a story of courage and hope, woven with a thread of victory." He accurately points out that the play was not purely a litany of victimhood, but he does underestimate the traumas the show revisits. His protests went unheeded; of the Broadway plays that opened in fall 1960, only *The Wall* did not have advance bookings from Jewish organizations. At the end of his *ADL* essay, Lampell makes his own connection to what was then the gold standard: "It [*The Wall*] had its tender moments, but it was not, like 'The Diary of Anne Frank,' a delicate and muted play."[124]

The Diary of Anne Frank, with its universalizing message, offered Jews and gentiles a way to embrace the memory of the Nazi genocide, certainly to the point of tears but without being subjected to the dark realities of Nazi barbarism or the less-than-benevolent behavior of some Jews. Likewise, Anne Frank was used as a symbol of optimism in the face of discrimination and continues to be so to this day. Eleanor Roosevelt, in her introduction to the first English-language edition of the diary, identifies this quality, praising Anne as transcending "war's greatest evil—the degradation of the human spirit. . . . Anne's diary makes poignantly clear the ultimate shining nobility of that spirit."[125] Take Anne's sanguine words from her diary, articulated twice in the play, first by her: "I still believe, in spite of everything, that people are really good at heart."[126] Shortly before the curtain falls, with Anne now dead and her father holding her recovered diary, this optimistic sentiment in the wake of adversity—the *locus classicus* of all Holocaust theater and perhaps the Holocaust as a whole—is repeated in a voiceover. Lampell's *The Wall* is much more about Nazi persecutions and diverse Jewish responses to crises, providing the kind of complicated Jewish characters that Serling, too, refused to shrink from presenting.[127]

Because of the possibilities of television and the extended length of his 1982 made-for-television version of *The Wall,* Lampell was much longer and able to tell more of Hersey's story and had plenty of airtime to flesh out "the family": Rachel Apt, strong and sure; Berson, clever but remote; Mauritzi Apt, chillingly callous; Reb Mazur, ever faithful; and Stefan, self-absorbed and traitorous. Finally, with ample time to convey "the inner life" of his characters, Lampell crafted the story that he always hoped to tell: he could communicate to his audience some sense of "how [the characters] could have perpetrated upon each other the most savage cruelties and also the most tender love." Lampell's persistence paid off—third time's the charm—when his work won Peabody and Christopher Awards (the latter founded by a Catholic priest to honor media that "affirm the highest values of the human spirit").

Aired on CBS, *The Wall* commences with Jews building the wall that will eventually trap many of them in their final resting place. As the opening credits roll, a vast crowd of Jews enter the ghetto, with the camera, like that at the start of *In the Presence of Mine Enemies,* tracking over their exhausted faces. Tendering a further introduction to the hazard behind the ghetto's walls, a distracted old man walking with a cane accidentally bumps into a Nazi, who coldheartedly shoots him in reprisal. Near the outset a meeting is convened to talk about Jewish unification and rebellion, thus making the uprising more central to the television rendition than to the stage plays. The revolt allows extended scenes of fighting and a raucous climax, an opportunity for Lampell to appeal to an action-minded American public eager to see Jews fight back. Yitzhak, one of the militants, encourages his comrades to continue

fighting, so as to appeal "to the conscience of the world," and—in words that at this point amount to a refrain—"die defending Jewish honor."[128]

Mostly filmed in Poland, the docudrama is punctuated by common ghetto imagery and sounds, such as the whistling of trains in the background. To orient the viewer, dates are superimposed on the screen at strategic points. Throughout, the chaos of the crowded ghetto strengthens the power of the story, with dead bodies on the street and starving children scavenging for food. Freedom to convey the mosaic of life, and death, in the cramped, walled prison that was the Warsaw Ghetto appealed to Lampell. As he wrote in his preproduction assessment of the original play, published in *Midstream* magazine: "A major character of the event was the Ghetto itself—that raucous, teeming, funny, tragic, furiously alive community beating like surf against its prison wall. To try to compress it within a single room would cripple what was profoundly significant: the *size* of what took place."[129] Close to the finish of the telecast, a camera pans over the desolate ghetto for almost twenty seconds, showing nothing but rubble, grayness, and empty quiet (years later, in *The Pianist,* Roman Polanski also films the ghetto's devastation to strong effect). A teletype machine bears portentous words from the *Stroop Report:* "The Jewish Quarter of Warsaw is no more." A few survivors escape through the flooding sewer, at which point Rutka and Mordecai's baby, fittingly named Israel, cries and is smothered to death by Yitzhak. This change accords with Hersey's novel but differs from Lampell's first theatrical adaptation, which has the baby survive—although this respite from the horrors, real or imagined, that disturbed Lampell's reviewers was obviously still not enough to garner a positive response to the 1960 original. In the televised interpretation, as in the novel, Berson perishes, but four survivors—Rutka, Mordecai, Rachel, and Yitzhak—make it out of the sewer to join partisans in the forest. Taking a cue from the relatively "upbeat" denouement of *The Diary of Anne Frank,* the filmed show ends with two short but heartening sentences printed on the screen: "The Uprising began April 19, 1943. A year later there were still Jews fighting."

Both Serling and Lampell felt "responsible to the people who had played out that terrible hour in history," as Lampell so aptly put it, and indeed it was not heroism as much as the people, flaws and all, who figured into their conceptions, adding new layers to our understanding of the stories that transpired behind the walls that enclosed them. But in 1960 the Holocaust was not as readily a part of Americans' collective memory as it would soon become. The Eichmann trial had yet to polarize the American public, and survivors had still to tell their stories en masse. The "Holocaust" was a generalized concept, with few gradations, for the most ignominious moment in modern history and one the average American wanted to keep in

gauzy memory. By favoring saccharine versions of Anne Frank's story over those that did not skirt the grimmer facts, by choosing sentimentality and optimism over moral ambiguity and the chaos of brutality and annihilation, the early 1960s American public demonstrated—even in the face of genocide—that a neat, euphemizing ending was the only pill they could swallow. If an episode from the Holocaust was going to be told, then the Jews should not be morally equivocal, complicit, or anything but righteous. If an episode from the Warsaw Ghetto was going to be told, then it should be an account of the uprising, for in that there was at least purpose and a small "miracle" amid an ocean of despair. The uprising provided a story that could make a gentile's heart swell with emotion and respect, and a Jew's with hope and pride. For that sort of ghetto redemption narrative, Americans had to wait for Leon Uris's novel *Mila 18,* which came out the year after Lampell's and Serling's more honest (if less inspiring) productions and provides the focus of the following chapter.

3

I had to come face to face with a problem that many Jewish writers write about. There came that day of reckoning when I had to say . . . "I am a Jew and what am I going to do about it and how am I going to live with it?"

—Leon Uris, 1961

All you have the right to ask of life is to choose a battle in this war, make the best fight you can, and leave the field with honor.

—Andrei Androfski, fictional resistance leader in *Mila 18* (1961)

"I Am a Jew and What Am I Going to Do About It"

Leon Uris, *Mila 18*, and Muscular Judaism

Cultural representations highlighting heroism during the Warsaw Ghetto uprising continued after 1960 but with more socially than politically instigated goals. Notably, this "version" of the revolt is promulgated in one of the most public, widely available projects, Leon Uris's best-selling novel *Mila 18* (1961), which is more personal in tone than those created immediately after the events in question. Uris left relevant and revealing comments about why he viewed the uprising from the perspective of Jewish strength and victory—and the dignity that accompanies these traits—providing unique access to his preoccupations as a man and a writer. Looking at the larger picture, the far-reaching success of *Mila 18* and Uris's earlier narrative of Jewish empowerment, *Exodus* (1958), illuminates how American Jews wanted to imagine themselves, and how non-Jews wanted to imagine Jews, following the wreckage of the Holocaust. While Rod Serling's and Millard Lampell's endeavors enjoyed considerable audiences, Uris's *Mila 18* reached an enormous international readership. Mass-marketed and strategically aimed to alter erroneous perceptions of Jews by non-Jews and to invigorate post-Holocaust Jewry, *Mila 18*—building on the work of

John Hersey, Rod Serling, and Millard Lampell—further and firmly ingrained the Warsaw Ghetto, the uprising, and Jewish military achievement in American culture.

Uris's desire to highlight a Jewish fighting spirit and masculinity in his fictional account of the rebellion undoubtedly affords the most vivid and sustained attempt by an artist to connect valor with the events in the Warsaw Ghetto on Passover eve. *Mila 18* and *Exodus,* a novel about the founding of Israel, submit especially keen constructions of "muscular Judaism," the pervading theme in each book, that stress military skill and honor. Two of Uris's main characters in *Exodus,* Ari Ben Canaan and Dov Landau, are fearless, and the novel was embraced so broadly partly because of the pride they instilled in the Jewish public. Meanwhile, the story's engaging action-love story drew in gentile readers, who simultaneously received an education about Israel, Zionism, and the Holocaust. Like *Exodus, Mila 18* also functions, in large part, as Jewish propaganda by elevating the courageous Jew and thus shaping public memory. Anchored by the passionate hero Andrei Androfski, who mobilizes the resistance, *Mila 18* weaves a multilayered tale based on the establishment and ultimate liquidation of the Warsaw Ghetto and, of course, on the uprising—the event that initiates the novel's action and serves the author's purpose. Indeed, Uris mounts his own resistance to prevailing opinion by employing the resistance to counter essentialist versions of Jewishness, although in doing so he creates a version of "the Jew" that is just as essentialist. Assimilated, like many midcentury Jewish Americans who finally lived in the mainstream rather than on the margins, Uris felt sure-footed in his efforts to question and undermine long-standing Jewish categorizations.

In what follows, I intend to show how carefully Uris choreographed *Mila 18*—down to the book's artistic program and his subsequent efforts to capitalize on the novel's popularity—to augment his narrative purpose. Aside from this archaeological account, I offer some thoughts on why a story about the Warsaw Ghetto resonated so deeply with both non-Jewish and Jewish audiences at this particular time, a decade and a half after the true horrors of the Holocaust were revealed. That is to say, I consider what the reception of *Mila 18* conveys about the Warsaw Ghetto and the culture of Holocaust memory in America, alongside conceptions of Jewish identity, during the late 1950s and early 1960s.

Predecessors and Research

To best understand Uris's ethos of muscular Judaism and its portrayal in *Mila 18*, it is fruitful to begin with a discussion of the novel's predecessor, *Exodus,* which has received much more attention than its largely ignored counterpart. It was in *Exodus,*

preceded by *The Angry Hills* (1955)—which explores the Nazi occupation of Greece but does not include a main Jewish character—that Uris first addressed the uprising. As Uris wrote in his account of uprising survivor Dov Landau, one of the central characters in *Exodus,* the Jews in Warsaw "had concluded that it was a privilege to be able to die with dignity."[1] The catalyst for *Exodus,* Uris's six-hundred-page story about Israel's birth, was the 1948 Arab-Israeli War, during which Uris experienced his "first awakening to a Jewish consciousness."[2] With little Jewish education, including no background in Hebrew, and having failed English in high school three times, Uris researched the novel for two years. He explained his motivation in a way that indicates his focus on granting dignity to his Jewish readers: "Although I was strange to Jewish life, I wanted to be proud of my people. I wanted to be able to write a book about Jews and be able to face a Jewish audience afterward."[3] During the research phase for the novel, Uris traveled fifty thousand miles, by his estimate. He lived in Israel for more than seven months, read hundreds of books, conducted fifteen hundred interviews, and in his estimation took in the same number of films.[4] An immediate hit upon publication, the book was in 1960 transformed into a crowd-pleasing film starring Paul Newman and directed by Otto Preminger.

A best seller for nearly five months and with advance paperback orders of 1.5 million copies,[5] *Exodus* generated excellent and widespread publicity, convincing gentiles of Israel's importance and the fighting nature of Jews. Some denounced this birth-of-a-nation epic for a lack of nuance (an assessment of many of Uris's books), seeing it as a story conceived only in generalizations of black versus white, or good versus evil, a standardization on which Uris capitalized in light of his recently successful screenplay for the 1957 hit western about good guys versus outlaws: *Gunfight at the O.K. Corral.* As a reviewer in *Time* magazine observed: "Leon Uris writes Jewish westerns. In *Exodus,* the good guys were the Zionists, the homesteaders who fought for and founded the new state of Israel. The British and the Arabs were the bad guys, and no cattle rustler could be as sordid as the Arabs."[6] All the same, Uris made history into larger-than-life dramatic tales that appealed to the general population even as critics frequently panned them. The same *Time* review censures *Mila 18* for "dialogue that conjures up hours of bad movie time." Yet Uris might very well have been forgiving of such criticism, considering that the review also singled out the type of Jew—using Andrei Androfski as the paradigm—who opted "to sally out of bunkers like Mila 18 and salvage pride and honor in the suicidal, 42-day ghetto uprising that ranks in the legends of heroism as a modern Thermopylae."[7]

At the center of *Exodus* is Ari Ben Canaan, a member of the Mossad Aliyah Bet and Haganah, a leader and warrior who sometimes seems superhuman. Uris mentions Ari's towering (read: dominant) stature on numerous occasions and points out

that he possesses exceptional powers of persuasion, engenders the faith and trust of those around him, and can plot and execute extraordinary strategies (e.g., the plan early in the story to convince the British to release the *Exodus* ship). Adjectives or phrases used to characterize Ari throughout the novel include "remarkable" (40), "strapping" (48, 177), "clever" (50, 52), "all soldier" (282), and "an efficient daring operator" (320). While Ari is deemed "strong" (e.g., 249) several times, Uris takes this further by hyperbolically telling readers that Ari "had the strength of a lion" (272)—and in fact Ari means lion in Hebrew. When Kitty Fremont, Ari's gentile love interest, looks at him and thinks of his comrades, she sees "no army of mortals" but instead "the ancient Hebrews . . . no force on earth could stop them for the power of God was within them."[8] At the end of the novel, Ari's father refers to his son and the fighters as "Jewish Tarzans."[9] In the film version, Paul Newman portrays Ben Canaan, a brilliant casting choice. Already an American heartthrob, Newman was preternaturally handsome and himself Jewish. At the beginning of the film he surfaces from the Mediterranean against a night sky, with his crystal blue eyes and deeply tanned, glistening, and wiry bare chest adorned with a Magen David necklace. In the novel, Uris describes Ari as dark and large, unlike Newman, with fairer skin and a slighter build, but the star's innate sex appeal and good looks afforded no better propaganda for Jewish virility and bravado.

The themes in *Exodus* play out equally and obviously in Uris's next historical drama, *Mila 18*. As the dust jacket from the first edition announces: "The hero of *Mila 18*, however, is the Jewish people as represented by this handful of doomed men and women. It was fortitude and heroism like theirs that led to the creation of the State of Israel and the fulfillment of a two-thousand-year destiny. It was a proud moment in the history of Jews, and Leon Uris has brought it to life with all the conviction and drama of *Exodus*."[10] Using the same formula as in *Exodus*—weaving together various characters' stories, supplying copious amounts of history and integrating true figures into the fictional narrative, using flashbacks, referring to biblical matter, and setting up a good-versus-evil conflict—*Mila 18* provides a captivating retelling of the Warsaw Ghetto's establishment, liquidation, and uprising based on the kind of extensive research that Uris conducted for *Exodus*. Uris spent a week at the Ghetto Fighters' Kibbutz in the western Galilee, interviewing Antek Zuckerman and Zivia Lubetkin, two survivors living there; indeed, he dedicated *Mila 18* to Zuckerman and Lubetkin (likewise the dedicatees of Lampell's published two-act version of his play), as well as Israel Blumenfeld, another fighter. When Blumenfeld died prematurely, in March 1962, while the *Mila 18* phenomenon was still fresh in the public's mind, his obituary noted "it was his heroic efforts in the ghetto uprising that were said to have prompted Leo Uris to write 'Mila 18.'"[11] Uris's experience with the revolt's survivors

was so profound that in addition to dedicating the novel to this trio, he also became national chairman of the Ghetto Fighters' House Museum, located near the Ghetto Fighters' Kibbutz, heading a fund-raising drive in 1961. Earlier, he donated a portion of his *Exodus* manuscript for display in the museum. This donation was a surprise arranged by Uris when he received the Survivors Award from the kibbutz.[12]

In other research for *Mila 18,* the author spent time at the Yad Vashem archives in Jerusalem, visited Warsaw, and read Emanuel Ringelblum's *Notes from the Warsaw Ghetto,* which had been published in English translation only in 1958. Uris's understanding of the importance of Ringelblum's Oneg Shabbos archive was made manifest in speeches, such as one given for Jewish book fairs in November 1986: "When the Germans occupied Warsaw in nineteen thirty nine, Jewish scholars immediately realized that their only chance of survival might have to be through preservation of the word. What they wrote, what they hid and what was found has outlived the Nazis who tried to destroy them."[13] To further ensure the kind of accuracy and fidelity to history that John Hersey also sought when penning *The Wall,* Uris put together four chronologies of events within and outside the ghetto during the years in question, collected large maps of Warsaw, and even consulted a whole book specifying geographic areas of Warsaw.[14] Similar to *Exodus,* too, is Uris's rhetorical strategy—to create a tale that will unfailingly convince the reader of, above all, one salient point. In *Exodus,* the author's goal had been to widely propagate the importance of the State of Israel; in *Mila 18* he aimed to demonstrate Jewish courage during the Holocaust, although this is also demonstrated, albeit to a lesser extent, in *Exodus.*

Before Uris began writing *Mila 18,* he voiced his admiration for Hersey's treatment of the same subject. As he wrote in a 1957 letter to his father, albeit with a jab: *The Wall* was "the finest novel I ever read. Hersey, as a boy was a very sophisticated anti-Semite. It's hard to believe. I feel he is our most underrated novelist."[15] Later reviewers and fans also made logical connections between the two historical novels. A fan letter sent just one month after *Mila 18*'s publication lauded Uris's book over *The Wall;* perhaps its author was unconsciously influenced by Hersey's outsider status as a non-Jew and Uris's position as the son of a father who had immigrated from Poland (the family's original surname was Yerushalmi): "You might enjoy hearing that I found your book, exciting, stimulating, and thoroughly moving. Though I'd read Mr. Hersey's 'The Wall,' it remained for your pen to humanize the Warsaw Ghetto story!"[16] *Kirkus Reviews* mentions the two books in the same breath, not favoring one over the other, praising both for "employing the same unbelievable proof of man's capacity for suffering and ability to endure and fight and live, to tell it in a broader frame of reference, and to build, on factual details, a tremendous saga of adventure and heroism."[17] A critic for the *New York Times Book Review* states, "A few

years ago John Hersey wrote a moving novel about the magnificent forty-two-day uprising made in 1943 by the Jews of the Warsaw ghetto. Reviewers of 'The Wall' were virtually unanimous in their praise; and I, for one, felt that Hersey had written the definitive story of that incredible, courageous battle. With 'Mila 18,' however, Leon Uris proves how wrong such pronouncements can be; it is a book fully worthy of a place alongside 'The Wall.'"[18] A different critic at the *New York Times* also invokes *Mila 18*'s predecessor, which he calls "a magnificent reportorial novel," and testifies that while *Mila 18* "lacks the literary distinction of 'The Wall,' it is quite good."[19] *Library Journal* "highly recommended" Uris's offering "to all collections as a book to stand beside Hersey's 'Wall.'" Again swayed by Uris's Jewish heritage over Hersey's gentile background, the reviewer adds, "because of Uris's advantage of his more personal involvement, his book may well outrank the earlier classic."[20]

Uris initially conceived *Mila 18* as a film, not a novel, and in January 1959 he began researching the project in earnest. In Copenhagen in April 1959 he had a change of heart and also envisioned a trilogy of books featuring Jewish strength. As Uris wrote in a letter to Tim Seldes, his editor at Doubleday: "Tim—please keep this quiet (you + Ken only and also advise Willis of this letter) but I am so wild about the ghetto material I want to do a short (300 page) novel on it—my UA contract is <u>not</u> signed and I'm free to write it if we see fit. Now here's the thing—the ghetto book will be part 2 of a trilogy (EXODUS is #1) and [the] #3 idea was given to me by no less than Ben-Gurion and it is the story of Massadah—the fort which held against the Romans for 3 years—its virgin and a helluva story. Actually the trilogy would be written in backward order but span 2,000 years and the 3 great stands of the Jews." At the top of this letter Uris wrote "confidential" in all capital letters and with a pink pen. Obviously excited, he concluded by writing, "Blood oath—don't whisper a word about Massadah—why no one has thought of it simply beats [the] hell outa me."[21]

Central Characters and Historical Models: Alexander Brandel and Andrei Androfski

Mila 18 was prompted by Uris's research for Dov Landau's story in *Exodus* (book 1, chapters 22–26), which chronicles how the teenaged Landau survives the uprising as a forger and then a *Sonderkommando* in Auschwitz. Most chapters of *Mila 18* open with a journal entry written by Zionist and underground leader Alexander Brandel (this format changes at the end of the novel, after Brandel dies in the revolt); the journal begins in August 1939 and ends in December 1943. Historian Raul Hilberg explained the significance of such chronicling in reference to Adam Czerniakow's

diary, tirelessly kept from the week before the war to a few hours before he killed himself; even if Czerniakow failed to save his coreligionists, he still "did something very important. . . . he left us a record of what had happened to them in a day-by-day fashion" for nearly three years, as Hilberg put it in Claude Lanzmann's epic documentary *Shoah*.[22] Adam Czerniakow's example, along with Ringelblum's Oneg Shabbos archive and diaries by ghetto inhabitants Chaim Kaplan (September 1939 to August 1942) and Mary Berg (covering October 1939 to July 1942), three other oft-consulted firsthand accounts that have survived, provided a vital plot device for Uris, as it did a decade before for Hersey. Structuring *Mila 18* around Brandel's journal—which the character Rabbi Solomon exalts as a sacred book that "will sear the souls of men for centuries to come" (224)—allowed Uris to impart ample historical facts, especially those chronicling German anti-Semitism, atrocities, and oppression. Recall that the radio plays discussed in chapter 1 also added such material to otherwise fictional accounts. Noach Levinson's journal in *The Wall* functions in this vein, although excerpts from his journal constitute all of *The Wall,* while Uris intersperses journal entries into more traditional storytelling. Chapter 30 in part 2 of *Mila 18* opens with one of the novel's longer diary entries, wherein Brandel first describes Jewish efforts to maintain cultural activities amid the terror, noting the ghetto's symphony and theatrical productions. Brandel then turns to the distressing aspects of ghetto life: attempts to smuggle food; a climbing death rate from typhus and starvation, 150 people a day in November and still counting; and the SS's filming of delousing efforts as evidence that the Jew is a "'sub-human' disease carrier" (277–81).

Toward the end of the book the narrative revolves, in part, around preserving Brandel's journal and notebooks and the accompanying archive produced by the Good Fellowship Club (a stand-in for Ringelblum's Oneg Shabbos undertaking) for posterity. In January 1943 Brandel has temporarily withdrawn, drowning in depression. Ervin Rosenblum, who is American journalist Christopher (Chris) de Monti's Swiss News Agency photographer and a Polish Jew ultimately condemned to the ghetto, briefly takes over the journal, counting as parts of the archive fifty volumes in fourteen milk cans buried in different places, along with ten other milk cans and iron boxes holding photographs, diaries, poetry, and essays. As he prepares to hide the materials collected to that point, Rosenblum reflects, "I am almost blind from the years of working in the cellar in bad light with these notes. My hands and shoulders are swollen with arthritis from the dampness. I am in pain all the time. How much longer can we go on?" (379). Saving the gentile journalist de Monti provides some of the tensest moments of the latter half of the novel; his knowledge of the archive's location will allow it to be reclaimed at the end of the war, but his death would most likely mean that the archive would be lost forever. Rosenblum explains, "We

have placed the most urgent priority in getting Chris out of Poland, for he alone is our greatest hope of bringing world attention to the holocaust which has befallen us" (378), and Brandel calls Chris "our passport to immortality" (449). The archive causes the Nazis a great deal of consternation, as they rightly fear that the material accumulated by the ghetto's Jews will condemn them. Nazi Alfred Funk rationalizes: "We cannot proceed with the final liquidation of the ghetto until these records have been found. . . . We cannot permit their distortions to be published" (381). The cynical Nazi Horst von Epp humorously observes: "Would you say that this desire to find the archives is more like a dog scratching frantically to cover up his dung pile?" (384).

Uris's portrayal of twenty-six-year-old Andrei Androfski, based on Mordecai Anielewicz, centers on his strength and intrepid nature. Andrei is a man imbued with "mystic power" (518) who defies the hackneyed convention of the cowardly, scrawny Jew. Uris's view of himself was not that different, and this self image as an aggressive American Jew decisively informed *Mila 18* and several of his other novels. A veteran of the U.S. Marine Corps, Uris served for three years in the South Pacific, beginning when he was seventeen years old, after lying about his age. During those years he worked as a radio operator but was involved in some combat at Tarawa and Guadalcanal. In his first work of fiction, a story about the Marine Corps titled *Battle Cry*, Uris revealed his special focus on robust Jews serving in the military. In *Battle Cry*, the fourth-highest-selling book of 1953 (James Jones's *From Here to Eternity* was the fifth), the Jewish captain Max Shapiro—one of a number of diverse ethnic characters in the book—dies valiantly, as does the drafted Jewish radio operator Jake Levin.[23] Uris treats Shapiro much like his successors Ari and Andrei: "The men in the CP gazed in awe. Max Shapiro was moving as unconcernedly through the hailstorm of lead as if he was taking a Sunday stroll through a park. . . . The legend of Two Gun Shapiro was no idle slop-shute story; it was quite true."[24]

The international success of *Exodus*—in both print and film—assured interest in any novel written by Uris and thus allowed him, through *Mila 18*'s Andrei, a chance to depict Jewish courage and physicality for all to read about once again. Early on, Andrei's strong body is detailed; the reader learns that when he kicks, "leg muscles [are] fairly rippling through his trousers" (15). His athletic ability is confirmed when readers discover that he played for the national soccer team (38), recently won the light-heavyweight wrestling championship of the Polish Army (34), and, as Andrei himself boasts, "can throw a javelin farther and jump a horse higher than almost any man in Poland" (39). His high rank in the Polish Army also receives early attention (15, 34). Before he meets his love interest, Gabriela Rak, a Polish Catholic, she sees him from afar and recalls his nickname: "The Tarzan of the Ulnays" (34). After making his acquaintance, Gabriela is "consumed by his great and wonderful power.

. . . to her, Andrei was like David of the Bible. . . . He was a giant who lived his life for a single ideal. . . . He was a symbol of strength to his friends" (45, 46). The examples of Andrei's corporal supremacy are endless, carrying through the entire novel, from battles in the Polish Army, where his peers tolerate him—despite his Jewishness— because of his strength, to the climactic rebellion. As the fighting winds down and weapons become scarce, Andrei engages in hand-to-hand combat (506) and manages to survive nearly to the end partly because his "eyes could penetrate the darkness with the sharpness of the large cat he was when he moved in the night" (504).

Efforts to Dismantle a Shibboleth

Related to stereotypes of Jewish cowardice and deficient bodies (a subject addressed in chapter 1) are those of supposed Jewish disinterest and inability to participate in the military, a shibboleth that troubled Uris immensely. Uris found any thought of a cowering Jew anathema and countered this perception repeatedly and sometimes with hyperbole, as evidenced by his dogged focus in *Exodus* and *Mila 18*. *Guardian* critic Patrick Cruttwell could not get past Uris's single-mindedness, dubbing *Mila 18* "nothing but a long sickening scream of anger and horror and racial pride."[25] Uris's personal correspondence also evidences his rigid feelings about so-called cringing Jews. Shortly before the publication of *Exodus*, Uris wrote a letter to his father about his recent reading of *The Diary of Anne Frank*: "[I] was tremendously shaken up by seeing it. But in the final analysis must temper my feelings with one of anger and resentment. I do not like to see Jews hiding in attics and feel there is something far more decent about dying in dignity which is of course the choice that every Jew had. They did this in the Warsaw Ghetto. . . . ANNA FRANK was badly received in Israel, for they have a strong feeling about Jews who will not fight back."[26] Three years after the publication of *Mila 18,* Uris again disparaged this icon of the Holocaust: "I did not see the Anne Frank television show, but speaking in generalities I am against the sentimentalizing of her death. She is, to me, the symbol of the passive Jew who died quietly and as you know from my writings this goes strongly against my grain. I like my Jews mean and fighting."[27]

Over the course of his long career, Uris tenaciously concentrated on Jewish leaders in fighting scenarios, aiming to counter ideas about Jewish faintheartedness, disloyalty, and physical inferiority, which he, and the general public, encountered in numerous venues. Even a late nineteenth-century volume on diseases, for instance, chronicled the Jewish failure to fight: "Since they were conquered they have never from choice borne arms nor sought distinction in military

prowess. . . . To be plain, during their most severe persecutions nothing told so strongly against them as their apparent feebleness of body."[28] Mark Twain, in an essay in *Harper's Monthly* from 1899 that mostly defends Jews, still points out their purported spinelessness: the Jew "is a frequent and faithful and capable officer in the civil service, but he is charged with an unpatriotic disinclination to stand by the flag as a soldier."[29] In a postscript penned a few years later and titled "The Jew as Soldier," Twain rescinded this insult, upon discovering to the contrary that Jews participated in American wars: "I was not able to endorse the common reproach that the Jew is willing to feed upon a country but not fight for it. . . . That slur upon the Jew cannot hold up its head in the presence of the figures of the War Department. It has done its work, and done it long and faithfully, and with high approval: it ought to be pensioned off now, and retired from active service."[30] Even so, before and after Twain's qualification, the slur of cowardice, physical inferiority, and disloyalty persisted. In 1895 Simon Wolf, a lawyer and activist, wrote a book, *The American Jew as Patriot, Soldier, and Citizen,* intent on dispelling the claim that Jews reneged on their military obligations in American wars, above all in the Civil War, but also in the War of 1812 and the Mexican War. Wolf noted that Jewish soldiers, in the armies of both the North and South, exceeded their proportions in the general population.[31] Yet still, a 1903 article in *Popular Science Monthly* perpetuated a related canard: "Jewish immigrants of a military age who could pass our army requirements for recruits are comparatively rare."[32]

As mentioned in chapter 1, a few mid-twentieth-century Jewish American apologetics touted Jewish accomplishments in the military, among which were Ralph Nunberg's book *The Fighting Jew* (1945), which notes, "Jewish membership in the armed forces of our country is 40 per cent higher than that of the non-Jews!"[33] Mac Davis's author's note in *Jews Fight Too!* (1945) melodramatically pursues the same theme: "Jews have fought, bled, and died on all the far-flung fronts around the globe. They were in the battle for Africa . . . in the battle for Britain . . . at Pearl Harbor . . . at Stalingrad . . . at Dunkirk . . . in the steaming jungles of Guadalcanal . . . at Tarawa . . . in the skies over Berlin . . . on the bloody beaches of Italy . . . and on D-Day, in the Invasion of France. Everywhere, Jews took up the challenge and fought."[34] Rufus Learsi's *Jew in Battle* (1944) extols not only the uprising but Jewish battles throughout history. Its third and final chapter, titled "The Jew Fights for America," amounts to a defense of Jewish loyalty to their country. Such participation and sacrifice, Learsi argues, should be acknowledged as a "splendid" and "shining record" as well as a "truth" that "should be displayed if only to save Christians of good-will from being infected by the anti-Semitic virus."[35] Several photographs of Jewish soldiers punctuate Learsi's points.

Even the children's magazine *World Over* brandished Jewish military activities. In the lead article of the final issue of 1942, titled "The Fighting Jews" and obviously published before the uprising, the author asserts that although "Jews are called 'The People of the Book.' . . . Jews in the past and today, have known how to fight, when a cause is just and right." The unnamed author offers the typical facts:

Today . . . Jews are fighting bravely under the flag to which they owe allegiance. . . . In the last World War over a million Jews fought in the Allied armies. In the United States there were nearly 250,000 Jews in the armed forces. There were ten thousand Jewish commissioned officers. The Distinguished Service Cross was awarded to nearly two hundred Jews. . . . Jews have fought in every American war for freedom, starting with the Revolution itself. There were Jewish heroes in the Civil War, in the Spanish American War, and in the First World War. Now once again by the tens of thousands Jews are fighting for American freedom, fighting to defend the country which they helped to build up.[36]

As late as 1967 an ambitious edited volume still aspired to "set the record down but also to set it straight" by disproving "the dangerous myth that the Jews did *not* resist." Titled *They Fought Back: The Story of Jewish Resistance in Nazi Europe,* the volume opens with an introduction that unsurprisingly favors the uprising, followed by the book's longest essay, about the insurrection.[37]

Jewish masculinity and willingness to fight, in Uris's life and art, conspicuously contradicted pervasive, unflattering tropes of the meek, bookish, and passive Jew. At the same time, Uris was sure to tout Jewish contributions to American culture. In remarks given at the 150th-anniversary celebration of B'nai B'rith in Washington, D.C., in October 1993—for which President Bill Clinton, wearing a *kipah,* held a *havdalah* candle and then delivered the address—Uris lauded the freedoms afforded Jewish immigrants in the United States and Jewish contributions to their country: "No community is more loving or loyal than the Jews. We, who represent less than two percent of the people, have contributed far more than our meager numbers to the greatness of our nation, as our gift of over sixty Jewish American Nobel Prize Laureates will testify. We have earned and deserve the respect of our countrymen."[38] Uris's words at the B'nai B'rith celebration, held at the Jefferson Memorial, may in part have been an effort to combat any vestiges of anti-Semitism in America and elsewhere, an overriding preoccupation of the author—who himself experienced anti-Jewish sentiment as a child—alongside his attention to muscular Judaism. In speeches Uris frequently returned to Jew hatred. One regularly delivered speech at Jewish book fairs included these strong words: "For myself, I have come to conclude that the greatest moral blight on the mind of man for two thousand years has been the cancer of anti-Semitism.

My anger at this has never diminished."[39] On various occasions Uris specifically said that the Holocaust made him a Zionist and that he would have joined the Irgun if he had lived in Palestine. It is noteworthy that Uris's books emphasize a particularized Jewish experience and anti-Semitism, whereas Rod Serling primarily wrote about mass prejudice. In Serling's various Holocaust episodes, aside from *In the Presence of Mine Enemies,* he mostly sidestepped Jews, aiming instead to include all peoples who perished during the Nazi genocide, even though the reason he wrote about the Holocaust was, as it was for Uris, his Jewish identity.

In *Mila 18,* Andrei provides the most potent example of the type of Jewish warrior advocated by Uris (and artist Arthur Szyk, as explored in chapter 1), but his compatriots also demonstrate their heroism, markedly during the uprising—which Uris manages to make suspenseful even though readers already know the outcome. Before this climactic event, though, Nurse Susan Geller goes to the death camps with the children under her care in the ghetto's orphanage rather than let them perish, terrified, on their own—a parallel to the real-life heroics of orphanage head Janusz Korczak (discussed at length in the next chapter). Wolf Brandel, Alexander Brandel's teenage son and an idealistic leader of the resistance, and his equally idealistic girlfriend, Rachael Bronski, the daughter of Paul and Deborah Bronski, mature physically and emotionally in the novel and discover an inner strength (and their love for each other). Wolf volunteers as a runner, a Jew who, among other tasks, sneaks onto the Aryan side to distribute information about conditions in the ghetto and then sneaks back in with smuggled food and weapons. During the revolt, Wolf, promoted to Andrei's first lieutenant, is one of the primary resistance leaders. After the ghetto suffers its final defeat, Wolf and Rachael guide twenty-some starving, exhausted survivors through chest-high water in the sewers to safety. Most forcefully, as the story climaxes on the dramatic, eighth day of fighting, Uris broadly describes Jews who "turned savage," fearlessly "hurling themselves into German ranks as living grenades and torches. Cornered, out of ammunition, they fought with rocks and clubs and bare hands. . . . They fought like maniacs" (493). Emphatically, Uris describes news accounts: "Tales of the fantastical Jewish courage dribbled out. The myth of Jewish cowardice was burst" (493). In the midst of these final dramatic fighting scenes, Alexander Brandel—a pacifist who has only slowly come around to a strategy of armed resistance, much like Ringelblum—chronicles in his diary: "Our boys and girls still fight fiercely. . . . I will die with pride" (502). Paraphrasing the January 22, 1943, call to resistance by the Jewish Combat Organization—"Let everyone be ready to die like a man!"—Andrei reiterates Brandel's point in one of his last utterances to his troops: "Now hear me. So long as your lungs breathe, you fight" (518).[40]

The characters in *Mila 18* fight for honor rather than for the establishment of a new homeland, and, crucially, they know that by fighting they will most likely perish but will win a moral victory, even in death. From the start, Andrei favors John Steinbeck's *In Dubious Battle* (1936), of which a few lines are reproduced in *Mila 18,* because it passionately tells "of fighting for lost causes," over Hayim Bialik's prose, wherein the poet merely hopes, as Andrei reads in another quoted passage, that "'this is the last generation of Jews which will live in bondage and the first which will live in freedom'" (44).[41] Here, as in many other areas of the book, the characters' actions mirror reality; the underground Polish Jewish newspaper *Biuletyn informacyjny* (*Information Bulletin,* no. 17 [April 29, 1943]) pronounced the uprising, in an article titled "The Last Battle in the Great Tragedy," "a victory in [the fighters'] eyes if the forces of the enemy were weakened just a little . . . a victory in their eyes to die while their hands still grasped arms."[42] Building on this historical perspective, the last words of *Mila 18,* penned by the surviving gentile Christopher de Monti, who paraphrases Brandel in the final journal entry, from December 1943, read: "I die, a man fulfilled. My son shall live to see Israel reborn. I know this. And what is more, we Jews have avenged our honor as a people" (539). Such a "heroic death," as David Ben-Gurion coined it in reference to the smaller January rebellion in Warsaw, persuasively negated misconceptions about substandard Jewish bodies and spirits while simultaneously restoring dignity through a new Jewish ideal.[43]

Along with promulgating a Jewish fighting spirit as a means to reverse unflattering perceptions of his coreligionists, Uris imparts many historical details about this low moment in Jewish history and the attendant ideologies of the time. Aligned with this goal is an improvement in Uris's characterization since *Exodus;* the characters in *Mila 18* are comparatively nuanced, insofar as they are not quite as rigidly archetypal as they had been in Uris's past novels. This observation even pertains to Andrei, who at times allows himself to succumb to exhaustion, emotional and physical, from his various battles and emotional choices (in *Exodus* Ari only has one true moment of vulnerability, at the end of the book, and this is really a ploy on Uris's part to consolidate his hero's romance with Kitty, not to construct a figure with subtleties of character).

Like his recent predecessors, Uris does not portray all Jews as heroic and good. In *Mila 18* he creates representative figures to articulate the distinct philosophies of the moment; some Jews want to fight, others think appeasing the Germans will get them safely though the war, still others assimilate and compromise their Jewishness to survive (Paul Bronski), and some will even throw their coreligionists into the fire, so to speak (the treacherous Max Kleperman), in order to make money and live. Further, Uris sets up the classic juxtaposition between the Torah Jew, Rabbi Solomon, who believes that faith and God will see Warsaw's Jews through the war,

and the secular Zionists, who partake in the rebellion (a juxtaposition also found in Serling's *In the Presence of Mine Enemies*). Initially, as notions about resistance begin to percolate, Rabbi Solomon exhorts God for divine protection: "We defend ourselves by living in the faith which has kept us alive all of the centuries. We defend ourselves by remaining good Jews. It will bring us through this hour as it has through all the rest of our crises" (137). Ultimately, though, the rabbi supports the fight. As in *Exodus,* the story nears its end with a Passover Seder, the annual spring holiday that celebrates Jewish freedom. At the Seder, Rabbi Solomon offers a blessing and connects the ghetto militants to their larger fighting history: "Remember the stories of our people! Remember Betar and Masada and Arbel and Jerusalem. Remember the Maccabees and Simon Bar Kochba and Bar Giora and Ben Eliezer! No people upon this earth have fought for their freedom harder than we have" (470). Nazis in *Mila 18,* too, provide a range of personalities. Along with vicious, depraved Nazis (Sieghold Stutze) are men such as Horst von Epp. A sophisticated intellectual in charge of Nazi propaganda, von Epp does not believe in Nazi tenets or violent tactics, but he realized early on that joining the party could serve his desire for a pleasurable lifestyle. Von Epp reads Freud, even though his work is banned, to help him interpret what he openly perceives as the strange behavior of his Nazi peers (382). As the revolt nears, von Epp presciently comments to a Nazi commander: "Our names will be synonymous with the brotherhoods of evil. We shall be scorned and abused with no more and no less an intensity than the scorn and abuse we have heaped on the Jews" (458). By no means are the individual characters complex, but at the least Uris sets out the varied philosophies of the figures who lived in the ghetto. Such a cross section also appeared in Jon Avnet's NBC miniseries *Uprising* (2001), another representation of the ghetto that nonetheless privileged the fight over all else, and in the network's earlier miniseries *Holocaust* (1978), which broadly looked at several Holocaust "experiences," from Treblinka to Babi Yar to the Warsaw Ghetto.[44]

Allied with the notion of the weak, unsoldierly Jew is the stereotype of the effeminate Jew. As Paula Hyman has observed, "By caricaturing Jewish men as feminized, antisemites and their fellow travelers attempted to strip them of the power and honor otherwise due them as men."[45] Sander Gilman advances this analysis, connecting the male Jew's alleged femininity to circumcision, confirming the ritual affirmation of Jewishness as emasculating in gentile eyes: "the mutilation of the penis was a feminizing act."[46] Gilman explains, for example, that late nineteenth-century Viennese slang used the word "clitoris" to connote Jew, so that female masturbation was "play[ing] with the Jew."[47] The rite of circumcision, Freud contends, commonly associated in the Christian mind with Jews, is also "unconsciously equated with castration"— and Freud connects this castration anxiety to the "roots of anti-Semitism."[48] The

impression of the Jewish man as emasculated or as a woman—inadequate and powerless because of his circumcised penis—provides insight into why some gentiles have connected sexuality and masculinity with Jewish victimization.

What is more, modern psychoanalysis has identified the belief that a penis makes one sex "better" than the other. Freud implies as much when he states that from certain standpoints "what is common to Jews and women is their relation to the castration complex."[49] Freud's case history of little Hans illustrates the unfortunate conception of woman as less than man. Hans, an eight-year-old boy obsessed with genitalia, comes to a shocking conclusion when he realizes that women and men have different genitalia. Freud paraphrases his conversation with Hans: "Could it be that living beings really did exist that did not possess widdlers? If so, it would no longer be so incredible that they could take his own widdler away, and, as it were, make him into a woman!"[50] Uris attempts to discredit this canard in *Mila 18* with his characterization of Andrei (and Ari in *Exodus*) as handsome, virile lovers who inspire the devotion of beautiful gentile women; to be sure, the regenerated and thus potent, muscular Jew links to sexuality as well. In Andrei's case, he inspires the devotion of the striking Catholic Pole Gabriela Rak; Uris was also married to a non-Jew, Betty Beck, at the time he wrote *Exodus* and *Mila 18,* and in two subsequent unions (although his third wife, Jill, converted to Judaism), a point he noted publicly, perhaps with the same aggrandizement by which he celebrated Jewish manliness in fiction. Andrei embodies sexiness, both in his actions and his physical prowess, which translates into a well-muscled body. To state it bluntly, Andrei's body and person afford a foil to the pale, scrawny yeshiva boy and the sexually frustrated Jewish neurotic like Philip Roth's Alexander Portnoy or, in Uris's story, Paul Bronski. A bookish Jew complicit with the Nazis, Bronski loses his wife, Deborah, to the non-Jewish Christopher de Monti, who favors resistance.

Book Jackets as Paratexts

The notion of the Jewish male as effeminate, physically substandard, and Other because of his so-called truncated penis and impotence may have influenced the conceptualization of a countertrope found on the first-edition book jackets of both *Exodus* and *Mila 18*. The earlier novel's jacket (fig. 24), designed by Sidney Butchkes with a drawing by Harlan Krakowitz, presents a strapping freedom fighter in army fatigues, extending the vertical length of the cover, with his gaze cast to the distance. There is nothing nonchalant about his posture. He confidently holds his rifle, which points upward and also guides the viewer's eye to the author's name (not directly

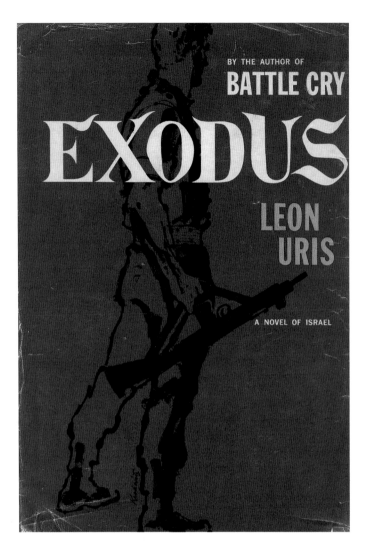

Fig. 24 Book cover of Leon
Uris, *Exodus*, 1958.

influenced by Uris, the movie poster by graphic designer Saul Bass, also Jewish, exploits the same motif: five arms stretch upward with one holding a rifle aloft). On the dust cover of *Exodus* the reader encounters a representation of the militant Jew before reading the novel.

This jacket, as well as the covers described below, functions as a paratext, which Gérard Genette defines as a threshold, "a zone between text and off-text, a zone not only of transition but also of *transaction*: a privileged place of pragmatics and a strategy, of an influence on the public, an influence that . . . is at the service of a better reception for the text and a more pertinent reading of it." That is, paratexts consist of elements that accompany a narrative, that "surround it and extend it, precisely in order to *present* it . . . to ensure the text's presence in the world, its 'reception' and consumption in the form . . . of a book."[51] The power and influence of some of these devices shape the reader's experience, and other devices may cast light on the reception of a book over time. Among the many paratexts that Genette explores in detail are prefaces, dedications, epigraphs, and book jackets. Also of interest to Genette, and to me, are the epitexts, which Genette defines as "any paratextual element not materially appended to the text within the same volume but circulating, as it were, freely, in a virtually limitless physical and social space . . . anywhere outside the book."[52] To name a few epitexts relevant to this study: Uris's correspondence, interviews, and lectures. Both paratext and epitext, as demonstrated in this chapter, shed light on the cultural history and context of Uris's novels.

Returning to the book jacket for *Exodus:* there a Jewish fighter stands tall, from the bottom to the top of the cover, in profile. His gun lies against his leg, at the midsection of his right thigh. That gun, tilted upward in defiance, connotes a man's erect penis—namely, his virility. This iconic figure and pose appear at center,

amid a typeface that evokes a typical Hebrew font, tradi-
tionally thick, bold, and blocky with an occasional flourish
(such a "Jewish"-style print was banned by the Nazis). In
white capital letters, the typography complements the blue
background of the jacket, creating an obvious reference to
Zionist hues with a splash of gold, the color employed for
Uris's name. Beneath these essential details, in smaller white
letters, is a brief explanation of the book's contents, "A Novel
of Israel." Uris was so enamored of his book's cover that he
had Francis Whitaker, an esteemed blacksmith who helped
renew the art of modeling iron, design a wrought-iron
freedom-fighter gate based on the *Exodus* jacket for the
entrance of his Aspen, Colorado, home (1975). Whitaker
took the two-inch-high original figure and enlarged him to
forty-two inches. Graceful lines radiating from the figure's
waist accentuate the fighter and his gun. Whitaker's interest
in negative space, the shapes created not only by the iron
but by the empty areas of the design as well, is apparent in
the twin Stars of David on the side panels of the gate and the
outlines of the figure's clothing. Characterized by Whitaker
as "frankly contemporary in design and technique," this gate

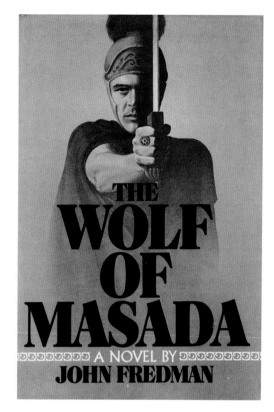

was one of many by the artist, although notably less delicate and graceful than some
of Whitaker's other work.[53]

Fig. 25 Book cover of
John Fredman, *The Wolf of
Masada*, 1978.

The ploy of the Jewish insurgent was not endemic to Uris's dust jackets
even as his books were among the first to feature the tough Jew. As Paul Breines
observes, "Rambowitz novels" featuring fighting Jews gained ground especially
after the mid-1970s. In an instructive discussion of numerous books highlighting
Jewish aggressors, Breines hypothesizes that the Six-Day War initiated "the Jewish
American cult of both Israel and tough Jewish imagery," after which this material
waned until the 1973 Yom Kippur War.[54] At that time, with Israel showing some
vulnerability even in victory, Jewish potency needed to be reasserted, hence the
emergence of these so-called "Rambowitz novels," books like Uris's that tell stories
about self-reliant, untroubled Jews without a hint of timidity or schlemiel-like qual-
ities. Since *Exodus* and *Mila 18* predate the period Breines investigates, perhaps their
positive reception spurred subsequent writers in this direction. The Munich mas-
sacre at the 1972 Olympics may have played a role in the upsurge as well. Another
fictional retelling of Jewish fortitude, John Fredman's *Wolf of Masada* (1978), chroni-
cles the great showdown on the mountaintop, with a dust jacket depicting resistance

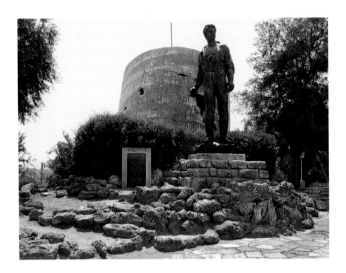

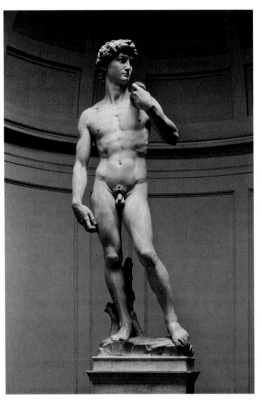

Fig. 26 Nathan Rapoport, monument to Mordecai Anielewicz, 1951. Bronze and concrete with stones. Kibbutz Yad Mordechai, Israel. Photo: Wikimedia Commons (Bukvoed).

Fig. 27 Michelangelo, *David*, 1501–4. Marble, height 13 ft. 5 in. Galleria dell'Accademia, Florence. Photo: Wikimedia Commons (Jörg Bittner Unna).

leader Simon ben Eleazar as a chiseled Greek God with massive muscles and clad in armor (fig. 25).[55]

A larger-than-life-size sculpture of Mordecai Anielewicz (1951) overlooking Kibbutz Yad Mordechai in southern Israel similarly attempts to portray such fortitude (fig. 26). Even if in life Anielewicz wore glasses and was on the thinner side, sculptor Nathan Rapoport (who also sculpted the Warsaw Ghetto Monument on the site of the rebellion in Warsaw) depicts an unbespectacled Anielewicz holding a grenade in his right hand, with a slightly open shirt to reveal heavy musculature. Anielewicz gazes over his left shoulder, resolutely into the distance, his face in three-quarter view. No doubt this pose was influenced by Michelangelo's *David* (1501–4), modeled after the young shepherd and later king who also fought against a vastly stronger opponent (fig. 27). A stone plaque beneath Rapoport's sculpture records Anielewicz's final words (in a slight variation from chapter 1's epigraph): "My last aspiration in life has been fulfilled, the self-defense turned into a fact. I am content and glad that I was among the first of the Jewish Fighters in the Ghetto." The From Holocaust to Revival Museum, housed near the kibbutz, includes a permanent installation about Anielewicz and the ghetto's revolt beside other twentieth-century Jewish history.

Notably, the author photograph on the back cover of *Exodus* portrays Uris himself as a tough, confident Jew. Like the freedom fighter on the front, Uris, before an army jeep, wears military clothing and holds a large machine gun aimed upward, although more vertically, his hand casually placed near his pocket. A caption underneath his name reads: "With a patrol in the Negev Desert." Uris recalled: "I was in the Negev Desert with a patrol of Israeli paratroopers. You'll see on my dust jacket picture on the back of the book I'm hanging onto a machine gun. This appears romantic, but the fact is it was 127° in the shade and if I were not holding on, I would have collapsed."[56] Such a confession comes as a surprise, considering it nullifies Uris's conscious mythmaking in this image of ruggedness, but the average reader would be unaware of the truth behind the photograph. Confession aside, the author photograph conveys Uris's identification with the idealization of the Israeli soldier and his pride in Israeli militancy, made especially manifest during the War of Independence and then the Six-Day War a few years later. It also offers a visual corroboration—bolstered by many examples in his written documents—of how profoundly the fighting discourse so central to Israel's military ideology infiltrated the author's work.

The cover for *Mila 18* (fig. 28) just as forcefully continues the theme of Uris's *Exodus* jacket: Jewish might and battle readiness. Harlan Krakowitz again drew the jacket image, although here Al Nagy designed the cover. A drawing of a young partisan with a rifle strapped on his back, heavily shadowed on the right side of his body, takes up the top half of the jacket. He prepares to throw a bottle bomb, alight with a dash of red—the only color in this otherwise black-and-white rendering. On the left, in a simple red typeface, are the author's name and the titles of two of his earlier best-selling books, *Battle Cry* and *Exodus*. The title, rendered in large print, in blue and black, accompanies a short description, indicating that the novel relates a story about the uprising. Uris and his colleagues judiciously chose the color scheme. Uris addressed this matter in a letter from October 31, 1961, to editor Tim Seldes: "I was really impressed with the way that Exodus is still selling and how in the planning of the dust jacket of Mila 18 we so carefully reversed the colors so that every bookstore I went in had the two books side by side on display, invariably it was the most eye-catching item in the store. They really looked beautiful together, and amusingly enough, every bookseller who had the two books side by side believed he thought it up all by himself. I think our advance planning to make them companion features has really started to pay off."[57]

Uris's planning extended beyond the book's dust cover. When reviewing the galley proofs for *Mila 18*, he marked up the opening page, suggesting that the freedom fighter on the jacket of *Exodus* be reproduced to the left of the title page, along

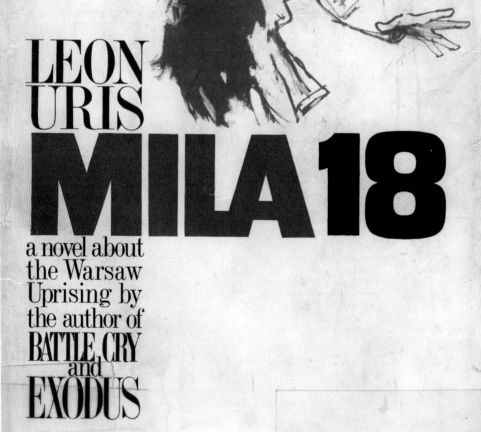

LEON
URIS

MILA 18

a novel about
the Warsaw
Uprising by
the author of
BATTLE CRY
and
EXODUS

Fig. 28 Book cover of Leon Uris, *Mila 18*, 1960.

Fig. 29 Title spread for Leon Uris, *Mila 18*, 1960, verso and recto.

with the list of other books by him. The following foundry proof and published book does include the fighter, who stands tall, gun in hand, deliberately pointed toward the titles of Uris's earlier novels (fig. 29).[58] Uris shrewdly capitalized on this well-recognized figure to move copies of his newest novel. Just as shrewdly, the repetition of this figure on an opening page of *Mila 18* further emphasized the defining ethos of the vigorous, fierce, and proud Jew. Subsequently, the freedom fighter became Uris's surrogate signature, appearing to the left of the title page in future books, pointing to the titles of previous novels.

The fighter's pose on the cover of *Mila 18* conspicuously recalls that of another great Jewish fighter: the biblical David as sculpted by Gianlorenzo Bernini in 1623–24 (fig. 30)—notably the most masculine of the trio of renowned sculpted *David*s from art history and the only *David* showing its subject in the midst of battle. Certainly Michelangelo's *David* possesses chiseled musculature, but the biblical hero appears introspective as he prepares to fight, and is meant to be admired as much for his physical beauty as for his bravery. The David of Donatello's bronze statue (after 1420), while shown victorious in battle, is not a mature man but a smirking adolescent. The cover designer for *Mila 18* has adapted the dynamic corkscrew spiral of the Bernini *David*'s torso as it twists with extreme effort in preparing to hurl a stone. Recounted in 1 Samuel 17:48–51, David's unlikely victory over the giant Goliath provided a

Fig. 30 Gianlorenzo
Bernini, *David*, 1623–24.
Marble, height 67 in.
Galleria Borghese,
Rome. Photo: Wikimedia
Commons (Sailko).

Fig. 31 Agasias of
Ephesus, son of Dositheus,
Borghese Gladiator, ca.
100 B.C.E. Marble, height
78 ¼ in. Musée du Louvre,
Paris. Photo: Wikimedia
Commons (Jastrow).

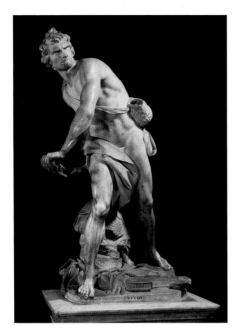

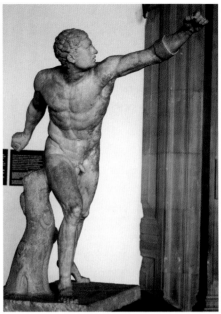

perfect analogy for *Mila 18*. With an inferior weapon, David managed to defeat his powerful foe. Similarly, Warsaw's Jews possessed inferior weapons, and although they did not win their battle against the heavily armed Nazis, they put up a lion-hearted effort. Further, David's pose, and by extension the Warsaw Ghetto resister's pose, has an even older precedent in the *Borghese Gladiator,* from around 100 B.C.E. (fig. 31). This Hellenistic marble sculpture, which has inspired copies in various locations in Europe and America, portrays a warrior engaged in combat.

The representation of strength and resistance on the jacket of *Mila 18* vividly contrasts with the original dust cover of John Hersey's *The Wall* (1950; fig. 32), on which an ominous wall dwarfs tiny Jewish figures, only lightly drawn in white, nearly fading out of existence before our very eyes. No doubt influenced by the original cover for Hersey's novelistic version, the book jacket of Millard Lampell's two-act script pictures a maroon monolithic wall with a small gray horizon barely peeking out at the top and the title of the play scrawled in white graffiti-like print (fig. 33). The dust jacket for Mary Berg's diary, published in English at war's end (1945), similarly references the ghetto's oppression, not its strength (fig. 34). The original book jacket comprises a monolith of bricks, closer to the red of blood than the darker maroonish hue of real bricks, with the volume's title in a burned patch at center.

David's conquest of Goliath also informed the work of a few other artists who wished to make a statement during the Holocaust, just as the small shepherd David

Fig. 32 Book cover of John Hersey, *The Wall*, 1950.

Fig. 33 Book cover of Millard Lampell, *The Wall*, 1961.

Fig. 34 Book cover of Mary Berg, *Warsaw Ghetto: A Diary*, 1945.

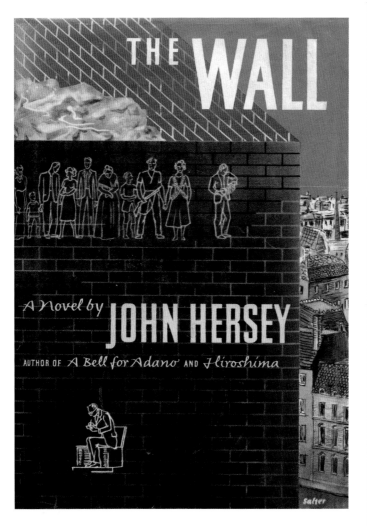

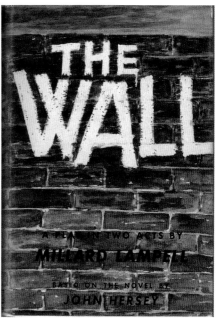

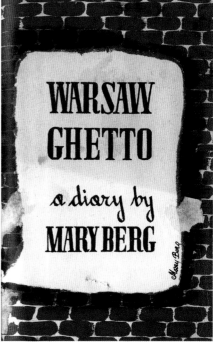

Fig. 35 Jacques Lipchitz, *David and Goliath*, 1933. Bronze, edition of 7, height 39 in. All rights reserved, © Estate of Jacques Lipchitz. Photo courtesy Marlborough Gallery, New York.

had been used metaphorically in much earlier sculpture, most notably in Italy in the aforementioned pieces by Michelangelo and Bernini. The Jewish Lithuanian-born artist Jacques Lipchitz, for instance, adopted this analogy in a sculpture from 1933 (fig. 35) that communicates his distress at this moment in history. Executed in simplified, blocky shapes, the youthful Jewish David, no match for his gentile opponent in physique or weaponry, embodies the power of right over might. Lipchitz's sculpture depicts an oversized, arching Goliath desperately trying to disengage the rope that David, sitting on the giant's legs and bracing himself on the small of his back, has looped around his adversary's neck and pulls with all his strength. To clarify the message of good versus evil, a swastika is emblazoned across Goliath's chest. As Lipchitz recalled: "During 1933 I had designed a series of maquettes on the theme of David and Goliath that were specifically related to my hatred of fascism and my conviction that the David of freedom would triumph over the Goliath of oppression. . . . I wished there to be no doubt about my intent so I placed a swastika on the chest of Goliath."[59]

In October 1962 Bantam Books released a paperback edition of *Mila 18,* following four printings of the hardcover version; the book had by then been named a Book of the Month Club selection in January 1962, a Doubleday Dollar Book Club selection in April 1962, and had won a Commonwealth Club silver medal in San Francisco in May 1962. *Mila 18* enjoyed the fourth highest book sales in 1961, with Irving Stone's *The Agony and the Ecstasy* at number one, J. D. Salinger's *Franny and Zooey* at two, and Harper Lee's *To Kill a Mockingbird* at three. Now classics, Henry Miller's *Tropic of Cancer* (six) and John Steinbeck's *Winter of Our Discontent* (ten) sold fewer copies than *Mila 18.*[60] Uris's publisher estimated that the paperback would sell between 2 and 2.5 million in the first year. Earlier that year, in June, Uris had written to his father that he had approved the cover of the paperback, noting, "it looks very fine."[61] The paperback cover (fig. 36) differs slightly from the image on the cloth edition. The same Zionist blue color Uris favored for the hardcover dust jackets of *Exodus* and *Mila 18,* as well as the paperback of *Exodus,* is used for the title. Underneath, a black-and-white rendering of a determined-looking man twisting his body, with a bottle in one hand and a gun slung down his back, correlates with the cloth version. To emphasize the figure's fighting nature, the artist has drawn him with a second gun in his left hand, the first significant difference

from the *Mila 18* hardcover. Two other additions can be found: a woman sits near the primary figure's right foot, grasping a gun, and a tank appears on the right, approaching menacingly. This image of fortitude repeats on the back cover in a mirror image, with text indicating that the first edition of *Mila 18* spent thirty-three weeks atop the national best-seller list.

Below the back cover's title, again partially colored Zionist blue, an entirely capitalized blurb overdramatically declares that inside a reader will find "the soaring story of the uprising which defied Nazi tyranny and Wehrmacht tanks with homemade weapons and bare fists in the most heroic struggle of modern times."[62] An excerpt reprinted from a *Chicago Tribune* review praises the book: "Tremendous! Magnificent! Uris has written a great angry torrent of a novel!" This type of acclamation was common, but less laudatory assessments appeared on occasion. A review in *Atlantic Monthly* derided *Mila 18* as "comedy, but not by the author's conscious design. Leon Uris has written 500-odd pages of melodramatic hoop-la about a small group of beleaguered fighters making a determined stand against superior forces. . . . It is to be hoped that Mr. Uris' travesty of their achievement will be quickly forgotten."[63]

Clearly, this would not have made good publicity material for the paperback cover. In sum, unlike Hersey's and Berg's book jackets, Uris's *Mila 18* covers were unabashedly meant to signal fighting and strength, not oppression and destruction.

Fig. 36 Book cover of Leon Uris, *Mila 18*, 1962. Paperback edition.

Uris's Related Warsaw Ghetto Endeavors

Seven months before the book's release, a prepublication article written by Uris came out in the periodical *Coronet*. Titled "The Most Heroic Story of Our Century," the article tells an intense, shortened version of *Mila 18*'s story and explains how Uris conducted some of his research. The essay is illustrated with four drawings, two of which advance an agenda similar to that of *Mila 18*'s subsequent book covers. The first drawing depicts the Nazi reaction to a Jewish assault (fig. 37). A caption explains to readers: "The Nazi became a flaming torch as the fire bomb smashed into him. Then the rebels opened fire."[64] Three Nazis express shock at the Jewish offensive; the Nazi

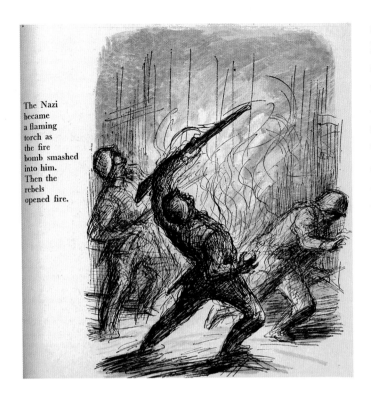

The Nazi became a flaming torch as the fire bomb smashed into him. Then the rebels opened fire.

struck by the firebomb staggers backward, losing control of his rifle; one runs away; and a third looks upward in shock at the unpictured fighting Jews atop a building. A second illustration shows a Jewish man and woman fighting side by side, makeshift weapons in hand, as a tank approaches; the caption reads: "Men, women and children charged tanks barehanded—refused to be taken alive" (fig. 38).[65] The penultimate illustration depicts a man and a woman wading through the underground sewers toward escape while grasping rifles; the last, a group of captured Jews, hands in the air in defeat. Nevertheless, this caption announces: "A handful of survivors were rounded up—but the spiritual victory was theirs."[66]

In contrast to Arthur Szyk's sometimes mocking images, Uris's work concentrated almost solely on Jewish strength, even

Fig. 37 Illustration for Leon Uris, "The Most Heroic Story of Our Century," from *Coronet*, November 1960. Photo: Sherri L. Long.

when exploiting the success of *Mila 18* in unexpected ways. For example, in the late 1980s, Uris and his third wife, Jill, began "performing" an enactment of the uprising titled *The Rising of the Warsaw Ghetto*. Importantly, this is not a reading from *Mila 18* or an excerpt from it, but a presentation grounded on actual occurrences during the insurrection. Reading from a script penned by Uris, the pair alternately speak as they dramatize the ghetto's events. At the beginning of the script, Jill describes the trapped inhabitants' work on the Oneg Shabbos archive: "Their most urgent mission was to save the volumes of notes written by rabbis, scholars and historians. Notes that would speak, for millenniums, of the wanton destruction of a magnificent culture."[67] In reference to the battle, Uris, echoing one of Alexander Brandel's fictional journal entries, frothily paints a picture: "That night the Star of David flew over the first piece of autonomous Jewish land in nearly two thousand years. It was a nation of a square mile. Its capital, the bunker beneath Mila 18."[68] They continue with a dramatic description of the revolt in five pages, much in the manner of the radio plays from chapter 1. The script includes dialogue, uttered by Uris, that connects to the illustration on the jacket of *Mila 18*: "A fighter was to signal the uprising by hurling a bottle bomb. His hand trembled so that one match after another burned out. At last he ignited the bottle and threw it to the street. It hit a German on the helmet

and turned him into a torch. All around the intersection, the Jews opened fire."[69]

Uris so identified with the ideal of the muscular Jew that, remarkably and problematically, near the end of this presentation he and his wife take on the personas of another couple, Antek Zuckerman and Zivia Lubetkin—the uprising survivors whom Uris met during the research phase of his book—using exact words from accounts they gave of the revolt. The reading ends with Uris's summation of the battle's historical consequence: "If the Warsaw Ghetto marked the lowest point in the history of the Jewish people, it also marked the point where they rose to their greatest glory, for from the

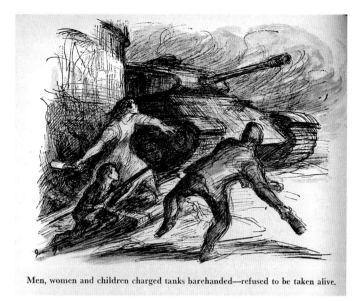

Men, women and children charged tanks barehanded—refused to be taken alive.

rubble of the ghetto they avenged and redeemed their honor as a people."[70] Among other venues, this reading was delivered for Jewish-studies departments and at Yom Hashoah events, together with a conventional speech from Uris. In fact, Uris was a featured speaker at Yom Hashoah commemorations and celebrations of Israel for years. He was glad to take part, believing that Yom Hashoah was a "sacred occasion."[71] Uris was invited to join celebrations of Israel's fortieth anniversary at Carnegie Hall and the Kennedy Center. In addition to remarks about Jewish strength, he made statements about anti-Semitism and spoke about the Holocaust more than the State of Israel. One of his favorite lines, repeated in numerous speeches, invoked the correlation between the Holocaust and Israel: "We all became Jews after the Holocaust and sons and daughters of Israel in 1948. . . . We are the oldest players in the world in the game of survival."[72]

This theme resonated in a speech that Uris delivered during a B'nai B'rith trip to the Soviet Union. Despite its name—"The B'nai B'rith Leon Uris Tour to the USSR: Exodus, a New Chapter"—the trip made additional stops in Latvia, Warsaw, and Budapest. Four hundred people came to hear Uris speak in Riga, Latvia, in the Hall of the Communist Party, where he also signed copies of *Exodus*. In this fairly autobiographical speech, from October 15, 1989, Uris talked about his childhood in Baltimore, his youthful experiences with left-wing groups, and his time in the marines, a period when he downplayed his Jewish background. It was after he learned about the Holocaust, Uris explained, that his perspective on his Jewishness changed: "The day I became a Jew for life was the day we started to learn about the Holocaust. . . . the Holocaust became the most damaging, long lasting impact

Fig. 38 Illustration for Leon Uris, "The Most Heroic Story of Our Century," from *Coronet*, November 1960. Photo: Sherri L. Long.

on my life and I think the lives of every Jew in America and probably every Jew in the world." Further, as Uris put it, *Exodus, Mila 18,* and later *QB VII* "fulfilled my own obligation towards the Jewish people and how they had suffered during the Holocaust and to let the world know about them."[73] Never one to shy away from his dominant narrative, Uris also attributed the success of *Exodus* to its story about the fighting Jew, which "broke a 2,000 year misconception that Jews would not fight."[74]

Particularly poignant is Uris's recollection of a speech he made during this visit to eastern Europe. In Warsaw on the B'nai B'rith trip, Uris also served as a "scholar-in-residence" for a Dor l'Dor United Jewish Appeal mission to Poland, which then went on to Israel. One evening Uris stood in front of Rapoport's Warsaw Ghetto Monument, near Mila 18's former location, with Ernie Michel, former executive vice president of the UJA-Federation of New York, this mission's leader, and a survivor of Auschwitz. As Uris struggled to read his notes in the dark, onlookers lit torches around him so that he could continue. Uris later remembered in various speeches:

The monument wavered in eerie shadows as I read a passage [from *Mila 18*] where a young boy had been taken from the ghetto because he was deemed to have the best chance to survive because of his strength and character. His uncle, a commander of the Jewish forces[,] ordered him to survive for a hundred thousand children who would be murdered in Treblinka. At that instant, I felt something hot on my hand and saw something splatter on the pages of my notes written on Warsaw Holiday Inn stationery. At first it appeared to be blood, but as it hardened, like a seal, I realized it was wax dripping from someone's torch. I looked up and saw Ernie Michel holding the torch over me. The boy I was reading about could have been Ernie, being ordered to survive. In that instant, I felt the miraculous embodiment of the miracle of Jewish survival. I knew I had found my answer to the wonderment of our existence. And so it is. And so it is, my brothers and sisters. . . . We are family.[75]

Here Uris affirms his belief in the Jewish people and in the miraculous nature of Jewish survival during the Holocaust. As the narrative goes near the end of *Mila 18:* "A month was coming to an end. It was a miracle, but over half the joint fighters were alive and armed" (504). Even though Uris spins stories about the cunning and strength of Jewish individuals, he still dubs the establishment of the State of Israel and the ability of the ghetto underground to hold off the SS a wonder beyond comprehension. As Uris explained in an article he wrote about his penning of *Exodus:* "I wanted to find the anatomy of a miracle; for when one speaks of Israel, they speak of miracles."[76]

Undoubtedly Uris saw Israel's founding as a miracle, and in a sense Uris sets up the story in *Exodus* so that the establishment of Israel is ordained by God, or divine will. At times the drama takes place in religious terms: biblical citations set the tone at

different times, and various characters, including Ari, quote scripture. Nonetheless, in the end Uris acknowledges that this miracle is in the hands of men, not God: "I found that miracle makers were men with calloused hands. Miracles come from the same place good books come from . . . hard work."[77] Similarly, in *Mila 18* a ragged, starving band of militants with a meager arsenal manage to hold back the Germans longer than the Polish Army had. For Uris, *that* startlingly triumphant fight was also a miracle; the unbelievability of the Jews' stymieing the Germans, even briefly, inspired—as described in this book's opening chapter—H. Leivick to title his 1944 stage play *The Miracle of the Warsaw Ghetto* (*Der Nes in Geto),* and *The Day* reporter Samuel Margoshes to dub the revolt "one of the miracles of our age." Clearly those who died wished for one. Uprising survivor Marek Edelman recalled of his friend Mordecai Anielewicz: "I think all along he had actually convinced himself of the possibility of some sort of victory. Obviously he never spoke about it before. On the contrary. 'We are going to die,' he would yell, 'there is no way out, we'll die for our honor, for history . . .' All the sorts of things one says in such cases. But today I think that all the time he maintained some kind of a childlike hope."[78]

Uris's attention to children in the recollection of his speech in front of Rapoport's memorial, in lieu of his ever-present interest in Jewish physicality, relates to a surprising image that the author kept near his desk as he wrote *Mila 18:* a reproduction of a work of art, most likely a lithograph or drawing, depicting a wide-eyed boy looking up at the legs of a Nazi and other children lining the background with a wall behind them (fig. 39). The back of the picture reads, "This photo was keep [*sic*] in view at all times while Leon Uris worked on Mila 18," and it is peppered with twelve thumbtack holes, suggesting the picture was moved around Uris's workspace many times.[79] Among the black-and-white photographs of the ghetto and the Holocaust that Uris kept in his files was the iconic *Stroop Report* photograph of the Warsaw Ghetto boy.[80]

As mentioned at the beginning of this chapter, *Mila 18* was originally conceived as a film. After the book's publication, Uris fervently tried to get the book on the screen. In the winter of 1961 he wittily wrote to Tim Seldes about problems trying to sell the film after the book's publication: "The Manulis Frankenheimer [movie] deal fell through, and at this moment it appears that we have as much chance of selling Mila 18 for movies as settling the Arab refugee problem."[81] Nevertheless, Uris forged ahead, completing the first version of the screenplay in November 1965, which he rewrote at various times over the subsequent years, to no avail. Nearly two decades had passed when, in the fall of 1984, Uris received a contract and sizeable advance from Paramount Pictures, but a year later that deal fell through as well. In January of 1989 talks were renewed but the terms never settled. That April, a *Mila 18* movie was again negotiated; a list of possible directors was even compiled,

137

Leon Uris

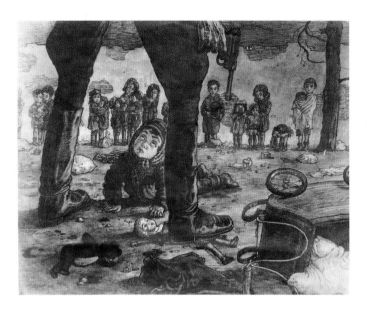

including Roman Polanski, Milos Forman, and Barry Levinson at the top of the list and in that order. A contract was issued but not signed. Uris also received independent inquiries about the making of a *Mila 18* film. A June 1979 letter to Uris from a criminal attorney in Minnesota lamented that no movie had been made of *Mila 18,* which he had recently reread for the fourth time. The lawyer praised the novel as "the most wonderful story I've ever been exposed to," and even though he had no experience making movies, he offered to help Uris put a film version together.[82] Uris snidely wrote back: "I don't wish to be demeaning but your suggestion makes about as much sense as becoming head coach of the Pittsburgh Steelers for the coming season."[83]

All the while, Uris's lawyer, business manager, and fellow marine, Herbert Schlosberg, worked tirelessly to find a company to produce the film. Part of the problem was that Uris was reluctant to cede control of elements of the production, likely a reaction to director and producer Otto Preminger's removing Uris as the scriptwriter for *Exodus,* instead hiring Dalton Trumbo to adapt the screenplay. Uris remained bitter about this until the end of his life; in 2002 he railed: "I got a royal fucking from the Preminger brothers, who were a couple of Viennese thieves. . . . it was a monstrous experience. Otto was a terrorist—he's Arafat, a Nazi, Saddam Hussein."[84] For *Mila 18,* Uris demanded the right of approval for the director and also for the actors playing Gabriela and Andrei. In a letter to an attorney trying to put a contract together, Schlosberg indicates that Uris did not need to approve other parts but did encourage the casting of Jon Voight to play Christopher de Monti and Dustin Hoffman as Paul Bronski.[85]

In 1990, after Uris wrote a Broadway stage production based on his novel *Trinity* (1976), he somewhat illogically believed that might pave the way for a film version of *Mila 18* (a Broadway musical, based on *Exodus* and called *Ari,* ran for nineteen performances in 1970–71). A hopeful letter from Ira Trattner to Schlosberg in 1991, two weeks after Iraq fired scud missiles into Ramat Gan, reported that the director Luis Mandoki was interested in making a *Mila 18* movie: "As Luis so aptly put it the other day, now is the time to remind the world why Israel must always defend itself and strike back against all aggression. While the war rages in the Persian Gulf, the

restraint shown by the Israeli government in its decision not to immediately retaliate against the terror of Iraqi missile attacks on its civilian population becomes all the more remarkable."[86] Mandoki's observation seems to nod toward the dual perspective that the Jews' failure to defend themselves brought on the Holocaust and that the larger public needed to see filmic "evidence" of the results of World War II to remind them why Jews must always defend themselves. In the end, the film was never made, but as late as 1992 a cast list was debated. Among the actors proposed for the role of Andrei were Michael Douglas, Harrison Ford, Richard Gere, Liam Neeson, and even Mel Gibson (which, in light of his much later behavior, is ironic). For Gabriela Rak, Michelle Pfeiffer, Jessica Lange, Uma Thurman, Meryl Streep, and Kathleen Turner were names bandied about. Evidently Uris and Ira Trattner, the hopeful would-be producer of the film, were aiming high.[87]

Exodus Revisited, Jewish Might, and Other Projects with Jewish Themes

One other project by Uris demonstrates as blatant an interest in muscular Judaism, *Exodus Revisited* (1960), a nonfiction photo-essay that came out the year before *Mila 18* and was intended, in part, to reiterate the leitmotif of the already-published *Exodus* and the forthcoming *Mila 18*.[88] Like *Exodus*, *Exodus Revisited* tells a story—in this case nonfiction but from an unquestionably political, biased, Zionist view— of Jewish persecution, Israel's necessity, and the country's subsequent founding. A Jewish fighting spirit punctuates this story, as delineated in detail in *Mila 18*. *Exodus Revisited* is illustrated with more than three hundred black-and-white photographs by Dimitrios Harissiadis, with whom the author traveled through Israel. The over-sized volume begins with images of the land and brief words about biblical history. To establish a precedent for Jewish might, an early spread juxtaposes the two epic revolts Bar Kochba and Masada, with, on the left page, a three-quarter-page photographic detail of a heroic sculpture of an unidentified man, presumably Simon Bar Kochba, considering the accompanying text, and a smaller photograph of Masada on the right page (pages 38 and 39). Uris follows this material with a reference to two biblical figures whose Jewish strength is underscored in the Bible, Samson and David (40), with the powerful Samson resurfacing later in the book (237, 248). In the same breath, Uris fast-forwards to modern times, mentioning Ashkelon, an Arab village captured by Israeli forces in November 1948. Interspersed with celebratory references to the remarkable changes that sabras (native-born Israelis) wrought on the land of Israel are copious stories of Jewish fortitude along with that of the modern-day fight for the establishment of an Israeli homeland. For example, when Uris notes

that "Jewish villages of the 1880s barely held their own" and that "Jews knew little or nothing about farming and as little of fighting" (52), he sets the stage for subsequent Jewish success at both these endeavors by evincing his brethren's keen learning curve.

At this point, *Exodus Revisited* concentrates explicitly on Zionism. Uris expounds on this theme more than once when the need for a Jewish state enters the narrative—for example, vis-à-vis an observation about the increased oppression of eastern European Jews (51), on a page featuring a photograph of Zionist Theodor Herzl's grave. Still, Uris, by connecting Zionism with bravery, finds a way to return to his most persistent thesis when he relates the story of Sarah Aronson, a Jewish woman who worked as a spy for the British on behalf of the Zionist cause. Captured by the Turks in her home and tortured for information, Aronson did not crack. Dramatizing the events, Uris writes that, "nearly insane with pain," the resolute Aronson shot herself rather than betray her coreligionists (58–59). To highlight the importance of Zionism at the end of World War I, when Palestine came under British rule, no illustration is reproduced to distract from Uris's description: "Zionism had built a strong international machinery, and the Haganah, an army of self-defense, came into being" (61). Advancing this idea, Uris pens words about the growth of Palestinian Jewry (75), distinct from earlier Jewish immigrants to Eretz Israel: "In the Third Aliyah a new kind of Jew came into being—the fighter and the farmer. The native born were called *sabras,* after the fruit of the cactus which is tough and tender at the same time. To them fell the monumental task of leading the Jewish people to a status of dignity they had not known since the dispersion" (50). The purely illustrative photographs show several Israeli landscapes, the most abundant images in the book, together with a number of portraits of Israeli leaders. Uris dedicates over a dozen pages to descriptions of Haganah battles during World War II, culminating with his observation that many Jews died to secure a Jewish state, thereby proving "Jewish self-determination" to the British (91).

Scattered over the next twenty-some pages are additional accolades for Jewish fighting with yet further Israeli landscapes. The War of Liberation garners praise, and Masada is again invoked, on a page without an image: "The saga of the settlements did justice to the great fighting tradition of the Biblical Hebrews" (93). Further, Uris recalls how Kibbutz Yad Mordechai, named after Mordecai Anielewicz, "withstood the siege for three months . . . [and] the Arabs soon learned that every Jewish village would have to be conquered at the cost of sustained inch-by-inch fighting." Rapoport's sculpture of Anielewicz accompanies this text, with views from the back and front (102). Uris, among other encomiums to Jewish fighting, extols the "inspiring defense at Safed" with "heavily armed fighters" who were "outnumbered" and faced "Arab weapon superiority" (104), and notes that the "Army of Israel grew stronger and stronger and

dealt the transgressors defeat after defeat" (121). Uris's unrelenting focus on a succession of military conquests and Jewish strength, including Tel Hai (128) and many others, is so excessive that it nearly negates the point he is trying to make.

Book 2 of *Exodus Revisited* tones down the military triumphs a bit and instead celebrates the land of Israel: its people, lifestyle, and other achievements (scientific, educational, agricultural, and so forth). But with around twenty pages left in book 2, Uris returns to his central premise, beginning with a portrait of Yigael Yadin, a leader of the Haganah (252). This portrait is soon followed by one of Dan Ram, "a hero of Hanita" who helped still the Arabs in the late 1930s (254). Most essential for this chapter's argument is a large section, near the end of the book, devoted to the Warsaw Ghetto uprising, beginning with a portrait of Antek Zuckerman (255). The caption underneath his smiling yet somewhat pensive bust-length photograph partially states, "This man is a living legend. . . . He and his comrades staged the first rebellion against the Nazis and sounded the great trumpet that signaled the return of the Jewish people to their Biblical tradition as great fighters" (255). Again, Uris returns to a biblical precedent that connects Jewish might with ancient notions of Jewish identity. What comes next is the longest verbal passage of *Exodus Revisited*: Zuckerman's recollection of the revolt, standing alone on a single page with no need of distracting imagery beyond his vivid account (257). After Zuckerman's reminiscence come words from Zivia Lubetkin, Zuckerman's wife, glorified by Uris as "a heroine of the Warsaw uprising" (258). Lubetkin recounts the end of the battle and the survivors' escape in the sewers and ends by remembering her thoughts amid the terror (words that Jill Uris spoke in her dual enactment with her husband, *The Rising of the Warsaw Ghetto*): "I kept telling myself . . . 'I'm going to survive . . . I'm going to survive . . . I'm going to live and see Israel'" (259).[89] A relaxed photograph of Lubetkin and Zuckerman, an attempt to demonstrate that they have moved beyond the past to a more settled present, appears above this proclamation of hope (258–59). Fittingly, close to the end of the volume Uris conveys additional approbations of Jewish fighting against Arabs and other Middle Eastern oppressors between four photographs of Israeli troops marching. He histrionically writes, "With the wrath of God in her soul, Israel crossed into the Sinai and obliterated the Egyptian Army" (265), and when detailing Arab aggression, he states that the "tough little army of Israel watches" (271). Overall, *Exodus Revisited* is a beautiful collection of photographs partly marred by Uris's overly simplified conception of Jewish/Israeli identity. His effort to thwart long-standing Jewish stereotypes falls flat, rather than empowers, because of his over-the-top dogmatic approach.

Uris's "performing" of aspects of both *Exodus* and *Mila 18* later in life—from *Exodus Revisited* to his sponsored trips to eastern Europe to his and Jill Uris's *Rising*

of the Warsaw Ghetto enactment—suggests that at times he may have realized that his great strength was not as a writer but as a kind of multimedia performance artist who did not see his work as confined to one genre: fiction. Further, in yet another crossing of boundaries and perhaps also a demonstration of egotism, Uris's donation of a portion of the *Exodus* manuscript to the Ghetto Fighters' House Museum for display provided Uris an opportunity to create a literary legacy disproportionate to his often mediocre writing skills. Put plainly, it seems rather peculiar for a best-selling novelist to offer a piece of his mainstream fiction to a museum, thereby attempting to imbue his writing with a kind of talismanic authority; Ringelblum's work would seem a much more natural artifact for commemoration at the Ghetto Fighters' House Museum. The museum serves as a massive paratext amplifying the quasi-scriptural authority of Uris's novel.

After *Mila 18,* Uris wrote two novels on non-Jewish topics, *Armageddon: A Novel of Berlin* (1963) and *Topaz* (1967), which take on black-and-white themes of historical consequence—democracy versus Communism—but within the context of the Cold War. In 1970 he returned to Jewish matter in *QB VII,* a story about a Polish doctor who worked in a concentration camp. *QB VII* is a fictionalized version of an actual libel suit brought against Uris for his brief allusion in *Exodus* to Dr. Wladislaw Dering, a doctor who allegedly performed seventeen thousand experimental surgeries without anesthesia at Auschwitz (an adaptation of the book aired as a well-watched ABC television miniseries in 1974). Future novels that explored Jewish subjects include *The Haj* (1984), essentially the historical events in *Exodus* from an Arab point of view, and *Mitla Pass* (1988), another story of Jewish grit set during the Suez Crisis in 1956. Colonel Zechariah's character in *Mitla Pass* is based on Ariel Sharon, and the fictional Gideon Zadok, an American Jewish novelist and screenwriter who served as a Marine during World War II, bears obvious affinities with Uris. Uris also collaborated with his wife, Jill Uris, on a full-length photo-essay: *Jerusalem: Song of Songs* (1981). Intended to be a travel book, *Jerusalem: Song of Songs* more often than not is suffused with Uris's typical celebratory tone about Israel and its people. At the time of Uris's death, he was working on a project about immigration to New York City's Lower East Side, a fitting culmination to a career that included thirteen novels.

The Plight of the Jewish American Novelist

As a book about the extraordinary clash between underarmed but determined Jews and treacherous Nazis, *Mila 18* highlights heroism, even if it must necessarily address issues of Jewish discrimination to articulate the story accurately.

Literary critic Leslie Fiedler astutely observed, just two years before the publication of *Mila 18*, "one of the problems of the practicing Jewish-American novelist arises from his need to create his protagonists not only out of the life he knows, but *against* the literature on which he, and his readers, have been nurtured . . . to create a compelling counter-image of the Jew."[90] Indeed, Uris's approach differs from American literature before and after *Mila 18*, which often perpetuates clichés and caricatures of Jewish dishonesty, ineptitude, and victimization, and thereby also subverts the "horizon of expectations" as per Hans Robert Jauss's formulation (explicated in the previous chapter). Esteemed American writers, ranging from Nathaniel Hawthorne to e. e. cummings and F. Scott Fitzgerald, employ such characterizations in their work. Other authors, Jews included, have described a more nuanced Jewish experience than does Uris, an experience sometimes populated with unflattering characters. Around the period Uris wrote *Mila 18*, for example, Isaac Bashevis Singer famously wrote about the schlemiel figure—first in English with his incompetent, tortured simpleton in "Gimpel the Fool" (1953), then with many other bumbling, powerless antiheroes. Some characters in Bernard Malamud's novels exemplify the suffering Jew; in *The Assistant* (1957), an employee describes the Jewish grocer Morris Bober as living in "an overgrown coffin" and characterizes him and his fellow Jews as "born prisoners."[91] Set during World War II, Philip Roth's ironically titled story "Defender of the Faith," first published in the *New Yorker* (March 14, 1959) and reprinted later that year in *Goodbye, Columbus*, tells of a group of conniving Jewish army trainees who take advantage of a Jewish sergeant; one character tries to shirk a detail in the Pacific (this plot device surely piqued Uris). Edward Lewis Wallant's novel *The Pawnbroker*, released the same year as *Mila 18* and eventually made into a motion picture (1965), presents Holocaust survivor Sol Naizerman as indifferent, haunted by the past, and bitter. Naizerman, intent on isolating himself from humanity instead of joining it, may have survived the Holocaust, but he is a broken man.

In contrast, Uris's Andrei is not the "typical" Jewish male, or the typical male at all. Not physically small, emotionally insecure or broken, or indecisive, Andrei as portrayed by Uris is almost a superhero, deliberately distinct from the stereotypical Jewish man that the author perceived as prevalent in much writing by his coreligionists. As Uris explained in a *New York Post* interview: "There is a whole school of Jewish American writers who spend their time damning their fathers, hating their mothers, wringing their hands and wondering why they were born. . . . These writers are professional apologists. . . . I wrote *Exodus* because I was just sick of apologizing—or feeling it was necessary to apologize. . . . We Jews are not what we have been portrayed to be. In truth, we have been fighters."[92] On the opening page

of paperback editions of *Exodus,* before even the title page, Uris similarly opined, for his considerable audience, in what Genette designates a later paratext: "All the cliché Jewish characters who have cluttered up our American fiction have been left where they rightfully belong, on the cutting-room floor. I have shown the other side of the coin and written about my people who, against a lethargic world and with little else than courage, conquered unconquerable odds. EXODUS is about fighting people, people who do not apologize either for being born Jews or the right to live in human dignity."[93] Unquestionably, Uris fashioned Ari and then Andrei with an American audience in mind; as he wrote to his father in a letter from 1956, during the development of the novel: "I believe it will be like a breath of spring air for the American people to meet Mr. Ari Ben Canaan, the fighting Jew who won't take shit from nobody . . . who fears nobody. He will be a departure from the Mailer . . . Morningstar apologetics. He will be a revelation for America."[94]

Two years later, Philip Roth, one of America's rising literary stars, offered a notable rebuttal to Uris's comments in the *New York Post* and his famous novel. Having recently published the praised but controversial short-story collection *Goodbye, Columbus* (which contained "Defender of the Faith"), winner of the 1960 National Book Award for Fiction, Roth recognized Uris's barb in the *New York Post* as directed at him. He acknowledged the interview in a 1961 speech, called "The New Jewish Stereotypes," at an Anti-Defamation League symposium held at Loyola University (the speech was published that year in adapted form in the journal *American Judaism* and then in a 1975 collection of Roth's writings, where it was retitled "Some New Jewish Stereotypes").[95] In his speech the younger author takes offense at Uris's characterization of the warrior Jew, although he acknowledges that much of the American public finds such an image "rather satisfying." When looking at the larger picture, Roth debunks Uris's claim, calling his comments about Jews as fighters "bald and stupid and uninformed." He judiciously explains: "There is really not much value in setting oneself the task of swapping one stereotype for another."[96] Roth also devotes a fair portion of the essay to his interesting hypothesis that non-Jews were so interested in *Exodus* because the book does not burden them. He contends that the story dissipates "guilt, real and imagined. It turns out that the Jews are not poor innocent victims after all—all the time they were supposed to be being persecuted, humiliated, and mocked, they were having a good time being warm to one another and having their wonderful family lives . . . [which] surely can soothe consciences: if the victim is not a victim, then the victimizer is not a victimizer either."[97] Additionally, Roth argues, if the Jew is a participant—a person, in the case of *Exodus,* who fights and kills for his land and, in the case of *Mila 18,* who attempts to fight for his life—then gentiles can feel relief.

Although not about Israel's origin, Philip Roth's *Counterlife* (1986; winner of the National Book Critics Circle Award in 1987) partially takes place in Israel and provides some material about the pervading theme of this chapter—heroism. One cannot help but wonder if Uris figured somewhere in Roth's thoughts as he wrote certain passages of this later novel.[98] Told in five nonlinear, freestanding sections that explore the structure of fiction as well as tell a story, the narrative revolves around Roth's frequent protagonist and surrogate Nathan Zuckerman and his brother, Henry. Each of the five sections delves into identity questions anew. In one chapter, "Judea," Nathan reflects on his father's reaction to the Six-Day War: "'Now,' said my father, 'they'll think twice before they pull our beards!'" Nathan, as narrator, comments on his father's viewpoint: "Militant, triumphant Israel was to his aging circle of Jewish friends their avenger for the centuries and centuries of humiliating oppression; the state created by Jews in the aftermath of the Holocaust had become for them . . . the embodiment of intrepid Jewish strength. . . . Jewish helplessness in the face of violence is a thing of the past."[99] Later in that chapter an Israeli settlement leader named Mordecai Lippman decries Nathan's "galut mentality"—as evidenced in Nathan's case by his writing and thinking about violence without partaking in it. In contrast, the militant Israeli "does not *dream* of violence—he *faces* violence, he *fights* violence. We do not *dream* about force—we *are* force. We are not afraid to rule in order to survive . . . *we are not afraid to be masters.*"[100]

Most vigorously, a little over midway through this novel about the alternative realities of being a Jew, a nameless El Al security agent interrogating Nathan rages in reference to the Six-Day War:

The weak little shnook Jew was fine, the Jewish hick with his tractor and his short pants, who could he trick, who could he screw? But suddenly, these duplicitous Jews, these sneaky Jewish fuckers, defeat their three worst enemies, wallop the shit out of them in six fucking days, take over the entire this and the whole of that, and what a shock! . . . They told us they were weak! We gave them the fucking state! And here they are as powerful as all hell! . . . A powerful Jew with a Jewish id, smoking his big fat cigar! Real Jewish might![101]

This passage confirms Roth's ongoing exploration of a binary opposition between Diaspora Jews and Israeli Jews, fleshed out years before in *Portnoy's Complaint* (1969). Comparing himself to Israeli men with whom a girlfriend is acquainted, and in response to her admonishment of his self-deprecation, Alexander Portnoy ponders: "By dawn I had been made to understand that I was the epitome of what was most shameful in 'the culture of the Diaspora.' Those centuries and centuries

of homelessness had produced just such disagreeable men as myself—frightened, defensive, self-deprecating, unmanned and corrupted by life in the gentile world. It was Diaspora Jews just like myself who had gone by the millions to the gas chambers without ever raising a hand against their persecutors, who did not know enough to defend their lives with their blood. The Diaspora."[102] In this monologue and elsewhere, Roth's characters question, define, and/or interrogate their Jewish identities (sometimes obsessively), contrary to Uris's strong and sure Jewish figures. Unquestionably, Uris had a specific agenda as he created his Jewish supermen, and that agenda also included a juxtaposition—implied but not explicitly stated—between the Diaspora (read: American) and Israeli Jews, even though a few of his novels exalt the American Jewish military man (e.g., *Mitla Pass*). As Roth himself observed: "There is the image that Leon Uris has sold . . . to make the Jew and Jewishness acceptable and appealing and even attractive."[103]

In *Mila 18* and his other Jewish-themed novels, Uris expressly and proudly sought to do exactly what Roth accuses him of—not only through his swashbuckling, appealing Jewish characters but also by presenting his super Jews and their plight to a general audience in an easily digestible form. Soon after the publication of *Exodus* and before *Mila 18*, Uris said: "I wanted to write *Exodus*, not only for the Jewish people, but I wanted to reach beyond to the great American public."[104] In a review of *Mila 18* that also spends time parsing *Exodus*, critic Midge Decter discusses Uris's novels in a way that confirms Roth's assessment: "[Uris] has become the master chronicler and ambassador of Jewish aspiration not only to the Gentiles but to the Jews. . . . By now it is unlikely that more than a handful of literate Americans have not either read one of his Jewish novels or been engaged in at least one passionate discussion about him with someone who has. . . . By themselves [*Exodus* and *Mila 18*] have seemed to accomplish what years of persuasion, arguments, appeals, and knowledge of the events themselves have failed to do."[105]

The Wide Reach and Attraction of *Mila 18*

Uris's shaping of the Warsaw Ghetto uprising to suit his purposes certainly says something about who he was as a man, a Jew, and a writer. For the many Americans who welcomed the author's conception of the twentieth-century Jew, Uris tendered a display of Jewishness that was counterposed to a pre-Holocaust and Holocaust Jewishness, and as such the overwhelming success of *Mila 18* simultaneously offers a perspective on postwar perceptions of the Holocaust held by Jews and non-Jews. In *Exodus*, Ari affords a positive example of a post-Holocaust Jew, whereas in *Mila*

18 Andrei demonstrates that such masculine Jews existed during the Holocaust. In Uris's two sweeping, Jewishly inflected novels, these idealized types were constructed, in both text and image, to prove that Jews cannot and did not inherit a fainthearted nature. To that end, *Mila 18* is not so much constructed as a book about the loss of Jewish life in Europe, even though most of the characters in it do die, nor is it a book conceived with a memorializing function. That is, Uris did not stage the events in the Warsaw Ghetto as a means of Holocaust remembrance but as a tool to influence postwar views of Jews. Like some of the cultural productions considered in chapter 1, also tinged with muscular Judaism, Uris's project aspired to reinvent and reinvigorate Jewish identity. Unlike these earlier cultural artifacts, as well as Uris's *Exodus*, the 1961 novel was not explicitly crafted toward a political end, although his ever-present desire to evince the vital importance of the State of Israel served as a secondary goal. (Recall, however, director Luis Mandoki's comment that the time was ripe to make a *Mila 18* movie in 1991 in response to Iraq's missile attacks on Israel.) Rather, *Mila 18* was meant to serve a social purpose, to once again undermine the view of Jews as weak and unresponsive, an ever-prevailing misrepresentation that unfortunately continued into the late 1950s and early 1960s, when Uris penned his novel and after its release.

An immediate hit, *Mila* 18 was available not only in bookstores but in department stores like Macy's and Gimbels and the music store Sam Goody. It was translated into multiple languages, including German, French, Danish, Portuguese, Hebrew, Spanish, Japanese, Norwegian, Swedish, Dutch, Finnish, Yugoslavian, and Croatian, and was even serialized at the time of publication in the Yiddish newspaper *Der Tog*, from July 1961 until early 1962 (*Exodus* was serialized in *Der Tog* as well).[106] A newspaper article from October 1961 about Adlai Stevenson makes mention that among the novels he had recently read was *Mila 18*.[107] A notice in the *New York Times* from September 22, 1961, sought to bring in worshippers to the Stephen Wise Free Synagogue, where the rabbi would be delivering a sermon and review of *Mila 18*. As late as 1983 the novel received attention as a favorite book read by a public figure, when Mets first baseman Keith Hernandez reported, in a *New York Times* article featuring the all-star, that he loved Uris's novels about "'Europe and the Jews: 'Mila 18,' about the last block left in the Jewish section of Warsaw.'"[108]

Mila 18 still made headlines in the twenty-first century. A *New York Times* article from 2001 featuring Miramax Films cochairman Harvey Weinstein ran as part of a series in which eminent directors, producers, actors, and others in the film industry picked and discussed a film that had "personal meaning." Weinstein chose *Exodus*, which he originally saw when twelve years old. At that time the film "blew [him] out of his chair," but Weinstein retrospectively assessed the filming technique during the

movie's first half as "wooden," "deadly dull," and "clumsily staged." During the screening, Weinstein laughed at some of Otto Preminger's direction, although the second half impressed him more, and he consistently praised Trumbo's dialogue. In the end, Weinstein still felt that the "theme of the film was great," and recollected: "When you're a young Jew living in Queens in 1960, and you see Paul Newman as a Jewish commando, you see women fighting alongside men, you see the commitment. I guess it made Jewish-Americans proud to be Jewish, proud of Israel. It did me." Further, he remembered, "guys like me, we grew up with two kinds of Jews—you know, the Jews who marched into the concentration camp and the Jews who fought. So for us, as young kids, you know, this was the movie where we had our first Jewish hero. . . . Suddenly for us there was this new Jewish way of thinking. Instead of growing up to be a professor, a lawyer or a doctor, you could grow up to be a soldier, you know, for your people. You can be tough. You can be John Wayne, too."[109] Weinstein's impression of the story in *Exodus* signaled his receptiveness to a particular transmission of a distinctive type of Jew: one he could celebrate and with which he could positively identify. Aside from the film's influence on Weinstein as a child, he chose to view it because he had acquired the rights to film *Mila 18* a year and a half earlier, after twenty years of trying.[110] He recalled promising an aunt, who gave him Uris's books to read when he was a child, that someday he would make *Mila 18* into a movie. To date, the film has not been made, but Weinstein has said on a number of occasions that he still plans to adapt *Mila 18* and is considering directing it himself.

Two fan letters, among many Uris kept in his files, reveal representative responses to *Mila 18*'s counternarrative, the first in line with Weinstein's assessment. As one Jewish admirer wrote to Uris in 1961: "I have always decried the Jew who ran from his oppressor and prayed for deliverance instead of standing and fighting like a man. The State of Israel of course to our joy, has changed this picture of the cringing Jew. *Mila 18* gave us the reincarnation of the ancient Hebrew, the brave and powerful warrior when he had to be."[111] The writer signs off by suggesting that Uris write a book about the Maccabees. In October of that same year another admirer wrote from a Christian perspective:

I have neither the eloquence of Alexander Brandel nor the wisdom of Rabbi Solomon; I have only the quality of being grateful. I am grateful for being able to read both "Exodus" and "Mila 18" . . . I am grateful as a Christian to be able to say to my Jewish brethren, "We shall die before we allow a people to be so persecuted because of their religious persuasion." "Mila 18" has opened my eyes in another way. It is hard to realize the struggle for survival so engrained in the soul of man; you have demonstrated in your writings the spirit which has enabled the Jewish culture to survive thousands of years of persecution and to emerge victorious

and even more strong. It is my hope that the many thousands of people who have read and will read "Exodus" and "Mila 18" will better be able to understand their Jewish brethren.[112]

The awakening of consciousness to what Jews had suffered and what they had stood up against over the centuries lies at the core of Uris's work, initiated by his distaste for the deeply ingrained stereotyping of the Jew as weak and cowardly, accompanied by his determination to subvert this epithet, redeem the Jewish image, and create a new conversation. The novel's reach was tremendous, extending even to bookstore browsers who may only have encountered *Mila 18* (and *Exodus*) as they casually walked past their persuasive, even propagandistic, covers displayed on a shelf. Setting his story in the ghetto, not a concentration camp, enabled Uris to write not only about a valorous battle but also about the importance and strength of a Jewish community, Hersey's voiced goal as well.

It would be facile to suggest that *Mila 18* was only a runaway best seller because Uris adeptly created a universal tale with elements that could easily be translated into the type of story Americans would understand: good guys versus bad guys (a "western," as an aforementioned reviewer dubbed an Uris novel) complemented by three appealing, seemingly doomed love stories (Gabriela and Andrei, Deborah and Chris, Rachael and Wolf). Put another way, *Mila 18* is more than a novel tailor-made in a format familiar to a broad American audience. That audience could instead have turned to any number of formulaic books, perhaps even those westerns to which Uris's work was compared, that would have left a reader unburdened by copious and disturbing history and distressing amounts of suffering and carnage, which his predecessor Hersey sidestepped to a degree. *The Wall*, in fact, may have primed some American readers to pick up *Mila 18*, not realizing the gruesome reality to which they would be subjected. At the same time, *Mila 18* was able to keep readers at a bit of a distance, considering Uris wrote it in the third person, whereas Hersey wrote in the first person. Certainly *Mila 18*'s success was conditioned by the public's appreciation of its predecessor, *Exodus*, published only three years before, and Jews would especially have been drawn to the book because of its empowering narrative. But what of the non-Jewish favor for *Mila 18*?

It is worth revisiting Philip Roth's observation that non-Jews were attracted to *Exodus*, and by extension *Mila 18*, because muscular Jews offered non-Jews relief in light of the grim, unfathomable revelations of the Holocaust. This may, in part, explain the two novels' appeal, but comments by *Midstream* writer Joel Carmichael expand and nuance the "Uris effect." Carmichael, in a tremendously scathing essay triggered by the publication of *Mila 18*, calls *Exodus* and *Mila 18* "absurd" as literature,

"repellent as prose," "sub-literary," and "preposterous," while simultaneously parsing why the public so wholly embraced Uris's books.[113] In reference to gentile interest in *Exodus* and *Mila 18,* he observes that the factuality of the novels helped their cause because as works of the imagination they would frighten away readers.[114] Carmichael marvels that such stories piqued readers' interest, considering that not much time had passed since the events in question and thus for many the Holocaust was a story lived out in newspaper accounts that, he asserts, were not even read with much concern at the time they appeared. By Carmichael's recollection, the non-Jewish response to the Holocaust was either apathy or shock, and Uris's books suited both of these responses, filling a niche for those who were ready to increase their awareness of recent history, ingesting it in a "small, convenient package . . . [that] is so negotiable it is no longer disturbing."[115]

Mila 18's resonance with non-Jews can be attributed to a desire on their part to learn about Judaism and the Holocaust in a form more accessible than a history book and less devastating than film reels of the camps—whether or not the readers were apathetic or shocked in the immediate post-Holocaust years. Carmichael scoffs at Uris for his "unique blend of insipidity and simple-mindedness," but it could also be argued that the popularity of *Exodus* and *Mila 18*—stereotypes, chauvinism, and sensationalism be damned—served not only to boost morale for Jews but to disseminate a valuable history lesson for non-Jews. As put in a previously quoted fan letter to Uris from a Christian reader: "It is my hope that the many thousands of people who have read and will read 'Exodus' and 'Mila 18' will better be able to understand their Jewish brethren."[116] To be sure, for readers who did not know about the Warsaw Ghetto and the uprising, *Mila 18* acquainted them with it, with the destruction of thousands of years of rich European Jewish tradition, and with myriad details about the Holocaust—and the importance of that cannot be understated. The same can be said, it must be noted, of the nine-hour docudrama *Holocaust,* which, while criticized, most famously by survivor Elie Wiesel, for "trivializing" the Holocaust and turning it into a "soap-opera," reached a massive global audience.[117] An estimated one hundred million Americans learned about the Nazi genocide over four evenings in April 1978, the last of which fell on the thirty-fifth anniversary of the uprising.[118]

In a sense, Uris was in a Catch-22, an apt analogy considering that the title of Joseph Heller's 1961 novel—originally *Catch-18*—was changed because of the preceding publication of *Mila 18.* Uris aspired to make Jews, Judaism, and the Holocaust understandable to general readers of all faiths and to do so within the limits of his own writing capabilities and the capabilities of the average reader as he saw them. Whatever Uris's literary limitations, many of which critics have

rightly pointed out, he succeeded—albeit via a form very different from that which Emanuel Ringelblum imagined—in making the Warsaw Ghetto, its residents, and the destruction of Polish Jewry known. That is to say, Ringelblum's Oneg Shabbos group was created to bear witness, to "let the world read and know," as an anonymous writer for the archive put it, and however unappealing some found aspects of *Mila 18*, Leon Uris did just that.[119]

4

Sometimes I have the feeling that I would like to paint one million Jewish icons. One million of these Warsaw boys, for the number of children who were murdered.

—Samuel Bak

I am hungry, I am cold; when I grow up I want to be a German, and then I shall no longer be hungry, and no longer cold.

—Diary entry by a child in the Warsaw Ghetto

"I Would Like to Paint One Million Jewish Icons"

Samuel Bak's Painted Memorials and the Traumatic Loss of the Youngest Generation

Some of the most heartrending stories entwined in the history of the Warsaw Ghetto concern children. Judenrat leader Adam Czerniakow killed himself by swallowing a cyanide pill on July 23, 1942, the day after the SS asked him to compile a list of six thousand people, including children, to be transported to Treblinka; at that time Czerniakow realized his strategy, working with the Nazis, was futile and the children's extermination imminent. He left a note referring to this calamity: "The SS wants me to kill children with my own hands. There is no other way out and I must die."[1] Soon another tragic event occurred: Janusz Korczak (born Henryk Goldszmidt), a highly esteemed author, educator, and pediatrician whose dedication to the ghetto's orphans in his care was so unwavering that he selflessly accompanied approximately two hundred of them from Warsaw to Treblinka on August 5, 1942, perished with his beloved children, even though the Nazis offered him freedom. Knowing the children's final destination, Korczak still dressed them in their Sabbath best and led his charges, all singing in an orderly line, to a freight car at the *Umschlagplatz*, telling them that they were going on a picnic. These prominent stories, and so many others

that are known, as well as those we can only imagine, resonate deeply. Indeed, the memory of innocent, bewildered, and terrified Jewish children, in Warsaw as well as throughout Europe, tortured and then brutally extinguished during the Holocaust, thereby obliterating the continuation of generations, can never be numbed. Only 11 percent of prewar Europe's Jewish children survived, translating to the murder of an estimated one and a half million Jewish children, effectively wiping out millions of future Jews.[2]

The next two chapters aim to unpack various cultural responses to children and the ghetto rather than argue for a specific claim, but they still identify a handful of threads that run through the material. Representations of children and the Warsaw Ghetto serve, expectedly, as signs of innocence and loss and searing commentary on the cruelty wrought by Nazis on the most vulnerable. Others rely on the unlikely survival of children instead of their unthinkable deaths, providing a sugarcoated, albeit much-needed, legacy of hope, redemption, and regeneration for American Jews (however elusive and deceptive this may be). Broadly, I am interested in how a range of depictions featuring children have served as points of access into the ghetto, and in the vocabulary artists used to traverse this fraught terrain. I pay special attention to two extensive projects from the late twentieth and early twenty-first centuries by a pair of visual artists: Samuel Bak and Joe Kubert. This chapter's primary focus is on the earliest of child survivor Bak's series of some seventy-five paintings (1995–2008) based on the haunting photograph of the Warsaw Ghetto boy from the *Stroop Report,* an image of childhood lost that has intrigued a number of artists. The following chapter examines Kubert's graphic novel *Yossel: April 19, 1943* (2003), a work of historical fiction that explores what the artist's life might have been if his family had not escaped Poland when he was an infant. The artists' backgrounds as children from eastern Europe strongly shaped their interpretations of children in the Warsaw Ghetto, which are thus imbued with revealing autobiographical resonance. Also noteworthy is the form these artistic responses, born out of trauma, take in the categories of "high" and "low" culture, as well as the intended audience for these diverse undertakings.

Prioritizing the Tragedy of the Children for Maximum Emotional Response

Holocaust children figured in cultural projects long before Samuel Bak produced his Warsaw Ghetto paintings. Recall, for instance, Arthur Szyk's vitriolic political satires and pro-Jewish images, several from his portfolio *Ink and Blood: A Book of Drawings* (1946), which comprised seventy-five illustrations, including the celebratory color

Fig. 40 Arthur Szyk, *To Be Shot, as Dangerous Enemies of the Third Reich!*, 1943. Pen and ink and pencil, 7 × 11 in. Reproduced with the cooperation of The Arthur Szyk Society, Burlingame, Calif., www.szyk.org.

plate *Battle of the Warsaw Ghetto* and a portrait of a maniacal Hitler, arrestingly titled *Anti-Christ*. An equally disconcerting plate in *Ink and Blood*, gaining its power not from a caustic edge but from the discordant and disturbing nature of its representation, is a black-and-white print, *To Be Shot, as Dangerous Enemies of the Third Reich!* (dated 1944 on the sheet but originally published in *PM* on December 14, 1943; fig. 40).

Less cluttered and more simply rendered in line than Szyk's detailed miniatures, *To Be Shot* portrays two children wearing Star of David armbands. This boy and girl stand before three Nazis, with two other SS men holding their guns erect, guarding the helpless pair. Hitler's portrait, hanging on the wall behind the scene, accentuates the danger that the children are in, not the nonexistent threat they pose. While not explicitly presenting children in the ghetto—although, considering the armbands and the prominence of the Warsaw Ghetto in the portfolio, the pair may very well have had Polish origins in Szyk's mind—this image manipulates the viewer by picturing wide-eyed children doomed to die simply because they happened to be born Jews. These are not rosy-cheeked children looking toward the future but innocents who will soon meet their death. Confusion rather than fear underscores their innocence: they do not even know enough of human evil to be completely afraid. Corresponding to Szyk's aim—to create propaganda easily accessible to a large audience during the war—this image is more easily accessible than those that are particularized in later decades, like the visual paraphrases, examined below, of the Warsaw Ghetto boy by Samuel Bak and others. Peter H. Bergson's Emergency

Committee to Save the Jewish People of Europe capitalized on the effectiveness of images of children to demonstrate the absurdity and abject evil of the Final Solution in the 1940s. During the war a reproduction of Szyk's image appeared on prints and fund-raising stamps as a rallying cry for the United States to take action.[3]

Violence against children—against the most defenseless and confused—is especially difficult to tolerate. Verbal and visual representations of such constitute palpable evidence of SS depravity and callousness and are exceptionally painful. Starving, unwashed, and often orphaned children begging daily for bread until exhaustion and deprivation depleted them to the point of weakness and apathy; children huddled together on the streets under inadequate blankets and wrapped in rags, trying to stay warm; and brokenhearted mothers watching their children die and even cuddling their dead, sometimes frozen, children are among the most potent images from, and about, the Nazi genocide. The physical and psychological torture of children often imparts a more forceful sense of victimization than the degradation and annihilation of an adult. As Lawrence Langer posits: "The extermination of children during the Holocaust remains a unique atrocity, one which more than any other offends the sensibilities and the imagination of men who consider themselves civilized. If man's fate in war is to die, and woman's to mourn, a child's fate—as always—is to live and rejoice in his youth and innocence while they last; and the mind has special difficulty adjusting to any situation that reverses this 'normal' trend."[4] While there are myriad ways to confront the most awful in the Holocaust, children's distress evokes almost universal distress in most viewers. Further, parents and many other adults recognize their responsibility as protectors of the younger generation, a responsibility made impossible by the Nazi genocide.

Images of this sort do not only tender gripping "proof" of Nazi barbarity. Because viewers can easily identify with children, as Marianne Hirsch observes, in relation to photography, children allow "virtually universal availability for projection," however problematic that may be.[5] Elsewhere and analogously, Hirsch convincingly argues that photographic images of children (and I would extend this observation to other representations of children) "elicit an affiliative and identificatory as well as a protective spectatorial look."[6] In other words, we are not all parents, but we have all been children; we have all experienced confusion, fear, and vulnerability in confrontations with adults, but very few at the level of those who endured the Holocaust. Imagining those emotions through the eyes of a Jewish child in wartime Europe places a premium on Nazi monstrosities, augmenting and making more tangible the devastation and catastrophic impact of the Holocaust. The United States Holocaust Memorial Museum deftly deploys children to this end. While the children's experience must necessarily make up only part of the museum's historically grounded narrative, the

manner in which the museum displays that experience manipulates visitors' emotions, provoking maximum emotional response.

Chartered in 1980 by an act of Congress and characterized as a "living memorial," the museum, located on the National Mall, exists to educate visitors about the Holocaust, encourage education and research (the fifth floor houses a research institute with archival records and other resources, and the second floor houses the Wexner Learning Center), and serve as the nation's primary site of remembrance. The history narrated in the museum, in the words of the museum's project director, Michael Berenbaum, "cuts against the grain of the American ethos. . . . [It is] a violation of every essential American value." In narrating it, the museum seeks "to reinforce the ideas of inalienable rights of all people, equal rights under law, restraint on the power of government, and respect for that which our Creator has given and which the human community should not take away."[7] In other words, the lessons of the Holocaust serve as a terrifying, cautionary reminder of what can happen when oppression and bigotry thwart democratic ideals. At the time of the museum's charter, Congress passed a bill enacting a national annual week of Holocaust remembrance that purposefully overlaps with Yom Hashoah.

Visitors to the museum enter the building via a four-story atrium known as the Hall of Witness, a symbolic and fragmented architectural space designed to disorient and, in part, evoke, in its form and material, the architecture of the death camps. Three floors house the permanent exhibition, beginning on the fourth level, "Nazi Assault: 1933–1939," which conveys the progression of restrictions, the use of propaganda to garner support for government-sanctioned anti-Semitism and violence, and the ensuing terror. The middle level, "The 'Final Solution': 1940–1945," occupies the third floor. This portion of the core exhibition documents the segregation, humiliation, and systematic murder of Europe's Jews along with millions of other undesirables, as defined by the Nazis, including Roma, homosexuals, and Jehovah's Witnesses. The final level, on the second floor and called "Last Chapter," chronicles the Holocaust's final months and the aftermath: camp liberation, prosecution of Nazi criminals, and the postwar lives of survivors.

The museum's emphasis on children and their deaths caps the second floor of the permanent exhibition. Visitors first learn about the escalation of the Final Solution, including death marches, and then view graphic liberation films. Following the war's end, the narrative outlines the ways in which displaced persons rebuilt their lives, the creation of the State of Israel, and immigration to Israel and the United States. At the last stop of the entire permanent exhibition, one arrives at *Testimony,* a film featuring interviews with survivors that runs a little over an hour and fifteen minutes. *Testimony,* stressing hope at times, supplies something of a triumphalist ending to the

157

Samuel Bak

museum's narrative; survivor testimony commonly ends by conveying the renewal of broken lives through details about the regeneration of family—a recounting of subsequent generations as tangible evidence of survival. But before this last stop, and most relevant to my observations here, visitors encounter a section fully devoted to children, an arrangement meant to cement this material in one's mind as the exhibition nears its end. Museum visitors walk through a long hallway devoted to the various experiences of the Nazis' youngest targets: children in hiding, children in the camps and ghettos, and children, mostly orphans, in the post-liberation phase of their lives. As the panel introducing this section announces: "The Nazis' attitude toward their youngest victims was one of cold-blooded callousness." The panel goes on to explain that ghetto life was particularly hard on children due to hunger, disease, and an environment of begging and smuggling. The last paragraph of this panel, a single sentence, needs no explication: "More than one million children and infants died in the Holocaust."

Photographs of emaciated, wide-eyed children overlaid with short descriptions amplify the poignancy and heartbreak of the installation. Among the most challenging are two different photographs of a child on one side of a fence, with his parents on the other. One shows a boy from the back, a yellow star stitched onto the shoulder of his coat, looking at his parents, who are so close but so far away. The caption explains: "Families were often separated when deported from ghetto to camp." In another, a ghetto boy claws at a fence, his mother on the opposite side. A different photograph displays a succinct and effective caption: "After arrival at Auschwitz most children were murdered within a few hours." Another: "Pregnant women and mothers with children were immediately gassed." Photographs from the Warsaw Ghetto show sick children in a clinic, and a separate display includes toys and children's artwork from Theresienstadt.

Walking out of the permanent exhibition, visitors encounter the Hall of Remembrance, a light-infused national memorial to the victims and also a contemplative space within which one finds an eternal flame and memorial candles for visitors to light. Emerging from this space, one can opt to visit the Wexner Learning Center to learn about contemporary cases of genocide, or proceed downstairs to the first floor to exit the building, or descend another flight of stairs to the concourse level, designed to house classrooms and visiting exhibitions. Adjacent to these classrooms, the children's Wall of Remembrance features a mural of more than three thousand ceramic tiles painted by schoolchildren in the 1980s, depicting their feelings and observations about the Holocaust. One of the saddest and perhaps most haunting observations about the Holocaust stretches above this display, a quote from diarist and poet Yitzhak Katznelson, whose words live on even though he did not.

Of the children, he wrote, reminding us of the irreparable loss of innocent life and future generations: "The First to Perish Were the Children. . . . From These the New Dawn Might Have Risen." This wall functions as a memorial, dedicated solely to the more than one million Jewish children killed by the Germans, separate from the Hall of Remembrance.

That the museum erected a wall specifically dedicated to children invites us to rethink how children appear in the permanent exhibition. Indeed, that the museum's curators viewed the child's experience, and remembrance of it, as so important as to create such a wall invites attention to a small, child-specific display about Anne Frank on the third floor of the exhibition. Entering the third floor, one first encounters this section about Anne Frank's life—which is entirely logical considering her diary's prominence—complemented by photographs of her and the well-known secret annex where she hid from the Nazis. Fitting the museum's emphasis on children, the signage explains her prominence, or at least how the museum has framed it: "Through her diary, Anne Frank has become a symbol of lost potential." It is this particular framing that merits mention. Her characterization as the child of "lost potential" connects her to the museum's larger program about children and its elevation of the children's plight to maximize the impact of their loss. Museum literature commonly employs photographs of children to appeal to the reader's best sensibilities; examples include a magnet with two boys wearing coats marked with Star of David patches, and a full-page advertisement in the museum's magazine, *Memory and Action,* featuring those same boys and the question, "Who will tell their stories? With your support, we will." Other support materials adopt the ubiquitous Warsaw Ghetto boy photograph—reproduced on the front of a pamphlet available at a kiosk in the Hall of Witness.

I have looked at the museum's narrative with an eye on the children to establish how their experience plays out in the most visited and prominent institutionalization of the Holocaust's narrative in the United States, and arguably the world, and how it has been, in a sense, exploited. Here and elsewhere, artists, writers, and others consistently prioritize the tragedy of the Holocaust's children, both for the sadness incurred by their loss and suffering and for the subsequent response to that trauma. What might seem incongruous at first glance but makes sense in light of the reverence given over to children is the dedication of a scholarly volume about Jewish resistance, from 1967, that brings the slaughtered young front and center: "To the memory of the 1,200,000 Jewish children murdered by the Nazis in the ghettos and death camps of occupied Europe." Moreover, above this dedication the editor of the book includes a woeful quote from Emanuel Ringelblum about the cruelty wrought on the children: "Even in times of savagery the most brutish barbarians were not

159

Samuel Bak

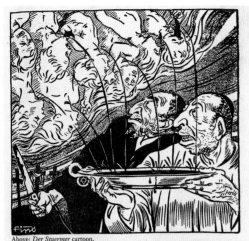

Above: *Der Stuermer* cartoon.
Below: ... and this is what the Nazis did to children all over Europe.

Official Photo from the U.S. Office of War Information

Fig. 41 Illustrations from
The Black Book, 1946.

devoid of a human spark. For they did usually spare the children. This cannot be said of the Hitlerite beast who is out to devour the most precious ones, the ones who arouse the greatest compassion—innocent children.'"[8] During the war years and after, from victims of the Holocaust to those engaged in programs of remembrance, historians, exhibition designers, artists, and others understood that children add to the urgency of it all.

During the immediate postwar period, some venues and publications also exploited Nazi abuse of children to underscore SS brutality. *The Black Book: The Nazi Crime Against the Jewish People* (1946; described in chapter 1), a sweeping elaboration of Nazi crimes against the Jews, stressed the cruelties visited upon children to establish its case. As written in the introductory indictment: "It was a refinement of Nazi torture that parents could see their children waste away before their eyes, as well as await their own inevitable doom."[9] Two adjacent illustrations in an early section of *The Black Book* provide visual complements to the text's condemnation (fig. 41). Atop the page, a cartoon from the widely circulated anti-Semitic weekly *Der Stürmer* portrays two gruesome, hook-nosed Jews collecting the blood of comely German children in a platter marked with a Star of David on its handle, a modern conception of the age-old blood libel (the accusation that Jews murdered Christian children to use their blood for ritual purposes, alleged most frequently at Passover). This stylistically expressionist cartoon provided "evidence" of Jewish barbarity, showing the German people why the Jewish people should be stamped out. For such assaults on the German young, the commensurate repercussion, naturally, was destruction of the Jewish young, as evinced in a photograph underneath the *Der Stürmer* image. That photo, from the U.S. Office of War Information, shows a pile of corpses with three murdered children at the forefront.

German children were in many ways victims too, even if they were not tortured and systematically killed. When describing the racial doctrines being taught to young Germans, the authors of *The Black Book* note that children of the so-called "master race" learned to "vent their savagery and do so with immunity. Children need little incitement to attack the weak."[10] The indoctrination of German children to Nazi ways of thinking included illustrated storybooks, nursery rhymes, and songs.

In a seemingly innocuous fairy tale, Hansel and Gretel are pictured as blond and blue-eyed, while the witch is a wicked Jew. Ernst Hiemer's *Poisonous Mushroom* (1938), a compilation of seventeen illustrated stories, begins with a story of the same name. It tells of a mother and her son, Franz, gathering mushrooms in a forest. The mother explains to Franz that some mushrooms are safe to eat and others poisonous. Using this observation to make an anti-Semitic analogy, she cautions that some mushrooms are good and some bad, just as some men are good and some bad. The mother asks her little boy if he knows who the bad men are, to which he replies: "Of course I know, mother! They are the Jews! Our teacher has often told us about them." Happy with Franz's response, the mother further enlightens him about "poisonous Jews," who disguise themselves and are not as friendly as they may seem to be, hence cannot be trusted: "For our *Volk* they are poison . . . Just as a single poisonous mushroom can kill a whole family, so a solitary Jew can destroy a whole village, a whole city, a whole *Volk*. "[11] Unsurprisingly, Hitler also perniciously branded Jewish children. In *Mein Kampf* he wrote about a Jewish boy "with satanic joy in his face . . . [who] lurks in wait for the unsuspecting girl whom he defiles with his blood, thus stealing her from her people."[12] *The Black Book* includes a few quotes from *Der Stürmer* that purport to be Talmudic in origin, intended to show the degeneracy of Jews with regard to non-Jewish children: "A non-Jewish girl may be defiled as soon as she is three years old."[13] These types of falsities, *The Black Book* explains, encouraged and made the extermination of Jewish children acceptable.

Children's Stories About the Warsaw Ghetto's Children

Among the first widely circulated stories in the United States about children in the Warsaw Ghetto were stories for children. Entirely honest imaginings in visual or written form would obviously have been too much for a child's eyes, so these necessarily sidestepped the most scabrous details. Published during the academic year by the Jewish Education Committee of New York from 1940 to 1983, the bimonthly magazine *World Over* aimed to enrich Jewish literacy for children at all levels of religiosity. Distributed to children enrolled at Sunday Schools, each issue included a variety of articles: fictional and folk stories, news coverage, profiles of distinguished contemporary and historical Jewish figures (e.g., Rashi, Moses Mendelsohn, Hayim Bialik), and essays on Jewish children and customs in Israel and different parts of the world, including holidays and Jewish symbols, often accompanied by illustrations.

 World Over did not skirt the shocking facts about the Nazi annihilation, but they did temper them, and children did fare better in the denouement of the magazine's

accounts than they did in reality. Fictional stories told through the eyes of children informed young readers about hunger, daily fear, and, predictably, Jewish attempts to resist—both spiritually and physically. News stories, at the front of each issue, avoided specifics but did not parse words. A news report from January 8, 1943, generally addressed the ghetto experience by quoting a declaration from the United Nations: "In Poland, which has been made the principal Nazi slaughterhouse, the ghettos established by the German invader are being systematically emptied of all Jews except a few highly skilled workers required for war industries. None of those taken away are ever heard of again."[14] These kinds of alarming actualities were balanced by positive stories. Two months earlier, the magazine had, under the headline "A Child's Song of Courage," reprinted a hopeful poem by a child trapped in the Warsaw Ghetto, whose second stanza reads:

> I must save my nerves,
> And my thoughts, and my mind
> And the fire of my spirit;
> I must be saving of tears that flow—
> I shall need them for a long, long while.[15]

A black-and-white ink portrait of a "typical" boy from the ghetto accompanies the verse; he wears a cap and a jacket, and his eyes longingly look ahead to something better. The journal optimistically introduces the poem: "The children of Poland are matching the courage and faith of their parents in the struggle for Jewish existence against the Nazi oppressors. They are studying and learning so that they can take their part when they grow up to rebuild Jewish life."[16] The magazine presupposes that the children will live, or at least suggests that outcome to its readers, thereby promulgating hope for the future. Around the same time, the magazine ran an affirmative article about a Russian Jew who risked his life to save the Torah scrolls from a synagogue in Stalingrad that had been bombed by the Nazis.[17]

Over the years, stories in *World Over,* both fiction and nonfiction, tackled the uprising. "Revolt of the Warsaw Ghetto" (October 29, 1943), set across a two-page spread with three illustrations depicting hand-to-hand combat or Jews brandishing weapons, came out six months after the rebellion.[18] In a narrated documentary-fictional account, the author concedes that the Nazis ultimately overcame the ghetto's defenders but, with an encouraging spin, "not before they had added a glorious chapter to Jewish history. The Battle of the Warsaw Ghetto will go down as part of the world's struggle for freedom."[19] To cushion the story further, the author quotes a portion of "A Child's Song of Courage." An issue close to the first

anniversary of the rebellion ran a short article, "The Jewish Underground Fighters" (April 13, 1944), that nods to the uprising and points out revolts in other places, thus subverting the idea that Jews went to the death camps like sheep to slaughter, a tack also taken in reports for adult audiences.[20] The following issue (April 28, 1943) featured a full-page news item: "Remember the Battle of the Warsaw Ghetto." This piece reported on commemorations throughout the country with laudatory remarks: "Although they pitted themselves against the enemy's overwhelming numbers and their uprising meant certain death, these heroic Jews chose to die fighting."[21] A reproduced statement from Judge Joseph M. Prokauer of the American Jewish Committee reinforced this perspective: "In all the heroism of this worldwide war, no single act compares with the valor of the starving, downtrodden Jews of the Warsaw Ghetto. For thirty-seven days from April 19 to May 25th, this group of Jews fought the Nazis, fought them, until they had no more ammunition, no more strength,—fought them, until they died. . . . The battle of the Warsaw Jews, their hopeless battle, must ever be an inspiration to us all."[22] Moreover, a selection from the final pages of John Hersey's *The Wall,* about the escape of a few members of "the family," was even reprinted in an issue the week of the insurrection's seventh anniversary.[23]

A collected volume of *World Over* pieces, published in 1952 and used as a religious-school textbook, cherry-picked a number of stories and nonfiction articles. Two of those stories centered on the ghetto: Stephen Fein's "Hanukkah Light in Warsaw," about a child in the ghetto who, before the uprising, improbably detonates a grenade in a small act of vengeance on the Nazis, and Elchanan Indelman's "Underground Brigade," about children clandestinely studying the revolt of the Maccabees and the legacy of Bar Kochba, who then participate in the rebellion.[24] Of the little more than one hundred chapters, only a handful examine the Holocaust, and those that do focus on either resistance in the Warsaw Ghetto or general rebellion against the Nazis. It bears repeating that *World Over* took into account the audience confronting this material, and so these narratives soft-pedal historical realities, attempting to extract a moment of uplift in an effort to mitigate their impact on the magazine's young readers. Likewise, other publications aimed at Jewish children took pains to underscore the ghetto's resistance. The fourth and final installment of the book series *Highlights of Jewish History* takes its readers from the Middle Ages to what was then the current time (1957). The second-to-last chapter, "War and Resistance," first confirms with statistics the Jewish ability to fight across borders, akin to those books written for an adult audience, then provides a brief account of the growing resistance in the ghetto and the actual fight, marked by laudatory words. To be sure, the rebels partook in a "glorious resistance," and Mordecai Anielewicz "met a heroic death."[25] A book of short comic strips, each accompanied by a page

163

Samuel Bak

WE REMEMBER OUR HEROES

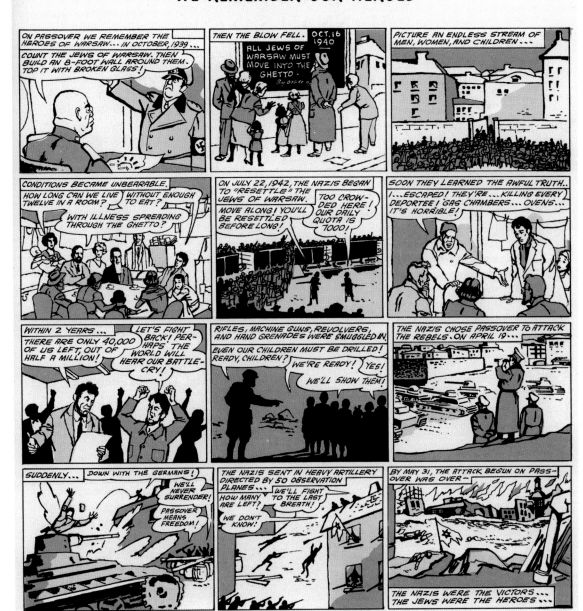

of text, *A Picture Parade of Jewish History* (1963) devotes an entry to the Warsaw Ghetto in lieu of any other reference to the Holocaust. One of the final comics in the volume, "We Remember Our Heroes" impressively manages to compress the history of the ghetto and the resistance into twelve panels, colored in shades of blue against white (fig. 42). A decimated ghetto ablaze fills the final panel. Next to a tattered flag, marked with a Star of David, a dead figure lies on a rock, under which a narrative box contains words meant to uplift: "The Nazis were the victors. . . . The Jews were the heroes."[26]

Samuel Bak's Studies of the Warsaw Ghetto Boy

In marked contrast, Samuel Bak (b. 1933), born in Poland the year Hitler became chancellor, and one of a few survivors of the Vilna Ghetto, has no interest in conveying an attenuated or heroic story, nor does he shamelessly exploit children to appeal to a viewer's despair. Bak's journey to freedom was a twisted one. When the deportation of Vilna's Jews began in September 1941, Bak and his mother found refuge in a Benedictine convent, aided by his grandfather's sister, who had converted to Catholicism as a child. After the convent came under scrutiny a few months later, Bak, now aged eight, and his mother returned to the ghetto, where they lived until September 1943. At that time, the pair was deported to a forced-labor camp in Vilna, HKP (Herren Kommando Platz) 526, where they were reunited with Bak's father. Following a daring escape from HKP 526 on March 27, 1944, during the children's *aktion* (when the SS removed most of the 250 children remaining in the camp), with Bak smuggled out by his father in a sack filled with sawdust, he and his mother once again found safety at the convent until the city's liberation by the Red Army in July 1944. By war's end, the Bak family had been annihilated, save for Samuel, aged twelve, his mother, and only a few other relatives. A three-year stay in the Landsberg displaced persons' camp preceded Bak's formal art training in Germany and subsequent immigration to Israel in 1948, where he continued his studies at the Bezalel Academy in Jerusalem, and then in Paris and Rome. Bak lived a peripatetic life—the life of the diasporic Jew—before settling permanently in the United States, where he has lived, in Boston, since 1993.

Bak has made a career exploring themes related to World War II, examining the Holocaust in a meticulous figurative style reminiscent of Italian Renaissance art but infused with surrealistic and symbolic elements. He creates metaphorical, precisely rendered paintings in various series, drawing on recognizable Jewish signs and old-master techniques. Relevant to the subject at hand, Bak painted more than

seventy images based on one of the best-known and most arresting photographs from the Holocaust (fig. 43), to which I have already alluded at several points in this study. This disturbing shot of a child with his hands held up, which illustrates Jewish powerlessness and defeat through a view of a helpless child, was initially found in SS General Jürgen Stroop's official victory report, which details the final destruction and liquidation of the Warsaw Ghetto.

One of forty-nine images from the *Stroop Report,* this familiar and oft-reproduced black-and-white photograph pictures a boy around seven years old in the Warsaw Ghetto. Surrendering, he wears a coat, hat, and short pants, with black dress socks pulled up almost to his knees—crooked knees that are nearly knocking. A woman, presumably his mother, stands next to him with the last of their possessions in heavy bags hanging on her arms. She looks backward at a Nazi in high black boots, an official uniform, and a hardhat, his gun trained on the boy—surely she is terrified that the German might pull the trigger. Alone and unprotected, the boy stands at the forefront, in an empty space, slightly apart from the crowd, with the sun-inflected paving of the street behind him silhouetting his figure. The boy stares hollowly forward, his lips quivering, or at least turned down in silent fear and confusion.[27]

Originally titled *The Jewish Quarter of Warsaw Is No More!*, the elegantly leather-bound document, which was presented as evidence at the Nuremberg trials, is now less antagonistically referred to as *The Stroop Report.* Following an introduction by Stroop with a bureaucratic narration of the battle, including a list of Germans wounded and killed, are copies of daily telex communications spanning April 20–May 16, ending with the general's intention to blow up the ghetto's synagogue, a fitting finale to the eradication of Warsaw's Jews. A "Pictorial Report" comprising fifty-two photographs, one of which is the image of the boy with his hands aloft, constitutes the last third of the album. Three copies of the report were made—one each for Heinrich Himmler and Friedrich Krüger, and one proudly remained in the hands of Stroop himself.

The thirteenth photograph, of the Warsaw Ghetto boy, bears a caption, "Pulled from the bunkers by force," that typically describes the picture in question, exalting Nazi aggression and callously ignoring the human reaction of the Jewish figures. Overlooked by many viewers riveted by the central child is the crowd of other deportees behind him, including three other children: a boy whose face peers from behind the principal boy's mother, a young girl at the far left margin, and an even younger child squeezed in the back, nearly at center, between other evacuees holding satchels on their shoulders. On the recto of the two-page layout another photograph, labeled "These bandits offered armed resistance," shows adult Jews with their arms raised in surrender. Note the telling use of the past tense—the bandits "offered"

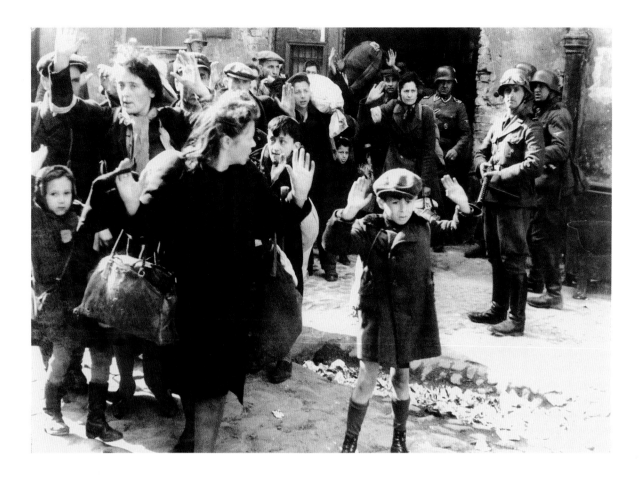

resistance—along with visual evidence of the Jews' submission to substantiate their ultimate failure, both essential to the perception that the SS wanted to promote.

Several other photographs in the report show Jews surrendering; the fourth presents approximately twenty well-dressed executives from the Brauer Company lined up with arms raised, approached by an SS soldier ("The Jewish department heads of the armament firm Brauer"). A picture directly following that of the Brauer executives presents a close-up of a handful of those men being questioned by two Nazis ("The Brauer firm"). A third photograph in this sequence receives the same label as the image of the boy, "Pulled from the bunkers by force," and captures a group of walking Jews, some of whom raise their arms, guarded by Nazis. Jews succumbing with their hands held high, clearly a favored pose meant to display Nazi domination, supplement even more disquieting photographs. Numerous photographs in the report chronicle the ghetto on fire and in ruins and demeaned Jews fated for the gas chambers or a fiery death within the ghetto's walls. Needless to say, the report's intention was to degrade the Jews and their resistance and to

Fig. 43 Photograph from *The Stroop Report,* 1943. Photo: Wikimedia Commons (Durova).

Samuel Bak

exalt Stroop's operation. Even though it took four weeks to control the "bandits," as Stroop calls them, and the much better equipped Germans endured substantial casualties, the general still characterizes Jews as "inherently cowardly." Further, Stroop brags of his soldiers' fortitude: "The longer the resistance lasted, the tougher became the men of the Waffen-SS, Police, and Wehrmacht, who tirelessly fulfilled their duties in true comradeship and stood together as exemplary soldiers. . . . they must be given special recognition for their daring, courage, and devotion to duty."[28]

Vital to cultural representations of the ghetto, the widely circulated *Stroop Report* photo of the capitulating boy simultaneously serves as a *memento mori* of the Holocaust, an icon of children lost during the Nazi genocide, and a general reminder of the fragility of life and human rights. The same can be said for Samuel Bak's paintings that appropriate the photograph. That is, in Bak's paintings the Warsaw Ghetto boy functions as a memorial to the murdered children of the Holocaust, as he has said on several occasions, and the objects surrounding the child in various versions—books and toys, for example, now merely detritus—act as metaphors for the Jewish young who will never have a chance to enjoy or outgrow them. More locally, his cycle of Warsaw Ghetto boy paintings, which are tightly bound to Bak's own survival story, also resonates as the end of childhood, in the Holocaust and otherwise, and serves as a personal exploration of the artist's survivor guilt. I am especially interested in how the martyred boy acts as a surrogate self-portrait of the artist and, by extension, how he acts as an effective and affective symbol of Bak's trauma—suggested by the artist's incorporation of himself into some of the earliest paintings in the series, none of which has been subjected to a sustained examination.[29] By looking carefully at a few paintings of the Warsaw Ghetto boy that include Bak, from the year he initiated the series (1995), one can better understand how the larger body of works affords a continuous narrative yoked together by Bak's traumatic memories of his slaughtered brethren in conjunction with his living presence.

Bak's first image of the Warsaw Ghetto boy, *Study A*, from 1995 (fig. 44; the studies are lettered A–J and were all painted in 1995), tellingly incorporates a self-portrait. Pushed close to the picture plane of this intimately sized canvas (25 ¾ × 21 in.), with little buffer zone between him and the viewer, the Warsaw Ghetto boy stands at center, truncated below his waist. Much of his face and body resemble rock, placed against and almost merging with the brick wall of the ghetto that encloses him (*Walled In,* from 2008, fully fuses the boy to the wall, constructing the shape of his body from bricks flatly melded into the wall's surface). The boy's back presses up against the wall as if he has been backed into a corner, which emblematically he has

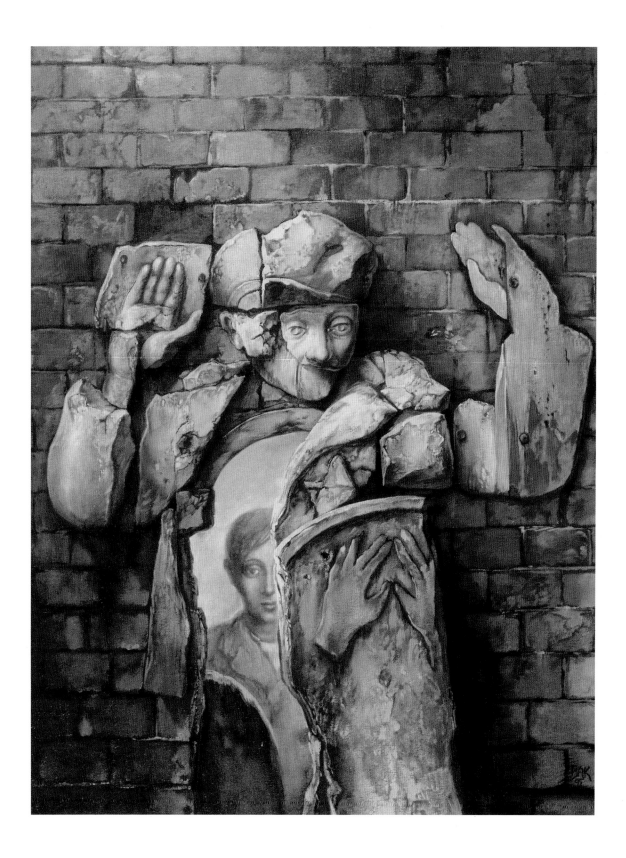

Fig. 45 Gravestone of Rabbi Meschullam Kohn, 1819. Fürth, Germany. Photo: Wikimedia Commons (Alexander Mayer).

been; the bricks remain intact, while the rocks—ostensibly a nearly impenetrable material—composing the boy have started to crack. His cap, for example, is broken through the brim; his coat's right lapel is similarly disrupted (*Study J* is a detail of the boy's face, depicted as shattered rock). Stigmata, a mark of the martyr and most notably associated with Jesus, puncture his hands (*Study B* removes the boy from the ghetto's wall and places him, bloodied and battered, on a wooden cross set against a receding landscape). The stigma on the boy's left hand stands out most conspicuously. His arm and hand resemble wood, a more fragile material than rock, and a nail still pinions the boy to the wall (*Study I* tacks his hands, severed from his body, to a wooden backdrop). To the Nazis, the boy's identity as a Jew marked him as an object for death, an anonymous cutout rather than a person of flesh and blood.

Beginning at the Warsaw Ghetto boy's chest, the left side of his body no longer approximates the body of the child in the photograph. Instead, a rounded form morphs into an oblong shape evoking a covered Torah, like that found in a synagogue's ark. Upon the imagined ark, which melds with his body and denotes his Jewishness, Bak painted a second set of hands, the fingers spread in an unnatural configuration, with two middle fingers and a thumb connected and the outer two fingers splay outward. That formation calls forth the priestly blessing, decreed in Numbers 6:24–26: "The Lord bless thee, and keep thee; The Lord make His face to shine upon thee, and be gracious unto thee; The Lord lift up His countenance upon thee, and give thee peace." Kohanim, priests descended from the biblical Aaron, the first high priest, blessed the Jewish people in this way each morning after the sacrifice at the Holy Temple in Jerusalem and during holidays and Sabbath services. A rabbi raises his hands with palms facing downward and forward, the four fingers separated into two groups, the thumbs touching, a gesture occasionally reproduced on tombstones and Jewish ritual objects (fig. 45). The fingers are purposefully split into the Hebrew letter shin, the twenty-first letter of the Hebrew alphabet, arranged as three pronged lines that look like a crown. A shin serves as a symbol for *Shaddai* (Almighty God), one of several Hebrew words for God. Traditionally, congregants avert their eyes when this blessing is made, because the Divine is said to shine

through the rabbi's open fingers, which have formed "windows" to let light in.

That deliberately placed gesture does not signal God's light or a blessing in *Study A,* for in Bak's estimation God's light did not shine, nor did he bestow blessings, during the Holocaust. Bak explored his perspective on the Divine's conspicuous absence during the Holocaust in works painted around the same time he began the Warsaw Ghetto series. For example, the stone wreckage in *Shema Yisrael* (1991; fig. 46), a canvas from his *Landscapes of Jewish Experience* series (1990–96), represents ruins devoid of human form.[30] Atop the mountain of rubble sit the Tablets of the Law (which also appear in other images, e.g., *De Profundis* [1992]), functioning as gravestones as much as laws for the Jewish people to live—or die—by. These tablets transmit none of the commandments but remain blank except for two yods: Hebrew letters that signify God. Directly below the upright tablets are piles of stone, alterna-

Fig. 46 Samuel Bak, *Shema Yisrael,* 1991. Oil on canvas, 32 × 39 in. Image courtesy of Pucker Gallery.

tive shattered tablets. Notably, out of the wreckage peeks a broken stone with the number six, indicating a commandment brazenly broken by the Nazis—thou shalt not kill—and likewise referencing the six million Jews murdered. Spelled out in Hebrew at the foot of the mountain is a cracked and damaged stone rendering of "Shema Yisrael," the profession of faith in all Jewish services, the start of the verse that affirms a monotheistic God (Deuteronomy 6:4). As witness to trauma and destruction, Bak cannot and does not, in this descriptive and grim canvas, assert his faith in God after enduring the Holocaust; foreign to the artist is that faith assiduously espoused by the rabbis in *The Wall* and *In the Presence of Mine Enemies*—that very faith scorned by Hayim Bialik, who chastised believers who placed their lives in the hands of God rather than in the arms of combat. Bak is not alone, as faith eluded many survivors; Elie Wiesel's seminal memoir *Night* (first English edition in 1960) in part chronicles a like-minded loss of faith. In *Shema Yisrael,* Bak presents a cold, aloof terrain suffused with shades of gray and purple, the predominant hues

of his despairing topography. Four years later, in *Study A,* the partially splintered Torah bearing the useless priestly blessing, then upon a murdered child, once again negates God's presence.

While Bak's point of departure is the boy who dominates *Study A,* the broken Torah and by extension the boy's fractured body allow the viewer access to the world outside of the wall's gaping hole. Standing outside, against an open blue sky rather than a closed brick wall, and thereby free, another boy—the same age as the Warsaw Ghetto boy—somberly gazes at the viewer (*Study G* places the boy amid barren trees and a broken stump). That this second child, a self-portrait of the artist, emerges at the outset of the extensive series, cannot be underestimated. From the start Bak establishes his connection to the Warsaw Ghetto boy and at the same time his contrary position as a survivor and witness instead of a child fated to die. Bak has reflected on the larger series and his identification with the Warsaw Ghetto boy: "He has never stopped questioning me. In the Vilna Ghetto, I was his age and I looked—as did thousands of other children destined for the same fate—exactly like him. Same cap, same out-grown coat, same short pants. I always considered this picture a kind of portrait of myself in those times."[31] In words and paint, Bak recognizes the improbability of his survival, and the precariousness of it pervades his work. Because this chapter investigates only Bak's initial studies of the Warsaw Ghetto boy and especially his self-portraits alongside him, it is crucial to acknowledge the artist's veiled "appearance" as the murdered child's "alter ego," to use the artist's words, in dozens of the series' subsequent paintings that do not receive sustained attention here.[32]

Study F, small in size like all of the studies, includes a self-portrait of the artist as a middle-aged man (fig. 47). On a vertically oriented canvas, the painting shows the Warsaw Ghetto boy's entire body, fashioned as the kind of wooden panel one expects to find at country fair, with a cutout head in which a visitor might place his or her own face to take on the persona of the panel's image. Bak paints this version of the Warsaw Ghetto boy as faceless, with the artist's countenance at around sixty years old, the age at which he painted the canvas, partially filling the hole where the dead boy's face should be. He appears a step behind the propped up boy, gazing warily out in three-quarter view. The boy's buttressed body could easily have been Bak's if not for several fortuitous events that saved his life. At numerous times in his autobiography, *Painted in Words,* Bak acknowledges the "miraculous" circumstances that fostered his survival. Bak reflects: "I owe my survival to a series of miracles that never failed to arrive." And later: "Again and again I tell myself that the odds of surviving were much less than one in a hundred, and that ten improbable miracles were necessary for a person to survive."[33] The Warsaw Ghetto boy and Bak stand as just two of millions of children who died in the Holocaust or survived it. Bak's painting asserts that

hatred and intolerance could mark anyone a "Warsaw Ghetto boy," that anyone's face could fill the empty hole that was once a living, breathing child in eastern Europe, because as long as prejudice remains, we are all at risk of persecution.

In other paintings in the series, Bak explores the boy's position as a synecdoche for the Holocaust's murdered Jewish children by fashioning him without features. That is to say, the boy's head takes shape but without any indication of his specific physiognomy. Owing to his facelessness he becomes dehumanized and anonymous, even more obviously denoting the multitudes of children who died in the Holocaust as well as the Nazi opinion of Jews as anonymous (faceless) vermin deserving of extinction. Child, adult, male, or female, at no time did Nazi ideology acknowledge Jews as unique individuals with families, histories, or their own humanity; the caption to one photograph in the *Stroop Report* lumps together Jews as the "dregs of humanity." Three of Bak's Warsaw Ghetto boy studies explore this treatment. In *Study B* a piece of paper on which a red target has been drawn covers the boy's face, for he has

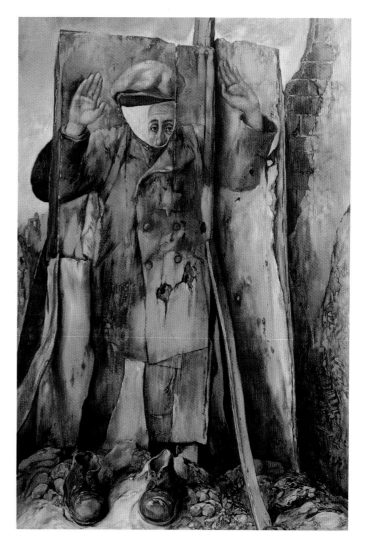

Fig. 47 Samuel Bak, *Study F*, 1995. Oil on canvas, 23 ⅞ × 15 ⅝ in. Image courtesy of Pucker Gallery.

been targeted for death, and by extension synecdochically signifies the targeting of all Jews for death (fig. 48). *Study C* includes a trio of Warsaw Ghetto boys, two of whom are pictured with vacant visages (fig. 49). One wears the striped uniform required of Auschwitz inmates, and Bak places a Star of David badge on a second faceless Warsaw Ghetto boy, thus using the boy as a type to bear different key signifiers of the Holocaust experience, not just the ghetto. In all three renditions of the child, some of his limbs are rendered as wood. At the far background, Bak's childhood friend Samek Epstein's face peeks from behind his better-known counterpart, giving an identifiable name to a child who died in the Holocaust. The face of the single Warsaw Ghetto boy in *Study D* is a blank piece of paper in the shape of a face, but it remains void

Fig. 48 Samuel Bak, *Study B*, 1995. Oil on canvas, 25 ⅝ × 21 ⅛ in. Image courtesy of Pucker Gallery.

Fig. 49 Samuel Bak, *Study C*, 1995. Oil on canvas, 21 ⅛ × 25 ⅝ in. Image courtesy of Pucker Gallery.

Fig. 50 Samuel Bak, *Study D*, 1995. Oil on canvas, 21 ⅛ × 25 ⅝ in. Image courtesy of Pucker Gallery.

of expression or features (fig. 50). One could draw any child's features on it—any of the destroyed children of the Holocaust—just as any face could fill the hole in the wooden panel of *Study F.*

Bak's Self-Portrait

The culmination of Bak's 1995 Warsaw Ghetto boy studies came toward the end of the year, extending into the next, with a much larger conception. Measuring 5 ¼ by 6 ½ feet, this complex composition, executed in a limited palette of brown and orange shades that Bak explored in *Study D,* bears the revealing title *Self-Portrait* (1995–96; fig. 51). With smoking chimneys and ruin suffusing the murky landscape behind him, the boy's body fills the center of the canvas but does not provide the painting's focus, in part because of his light demarcation, almost like a projection on a screen. The artist's self-portrait, painted more heavily than the Warsaw Ghetto boy and as such a tangible, living being, draws the viewer in first. Bak depicts himself slightly off-center and to the left of the boy, sitting on a chair and fully frontal, as the young man he was when he was lowered outside the walls of HKP 526. Two signs of his Holocaust ordeal literally and figuratively wrap around his body. He wears the ill-fitting coat of a dead boy from his hometown, which may connote an additional martyred child, whose memory Bak invokes in his memoir. That child's grandfather gave Bak the coat on the day Jews were evicted from their homes and resettled in the newly constructed Vilna Ghetto; as the old man handed it over sadly, he simply said, "He was your age."[34] The sack that delivered Bak to safety hangs loosely around the lower half of his body. A trio of repetitions of the Warsaw Ghetto boy surround Bak in the form of flat plywood figures, a motif Bak explored in *Study F.* The multiplicity of the boy's uplifted arms could reach down and smother the young artist, which, metaphorically, they have throughout the artist's adult life (dozens of wooden Warsaw Ghetto boys populate a desolate landscape in *Collective,* from 2007).

Another boy inhabits *Self-Portrait:* Bak's childhood friend Samek (Samuel) Epstein, who appears in *Study C.* As Bak reports in his autobiography, the boys were so close that their mothers occasionally dressed the two Samuels as twins.[35] Epstein, who disappeared at the time of the German occupation, was later found hiding in the cupboard of a gentile woman's apartment outside the ghetto. The Lithuanian police dragged him from the apartment and shot the crying child in a courtyard, an ignominious end that has perpetually plagued Bak.[36] In *Self-Portrait,* Epstein's head peers from behind the wooden Warsaw Ghetto boys, a red shroud draped over him, his body hidden. Possessing a gray, ghostly pallor, like the central boy, Epstein's face

indicates his status as a specter ceaselessly lingering in Bak's mind. Bak described his conflation of the Warsaw Ghetto boy and his youthful playmate: "Recently, something unexpected has happened to me. Whenever I look at these paintings [of the Warsaw Ghetto boy] I see Samek. And when he has eyes, which in many of my paintings he does not have, Samek looks back at me. We mirror each other . . . his presence an eternal reminder that very little, yes very little, separated me from the destiny that was his."[37]

Bak's autobiography references yet one other boy from the Holocaust whose memory has remained in his psyche since 1943. This boy was the subject of a black-and-white drawing by a figure Bak calls "the unknown artist," who also lived in the Vilna Ghetto. The unknown artist was referred to Bak as a possible mentor, but Bak learned, upon arriving at the young man's apartment, that the unknown artist had recently been sent to the Łukiszki Prison. Still thumbtacked to an easel was the unknown artist's drawing of a boy sitting at a table, upon which sat a white cup. Bak has since imagined that drawing as a possible self-portrait of the unknown artist as a sad-eyed child; he wore an oversized cap with a visor and a rumpled, worn coat—conjuring an analogue with the Warsaw Ghetto boy, although probably in Bak's memory more than in reality. Remembering his journey to the labor camp, undertaken soon after seeing the drawing, Bak mused in hindsight: "My crumpled and anguished young self, traveling on the German truck, cannot yet know that in many of my future paintings this boy will hold a prominent position. The boy of the drawing . . . will dissolve into the figure of the Warsaw ghetto's little boy. . . . In my work this most haunting of all images has absorbed my own small figure to make the three of us resonate as one."[38]

All five of the boys in *Self-Portrait* are positioned in three-quarter view, angled toward Bak—perhaps envious of his survival or, in Bak's mind, incriminating him for escaping the dark fate they did not. Resigned and stoop shouldered, Bak gazes dejectedly forward but does not make eye contact with the viewer. A large canvas stands upright behind the wooden Warsaw Ghetto boys, empty of image and therefore absent of any narrative meaning—blank, as are the dead boys' futures. Dejected but alive in his chair, Bak limply holds a paintbrush, the tool of his trade. He cannot adequately prettify the canvas, nor can he fill the rolled-up paper to his right or the blank sheets that litter the ground at his feet. Some of the paper scraps are not marked by a brush or a pen but held down by stones to keep them from flying away—a nod to the Jewish tradition of leaving stones on graves instead of flowers. The origins of this custom vary, but one account explains that while flowers die, stones do not, therefore indicating continuity of memory and fitting Bak's stated intentions to extend through his art the memory of those who died in the Holocaust. Describing his compulsion to paint, Bak invokes the placement of stones on Jewish

gravesites: "I have never fully clarified to myself all the reasons behind my obsessive need to produce art. Partly it must be a desire to give meaning to my miraculous survival. Like a Jew who visits a cemetery and leaves small stones on the graves of his beloved ones, I add painting upon painting as acts of remembrance."[39] Secondarily, the rocks and pebbles peppering the painting symbolize the rubble of the ghetto's walls. But to stay on point, within *Self-Portrait* Bak's hand is frozen, useless to depict what he feels in the company of these dead peers, much as the Warsaw Ghetto boy's hands are eternally frozen in surrender. The repetitions of the boy in this early canvas presage his copious reappearances in dozens of Bak's subsequent paintings, which variously repeat many iconographical elements populating the environment around the boy: empty shoes, wooden backdrops, and the boy portrayed as a cru-cified martyr. In *Self-Portrait,* as elsewhere, scraps of paper make up the Warsaw

Fig. 51 Samuel Bak, *Self-Portrait,* 1995–96. Oil on canvas, 63 × 78 ¾ in. Image courtesy of Pucker Gallery.

Ghetto boy, fragile and taped together, as if he were not human, only something to be thrown away.

The persistence of the dead boy in Bak's art and the dilemma of the artist's survival are encapsulated by the Warsaw Ghetto boy's act of submission. His trauma, forever captured in the original still photograph, Bak's paintings, and numerous other works that have appropriated the helpless gesture of this slaughtered witness, reverberates in an afterlife across borders. In unison, Bak, who conversely lived to bear witness, paints his own *temporarily* hopeless gesture in *Self-Portrait*. The hundreds of paintings he has subsequently lifted his hand to make, even though his family and peers were slaughtered, attest to the artist's successful realization of his purpose. In 1977 Bak wrote, affectingly addressing the dead:

And you, my dear friends of my childhood, whose memory I try to keep alive on innumerable canvases, you who continue to be present within me and within the spirit and heart of the other survivors, please help me . . . to attain this reality so that your sacrifice may not have been without meaning. I feel the necessity to remember and to take it upon myself to bear witness to the things that happened in those times, so that human beings today and those of tomorrow—if only it were possible—are spared a similar destiny on earth.[40]

Of his desire to extend the memory of the children who perished, Bak wrote comparably of the "unknown artist": "The Unknown Jewish Painter has become to me a sort of Unknown Soldier, whose nonexistent tomb I visit daily, trying to continue a vision that I think of as his. Were I not afraid of sounding presumptuous, I would say that in my daily toiling with brushes and colors there flickers a small flame in his honor."[41] And of the death of Samek Epstein: "It gives me comfort to think that in some way I can live today for the two of us and that his future wasn't totally obliterated, since by living in me he is still being remembered and he helps me to remember all of Them."[42]

For Bak, like other Holocaust survivors—as well as survivors of different disasters—memories of such traumas frequently remain latent or at least unexpressed for a period of time; traumatic memory often reaches into the future, first suppressed and then ever present. In her widely used formulation, literary critic Cathy Caruth underscores the belatedness of traumatic memories. Taking a cue from psychoanalyst Dori Laub, who formed like-minded conceptions after interviewing and working with Holocaust survivors, and Freud's earlier, foundational conception of trauma in *Beyond the Pleasure Principle* (1920), Caruth stresses that the traumatic "response, sometimes delayed, to an overwhelming event or events . . . takes the form of repeated, intrusive hallucinations, dreams, thoughts or behaviors stemming from

the event. . . . the event is not assimilated or experienced fully at the time, but only belatedly, in its repeated *possession* of the one who experiences it. To be traumatized is precisely to be possessed by an image or event."[43] In Bak's paintings this trauma (the Greek word for wound), is most certainly ever recurring and explored years following the initial event. To put it a different way, Bak works through his trauma vis-à-vis his incessant revisiting of and possession by images of the Holocaust in varying forms, and in particular the photograph of the Warsaw Ghetto boy, which he adopts, and adapts, for its personal resonance. Bak reported, in line with Caruth's thinking: "Of course my traumatic experience of loss and survival had eventually to find some appropriate outlet, but the search proved arduous. It took years to detach myself from the stifling fashions of contemporary painting and to understand where my own art was taking me. . . . My paintings are meant to bear personal testimony to the trauma of surviving."[44]

As a child survivor, Bak inherits the Holocaust, and in the Warsaw Ghetto boy series he attempts to bear witness for the ever-youthful dead. To transmit that trauma most powerfully, Bak decidedly moved away from the modernist idiom in which he had been working. After the war Bak made some drawings with Holocaust themes, but he soon primarily worked in a *de rigueur* abstract fashion. Around 1963, when Bak was thirty years old, his memories of the war came closer to the forefront and began to permeate his art, at which time he returned to a representational style—a style that could more obviously transmit to an audience his response to his wartime experience:

I realized that I had a special story to tell. There was a past that had been lying dormant in me. Indeed, my abstract canvases were letting it emerge . . . but was it understandable to others? I had a feeling that instead of unfolding my story, the abstract paintings were suppressing it. Now this past that was stirring and searching for expression made me ask myself how to let it speak. . . . [I had] a story about a trauma that had been silenced for too many years. . . . I was responding to something that was rushing out from the inside, something visceral, something that takes a long time for the mind to comprehend.[45]

The fallout from the Holocaust, which Bak calls a "heavy shadow," looms over him, and the Warsaw Ghetto boy lurks in his mind, repeatedly rousing the artist to his easel.[46] To be sure, the children of the Holocaust, and Bak's memories of the genocide he barely survived, cling to him like barnacles. Bak's need to paint the Holocaust is a *sine qua non,* an imperative, but considering his inexhaustible output and the vigorous pace at which he paints, his art appears to offer little salve for his memories.

Children in Fine Art by Secondary Witnesses

A few responses by other American fine artists to the Warsaw Ghetto's children are worth singling out. Ben Wilson's *Uprising in the Polish Ghetto* (ca. 1943; discussed in chapter 1), was painted while the war raged on, pictures a multigenerational group, including two children, and is somewhat ambiguous in conception save for a title that clearly guides the viewer (see fig. 3). A different painting from the same year, explicitly focusing on a child, would have been even less recognized as ghetto-related in its own time: Ben Shahn's small tempera-on-cardboard representation with the plain title *Boy* (1944; fig. 52). Unnerved by photographs chronicling the misery perpetrated by the Nazis that he saw when designing posters for the Office of War Information (OWI), before the powerful *Stroop Report* photograph became public and its subject achieved status as "the child of the Holocaust," Shahn appropriated a less compelling photograph from the Warsaw Ghetto as a source for *Boy*. This photograph, of a larger group of solemn children, provided the thin child that Shahn depicts at the forefront of his canvas. Nearly fully frontal, the boy protectively crosses his arms at his chest and stares hollowly forward. Set against a stark, indistinct landscape colored in a deep blue, the boy appears with a woman—not present in the original photograph—wearing black, likely his widowed mother. Ziva Amishai-Maisels contends that during the war years and for a period thereafter, Shahn was not ready to assert his Jewish identity in his art, fearing parochialism, and aimed instead for covert comments on the Holocaust.[47] Shahn's comment in *Boy* is indeed general. It is doubtful that viewers would recognize that this canvas pictured an actual child from the ghetto or would have read it as related to the war. Nor does Shahn make a statement about the heartlessness of the Nazis; his image does not tackle death or senseless murder, as do those paintings in Bak's Warsaw Ghetto boy series, which take on a particularist cast. There is something to be said for the fact that Shahn, a Lithuanian immigrant who throughout his life made art commenting on the social and political outrages of his adopted country, was moved by photographs of the ghetto, his work for the OWI, and his own Jewish background. But aside from a hollow expression and a woman wearing colors of mourning, the suffering is not obvious in *Boy*, the ghetto atmosphere not articulated, and the Holocaust not implied.

By the late 1960s American figural artists were inclined to specify their subjects. Jack Levine, another prominent social-realist artist of Jewish descent, made a lithograph of the Warsaw Ghetto, also based on a wartime photograph (1969; fig. 53). The ghetto looms behind a heavily shadowed group marching down the street, herded like animals by armed SS men. A mother and child lead the band of Jews; she holds a small suitcase in one hand, and her son grasps her other hand. Levine

came across this photograph in a magazine and gave credit to the photographer, sardonically dedicating it at the bottom of the print: "To an unknown German photographer at the Warsaw Ghetto." Of Levine's four prints from 1969, two were about the Holocaust, and these were his only two works about World War II. Levine's *Cain and Abel II* (discussed in chapter 1; see fig. 17), a lithograph published by the Anti-Defamation League, looks to the Bible to make an allegorical statement about the Holocaust. *Cain and Abel II,* done before the Warsaw Ghetto print, piqued Levine's interest in the Nazi extermination of Jews, but it was Jews in the infamous Warsaw Ghetto and the position of a child near death that attracted Levine to the original photograph and a specific ghetto narrative.

Like Shahn's source photograph, the photograph that Levine stumbled upon in a magazine only served as an inspiration. Staying largely faithful to it, Levine amended the composition according to his needs and the interpretation—one of senseless cruelty and the unfathomable loss of generations of Jews—that he wished to communicate. Levine lifted the arrangement for his ghetto lithograph from a painting he had done more than twenty years earlier, *The Passing Scene* (1941), showing a boy and his father holding hands at the front of the canvas, though he substituted mother for father, believing that a mother and child would be more affecting than a father and child. As a Jew and a father, Levine felt compelled to reconfigure the image, adamantly averring "it was something that just had to be done."[48] While Bak's urge to make art about children in the ghetto came from a very personal position, Levine more calculatedly held that a print featuring a child could lead an American audience into the alien world of the ghetto and the annihilation of eastern European Jewry. Always inclined toward particularity, Levine felt that he needed to point out specific injustices rather than

Fig. 52 Ben Shahn, *Boy,* 1944. Tempera on cardboard, 26 ⅝ × 18 ⅛ in. University of Michigan Museum of Art. Museum purchase, 1950/1.203. Art © Estate of Ben Shahn / Licensed by VAGA, New York.

Fig. 53 Jack Levine, *To an Unknown German Photographer at the Warsaw Ghetto*, 1969. Lithograph, 18 ½ × 25 in. Art © Susanna Levine Fisher / Licensed by VAGA, New York. Photo courtesy the Estate of Jack Levine and George Krevsky Gallery, San Francisco.

suggest larger problems. His oeuvre supports this philosophy; *Birmingham '63* (1963), a civil-rights commemorative, stands among his many socially conscious works. The Warsaw Ghetto photograph's impact on Levine cannot be overstated. For seven decades Levine's expressionistic style complemented a satirical eye that mostly recorded America's social and political injustices on canvas and paper. That he chose to address the Warsaw Ghetto serves as evidence of its resonance, and the surprisingly large size by which he rendered the lithograph, 18 ½ by 25 inches, is just as revealing.

In contrast, feminist artist Judy Chicago (born Judith Sylvia Cohen) often communicated broad themes in her work, about the Holocaust and otherwise. Her large-scale installation *Holocaust Project: From Darkness into Light* (1985–93) once again takes up the *Stroop Report* and its ever-present boy. A growing interest in her Jewish heritage had led Chicago to *Holocaust Project,* a didactic installation that was the culmination of eight years of research and exploration, including extensive reading on the subject, visits to concentration camps, archival work in eastern Europe, and a trip to Israel. The installation concentrates on the Holocaust from all perspectives, not solely a Jewish one. Chicago references other subjugated peoples often expunged from the historical record, such as homosexuals and gypsies, and makes a special effort to create imagery about how the female experience differed from that of men. Two stained-glass windows and a tapestry designed by the artist and executed by collaborators accompany thirteen tableaus consisting of Chicago's paintings and her husband Donald Woodman's photography on photolinen (a photosensitive material that enables the merger of their respective media). Information panels and an audiotape guide the viewer through the installation. Chicago chose tapestry as one of the media for the work "to emphasize how the Holocaust grew out of the very fabric of Western civilization," as she put it.[49] The tableaux interpret the events of the Holocaust and expand to other abuses of power such as American slavery and the Vietnam War.

Nine squares make up the second-to-last tableau, *Im/Balance of Power* (fig. 54), bisected by a scale of justice that cuts through the center square and the middle squares on all four borders. Placed in the central panel, the Warsaw Ghetto boy

anchors the entire image; a cropped reproduction of the photograph shows him and a few figures from the background of the original source. A Nazi soldier armed with a rifle, painted by Chicago in somewhat muted blue hues, lines the right side of the center square. That soldier, while based on the SS man with the gun in the original source, adopts a more aggressive stance and angry countenance. The vertical bar of the scale of justice divides the pair, cleaving child from adult, Jew from non-Jew, victim from perpetrator. Further, the soldier's placement at the front of the work presents a barrier between the viewer and the child, for the viewer is unable to save him, just as most Americans were unable to save the million and a half other murdered children. At each corner, Chicago repeats this arrangement: an original, stark, black-and-white photo of a child in dire circumstances beside a painting executed in reduced colors acting as commentary. A photograph in the upper left pictures two young female Israeli refugees juxtaposed with a beautiful home, to which they are denied access by a gate. The upper right square includes a photograph of an abused boy next to a tape measure quantifying his wounds. The boy is set against a man standing over and abusing a naked woman. In the bottom right corner Chicago appropriates another iconic photo of a child: the Pulitzer Prize–winning image of a nine-year-old Vietnamese girl running naked from her burning village following a napalm attack. Starving, bone-thin children from Africa appear next to a carefree Western couple enjoying a delicious meal in the final square on the left bottom corner.

Chicago universalizes the privation of children, anchored by an image from the Holocaust as her starting point. For Chicago, the Holocaust can denote larger issues of violence, discrimination, homophobia, women's rights, and, in the case of *Im/Balance of Power,* the powerlessness of children. As Chicago wrote in a journal detailing the research for and creation of *Holocaust Project:* "It's terribly painful to confront the conditions of many of the world's children. They are so utterly powerless. I'm trying to find a way to suggest (gently) that, even though the murder of one and a half million Jewish children was a terrible tragedy, we should also think about children today and how they're suffering and dying by the millions all over the globe."[50] More than twenty years after completion of *Holocaust Project,* Chicago reflected on what she perceived as the continuing resonance of the Warsaw Ghetto boy and *Im/Balance of Power:*

I chose the boy in the center image because he seemed paradigmatic of the treatment of children during the Holocaust and one of the questions I was raising: how can grown men point guns at children? It's a question that has become increasingly naïve in the face of the use of child soldiers not to mention Boko Haram and other Islamic terrorists using children as human shields, walking bombs, and training them in jihad from an early age. As I often

say, Elie Wiesel's long ago comment about how the unthinkable became the possible during the Holocaust has turned into an even more hideous reality as the unthinkable has become not only possible but prevalent.[51]

Such blatant universality angered some critics; Alvin Rosenfeld lambasted *Holocaust Project* for its "atrocious" concept and style and censured its conflation of the Holocaust with other injustices—for allying it with larger victimhood.[52] Similarly, Lawrence Langer is contemptuous of most representations not connected to survivors. He favors cultural producers like Bak and self-questioning, gut-wrenching work by direct descendants such as Art Spiegelman over literary works with generalized or positive denouements. Langer chastises Chicago for "preempting the Holocaust": "You *cannot* honor the particularity of the Holocaust in its uniquely Jewish features if your basic intention is to use it to illustrate the universality of evil and suffering."[53]

Unlike Shahn, who strove for universalism in 1944 as a means to avoid direct reference to his Jewishness and the Holocaust, Chicago made *Im/Balance of Power* in the multicultural nineties, a period when difference was celebrated and when the systematic extermination of European Jewry, and genocide in general, were collectively present in world consciousness. For her, the Warsaw Ghetto boy could symbolize the Holocaust and simultaneously connote other sufferings. A drawing conceived in preparation for *Holocaust Project, Grown Men Pointing Guns at Children* (1991; fig. 55), depicts the Warsaw Ghetto boy. The boy stands, of course, with his hands held up, at the left corner of the drawing, diminutive in size to accentuate his helplessness and physical status as a child. Lining the right side, the soldier holding the gun in the original photograph looms over him. In contrast to the small boy, Chicago draws the soldier three times larger, accentuating the SS man's power as an executioner and an adult. A faint outline of a second Warsaw Ghetto boy hovers behind the first, sharply drawn child, multiplying his signification, akin to Bak's multiple Warsaw Ghetto boys.

Another prominent artist associated with feminist art, Audrey Flack, painted two Holocaust representations: *Hitler* (1963–64; fig. 56) and her imposing eight-by-eight-foot canvas *World War II (Vanitas)* (1976–77; fig. 57). The former was made during the sixties, when Flack began to use photographs as source material for her figurative imagery. Initially she favored black-and-white news photographs, painting public figures in subdued colors, such as John D. Rockefeller (1963) and Hitler. Flack infused *Hitler,* which she refers to as "a ghoulish portrait," with her own commentary by distorting Hitler's features from the original photograph, taken during his visit to Poland.[54] *World War II (Vanitas)* combines a magnified, sharply

Fig. 54 Judy Chicago, *Im/Balance of Power*, from *Holocaust Project*, 1991. Sprayed acrylic, oil, and photography on photolinen, screen printing and fabric on photolinen, 77 ¼ × 95 ¼ in. Art © Judy Chicago / Artists Rights Society (ARS), New York, and Donald Woodman. Photo © Donald Woodman.

delineated still life with a painted reproduction of *Life* photographer Margaret Bourke-White's famous photograph of the liberation of Buchenwald. Rendered in black and white, the exhausted and stunned prisoners behind the barbed-wire fence contrast with the rich, glowing colors of the array of objects atop Bourke-White's duplicated photograph, including pastries, a red *yahrzeit* (memorial) candle dripping wax like blood, a rose, shiny pearls, and a Star of David from Flack's keychain. Many of the objects sit atop a book open to a quote about faith from the Hasidic leader Nahman of Bratzlav, as presented in Rabbi Abraham Joshua Heschel's introduction to Roman Vishniac's volume of thirty-one prewar photographs chronicling the life of Polish Jews.

In 2016 Flack looked back at *Hitler* and realized that she incorporated a loose rendition of the Warsaw Ghetto boy in the background. On the left side, the boy's capped head and oversized hands can be seen peeking out from behind the Nazis standing near the front of the picture plane. Soon after Flack made the connection to the Warsaw Ghetto boy, she decided to fashion a less expressionistic depiction of him (fig. 58). As in *World War II (Vanitas),* Flack employs her signature, highly realistic representational style and re-creates another iconic Holocaust photograph,

185

Samuel Bak

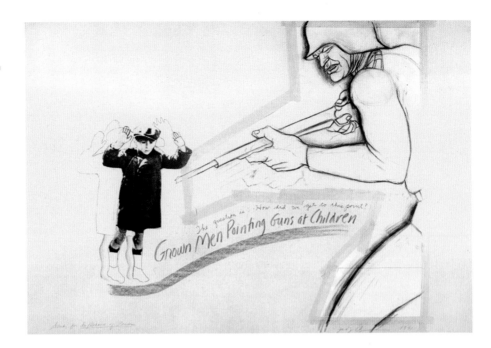

Fig. 55 Judy Chicago, *Grown Men Pointing Guns at Children—Study #1 for Im/Balance of Power*, from *Holocaust Project*, 1991. Collage and photography on Rives paper, 30 × 40 in. Art © Judy Chicago / Artists Rights Society (ARS), New York. Photo © Donald Woodman.

thereby creating a counterpart to the earlier work. The main group from the *Stroop Report* stands at the right, boxed into a frame, a simultaneous comment on the photograph's status as a symbol of the Holocaust and the ill-fated figures' boxed-in situation. At the same time, the boy steps out of the frame, indicating his particular significance as a figure who, in a photographic afterlife, transcended his position as a one-dimensional human being on a flat surface. Bright rays of yellow radiate from the doomed Jews, a compositional choice motivated by the first two lines of the third verse of Hirsh Glik's partisans' song, *Zog nit keyn mol,* which Flack wrote underneath the boy's feet: "The morning sun will tinge our today with gold, / And yesterday will vanish with the enemy." Flack contrasts the modern-day portrait of the Jewish woman at the front of the work, "who is very much present now in the twenty-first century, with the innocent little boy and everyone in the Warsaw Ghetto photo who are gone."[55]

The Warsaw Ghetto boy's ongoing circulation as the "poster child" for the murdered children of the Holocaust, to use Marianne Hirsch's term, makes it no surprise that Bak gravitates toward him.[56] His presence in Bak's art, and work by others, makes his absence—and the absence of all the children who perished during the Holocaust—ceaselessly palpable. An easily read signifier, the Warsaw Ghetto boy provides a visual to latch on to that does not need explanation. As a stock image he has become universalized—like many of the standard photographs of

Fig. 56 Audrey Flack, *Hitler*, 1963–64. Oil on canvas, 28 × 28 in. Allen Memorial Art Museum, Oberlin College, Ohio. Gift of the artist, 1993. Art © Audrey Flack.

Fig. 57 Audrey Flack, *World War II (Vanitas)*, 1976–77. Oil over acrylic on canvas, 96 × 96 in., incorporating a portion of the photograph *Buchenwald, April 1945*, by Margaret Bourke-White, © Time Inc. Pennsylvania Academy of Fine Arts, Philadelphia. Art © Audrey Flack. Photo courtesy of Louis K. Meisel Gallery.

the aftermath in the concentration camps or Margaret Bourke-White's devastating picture of Buchenwald. The Warsaw Ghetto boy has, at times, become such an exploited signpost for the Holocaust's children that viewers do not always know that the photograph was taken in the Warsaw Ghetto. Survivor Elie Wiesel invoked the boy during an address to the German Bundestag on January 27, 2000, to make a point about the inhumanity of the Holocaust's perpetrators, and even he was unsure about the boy's origins:

> There is a picture that shows laughing soldiers surrounding a Jewish boy in a ghetto, I think probably in the Warsaw ghetto. I look at it often. What was it about that sad and frightened Jewish child with his hands up in the air, that amused the German soldiers so? Why was tormenting him so funny? Were these soldiers, who likely were good husbands and fathers, not conscious of what they were doing? Weren't they thinking of their own children and grandchildren, who one day would have to carry the

Fig. 58 Audrey Flack, *The Warsaw Ghetto Boy*, 2016. Prisma color and pastel on paper, 20 × 24 in. Private collection. Art © Audrey Flack.

> burden of their crimes although, as I shall say later, they are innocent? Ivan Karamazov believed that "cruel people are sometimes very fond of children." Yes, but not of Jewish children.[57]

Bak embodies the history of the Holocaust's children—those that Wiesel so indignantly mentions to make his point—and his paintings of the Warsaw Ghetto boy speak to the ambivalence of what it means to survive. It is the legacy of the children, those who died and those who survived, that Bak mourns in his paintings. In the Warsaw Ghetto boy series, and in his autobiography, Bak wrestles with the ambiguities of his own existence, the randomness of his survival. Bak's unusual place as a child survivor profoundly marks his work—in subject and with every stroke of paint he layers on canvas to call forth the ubiquitous boy, at least in memory, in his art.

Janusz Korczak's Life and Sacrifice

No discussion of cultural representations of children in the Warsaw Ghetto would be complete without further remarks about Janusz Korczak. Known in Poland as "the Old Doctor," the name of a nationally aired radio show that he hosted, Korczak wrote pedagogical books on the care of children, widely read in their time by Jews and non-Jews. He believed in the individual rights of children and the importance of respecting them; Korczak expressed one of the core concepts of his philosophy in a single sentence: "Children are not people of tomorrow; they are people today."[58] Korczak founded the first children's newspaper and set up an elected parliamentary-style children's self-government in his progressive orphanage. In early acts of resistance, he refused to wear a Star of David armband and stubbornly insisted on wearing the uniform from earlier army service as a doctor, which earned him jail time. His noble death alongside his charges, though, towers over all of these accomplishments and has been told and retold in a variety of media. The Korczak story as cultural artifact is about the suffering of the children and their deportation, a vivid account of their march to death with one brave man, who stands for the compassionate others who tried—although not as dramatically—to protect the children but in most cases to no avail.

Korczak's life and sacrifice have engendered some of the most heart-wrenching representations concerning the Nazi genocide, but those geared to children offer a more measured entry into the Holocaust. The picture book *Child of the Warsaw Ghetto*, by author David Adler and artist Karen Ritz, describes the experience and resilience of Froim Baum, one of seven children and a survivor who shared his story with the author. Baum lived in Korczak's orphanage both outside and inside the ghetto when his mother could no longer provide for him after his father died. Adler describes Korczak as "a warm, kind man devoted to his children" and "a hero, a king, a gentle grandfather," and accompanying this text Ritz provides a loose likeness.[59] To convey the hopelessness of Baum's situation, the illustrations appear in muted tones with some color highlights. The story itself not only relies on Baum's account but also quotes from Chaim Kaplan's important diary and cites Jürgen Stroop's declaration at the fighting's end: "There is no Jewish quarter in Warsaw anymore!" Toward the end of the book, the story briefly describes the first small uprising, on January 18, and then the larger, sustained battle in the spring. Accompanied by a portrait of Anielewicz and a few fiery scenes, the text reads: "The Jews, led by Mordecai Anielewicz, with their meager weapons, were fighting an impossible battle. But the choice for them was one kind of death or another. They chose to die fighting." Although Baum survived Dachau and ultimately reunited with his two surviving

brothers in 1947, the author sadly closes the book with the always-shattering statistic: "Almost three million Polish Jews were murdered by the Nazis. In all, some six million Jews were killed. One-and-a-half million were children."

Christa Laird's fictional account, in the chapter book *Shadow of the Wall* (1990), revolves around a boy, although not an orphan, befriended by Korczak. That boy, who introduces readers to the perils of smuggling, witnesses Korczak and the deportation. Soon after, as the book ends, he escapes from the ghetto through the sewers—thereby transforming the story into one told from the point of view of a saving remnant (a construct discussed in the following chapter). A fairly lengthy postscript provides information about Korczak and a few other historical figures in the book.[60] Unlike stirring portrayals of Korczak's departure with the children to Treblinka—as featured, for example, in an agonizing scene in Jon Avnet's NBC miniseries *Uprising* (2001)— most children's stories close on a relatively happy note that the docudrama eschews. As Lawrence Baron observes in relation to Holocaust films for children, such representations follow a "classic disruption-resolution narrative structure."[61] That is, while a disruption occurs in Holocaust cinema geared toward children—Nazis subjugate, restrict, and murder Jews—these films end with a sort of uplift. *Shadow of the Wall* and *Child of the Warsaw Ghetto* necessarily adopt this approach while still familiarizing younger readers with the ghetto, the uprising, and the life of children in wartime Warsaw, as did some presentations of the ghetto in *World Over* stories.

Mary Berg witnessed the deportation of Korczak and his wards, as she records in her diary. After relating the doomed procession to the *Umschlagplatz,* she comments on Korczak's character and ends with a succinct yet vivid observation about the vacant children's home: "Thus died one of the purest and noblest men who ever lived. He was the pride of the ghetto. His children's home gave us courage, and all of us gladly gave part of our own scanty means to support the model home organized by this great idealist. He devoted all his life, all his creative work as an educator and writer, to the poor children of Warsaw. Even at the last moment he refused to be separated from them. The house is empty now, except for the guards who are still cleaning up the rooms of the murdered children."[62] Another witness, whose diary surfaced in the Oneg Shabbos archive, described the scene with reverence: "Janusz Korczak was marching, his head bent forward, holding the hand of a child, without a hat, a leather belt around his waist, and wearing high boots. A few nurses with white kerchiefs were followed by two hundred children, dressed in clean and meticulously cared-for clothes, as they were led to the sacrifice."[63] Alluding to another sacrifice from biblical times, where Abraham took his son to the altar at God's behest, the writer connects this ancient halted sacrifice with one that was with devastating effect carried out in the modern era. If Isaac had died, the Jewish people would have died.

And with the slaughter of one and a half million children in the Holocaust, the Jewish people nearly did die. For Jews, it is this terrifying realization that contributes to the devastation—that contributes to the power of children to serve as the starkest examples of what was lost. As a survivor, Bak functions as a bridge between history and memory, making the resonance of his paintings all the more powerful. He personally carries the baggage of the Holocaust's children, which makes his use of the overdetermined and ubiquitous Warsaw Ghetto boy less suspect than some second-generation artists who deployed the boy for other purposes.

Statues at Yad Vashem, Israel's Holocaust museum, memorial, and research center, and in Warsaw, near Nathan Rapoport's Warsaw Ghetto Monument, honor Korczak. At Yad Vashem, a nine-foot-tall bronze sculpture by Boris Saktseir, an immigrant to Israel from the Soviet Union, marked the one-hundredth anniversary of Korczak's birth (1978). One of Korczak's oversized arms embraces ten expressionistically rendered children, and the doctor's oversized head mournfully peers out from behind the grouping. The sculpture sits in Janusz Korczak Square, inaugurated in 2002. Treblinka's memorial to the dead comprises a remarkable seventeen thousand stones of varying sizes set in concrete, surrounding a central forty-foot obelisk. Some of those shards are inscribed with the names of towns from which Jews were deported, and a lone stone contains the name of an individual: Korczak. In Warsaw, leading from the *Umschlagplatz* to Rapoport's ghetto memorial, the Path of Remembrance comprises blocks of syenite inscribed with events from the ghetto and honoring the memory of those who lived there, including Korczak (as well as Emanuel Ringelblum). At the Okopowa Street Jewish Cemetery in Warsaw a bronze cenotaph depicts Korczak carrying one child, four others trailing behind him, leading his brood to the trains (1982). A stone memorializing the ghetto fighters also sits in the cemetery; its inscription reads: "This stone symbolizes the flame of passion that dwelled within those who fought during the Warsaw Ghetto uprising. Their bodies were left unburied beneath the rubble of Mila 18. Let Their memory live on with those who they fought for."

Only a few memorials to, and one sculpture of, Korczak exist in the United States. In Skokie, Illinois, survivors dedicated an eternal light in his memory. A bronze relief on the façade of New York City's Park Avenue Synagogue, above the Madison Avenue entrance, honors Korczak and the children (1980; fig. 59). Designed by Rapoport (whose ghetto fighter's memorial in Poland was partially recast and stands an impressive 7 ½ feet tall at the Workman's Circle National Headquarters in New York), the relief, poignantly titled *Korczak's Last Walk*, depicts eight orphans in movement, surrounding Korczak. The old doctor holds the youngest child, while some cling to him and others look around, terrified, reaching for the good doctor. An inscription above the relief reads: "To the sacred memory of the million Jewish

children who perished in the Holocaust." In April 2013, near Yom Hashoah, Park Avenue Synagogue's rabbi, Elliot J. Cosgrove, delivered words about the sculpture in his weekly sermon. Connecting the sculpture and the importance of its placement on the structure's façade to the purpose of his congregation, the rabbi said:

I cannot help but appreciate the decision of our synagogue's past leadership to put the Korczak sculpture where it is. If one understands the mission of this synagogue, as I do, to be to preserve our Jewish heritage and pass it on to our children, then every time you walk into this building, every time you enter this space, you are making a statement that the Nazis' hoped for victory—the Final Solution—will never come to pass. Nobody can bring back the hundreds of thousands of children who perished, but every time you are here, every young man or woman who emerges from this community, every Jew and non-Jew who comes into the orbit of this institution and what it represents—all of these are thundering statements that the values of Korczak, his children, those murdered in the Warsaw Ghetto and all the Six Million live on.[64]

Cosgrove, predictably, also spoke about the revolt, but less predictably he wisely warned his congregation about placing too much emphasis on heroism, while at the same time he acknowledged that doing so, in part, reveals ambivalence about confronting the horrors of the Holocaust. Most interesting, though, for my purposes here, especially in chapter 5, the rabbi offered a glimpse into the value of children to Judaism, and into how their survival, and deaths, resonate in a post-Holocaust world. Aside from the relief on the Park Avenue Synagogue, no other sculptures of Korczak exist in America, but a handful of cultural representations explore his empathy, efforts on behalf of the Jewish orphans in his care, and his selfless death.

Jeffrey Hatcher's play *Korczak's Children* premiered at the Children's Theatre Company in Minneapolis, Minnesota, in 2003, with later productions at venues in the United States and Israel. Rather than center on the deportation, the drama focuses on the orphans' staging of Nobel Laureate Rabindranath Tagore's drama *The Post Office* (1914), about a housebound Indian boy who maintains his optimism even as he closes in on death—a play Korczak purposefully chose to prepare the orphanage's children for their own probable deaths. Adam Silverman's three-act opera, *Korczak's Orphans* (2004; to a libretto by poet Susan Gubernat), initially inspired by its composer's visit to Yad Vashem, where he saw the sculpture of Korczak, hits on major points in Korczak's diary—notably children blithely playing around a dead body and their deportation with their mentor to the camps. Two recent novels reveal life in the ghettos through the voice of child protagonists. Jerry Spinelli's young-adult novel *Milkweed* (2005), a *New York Times* Notable Book of the Year, relates the experience of an orphaned

child who does not even know his own name or his background. Convinced that his name is Stopthief because that is what he hears yelled at him daily as he steals to survive, this fictional child visits Korczak at the orphanage. *The Book of Aron* (2015), a shattering novel by Jim Shepard, assumes the fresh and heartbreaking voice of a boy, Aron, who develops a relationship with the doctor and in the end boards the trains with him, crying in his arms.

None of the children remaining in Korczak's orphanage survived their deportation to Treblinka, although some of his former students did live to tell of his kindness. The survivor Bak, although not from the Warsaw Ghetto, adopts the best-known ghetto and the best-known child from the Holocaust to memorialize Korczak's children—and all the other children—in the ghettos and elsewhere, whose deaths leave one of the starkest, most indelible marks in the history of the Jewish people and beyond. In the earliest of Bak's Warsaw Ghetto paintings, he concurrently endeavors to transmit his own trauma to viewers in a post-Holocaust universe, who can then bear witness in the future. He offers his physical self in memory, his childlike presence punctuated by his complementary presence as the adult maker whose signature lines the bottom of the paintings, underneath the Warsaw Ghetto boy's spectral self. Bak thus doubles his identification with the dead child, and his signature acts like the memorial stones placed by Jews on gravesites. Even though Bak did not die in the Vilna Ghetto, his childhood did; he remembers the moment he was lowered into the burlap sack by his father as the final farewell to both his dad and his childhood: "I did not cry. I was ten years old, and I was an adult."[65] Later he laments: "My childhood paradise was not simply lost, as any Eden must be, but rather destroyed by eager human cruelty and meditated violence . . . that swept away that tender time."[66] Bak inscribes in his Warsaw Ghetto boy paintings the memory traces of all the children left behind in the Holocaust, those who perished and those who survived but left their childhood innocence in the abyss that was Hitler's Europe, including himself—and I would argue of the initial works in the series, especially himself.

Fig. 59 Nathan Rapoport, *Korczak's Last Walk*, 1980. New York. Photo: Daniel Barek.

5

There's no question in my mind that what you are about to read could have happened.

—Joe Kubert, introduction to *Yossel*

Hearing and reading of the oppression and slaughter of helpless, oppressed Jews in Nazi Germany . . . I had the great urge to help . . . help the despairing masses, somehow.

—Jerry Siegel, cocreator of Superman

"Our Children, Our Children Must Live"

Joe Kubert, Comics, and the Saving Remnant

Whereas Samuel Bak was an eyewitness to ghetto life, Joe Kubert, born Yosaif in 1926 in a Polish shtetl, could only imagine what life was like there. Kubert, of Hawkman and Sgt. Rock fame, was DC Comics director of publications, and he is considered by many the premier war-comics artist as well as a seminal figure from the Silver Age of comics. He also consistently depicted the Warsaw Ghetto in his work and always from the perspective of children. This chapter looks at a number of comics representing the ghetto's children, by Kubert and a few others, ferreting out the longings inherent in this material. A strong yearning for the Holocaust's horrific history to have a different ending animates comics. The medium, and in many cases the superheroes that go hand in hand with that popular genre, naturally accommodates fictional realizations of that fantasy, giving free reign to the desire to control a historical moment whose outcome defies our worst nightmares. In the cultural artifacts studied in this book the uprising has functioned in various ways, but one consistent leitmotif is the use of the fight as a salve for our wound. Though almost all of the ghetto's defenders died, we are at least slightly soothed by their courage. Comics

Fig. 60 Joe Kubert, "A Season in Hell," from *The Unknown Soldier*, no. 247, 1981. Reproduced by permission of the Joe Kubert Estate.

provide their own emollient by constructing happier, less bleak stories—often with redemptive and occasionally fantastical endings concerning children.

The Unknown Soldier and the Warsaw Ghetto

Unlike Bak's, Kubert's early audience typically comprised adolescents and young men—frequently those enlisted in the service, contemplating joining up, or recently released from duty—appropriate to the adult theme of deadly combat intrinsic to war comics. An initial project to engage the ghetto produced the distressing cover of the *Unknown Soldier*, no. 247 (January 1981; fig. 60), one of countless war comics that Kubert illustrated from 1955 until his death in 2012. A DC Comics character cocreated by Kubert in 1966, the Unknown Soldier appeared in issues of *Sgt. Rock*, whose titular figure remains the best-known character in the war-comics genre. The Unknown Soldier, who received his own series in 1970, suffered devastating injuries to his face from a grenade explosion during the first years of World War II, requiring heavy white bandages or masks to cover him from the neck up. This back-story allowed the Soldier to assume the persona of a disguised superhero, with latex masks and makeup, when his missions as a secret U.S. agent called for such. Mostly set during World War II, the Unknown Soldier's assignments included suppressing Nazis across borders—for example, saving General Eisenhower from an assassination attempt during the Battle of the Bulge (*Star Spangled War Stories*, no. 163, "Kill the General!," June–July 1972). Most extremely, in the final issue of the series' first run, the Unknown Soldier kills Hitler but makes it seem as if he took the cowardly way out by committing suicide (*The Unknown Soldier*, no. 268, "A Farewell to War," October 1982). It is not unexpected, then, that at some point the Unknown Soldier would make his way into the Warsaw Ghetto.[1]

A year before the first run of the series ended (it has since been reprised twice), the Unknown Soldier infiltrated the Warsaw Ghetto in the aforementioned issue (no. 247), dubbed "A Season in Hell," which details Nazi violence toward Polish Jews. To the left of the title headline for the story, on the first page of the issue, the Unknown Soldier's quest is laid out: "In every war there is a man who *no one knows,* yet who is known by *everyone!* He wears a *thousand faces*—fights countless battles—and *proves* that one man, in the right place at the right time, *can* make the difference!"[2] With just his bandaged head depicted, the Soldier surveys the ghetto immediately under this headline, a witness to Nazi cruelty; the full-page image shows a Nazi slamming the butt of his gun into a Jewish pushcart peddler's skull, with nearby SS men smiling and mocking the "Polish schweine." The Unknown Soldier responds to this viciousness,

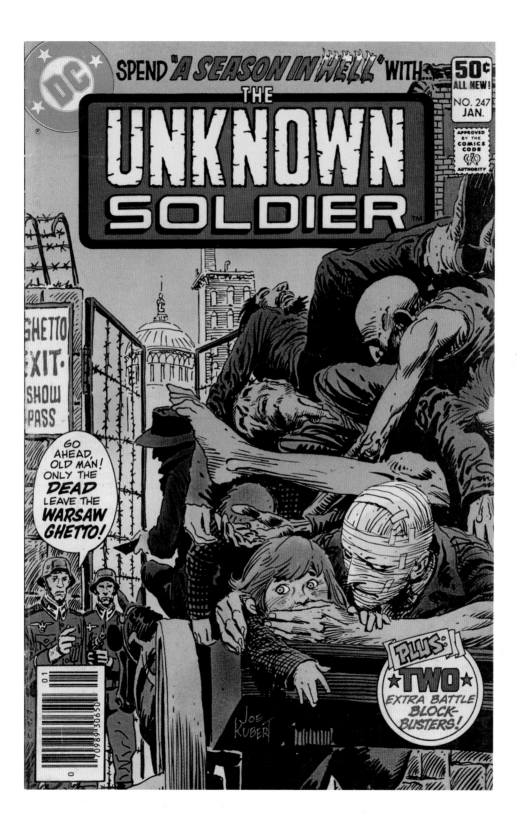

beckoning the reader: "Come with me now on my most harrowing adventure, as I fight my greatest battle." The weight given by the Unknown Soldier to his forthcoming mission as his "greatest battle" implies the significance of World War II as well as the Warsaw Ghetto for the writers and artists of the *Unknown Soldier,* in addition to American cultural inventions more broadly. Naturally, comics readers would anticipate an action-packed story about the uprising, but instead, a young child's miraculous escape unfolds, with the mounting resistance as merely the backdrop.

Part 1 introduces common archetypes: Nazi savagery; trucks filled with heaps of corpses; a bent, wizened Jew wearing a *kipah;* the younger generation prepared to fight; and escape through the sewers. A twist occurs when a learned professor entrusts the Unknown Soldier (first disguised as Stanislaus the peddler and then as Abraham the rabbi) with the mission to save his granddaughter Tovah. Meaning "good" in Hebrew, Tovah's name is an obvious metaphor intended to counter the Nazi characterization of Jews as bad—and Tovah's kindness and strength of character reinforce that notion (the partisans later call her "one of God's angels"). In part 2, as a side note, the would-be rebels militantly and resolutely declare that the following day they will rise against their oppressors: "We stand up like men . . . or die! Tomorrow!" (7). This material, expected but not explored in depth because the issue revolves around Tovah instead of the uprising, adds a precise historical bent to the story, typical of *Unknown Soldier* comics. Part 3, titled "Only the dead can hope," describes the Unknown Soldier's transport of Tovah out of the ghetto. This section recalls the earlier, mocking words from a Nazi soldier as he smashed the peddler's head with his gun on the initial full-page panel: "Ja! Only the dead leave the ghetto! Ha! Ha! Hah!" (1). The Unknown Soldier remembers this taunt and realizes they can only escape by hiding in a truck full of corpses that will exit the ghetto, pretending they too are dead. Before he can execute this plan, he scales a building with Tovah on his back and then coaxes her into the truck by explaining, "as horrible as it may seem, what the S.S. promises is more terrible." The brave girl replies: "Yes, soldier" (14). In a small square panel, one of four in the page's grid, their faces peer from the SS truck, marked with a swastika underneath them. This pivotal scene receives much larger treatment as the cover of the issue.

Kubert's cover, consistent with its increased size, intense coloration, and detail, imparts a more explicit rendering of the frightening episode than the panel inside. It conveys the moment in the story when the Unknown Soldier and Tovah escape the ghetto in a wagon piled high with dead, skeletal bodies. The Soldier places his hand over Tovah's mouth to keep her from shouting as her tiny head peeks from the side of the wagon, blue eyes wide with fear. One of Tovah's hands clasps the Soldier's arm, and the other hangs from the wagon. A reader cannot help but notice her tiny

fingers and by extension feel sad that this sweet, diminutive girl has suffered so profoundly. The ruddy, peachy flesh of Tovah and the Unknown Soldier contrasts with that of the rotting, brownish-gray, loose-limbed corpses haphazardly surrounding them. The pair's placement at the front of the picture, in the viewer's space, brings them into focus as much as the hues in which they are colored.

The *Unknown Soldier* cover brings home the sorts of monstrosities to which children were exposed. In the many diaries chronicling life in the Warsaw Ghetto, children and adults share excruciating particulars. Emanuel Ringelblum's prominent journal supplies examples:

The most fearful sight is that of freezing children. Little children with bare feet, bare knees, and torn clothing, stand dumbly in the street weeping. Tonight, the 14th, I heard a tot of three or four yammering. The child will probably be found frozen to death tomorrow morning, a few hours off. Early October, when the first snows fell, some seventy children were found frozen to death on the steps of ruined houses. Frozen children are becoming a general phenomenon. . . . Children's bodies and crying serve as a persistent backdrop. People cover the dead bodies of frozen children with the handsome posters designed for Children's Month, bearing the legend, "Our Children, Our Children Must Live—A Child Is the Holiest Thing."[3]

Two other frequently read diaries from the Ghetto, by Janusz Korczak and Mary Berg, afford related commentary. Korczak's diary narrates the daily trials of the children. In early August 1942, Korczak recorded a conversation with "little Hannah": "'Good morning.' She answers with a look of surprise. I plead 'Smile.' They are unhealthy, pale, lung-sick smiles."[4]

Berg's diary, smuggled out of Warsaw by Berg herself, recounts the distressing conditions in the ghetto—bitter cold, loss of possessions, and the despair of parents cradling their dead children. Started by Berg, a child herself, at the age of fifteen, the diary testifies to a young person's fear and reveals her mature and sensitive reactions. On July 10, 1941, Berg wrote: "I am full of dire forebodings. During the last few nights, I have had terrible nightmares. I saw Warsaw drowning in blood; together with my sisters and my parents, I walked over prostrate corpses. I wanted to flee, but could not, and awoke in a cold sweat, terrified and exhausted."[5] Janina Bauman's lesser-known diary tenders analogous remarks. She remembered a little girl whose parents made the anguished decision to give her up on the chance that she might survive. When the child arrived at the Bauman family's doorstep "from the deadly courtyard," the young Janina fed her warm water, sweetened with sugar. Forced to take on a role beyond her years, robbing her of her own childhood as much as the terror to which she was exposed, Janina nurtured "this helpless human crumb": "I

wanted her to be mine for ever. I wanted to care for her, to protect her from cold, from pain, from death."[6] Diarist Yitzhak Katznelson gruesomely reported that he frequently saw Nazis drag small children "through the streets to the railway yard—to die. The children writhed in their unclean hands; they wept, implored, screamed out, to the high heavens,—but these despicable beasts beat them mercilessly. They dragged them on, on towards the slaughter."[7]

The suffering of children became integral to cultural responses to the ghetto. Charles Reznikoff, a Labor Zionist lauded as one of the most prominent poets of the twentieth century, penned poems on Jewish history and verse replete with biblical allusions. The year Reznikoff died, he wrote his most searing work on a Jewish theme: *Holocaust* (1975), a 111-page, twelve-part series of free-verse poems based on transcribed court testimonials from the Eichmann and Nuremberg trials. Reznikoff underscores brutal, even stomach-churning, acts of violence in thematic sections titled, for example, "Massacres" (section 5) and "Gas Chambers and Gas Trucks" (section 6), all presented in dry, unadorned fashion like the court records from which they derive. Section 8, "Children," entirely about the young, chronicles the cruelty in their lives, in the ghetto and elsewhere. Section 4, "Ghettos," relates two shattering passages on children. The latter stanza ends the section:

> One of the S.S. men caught a woman with a baby in her arms.
> She began asking for mercy: if she were shot
> the baby should live.
> She was near a fence between the ghetto and where Poles lived
> and behind the fence were Poles ready to catch the baby
> and she was about to hand it over when caught.
> The S.S. man took the baby from her arms
> and shot her twice,
> and then held the baby in his hands.
> The mother, bleeding but still alive, crawled up to his feet.
> The S.S. man laughed
> and tore the baby apart as one would tear a rag.
> Just then a stray dog passed
> and the S.S. man stopped to pat it
> and took a lump of sugar out of his pocket
> and gave it to the dog.[8]

U.S. Poet Laureate and Pulitzer Prize winner Anthony Hecht took up the Holocaust in a number of poems, a lasting effect of his experience as a liberator of

the Flossenburg concentration camp. "The Book of Yolek" (1982) tells of the roundup of Korczak's children. The poem does not specifically mention the old doctor or the ghetto, but Hecht provides other clues, most notably the date of the deportation and an allusion to children "forced to take that terrible walk." Using the sestina form to jarring effect, Hecht does not weigh down the reader with a barrage of unmitigated horrors, as does Reznikoff. Rather, Hecht subtly evokes the memory of a single child, five-year-old Yolek, and then achingly insinuates his fate in the reader's mind: "Wherever you are, Yolek will be there, too. His unuttered name will interrupt your meal."[9]

Poet and child survivor Yala Korwin, like Samuel Bak, was born in Poland in 1933. She also found herself drawn to the Warsaw Ghetto boy. Although she was a survivor of a German work camp and not a ghetto, her first book of poetry, *To Tell the Story: Poems of the Holocaust* (1987), features a poem titled "The Little Boy with His Hands Up." She voices the power of the photograph in the final stanza of her potent verse:

> Your image will remain with us
> and grow and grow
> to immense proportions,
> to haunt the callous world,
> to accuse it, with ever stronger voice,
> in the name of the million youngsters who lie, pitiful rag dolls,
> their eyes closed forever.[10]

The first six stanzas of Korwin's poem evoke the boy's fear, as well as that of the figures around him. Readers are left to ponder the final lines, which create a disturbing image of the boy's death, along with that of the Holocaust's other children, by conjuring for readers their limp, lifeless bodies and comparing them to dolls, no less—toys never to be played with by children who have been destroyed by genocide.

Rod Serling's novella "The Escape Route," although not about the ghetto, taps into the same kind of visceral indignation stirred in readers when facing the abuse of children. A Jewish woman contemptuously describes Gruppenführer Joseph Strobe's crimes to him, characterizing Nazi philosophy as a faith, punctuating her case by strongly invoking the massacre of children: "The crematoriums—they were shrines, weren't they? And the gas ovens—temples of worship. And the slaughter of children—this was just some kind of ceremonial, wasn't it? A sacrament."[11] Serling's earlier teleplay, *In the Presence of Mine Enemies,* features a mother pleading for her sick baby and later carrying the dead child in her arms. In another instance, a young boy, when asked how long he has lived in Rabbi Heller's apartment building,

Fig. 61 Kenneth Treister,
*The Sculpture of Love
and Anguish* (detail),
1987–90. Miami Beach,
Florida. Photo provided by
Holocaust Memorial Miami
Beach.

replies, "As long as I have been hungry." Near the end, when Heller comes back to reality and finally apprehends what is happening around him, he repeats, twice for effect: "The children are dying in the streets. The children are dying in the streets."

One last example, again not explicitly about the Warsaw Ghetto, deserves consideration for its focus on children and especially their torment: a forty-two-foot-tall memorial, sculpted by Kenneth Treister, titled *The Sculpture of Love and Anguish* (1987–90), which sits in the heart of Miami Beach.[12] At the center of an outdoor plaza, a bronze arm festooned with 130 human figures in various states of misery, stretches to the silent heavens. Close looking at that arm, which bears a number from Auschwitz, reveals stories of families destroyed, children's suffering, and other vignettes about the loss of family and life. Treister often focused on children and their truncated lives; one of the most disturbing scenes portrays an emaciated baby being lifted to an equally pitiable figure who, most likely, will not be able to protect the child.

Surrounded by a round wall composed of Jerusalem stone, the plaza contains a series of additional freestanding sculptures. Upon entering the memorial space, one first encounters a woman protectively pressing her two children close to her body; perhaps inevitably, etched into the Jerusalem wall behind this grouping, is Anne Frank's classic quotation: "In spite of everything, I still believe that people are really good at heart." Such protection, Treister implies, was doomed to fail, considering that the final sculpture visitors see as they weave their way through the memorial space depicts the three original figures now lying dead on a pedestal, with the mother spooning her murdered child. Anne Frank's more morose sentiment accompanies this last grouping: "Ideals, dreams and cherished hopes rise within us only to meet the horrible truth and be shattered." Along the way, visitors pass two wailing children, with a father vainly consoling one; a granite wall etched with survivors' names; figures writhing in agony; and parents cradling their children. Toward the end, viewers walk though a stone tunnel called "The Lonely Path" and upon emerging confront one of the memorial's most difficult sculptures, in placement and execution. When visitors exit the tunnel, marked by the names of death camps, they encounter a sole crying child sitting on the ground, surrounded by nothingness, as she reaches for the help and protection she craves but cannot find (fig. 61). As visitors pass her, the central memorial comes into view.

Visuals in "A Season in Hell" communicate troubling circumstances but avoid any comparable sort of anguish or explicit horror; the Unknown Soldier's quest, in fact, concludes on an optimistic and unexpectedly moving note. After exiting the ghetto, Nazis threaten Tovah's life again right outside its walls. The Soldier turns the tables on the Nazis and uses their weapons to gun them down. To buy time to devise a way to defend himself and Tovah, the Unknown Soldier, by way of an interesting conceit, asks the SS if he can recite the Mourner's Kaddish, the ancient Jewish prayer for the dead. Accurately translated, the Kaddish's opening words appear in a speech bubble in a panel lined by corpses. Happily, the pair escape and share an affecting conversation. With their backs to the reader and holding hands, the Unknown Soldier and Tovah walk toward a new life. Tovah says: "You mean, soldier, I can have all I want to eat now . . . ?!? Grandfather would be so happy!" To which the Soldier responds: "Yes, little Tovah! You're safe now. . . . Forever!" And then he sentimentally adds: "Rest **easy**, professor!" (17). Tovah's strength during her precarious getaway and after the loss of her grandfather, surely murdered in the ghetto, along with her simple need—enough to eat—purposefully tugs at the heartstrings and softens the story's darkness.

While "A Season in Hell" ends hopefully, with Tovah's survival, it briefly circles back to the defiant Jews left in the ghetto by way of an epilogue written underneath the last panel: "The Warsaw Ghetto was ultimately doomed to failure—but the story of those valiant people and their glorious courage is immortal!" (17). Even with these final words about the insurrection, extolling the epic actions of the Jewish resisters while noting their grim end, what makes this comic so remarkable is that an avenging fantasy could so easily be drawn (e.g., Serling's revenge fantasies in "Deaths-Head Revisited" and "The Escape Route"). Still, the story concentrates on one life, a life that will help ensure future Jewish survival, and in this context the child's gender is particularly relevant—a small triumph, but a triumph to be sure. As diarist Katznelson wrote, the Jewish police took "young children, tender, pure, our hope, our future, our very best, our messiahs, our saviors!"[13] Even one such triumph would ever so slightly have mitigated the anguish of those, like Katznelson, who watched the young die. This Unknown Soldier issue, in which a child, Tovah, is saved, serves as a stark contrast to the story of Yossel, the doomed child-hero of Kubert's most sustained excursion into the events of the Warsaw Ghetto.

The Saving Remnant

Award-winning comic writer Bob Haney, who worked with Kubert for years, conceived "A Season in Hell" with his longtime partner, with whom he shared an interest

in Jewish topics and a predilection for the predicament of children. The pair also collaborated on "Totentanz" (*Star Spangled War Stories,* no. 158, August–September 1971), the German word for dance of death and the name of the story's fictional death camp. This issue has the Unknown Soldier entering an extermination camp disguised as a Jew to rescue an underground leader who provided crucial aid to Jewish refugees. The cover of this earlier comic book pictures inmates, including three children at front—the most vividly colored figures—staring desperately out through a barbed-wire fence (fig. 62). Until the turn of the twenty-first century, the brutality of the camps did not receive extensive treatment in comics, because, Kubert recollected, there was "a tacit understanding" that an audience of ten- to twelve-year-old boys would be ill-equipped for such harsh material.[14] Here Kubert seems to have forgotten that the war comics' audience was substantially less juvenile than that of superhero stories and funnies—or perhaps he simply underestimated it. There were, in fact, some surprisingly explicit handlings of the subject, including a three-page story in *Classics Illustrated* with the telling title "Death Camps" (1962); an April 1981 issue of *Sgt. Rock* containing a two-page story titled "Holocaust," which depicts the camps; and the second installment of *Blitzkrieg* (April 1976), a short run of DC comics that Kubert edited and for which he made the covers. *Blitzkrieg,* which controversially centered on the perpetrator's perspective during World War II and only ran for five issues, bore the subtitle *Searing Battle Sagas of World War 2 as Seen Through Enemy Eyes!* The comic distinguished itself not only by concentrating on Nazis rather than the Allies but also by showing unequivocal violence. The April 1976 issue includes a scene that exceeds monstrosities pictured in most visual representations of the Holocaust for adults: a view into a gas chamber strewn with dozens of scrawny, naked bodies in piles, with wafts of gas hovering above.

Titled "Walls of Blood," the eleven-page story in *Blitzkrieg,* no. 2, written by Kubert's Jewish colleague, DC Comics editor, and long-time collaborator Robert Kanigher and illustrated by Ric Estrada, takes place in the Warsaw Ghetto.[15] The assailed inhabitants are not identified as Jews, but two characters are named Esther and Mordecai—the latter nodding to Mordecai Anielewicz, and the pair also alluding to the near annihilation of the Jews as described in the book of Esther. Hence, the characters' identities are strongly implied, and the locale tenders further confirmation for most readers. "Walls of Blood" opens with a Nazi soldier complaining that he has been sent to battle on his birthday, a venal and egotistical comment—reiterated several times—in light of the day ahead for the Jews of the ghetto and the fact that many of them will not celebrate another birthday. Several panels represent ruthless treatment; on the second page another soldier repeatedly shoots a helpless Jew directly in the top of his skull at close range. Nazis mock the Jews; a soldier looks

at a wheelbarrow of piled emaciated corpses and says with disdain, "They die like flies," to which another responds, "A weak people," and a third rejoins, "They are unfit to live" (5). One soldier shows a fit of conscience while surveying murdered children haphazardly littering the ground: "A soldier shouldn't have to . . . execute . . . children!" (8). Like *The Black Book*, "Walls of Blood," while in a very different vein and for a very different audience, makes use of the guilelessness of children to augment the impact of Nazi turpitude. Most importantly, children provide readers with figures with whom to identify and mourn—a ploy of most comics described here. It was this missing piece, the failure to create characters with whom more viewers could identify and care about, that contributed to the negative reception of Serling's and Lampell's projects.

A grandfather and his grandchildren are the central characters. One grandchild, a girl cradling her baby, asks where they will find food in the ghetto, to which the grandfather, a pious man with a long white beard and wearing a *kipah*, replies, ever faithful, "The Lord will provide!" (4). Despite their hunger and fear, he exhorts his family to cel-

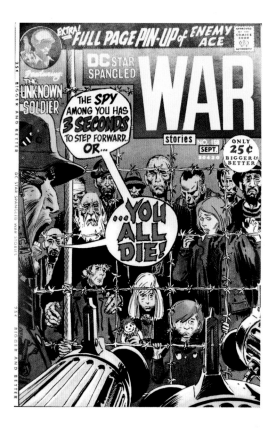

Fig. 62 Joe Kubert, *Star Spangled War Stories*, no. 158, 1971. Reproduced by permission of the Joe Kubert Estate.

ebrate his grandson Benjamin's thirteenth birthday, in Jewish life a day symbolic of emergent manhood. The next day Jews are deported to work camps, directed to the left and right, and an escapee from a concentration camp sneaks into the ghetto to warn his coreligionists about what awaits them. This page does not mince words or images. As the spared Jew relates his torment, his memories translate into visual form: a crematorium replete with smokestacks at full force and a soldier explaining to the camp's new entrants that they will be escorted to the showers by guards, followed by a shocking panel showing a pile of dozens of corpses inside the gas chamber. That interlude leads readers back to the grandfather, who encourages his progeny to fight, predictably invoking Masada when the children express their doubts, alongside panels of Nazis murdering children. Ultimately, the family joins the battle. A Nazi approvingly paraphrases Stroop's infamous proclamation on the final page: "The Warsaw Ghetto is no more!" On his death bed, the grandfather sends Benjamin through the sewers to safety with his dying words: "You . . are our only hope! The dead . . . will live on . . . in you!" (fig. 63). The second-to-last panel shows the grandfather dead, with a narrative box above his head. That caption does not appear in a standard rectangle but within an unfolded scroll bearing the words, "And so—on his thirteenth

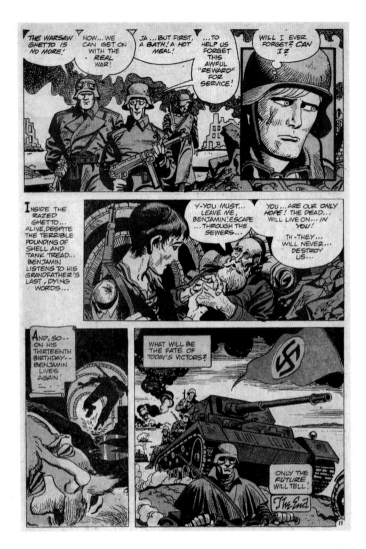

birthday—Benjamin lives again!" (11). Yet another child, like Tovah, will be saved and thus help perpetuate the Jewish people, a recurrent plot point that ties to the idea of the "saving remnant," an essential belief running through the Hebrew Bible.

The saving remnant denotes physical survivors of war and other catastrophes or the persistence of religious conviction after a period in which faith has been tested—as it was during the persecutions of pogroms and the Holocaust. Biblically, the saving remnant pertains to Noah and the survivors of the Flood, Lot's survival of the destruction of Sodom and Gomorrah, and Joshua and Caleb's survival in the wilderness, among other instances of Jewish fortitude. As written in Genesis 45:7, "And God sent me before you to give you a remnant on the earth, and to save you alive for a great deliverance," and then later in Isaiah 10:21, "A remnant shall return, even the remnant of Jacob, unto God the Mighty"—so that the Jews can serve as a "light of the nations" (Isaiah 49:6). Each Jew that survived the Holocaust, and especially the children, offered a sliver of hope that the Nation of Israel would continue to extend the destiny of monotheism and the Jewish

Fig. 63 Robert Kanigher and Ric Estrada, "Walls of Blood," from *Blitzkrieg*, no. 2, 1976. Reproduced by permission of the Joe Kubert Estate.

people would be redeemed. "It is as though the Nazi killers knew precisely what children represent to us," Elie Wiesel reflected. "According to our tradition, the entire world subsists thanks to them."[16] In *Blitzkrieg*, in regard to his grandson's survival, Benjamin's grandfather utters his final words with relief: "Th-they will never . . . destroy us . . ." (11).

Smuggling and Other Plots Involving Children

Child smugglers provide a recurring theme across media. Władysław Szpilman's memoir, later made into the movie *The Pianist* (2002), opens with an extended

recollection of child smuggling. Vividly and disturbingly, he recounts trying to help a child squeeze through a breach in the ghetto's wall with his smuggled bounty: "I pulled at his little arms with all my might, while his screams became increasingly desperate, and I could hear the heavy blows struck by the policeman on the other side of the wall. When I finally managed to pull the child through, he died. His spine had been shattered."[17] Roman Polanski's filmic adaptation re-creates this moment to extremely disturbing ends. The child protagonists in Jim Shepard's and Jerry Spinelli's novels keep themselves alive longer than expected due to their successful trafficking of food and other goods. The miniseries *Holocaust* depicts the ghetto's child smugglers and their quandary in several instances. A divided Jewish Council debates whether to condone or forbid smuggling, with the "character" of Anielewicz arguing in favor because "[w]e will all be killed anyway," and another character observing, "The boys [smugglers] may be our salvation." As the uprising draws near, the child smuggler Aaron helps an older character, Moses—the biblical names are intentionally invoked—smuggle guns into the ghetto for the fight. The pair ultimately die, hand in hand, shot in the back by Nazis while facing the ghetto wall.

Fig. 64 William Sharp, illustration for *The Wall*, 1957.

John Hersey's *The Wall* tells of the children's existence within the ghetto's confines but with fewer and less abysmal details than *Mila 18*. Rachel Apt organizes and runs a clandestine school, one born of anxiety, since an earlier secret school was discovered, provoking a deadly penalty: the teachers were shot and the students permanently disappeared. Nonetheless, parents send their children despite this peril because, as per Jewish values, "the drive to educate them is even stronger than fear."[18] At the middle-school level, archivist Noach Levinson comments, there tended to be a fair amount of absenteeism because students were busy smuggling food. Smuggling, he reports, was punishable by death. Without emotion, because these acts became commonplace, Levinson succinctly states, "Often children are shot" (162).

Smuggling receives an illustration in the Limited Editions Club version of *The Wall*. Artist William Sharp pictures three children crawling through rubble, each with a different expression: wary, angry, and scared (1957; fig. 64). Three of Sharp's twelve full-page aquatints, in fact, picture children. Near a passage about Jews moving into the ghetto, Sharp depicts a crowd entering their enclosed prison; at the head of the

mass, an exhausted family carrying their meager possessions trudge slowly forward, and a small girl with tired eyes carries her baby doll and holds her mother's hand. Hundreds of pages later, a mass of ghetto inhabitants walk stoop-shouldered, in the opposite direction, to the *Umschlagplatz*. Seen from the back, a boy at the front of the picture holds his father's hand as he heads toward his eventual death. That gesture of comfort, albeit futile parental protection, served Jack Levine as well in his oversized print of the Warsaw Ghetto.

The importance of children in Hersey's *The Wall* extends much further. Midway through, Rachel unites the disparate factions of the mounting resistance groups by silhouetting "the innocence and blithesomeness of the children against the week's general degradation" (283). Children, acclimated to the Nazi Gehenna, play a game called "selection," learned from their oppressors, and feel "tremendous pride—as if nothing finer could happen to anyone"—when chosen for the *Umschlagplatz* (296). As Korczak describes the children's dire existence and their resilience, or at least forced indifference, in a few simple sentences: "A dead boy is lying on the sidewalk. Nearby three boys are fixing something with some rope. At a certain moment they glanced at the body and moved away a few steps, not interrupting their game."[19] It is this startling revelation that Adam Silverman re-created in his three-act opera, *Korczak's Orphans*. Levinson works tirelessly on his archive because he reckons that the ghetto's inhabitants "are all doomed" and it "will be our only estate. We will leave no children" (327). In an effort to encourage an audience to attend a forthcoming presentation arranged to boost morale, children have been sent to announce it to the ghetto populace. Levinson realizes the "shrewdness . . . in sending this notification out by the children: letting the precious ones among us, our children, our Jewish future, risk life to announce a talk" will garner "a good crowd" (544).

The most affecting and longest-running subplot about a child in *The Wall* concerns Rachel's younger brother, David, whom she has raised since the premature death of their mother. Knowing that David, whom Levinson movingly describes as "a poor, skinny, little old man of a brother" (219), could fare better outside the ghetto, Rachel arranges for him to be placed on the Aryan side for eventual immigration to Palestine. Like David, the children of the ghetto, inured to foreboding, were indeed old men before their time. Korczak observed, "The Children's Home is now a home for the aged."[20] That extinguished childhood supplied a persistent theme for Samuel Bak, and Yad Vashem institutionally has recognized this sad reality with the dedication of the Garden for Children Without a Childhood on its campus (2002). This theme was acknowledged in children's stories as well. Reflecting on the cruelty in his life, the child-protagonist from the *World Over* story "Underground Brigade" discovers "a great secret; there were no children in the ghetto—no children at all. Big and

little, all had to fight for their existence. All had to suffer shame and humiliation."[21] Readers never learn if David Apt ultimately makes it to safety, but the possibility that he does provides the kind of hope inherent in the aforementioned *Unknown Soldier* issue, *Mila 18,* and other projects.

The consummate storyteller Leon Uris understood the potency of children to draw in and provoke readers, and the immeasurable power of their survival to foster readers' hope. Several storylines about children weave through *Mila 18:* the formation and maintenance of the Orphans and Self-Help Society; efforts to find children refuge outside the ghetto; and the hardships children withstood in the ghetto (children in *Exodus* also receive special attention). Uris even fictionalizes Korczak's selfless act of fealty in accompanying his orphanage's children to the death camps, having Susan Geller similarly chaperones her charges, calming them by explaining: "Aunt Susan has a wonderful surprise! Today we are going to the country on a picnic."[22] Indefatigably dedicated to the children in her care, Andrei's sister, Deborah, offered freedom by her gentile lover, stays in the ghetto with the handful of those remaining children. Following hundreds of pages of frightening details pounded into the reader, Uris allows a glimpse of something better. With the uprising nearing, Deborah's youngest child, Stephen, is secretly smuggled out of the ghetto to symbolically "live for ten thousand children killed in Treblinka" (461) and, more directly, to continue his family line. Andrei explains to his nephew: "It is the job of your mother and your sister and me to die for the honor of our family. It is your job to live for our honor" (460). It is this very plot point in *Mila 18* to which Uris referred in his speech in front of Nathan Rapoport's Warsaw Ghetto Monument (as described in chapter 3), when UJA mission leader, child survivor, and true-to-life saving remnant Ernie Michel stood beside him, the wax of his torch dripping on Uris's notes. As *Mila 18* nears its close, Gabriela, Andrei's Polish lover, "saves" another Jewish child; pregnant with Andrei's baby, and even though devoted to her own Catholic faith, she will raise the child as a Jew.

Similarly, the NBC miniseries *Holocaust* features a non-Jewish and Jewish love story. When Inge, a German Catholic, tells her incarcerated Jewish husband, Karl, that she is with child, he urges her to abort, to which she responds: "The rabbis say that every life is a sanctification. A holy spark."[23] As the docudrama ends, postwar, we see Inge with her son, Josef, a saving remnant, along with the only other surviving member of the Weiss family: Rudi, a young man in his early twenties and arguably the most prominent character in the docudrama, who will smuggle child survivors into Palestine. But to revisit Uris one last time: when writing *Mila 18,* he pinned a small photograph above his desk (as described in chapter 3). That picture, of a child in the Holocaust—a reproduction that shifted around Uris's writing area several

times, as indicated by the many thumbtack holes in it—supplied inspiration. Also relevant to the matter at hand, Uris alludes to the Warsaw Ghetto boy photograph in the novel. Near the end of the revolt, a boy and two girls around six years old are discovered in a bunker by German officers, who order the children to hold up their hands high so that they can be photographed "properly" (509).

Rod Serling's *In the Presence of Mine Enemies* also invokes the idea of the saving remnant. Uttering the final words of the teleplay, Rabbi Heller opines, in a mixture of despair and relief, thankful that his daughter Rachel will most likely make it to safety: "If we leave the world nothing . . . nothing except our bodies . . . nothing except the death rattle in our throats . . . nothing but the rubble that we deed to one another on earth—then there shall be no beginning. And, Paul, my son, there must be a beginning. There must always be another beginning." Earlier, when the rabbi has come to terms with Rachel's pregnancy resulting from her rape by the Nazi general, he explains to Paul why she must be allowed to escape the ghetto: "Your sister has no hunger for survival, Paul. But there is a sanctity to life. This is the basis of our faith. *Your* faith. Rachel is with child. Conceived in horror and shame, my son . . . but it is a life . . . and this life *is* precious."[24] Even in this extreme moment, with a child conceived in a sickening circumstance, the most religious cling to that life.

This cannot be said of the survivor Bak, whose primary goal was memorializing; for the artists discussed so far, the child's plight allowed them to craft what they believed, in part, to be projects of recovery, through the renewal of hope. Other artists, however, exploited the horrors—the emotional impact of suffering and murdered children—to shock. For some, the former tack, the idea that a redemptive ending can mitigate the offensives of the Holocaust or offer some sort of closure, engenders anger, because nothing about the Holocaust can provide solace. Lawrence Langer emphatically adopts this position, understanding the Holocaust as a universe of "choiceless choices," and rejects any efforts at reassurance.[25] Choiceless choices they most certainly were, but art is not life, and while art cannot allay offenses, it can reveal the mind-set of makers and the needs of the given time in which art was produced.

Consider a final example: a comic portraying a child and the Warsaw Ghetto, but not set in the Warsaw Ghetto, that expresses the idea of the saving remnant in a novel way. Published in the anthology series *Wimmen's Comix*, Trina Robbins and Sharon Rudahl's understated and moving *Zog nit keyn mol* (*The Partisans Song*) (1985; fig. 65) presents a black-and-white two-page intergenerational story in which a young woman prepares to leave for an unnamed demonstration to stand up for what is right. Stirred by the Warsaw Ghetto uprising, the original *Zog nit keyn mol* (1943)— translated as "Never say" and written by Lithuanian-born Hirsh Glik in his early

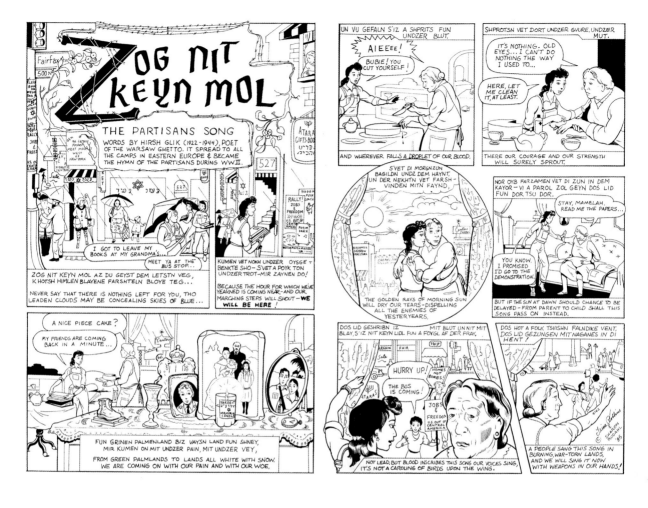

twenties—was intended to encourage continued resistance during the Holocaust, the predecessors to the young people of today, the comic suggests, willing to fight for justice. The young woman in the comic gets ready in the company of her immigrant grandmother, who, it is implied, taught her such values. Transcribed in translit-erated Yiddish beside English, *Zog nit keyn mol*—as previously mentioned, often sung at Yom Hashoah commemorations and appearing in Audrey Flack's image of the Warsaw Ghetto boy—runs throughout each panel of the comic, underscoring and intersecting with the contemporary story as it unfolds. In the final panel, when the grandmother waves goodbye to her granddaughter, her arm outstretched to the future, the reader glimpses a concentration camp tattoo etched into the elderly woman's forearm. The granddaughter, the fruit of the saving remnant, carries on a legacy of Jewish resilience and also embodies the continuation of the Jewish people. Peripherally, Kubert himself is a saving remnant—a Polish boy who by fortunate

Fig. 65 Trina Robbins and Sharon Rudahl, *Zog nit keyn mol (The Partisans Song)*, 1985. Reproduced by permission of Trina Robbins. Photo courtesy Trina Robbins.

211

Joe Kubert

happenstance left eastern Europe as a young child before Hitler came to power. Bak, on the other hand, fully embodies the idea of the saving remnant, and his work speaks to the aftermath of his survival.

Kubert's *Adventures of Yaakov and Isaac* and Spiritual Resistance

After insistent requests from Rabbi David Shalom Pape, editor of the *Moshiach Times,* published by Chabad (an influential, highly religious Hasidic movement), Kubert in 1984 initiated the series *The Adventures of Yaakov and Isaac:* two-page stories in comic-book form about brothers studying at a yeshiva.[26] Engaging biblical material, biographies of Chabad leaders, and Jewish history, the stories provide for readers life lessons rooted in Judaism, often by looking to the past to make modern Jewish life relevant (the magazine is a more religious version of *World Over*). Kubert aimed, he wrote, "to compose and illustrate stories that would be of interest to contemporary readers. . . . Stories that would evoke thought and emotion today, based on concepts that have existed for thousands of years."[27] In a compilation of these little-known comics published in 2004, Kubert's thoughtful reflections precede each story; the collection includes "The Importance of Torah" (1985), about the magnitude of faith; "The Jewish Heart" (1985), delimiting the significance of helping fellow Jews; and "An Act of Resistance" (1985), making use of the uprising to demonstrate dedication to the Torah and the significance of studying it no matter how exacting the circumstances— in other words, the importance of Jewish continuity at all costs. Throughout the series, Kubert manages to overcome the limitations of a two-page spread to recount details and ideas, often by adapting lessons learned in his earlier mainstream comics to appeal to Chabad youth. For example, in "The Jewish Heart" a soldier crouches in the trenches and then engages in hand-to-hand combat like characters in Kubert's many war comics. The influence of Kubert's prehistoric character Tor manifests in "An Act of Kindness" (1984) with renderings of a junglelike atmosphere, employed to enliven a message about kindness to animals as per Jewish values.

"An Act of Resistance," a title with a dual meaning, begins by superimposing two rectangular panels containing Yaakov's and Isaac's modern-day existence atop a full-page illustration picturing the much darker life of Jews in the Warsaw Ghetto (fig. 66). In one of the smaller panels Yaakov informs his younger brother, Isaac, having fun playing baseball, that the time has come to return to yeshiva. Isaac expresses his disappointment that the game will end. In the second small panel, overlapping the first modern-day exchange, Yaakov explains that the pair must go to school because learning Torah is "VERY IMPORTANT," penned in bold letters. To

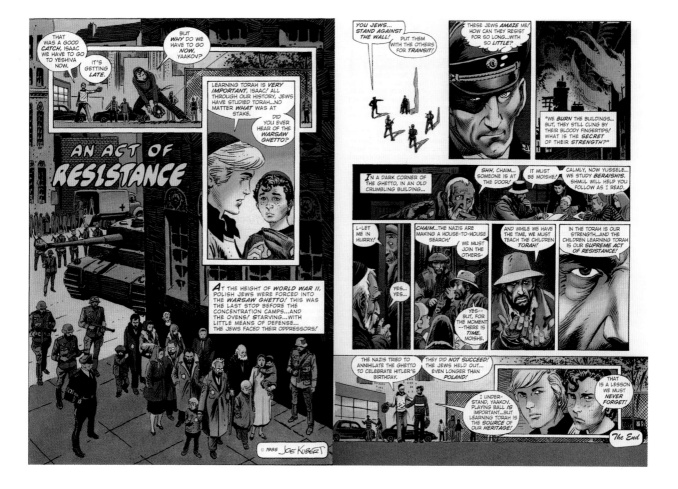

make his point, Yaakov asks Isaac if he knows about the Warsaw Ghetto. Yaakov proceeds to share with Isaac what happened there during the war, first describing Jewish oppression, underscored with a bird's-eye view of the ghetto and Jews marching, with Nazis aiming guns at their backs. This easily read scene communicates many details, including Jews marked by yellow badges, a Nazi commander wearing a swastika around his bicep, and a truck portentously looming in the background with a procession of nameless Jews filing into it. The first panel on the second page, one of eight panels about the ghetto, with two of contemporary life, supplies the only explicit image of Nazi tyranny. To emphasize both Jewish fear and Nazi brutality, the stark white background adds gravity to the ominous shadows cast by the SS squad surrounding a terrified trio of Jews about to be transported out of the ghetto—a family that ironically casts the longest shadow.[28]

"An Act of Resistance" juxtaposes two very different times, indicated not only through subject but also through divergent color schemes—the sun shines

Fig. 66 Joe Kubert, "An Act of Resistance," from *The Adventures of Yaakov and Isaac*, 1985. Reproduced by permission of the Joe Kubert Estate.

in the contemporary scenes, and a gray-green pallor of war and cold suffuses the Warsaw Ghetto. Expertly, Kubert communicates the story of Jewish resistance and deportation within tight page restrictions. Opening remarks by Kubert outline his perspective on the uprising, which, he asserts,

must and will be told over and over again. How a small vestige of young Jewish survivors fought side by side against the Nazi horde despite the knowledge that their deaths were inevitable. . . . But, another important aspect of this story is the continued faith displayed under extraordinary circumstances. . . . People held in the Warsaw Ghetto knew that the Nazis intended to kill them all, men, women and children. No one would survive. Yet, they continued to teach the children Torah. Above all else, parents believed the children must learn Torah. How else would the heritage survive? And the heritage does survive. . . . As the character in the story expressed, ". . . learning Torah is our supreme act of resistance."[29]

Kubert's commentary, in line with his story, underscores the lengths to which adults went to teach children and to keep Judaism alive for them—and hopefully for the future—even in the worst scenario (recall the efforts to educate in Hersey's *The Wall*). A long panel in the middle of page 2 portrays three children and three adults covertly studying; that narrow panel visually emphasizes the tight spaces where these clandestine activities took place. Significantly, the main child studying is named Yussele, Joseph Kubert's name in Yiddish and the title—spelled a bit differently—of his harrowing full-length graphic novel about a child in the Holocaust. One of the instructors, in a close-up of his determined face, makes intense eye contact with the reader and declares: "In the Torah is our strength. . . . And the children learning Torah is our ***supreme act of resistance!***" The story sets a moral example to follow—if children can attend to their religious duties when under fire, then a child has no excuse for grousing about Jewish education in modern-day America, a lesson also inherent in the aforementioned *World Over* article elucidating the poem "A Child's Song of Courage." That article describes children who, even in their bleak situation, continue to study and learn "so that they can take their part when they grow up to rebuild Jewish life."[30]

The type of resistance that Kubert highlights in his short story has been stressed in various ghetto accounts, fiction and nonfiction, a number of which have figured in this study. Indeed, resistance took forms other than the battle, including spiritual resistance and what Anielewicz dubbed "passive resistance" in the Jewish Combat Organization's call to arms: *"Not even one Jew must go to the train. People who cannot resist actively must offer passive resistance, that is, by hiding."*[31] Because Vladka Meed (born Feigele Peltel), who acted as a courier for the Jewish Combat Organization,

spoke Polish without an accent, she was able to move seamlessly between Jewish Warsaw and the Aryan side. In an autobiography and testimonies of various sorts, she has documented life in the ghetto, resistance, and the uprising. One essay clarifies that while resistance reached its apex with the insurrection, it "did not spring from a single impulse. . . . It was the culmination of Jewish defiance, defiance that had existed from the advent of the ghetto."[32] Meed saw the very act of living as resistance: "It was the Jews' daily struggle, their vibrant drive for survival, their endurance, their spirit and belief, which the Nazis failed to crush, even with their most dreadful atrocities. This was the foundation from which resistance in all its forms was derived. . . . Our aim was to survive, to live, to outwit the enemy and witness his destruction. Every effort that lent strength to this goal I see as an act of resistance."[33] She also chronicles cultural activities in the ghetto and other morsels of joy that residents cultivated among the atrocities, which have been part and parcel of earlier works described here, presented in considerable detail in vast novels like Uris's *Mila 18* and Hersey's *The Wall*. To recall one especially early example: the narrator in Morton Wishengrad's radio program *The Battle of the Warsaw Ghetto* (1943) calls attention to the cultural pursuits that took place in the ghetto along with details about children secretly learning. This show also exploits the distress of children when the boy Samuel's cries over his mother's death are heard in tandem with the Mourner's Kaddish.

A most bizarre form of spiritual resistance, but resistance nonetheless—and even augmented by a revenge fantasy—appears in a five-page comic from *Weird War Tales*. Titled "Colonel Clown Isn't Laughing Anymore" (1971, no. 36), the comic was scripted by Arnold Drake, with art by Frank Robbins and a cover by Kubert.[34] With echoes of Charlie Chaplin's *Great Dictator* (1940), but less success, a clown amuses the ghetto's residents by parodying Hitler. The clown introduces himself with his arm extended in a "Heil Hitler" salute and a comb held up to his lips mimicking the absurdity of Hitler's mustache (51; fig. 67): "I am der **fuehiest** fuehrer in der **world**!" This comic opens with a masthead introducing the story's title and extolling the armed resistance: "Virtually unarmed they staged the greatest uprising in the history of man! Out of the rubble of that valiant resistance comes the tale of the night when . . . Colonel Clown isn't laughing anymore!" Colonel Clown (né Yussel—coincidentally or not) entertains with parodic humor, which "managed to survive—in the form of the ***underground night club!***" Note the play on the word "survive," to indicate something other than the ghetto residents' lives, and on "underground," to describe a nightclub, not the ghetto's sewers or the underground fighters. Kitschy humor pervades this comic, which has the clown arrested for conspiracy against Hitler and condemned to death. Weirdly, as per the series title, the dead clown's costume—his

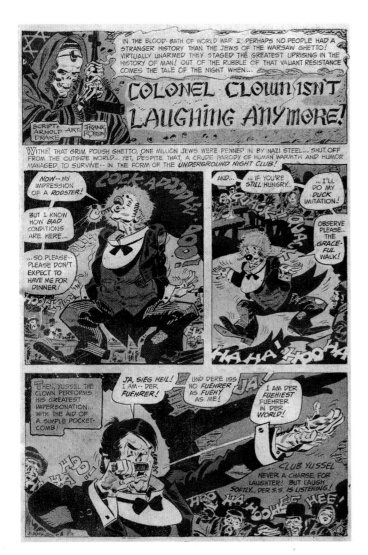

fake red nose, oversized shoes, and wig—take on a life of their own, and the surprised SS commander, Schroeder, suddenly finds himself wearing them. The uprising ensues, and the partisans' unexpected, if temporary, success is portrayed. At battle's end, Schroeder's men laud him for the victory, but by then he has been fully possessed by the clown. Schroeder mocks Hitler, giving the German soldiers reason to shoot their commander dead. The last panel of the comic depicts only ghoulish, bony fingers tapping on an unidentifiable surface, along with a narrative bubble containing an invitation to the reader: "Come! Let us all drum our fingers . . . to show how much we appreciated—Yussel's last performance!" (56). This revenge fantasy, as far-fetched as it is, predates the sensational and much-escalated reverse power play in Quentin Tarantino's *Inglourious Basterds* (2009).

Acknowledging that photographs of emaciated, hollow-eyed figures and bloated corpses in the street and other visuals of the day-to-day struggle during the occupation are very real, Meed reminds readers that most were taken by Nazis, thereby deliber-

Fig. 67 Arnold Drake and Frank Robbins, "Colonel Clown Isn't Laughing Anymore!," from *Weird War Tales*, no. 36, 1971.

ately projecting an image consonant with their goal "to demonstrate the helpless, spineless inadequacy of those whom they were planning to destroy."[35] Certainly the Warsaw Ghetto uprising stands as one of the grander acts of resistance during the Holocaust, but Meed points out: "Throughout the Holocaust, every Jew in his or her own way resisted the Nazis; each act of resistance was shaped by its unique time and place. The soup kitchens, the secret schools, the cultural events in the ghettos and camps constituted forms of resistance, the goals of which were survival with dignity, with 'menshlekeit.'"[36] For those left in the ghetto, resistance constituted the taking up of arms, but other acts of resistance as described by Meed are not lesser, just less dramatic. To be sure, there exist many gradations between victimization and heroism.

Kubert's *Yossel: April 19, 1943*

Kubert's next endeavor about children in the Warsaw Ghetto, *Yossel: April 19, 1943,* depicts a very personal sliding-doors story in which he imagines himself not as an immigrant in Brooklyn but rather as a child remaining in Poland during World War II. Kubert aimed this graphic novel at an audience different from that of his war comics and other undertakings: mature teenagers and adults. Told through the eponymous protagonist's eyes, *Yossel* revolves around how Kubert's life might have unfolded if the artist's family had not immigrated from their eastern European shtetl to the United States when he was two months old, in 1926. Yossel's story allowed Kubert to explore his "'what-if' thoughts . . . [in] a work of fiction, based on a nightmare that was a fact."[37] Knowing the persecutions he would surely have endured as a Jew in Poland during the war years, Kubert mused, "If my parents had not come to America, we would have been caught in that maelstrom, sucked in and pulled down with the millions of others who were lost. . . . The experience [of researching and making *Yossel*] was very personal, a little scary, and sort of cleansing. It was something I felt I had to do."[38] Kubert's reflection, as a secondary witness rather than a primary one, curiously echoes Jack Levine's earlier comment, coming from an analogous position, about why he wanted to confront the ghetto in his art. Nonetheless, Kubert's work originates from more of a personal place than that of Levine. Still, the sort of trauma Kubert addresses is different from Bak's: that of a man on the periphery of annihilation rather than at its center.

Yossel opens with the title character, at age sixteen, hiding in the sewers beneath the ghetto with a few remaining resistance fighters, observing that the partisans "have lived a hundred years of hell in the Warsaw Ghetto" (4). Most pages comprise a collage of sketchy black-and-white pencil drawings, as if Yossel himself made them, often hurriedly, as the events occurred. Kubert's choice to execute the story only in pencil, forgoing ink entirely, provides a perfect confluence of form and function; the colorlessness evokes the immediacy of the moment and also the cold, emotional darkness of the time, in addition to the frequently severe, gloomy climate. Further, as Brad Prager so aptly observes, Kubert's "unerased pencil markings also serve as a metaphor for the persistence of the past: it cannot be erased, nor can it be presented cleanly."[39] The collaged images are not constrained by grid-like panels but rather sprawl, undefined and often heavily shadowed, across the book's pages, which are grayish in tone, not a traditional white. The book's thick-stock pages and their muddied hue contribute to the sense that the illustrations were made in the time they portray, and add depth to the subtle gradations of the raw graphite, at times supplemented with white highlights. In what amounts to a long flashback, bookended by the uprising and

Yossel's death, the young artist describes his family's journey from a life of freedom to their travails in the ghetto, the privileges he gained as an artist for the Nazis, and his involvement with the resistance. Dialogue and descriptive information appear, not encapsulated in standard circular speech bubbles emanating from characters' mouths, but within sketchily lined, blocky squares and rectangles, circumscribing a font known as CCKubert, a crisp lettering style of the artist's invention.

For Yossel, drawing affords a diversion from a life of fear and engulfing desperation; he is a fictional "young artist of the ghetto," a phrase the real-life child artist of the ghetto Samuel Bak used to describe himself.[40] Bak treasured any scraps of paper he could find, as does Yossel, who sees drawing as his saving grace: "If I could not draw, I would not survive" (104), he writes, hunched over a piece of paper with a pencil gripped in his hand. Yossel notes that he "could create [his] own world" (7): "Drawing seemed to cleanse my mind, drive my fears into little corners and crevices" (13); "being able to draw was truly a blessing" (24). By page 8, Yossel recollects earlier Nazi tyranny: Kristallnacht, school restrictions, and the despoliation of Jewish property. The graphic narrative not only tells a story through one child's eyes, it also recounts the experience of other children. Yossel draws children scrambling for bread—"Every day I see starving children fighting others for a crust of bread" (31)—and shows a desperate woman clutching her child to her chest on the adjacent page: "A starving woman held an ailing baby to breasts bereft of milk. Lack of nourishment killed her slowly and her child would share the same fate" (32). The moving motif of the nursing mother, and especially one who can no longer offer sustenance to her baby, provides a common and effective tool for articulating the challenges of motherhood during crisis; on several occasions the U.S. government–funded Farm Security Administration's shooting scripts requested such coverage of victims of the Dust Bowl.

On the next page of *Yossel*, two small children stand in front of a corpse, hugging each other for comfort, about which the child narrator opines: "To live in the ghetto was to learn that the human animal can adapt to terrible, unimaginable conditions. The experience was insidious, because the horror manifested itself in slow increments. It took time, until death and dying became a normal, almost acceptable event. . . . Who could bear to look at the children who stood beside the body of their dead parent?" (33). Underneath this disturbing scene two wary boys look suspiciously around, in an illustration bearing affinities with William Sharp's aquatint of child smugglers made for the Limited Editions Club version of *The Wall*. In *Yossel*, a caption explains, "In the ghetto, young people created an alien life style. Stealing and smuggling enabled them to live. If caught, they joined the long line of corpses that exited the walls" (33).

Yossel's memories include ones that could very well have been those of his alter ego, Joe Kubert, considering that the fictional Yossel describes a first, failed attempt by the family to immigrate to America when his mother was pregnant with him—an actuality for the Kubert family. Yossel, the son of a kosher butcher, like Kubert, records his interest in re-creating the prehistoric world in comics and someday making American comic strips, which Kubert did vis-à-vis his character *Tor* before moving on to his celebrated war comics. The young Pole draws heroes and superheroes, but unlike the golem-like Superman, who saves the Warsaw Ghetto inhabitants in *Superman: The Man of Steel*, no. 82 (1998), no otherworldly being saves Yossel. Nonetheless, those same superheroes keep Yossel alive longer than many other Warsaw Jews, including his parents and sister, who are deported and killed in the camps, because Nazis exploit the young artist's talent for their own enjoyment. Yossel even adopts those "superhero" powers as a Warsaw Ghetto resister who takes information that he hears while drawing at Nazi headquarters back to the partisans, led by a fictional Mordecai, another comics homage to Mordecai Anielewicz. Later, Yossel plants two grenades in the Nazi police building and participates in the uprising—a revenge fantasy realized on behalf of a rabbi who, after his daring escape from the camps, met his death by hanging in the ghetto. In a dream, the real-life ghetto inhabitant Bak imagined himself as a superhero of sorts, a figure who gained protection because of his ability to become invisible and consequently felled four Germans. Bak, though, does not wake from his dream as a conqueror of Nazis, but as a child who has drooled on a clean piece of paper intended for a sketch, "the only testimony," he recalled, to his "superb act of heroism."[41] As in Kubert's fictional story, wherein he "would dream that my characters came to life and I was with them" (13), a superhero rescue is not to be. Instead, and unexpectedly, after delineating the dramatic action of the insurrection through strong angles and skewed perspectives in the manner of his war comics, Kubert dramatically kills his surrogate in the book's final pages.

With the resistance in full swing, in part initiated by Yossel's brave actions, the young artist describes being hit by a bullet, with pressure akin to his rabbi's "jabbing me with his finger to make a point in learning Torah" (118). The last three pages reveal Yossel's death. Kubert allots a full page to Yossel's fading consciousness; he draws Yossel's head six times, lolling backward with his eyes losing focus as he slowly dies (fig. 68). The book's final page does not show a prostrate or bloody Yossel, but a full-page piece of sketch paper (fig. 69). Poignantly, Yossel's drawings do not cover this page. The paper is devoid of imagery, like the empty scraps littering Bak's *Self-Portrait* and the blank canvas within it, just as Yossel is now devoid of breath. Kubert stuns the reader as he kills off his child hero, but in the end, although they may take different tacks—by saving a fictional child, because death would be too

Fig. 68 Joe Kubert, *Yossel:
April 19, 1943,* 2003.
Reproduced by permission
of the Joe Kubert Estate.

Fig. 69 Joe Kubert, *Yossel:
April 19, 1943,* 2003.
Reproduced by permission
of the Joe Kubert Estate.

painful, or by showing a child's misery and even destruction to forcefully bring home
the costs of the Holocaust—Kubert and the other artists and writers discussed so far
confirm that a child, as Ringelblum wrote, is most emphatically the holiest thing.
To put it another way, Kubert turns the idea of the saving remnant on its head by
not saving the child. By eschewing the redemptive narrative and serving the reader
the worst possible outcome, Kubert thus renews the ever-present ache of children
lost—of saving remnants that will never be.

John Hersey employed both approaches in *The Wall,* using children as both
a symbol of hope and a signifier of all that was lost. David Apt provides the trace
of redemption with his flight from the ghetto and possible survival. But close to
the denouement of the novel, Hersey, who was interested in conveying multiple
facets of the Holocaust's drama, pens a devastating incident that unapologetically
deprives readers of any affirmation. Near the end of revolt, with a hundred or so
remaining fighters in the bunkers, Rutka and Mordecai's baby, Israel, cries, at which
point fellow insurgent Yitzhak smothers him to death to keep him from alerting
the SS to the partisans' escape. Hersey briefly rekindles our hope when conveying

Rutka's resilience. Rutka tells Noach Levinson that when she regains her strength, she plans to have another child: "This possibility alone makes me optimistic." Levinson questions why she would be in a hurry to give birth: "Haven't you seen what can happen to Jews?" he asks. Still under fire, Rutka responds, already planning to renew the Jewish people: "Can't you see that that is exactly the reason?" (613). But then Hersey strips us of our relief, however muted, one last time. Post-uprising, when in the sewer awaiting word that the survivors can exit safely, Levinson receives news of a young girl near the back of the line: she had endured typhus and escaped from the *Umschlagplatz* but died a subterranean death. Levinson reflects: "She lived through all the hardships of the ghetto only to die of that horrible disease called waiting. . . . No! Tell me stories of life—of sensation, appetite, lust, zest, and gladness to be alive!" (620; ellipsis in original). Hersey does not let his readers forget that despite the extraordinary effort and courage involved in the revolt, as well as surviving daily life under Nazi rule, his novel remains tragic, as does the Holocaust itself, and the events told within it cannot be abated with false hope.

Source photos, such as that of the Warsaw Ghetto boy, who supplied a rough model for *Yossel,* aided Kubert in his narrative. Four pages before the story ends, Kubert draws Yossel in the clearest portrait of him in the book and only one of five full-length representations (fig. 70). Before then, Yossel mostly appears from the waist up and in the act of drawing, or Kubert concentrates on his weary, concerned face, a technique adapted from the artist's earlier Sgt. Rock stories; these life-or-death battle scenarios stressed the emotional consequences of war through the expressions of Sgt. Rock and other gritty members of the platoon Easy Company, as much as portrayals of war itself. Wearing a knee-length coat and brimmed hat tilted up to his right, his left eye partially shaded, Yossel bears some resemblance to the Warsaw Ghetto boy. Yossel, though, does not hold up his hands helplessly; rather, he is armed and shooting at the enemy, a fantastical act of revisionist history.

Before the 2000s, Kubert, and the genre of war comics as a whole, mostly handled children in the ghetto in a predictable fashion. The survival of Tovah in the *Unknown Soldier*—a child improbably redeemed—was conventional. Yossel's fate was not. None of Kubert's narrative and artistic decisions, however, is entirely unanticipated, considering the period in which he made *Yossel* and maybe also his

Fig. 70 Joe Kubert, *Yossel: April 19, 1943,* 2003. Reproduced by permission of the Joe Kubert Estate.

audience—although, even in his earlier work, he did not always follow his retrospective assessment that children were unprepared for the depravity of the Holocaust and should be spared explicit scenes. In *Yossel,* unleashed as a graphic novel after the turn of the century, exactly sixty years after the uprising, Kubert felt emboldened to do something different. No doubt his resolve was partially affected by working in a darker comics universe, one inhabited by such bleak comics as Alan Moore and Dave Gibbons's *Watchmen* and Frank Miller's *Dark Knight.* It would have been inauthentic to let Yossel live; in 2003 one was allowed to write a graphic narrative where no one gets out alive. Perhaps as relevant, Geoffrey Hartman points out, is that viewers and readers, bombarded with Holocaust imagery and other traumatic events shown by the media, have become desensitized, even partly deadened, to what was once the emotional power of the Holocaust.[42] To counter that effect, there has been an escalation of the Holocaust's grotesqueries in art, in an attempt to revive the shock to which audiences have been inured by overexposure, perhaps in an attempt to thwart that numbing. Kubert's *Yossel* pictures a litany of terrible details, and what more could the artist do to reanimate our horror than startle us by allowing the death of his child protagonist/alter ego?

Kubert's identity as a Polish immigrant who could easily have been a victim of Nazi genocide certainly helps to account for his personal and sustained foray into Holocaust subjects, as does his life's work in war comics. That he was able to imagine his surrogate dead confounds and may offer an example of survival guilt—but then again, how can anything surrounding the Nazi's killing program really make sense? Much has been written about the children of Holocaust survivors, and their experiences have been explored in sequential art; for instance, in Bernice Eisenstein's *I Was a Child of Holocaust Survivors* (2006) and in Art Spiegelman's seminal *Maus* (1986 and 1991), a metanarrative that became one of the most distinguished artworks about the Holocaust and triggered interest in graphic novels on Jewish themes.[43] Interspersed with his father's memories of his incarceration in Polish ghettos and camps are present-day images of Vladek Spiegelman narrating the story to his son, along with the younger Spiegelman's thoughts about creating his project. Spiegelman's attempt to share his father's tale and make sense of the legacy of the story for his own life, a generation removed from the war's consequences, exemplifies the concept of postmemory. According to Marianne Hirsch, who originally developed the principle while reading *Maus,* postmemory "characterizes the experience of those who grow up dominated by narratives that preceded their birth, whose own belated stories are evacuated by the stories of the previous generation shaped by traumatic events that can be neither understood nor recreated."[44] Eva Hoffman terms the children of survivors, of which she is one, the "hinge generation," a fitting

222

The Warsaw Ghetto

characterization for a generation in which "received, transferred knowledge of events is transmuted into history, or into myth."[45] The cover of Eisenstein's memoir vividly relays the author's second-generation, or hinge-generation, experience (fig. 71). In other words, the cover reveals the extent to which her parents' ordeal informs her identity. Against a blood-red background, a black-and-white portrait of Eisenstein as a child does not cast a shadow; instead, Eisenstein's parents provide the dark shadows behind her tiny body.[46]

As a child who barely sidestepped Nazi tyranny, Kubert occupies a unique position: not a survivor, like Bak, with his own lived memories, nor a direct descendant of the first generation, like Spiegelman or Eisenstein, but a man more closely linked to the war's disastrous consequences than the average American. Since her initial understanding, Hirsch has extended her construction of postmemory to include those without familial connections: "It is a question of adopting the traumatic experience—and thus also the memories—of others as experiences one might oneself have had, and of inscribing them into one's own life story."[47] Kubert turns Hirsch's observation on its head. In *Yossel*, Kubert did not adopt the traumatic memories of others into his life story. To put it plainly, he literally and artistically inscribed portions of his own life story into the Holocaust. The trauma and fate of the Jewish people, and especially those trapped in the Warsaw Ghetto, became an enduring concern for Kubert, who took the burden of the Holocaust on as his own, even problematically, to the point of identifying with his main character.

Transmitting through the comics' medium an experience he might have had, Kubert personally confronts the Nazi genocide and the central trauma of the twentieth century. In doing so, he becomes part of a collective that Geoffrey Hartman terms "witnesses by adoption" and a member of "the family of victims." Hartman asserts that while these so-called witnesses "cannot testify with the same sense of historical

Fig. 71 Book cover of Bernice Eisenstein, *I Was a Child of Holocaust Survivors*, 2006. Used by permission of McClelland & Stewart, a division of Penguin Random House Canada Limited.

Joe Kubert

participation [as survivors], for it did not happen to *them* . . . [t]his does not lessen . . . a moral and psychological burden."[48] Gary Weissman dubs this group "nonwitnesses," including those who engage extensively with the Holocaust but did not themselves experience it or directly connect through close personal ties.[49] According to Weissman, paramount for some nonwitnesses is a desire to immerse themselves in the Holocaust in the most immediate manner, to "actually feel the horror of what otherwise eludes them."[50] "For these nonwitnesses, the problem is not that the Nazi genocide is 'too horrible' . . . but that the 'threshold of revulsion' is set at too great a distance from the Holocaust," and therefore their efforts to make this connection can be excessive.[51] During the research phase of *Holocaust Project,* Judy Chicago engaged in the kind of extreme behavior that Weissman describes as a nonwitness's desire to experience the ineffable bestiality of the Holocaust in the most immediate manner possible. She spent more than two months in Europe and toured more than a dozen camps. At the Natzweiler concentration camp in France, Chicago climbed into a crematorium oven and lay inside it, had herself photographed there, and later reproduced the image in the published journal chronicling her experience of creating *Holocaust Project.*[52]

Kubert's Post-Holocaust Fantasy at Its Most Extreme

Kubert's Holocaust "experience" physically and historically eluded him, but emotionally it did not, even if that experience was not at all comparable with that of a survivor. Attempting to work through its resonances, to achieve the sort of "cleansing" he craved, Kubert conceived Yossel, a surrogate by name and partial biography, who enabled the artist to insert himself into the Holocaust in a post-Holocaust fantasy (to borrow another of Weissman's descriptors). For Kubert, though, that was not enough. In his "what if" scenario, Kubert inserts into the ghetto not only himself, but, in one deft splash page midway through the narrative—after a rabbi who has escaped the camps arrives in the ghetto to tell of his ordeal—the reader as well. At the same time, the rabbi's excruciating account (for which the aforementioned issue of *Blitzkrieg,* in which a camp escapee sneaks into the ghetto, serves as a precedent) offers an excellent example of a nonwitness's wish to partake of the Holocaust's assaults in extreme fashion—akin to earlier examples in Serling's "Escape Route" and Reznikoff's *Holocaust.*

Thirty-eight pages (39–76) are dedicated to a rabbi's didactic recitation of the death camps' horrors, his untenable position in the gray zone as a *Sonderkommando* at Auschwitz, and his loss of faith—a loss with which Bak struggles. The rabbi's

extensive dissertation stuns the reader in its unrelenting detail. He tells of deportation and cattle cars in which "babies suffocated" and the stench overwhelmed him (40); the selection and treatment of prisoners; and details of the barracks, down to dimensions. A full page attempts to convey the scope of the mass killings by channeling one of the most difficult exhibits at the United States Holocaust Memorial Museum. Kubert depicts a mountain of shoes, but he takes this further by also showing piles of hairbrushes and combs, luggage, glasses, and bundles of hair (51). Visually engaging with these objects, translated in Kubert's graphic narrative from authentic displays into artistic representations, causes disquiet, but obviously not as powerfully as the much larger actual piles of shoes at the museum, which overwhelm in size as well as stench. The museum's literature employs the shoes in their collection to similar effect. One museum guide cover features a photograph of a pile of dirty, discarded shoes, presented in a close-up detail tilted on an angle so that, disturbingly, the mound of shoes seems to spill into the reader's space. Because Kubert's shoes are in graphic-novel form, we cannot react to their smell or the physical reality of them before our eyes, but we still feel relatively besieged by his depiction because he has augmented the types of objects to signal the enormity of Nazi plunder. Similarly, the miniseries *Holocaust* vividly portrayed for its vast audience unthinkable acts to demonstrate the ruthless barbarity of the Nazi genocide, at times pushing the limits for network television. In one scene, dozens of naked prisoners are shot and fall into a pit, lying in bloody piles of twisted limbs, and in another, Nazis pitilessly burn to the ground a synagogue filled with Jews, amid strident screams of fear and agony.

Just when the rabbi in *Yossel* thought things could not get worse—for he does not share the remorselessness of Stefan Mazur, a member of the Jewish police in *The Wall*—he witnessed the gas chambers, peering through a peephole (readers are not privy to what he saw): "How can I describe what I saw? People were being gassed, murdered. Some crawled over one another in an attempt to breathe. It was horrific. Revolting. . . . Bodies everywhere locked in a struggle with death" (58, 60). Near the end of the rabbi's narrative, Kubert gives readers a break from the camp's specific terrors, but the break provides no relief. Occupying the center of a page, with only one small additional drawing in the upper right corner so as not to distract the reader from this emotive moment, the rabbi covers his face with oversized hands (fig. 72)—as if the larger his hands, the better he can shield himself from the torturous memories that gut him, a pose Kubert uses in several portraits of the rabbi (46, 63).

With his head bowed in sorrow, his faith eroded by his Nazi oppressors and the sickening actions that he has seen and undertaken, the rabbi despairingly utters: "Rebbe no more. No more Torah. N-no more teaching. I have seen things . . . d-done things. I have learned. There is no God" (77). Just as wrenchingly, in one of the earlier

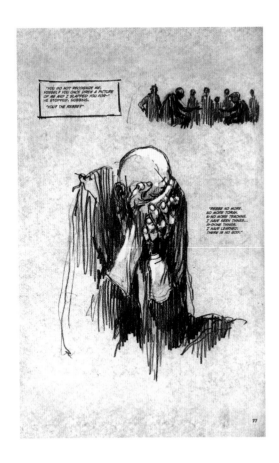

depictions of the rabbi covering his face and head in misery, he similarly states: "God had forsaken us, leaving only pain and no salvation. There was no God" (46). Body language throughout *Yossel* communicates the high anxiety and tension of the story, but in these expressionistic renderings of the rabbi's disillusionment, his agony reaches its nadir, bearing affinities with the pose of a figure in the far right background of Auguste Rodin's sculpture *The Burghers of Calais* (1884–89; fig. 73), an icon of fatalism and resignation that commemorates a different city under siege.

In subject and form, another potent comparison can be made with Ben Shahn's serigraph *Warsaw 1943* (1963; fig. 74), prompted by a drawing originally conceived for a competition commemorating the Warsaw Ghetto.[53] As opposed to Shahn's ambiguous painting *Boy* (see fig. 52), this work on paper explicitly memorializes the ghetto, the Holocaust, and the loss of six million Jewish lives. Rendered in black and brown, with a few precisely and effectively rendered lines, *Warsaw 1943* portrays a distraught figure from his waist up. He covers his face and head with oversized hands that—if read as those of a ghetto fighter—display remarkable courage and appear strong, but in reality could only offer a meager defense. In an effort to disappear, to escape from the sorrow that consumes him, the man hunches his shoulders, clenches his hands so tightly that his tendons show, and bows his head.

A thirteenth-century Yom Kippur prayer from the Musaf service, called the "Ten Martyrs' Prayer," appears in Hebrew below Shahn's anguished man: "These I remember, and my soul melts with sorrow, for strangers have devoured us like unturned cakes, for in the days of the tyrant there was no reprieve for the [ten] martyrs murdered by the government." Ziva Amishai-Maisels observes that Shahn purposely omitted the word "ten," which in the original refers to Hebrew martyrs killed in the second century by the Romans at the behest of Emperor Hadrian, to make the quote appropriate for Holocaust remembrance.[54] Clearly inspired by the poses in these well-known precedents, Yossel/Kubert's vital portrayal of the rabbi provides a capstone to the broken man's shocking revelations, which have been punctuated by equally shocking images of death, torture, and the results thereof: piles of bodies, a boy being electrocuted by a barbed-wire fence during a failed escape, and the exterminated inside a gas chamber. The rabbi puts all of his devastating recollections in

Fig. 72 Joe Kubert, *Yossel: April 19, 1943*, 2003. Reproduced by permission of the Joe Kubert Estate.

226

The Warsaw Ghetto

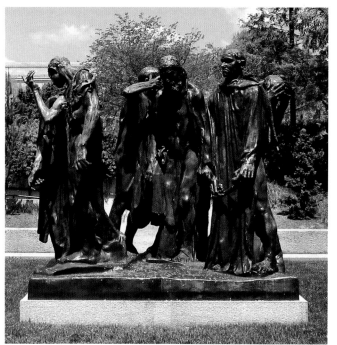

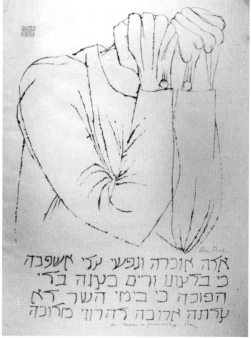

אֶלֶה אֶזְכְּרָה וְנַפְשִׁי עָלַי אֶשְׁפְּכָה
כִּי בְלָעוּנוּ זָרִים בְּעֻנָּה בְּרִי
הֲפוּכָה כִּי בִּימֵי הַשָּׂר דָּא
עָרְתָה אֲרֻבָּה לַהֲרֹזֵי מְלוּכָה

the hands of an artist, but also a child who, like Janina Bauman, Mary Berg, and the other children of the Holocaust, saw and experienced—in their most precious and vulnerable years—more than any human should.

Seven pages in *Yossel* are allotted to a single vignette, including the afore-mentioned splash page, which places the reader into the story by way of Kubert's foreshortening technique (fig. 75). Recording the rabbi's words in his sketches, Yossel shows him surrounded by heavy shadowing and standing in front of the arched furnace door of the camp's oven, dismayed and looking hollowly at the reader. This disconcerting scene situates the reader inside the oven, as if they were the reader's feet facing the rabbi, the reader thus a dead, soon-to-be-incinerated Jew. Distraught, the rabbi laments, and notice his special mention of children: "How many bodies did I carry to be incinerated? How many children? How many had I prodded into the furnace? I lost count. And how was it that I continued to live while so many others died?" (62). Most of the drawings in *Yossel* sprawl into the reader's space, pushing off the pages of the book, but only this one incident fully extends into that space. Making striking use of foreshortening, the image positions the viewer in a specific place known as the station point. Kubert exploits this technique to create an unsettling station point: supine on a slab, we look past our own feet to see the rabbi—who as

Fig. 73 Auguste Rodin, *The Burghers of Calais*, 1884–89. Bronze, 6 ft. 10 ½ in. × 7 ft. 11 in. × 6 ft. 6 in. at the base. Hirshhorn Museum and Sculpture Garden, Washington, D.C. Photo: Wikimedia Commons (AgnosticPreachersKid).

Fig. 74 Ben Shahn, *Warsaw 1943*, 1963. Serigraph with black and brown calligraphy, 33 ½ × 23 ½ in. Art © Estate of Ben Shahn / Licensed by VAGA, New York. Photo provided by VAGA, New York.

Joe Kubert

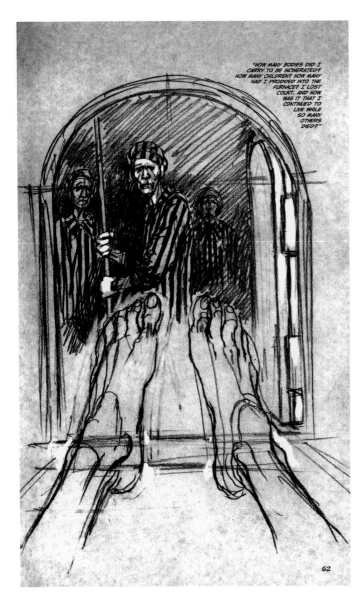

Inside the image: "HOW MANY BODIES DID I CARRY TO BE INCINERATED? HOW MANY CHILDREN? HOW MANY HAD I PRODDED INTO THE FURNACE? I LOST COUNT. AND HOW WAS IT THAT I CONTINUED TO LIVE WHILE SO MANY OTHERS DIED?"

Fig. 75 Joe Kubert, *Yossel: April 19, 1943*, 2003. Reproduced by permission of the Joe Kubert Estate.

a *Sonderkommando* was forced to destroy corpses in the crematoria—framed in the doorway of the oven.

Kubert's drawing evokes Andrea Mantegna's dramatic foreshortening in his painting *Dead Christ* (ca. 1480; fig. 76), with Jesus's feet prominently in the foreground. Kubert turns Mantegna's image inside out; the viewer is not only a dead Jew, he or she is also the dead Christ, the prototypical martyred Jew—a trope Bak frequently plays on in the Warsaw Ghetto boy series when showing the boy crucified with stigmata. Likewise, Kubert calls upon the tradition of the "Jewish Jesus," engaged, too, by Arthur Szyk in his print *De Profundis* (touched on in chapter 1). The rabbi holding the pole in Kubert's drawing also warrants comparison to those Romans holding lances in many images of the crucifixion composed during the Renaissance and the Baroque periods. Finally, just as Bak comments on the universality of hatred through his blank or gaping-faced Warsaw Ghetto boys, in this critical page Kubert makes a statement about the consequences of prejudice by offering a faceless, genderless victim, thereby enabling any reader to assume its identity and consequently its fate. Rod Serling similarly uses this ploy when he refers to an SS officer as a monster and "it" in his narrated teaser for "Deaths-Head Revisited" (described in chapter 2).

The extermination of children, the next generation, provided a major focus of the Nazi plan to remove Jews from the face of the earth. Most of those children that lived—because of the *Kindertransport*, their concealment as Christians, or the luck that Bak extols—were orphans who suffered unfathomable trauma. Nevertheless, their unlikely survival provided a much-needed legacy of reassurance for the Jewish people. Symbols of innocence and redemption, children no doubt afforded hope for

regeneration. As shown above, a number of cultural responses to the Holocaust have exploited this simple notion, a triumph of sorts, however hollow it may be, which makes Kubert's *Yossel* curiously anomalous. Here is an artist struggling to come to terms with his existence because of his family's fortunate immigration prior to the rise of Nazism. Not a child survivor, Yossel instead becomes a child hero—an active, valorous Jew—who helps set into motion the resistance, a movement that provided its own sign of hope to both persecuted European Jews caught in the "maelstrom," to use Kubert's words, and concerned American Jews across the ocean. The paradox here cannot be overstated; the resistance and

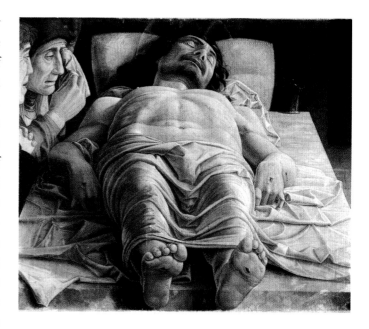

Fig. 76 Andrea Mantegna, *Dead Christ,* ca. 1480. Tempera on canvas, 27 × 32 in. Pinacoteca di Brera, Milan. Photo: Wikimedia Commons (Pethan).

courage of the fighters against all odds afford an overdetermined myth that elides its catastrophic outcome, because all hope, and most life, was still quashed. The problematics of the uprising's counternarrative are aptly communicated by survivor Primo Levi's broader observation: "A memory that is evoked too often, and expressed in the form of a story, tends to become fixed in a stereotype, in a form tested by experience, crystallized, perfected, adorned, installing itself in the place of raw memory and growing at its expense."[55] For political purposes, Israelis stubbornly cling to the idealized uprising as a badge of honor and strength, whereas Americans, even though their depiction of the rebellion does frequently demonstrate the triumph of strength over weakness, more often see how and why the ghetto's story defies such stereotypes.

Superman and the Warsaw Ghetto Boy Revisited

The Warsaw Ghetto boy appears, yet again, in 1998, in the unlikeliest of projects. Mentioned cursorily above, *Superman: The Man of Steel,* no. 82, a historical retelling of the good-versus-evil paradigm found in traditional superhero comics, sends Superman and Lois Lane back in time to the Warsaw Ghetto, where they encounter this atrocity from the past.[56] Drawn by Jon Bogdanove and cowritten by Bogdanove and Louise Simonson, three issues of the *Man of Steel* (nos. 80–82) address

229

Joe Kubert

neo-Nazism, anti-Semitism, Nazism, and the predicament of Jews within the ghetto. Their publication purposefully coincided with the sixtieth anniversary of Superman's debut, and the storyline itself pays homage to the Jewish roots of Jerry Siegel and Joe Shuster, the character's creators and the Cleveland-raised sons of Jewish eastern European immigrants. These high-profile commemorative issues feature not only a Jewish story, although somewhat veiled, but also Superman's descent into war-torn Europe. It bears noting that Superman and other superheroes participated in the war, so to speak, almost as soon as the genre premiered. On the classic cover of the first issue of *Captain America* (March 1941, no. 1) our hero unceremoniously punches Hitler in his face, and in a 1942 issue Superman stands atop earth with a squirming Hitler in one hand and Emperor Hirohito of Japan in the other (July–August, no. 17).

Following a confrontation with neo-Nazis in Metropolis in issue no. 80 ("The Superman vs. The Atomic Skull"), the next installment, "Superman in the Ghetto," swiftly finds Superman in war-torn Europe and in the company of two Jewish children (and a resistance fighter unsurprisingly named Mordecai), modeled on Siegel and Shuster, musing on their chances for survival. While the figures are never identified as Jewish (remember *Blitzkrieg*), which caused controversy, clues to their identity are numerous, making it obvious that the unspecified perpetrators are Nazis even though they, too, are not explicitly identified. For example, the two boys have discernibly Jewish names: Moishe, a writer, and Baruch, an artist, imagine a supernatural man who will save them. This attitude contrasts with the dogged Jewish mind-set underscored in earlier ghetto representations, which did not fix on a miracle as much as a heroic, albeit fruitless, resistance effort; *Man of Steel* takes place before the uprising and consequently does not tackle resistance efforts or the fight. Such thoughts, though, come more naturally to children, who relied on their imaginations to save, or at least assuage, them during the Holocaust. In Kubert's *Yossel,* before the eponymous boy takes up arms, he draws superheroes. Yossel picks up his pencil to "disappear," as he writes, from the world in which he is living, and even fantasizes about his "cartoon heroes. Flash Gordon. Tarzan. . . . The Phantom. . . . Strong and powerful. They could beat the Nazis. They could take us from this awful place" (19). Baruch and Moishe's "angel" looks conspicuously like Siegel and Shuster's Superman, wearing a cape and tights and surging through the air in a pose approximating Superman's.

By the third installment, "Superman Breaks the Wall!," readers have been spared little: piles of corpses, deportation, starvation, and typhoid all receive attention in both word and image. In one panel an emaciated girl contemplates eating a dead horse, recalling the episode in Hersey's *The Wall* as well as Millard Lampell's theatrical adaptations. This final issue's opening interlude has Superman rescuing haggard

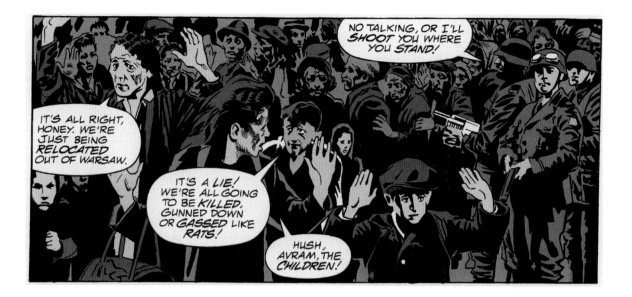

Fig. 77 Jon Bogdanove, "Superman Breaks the Wall!," from *Superman: The Man of Steel* 1, no. 82, 1998. Reproduced with permission of Jon Bogdanove. All characters © DC Comics.

deportees trapped in a boxcar. He learns from Lois Lane, who was also imprisoned in the boxcar, that the Nazis are planning, without mincing words, a "Final Solution . . . [a] brutal comprehensive plan for Genocide!" (4). Soon thereafter, the reader confronts figures from the *Stroop* photograph, stretched horizontally across an entire page, including the Warsaw Ghetto boy and his mother in the foreground, the mother and daughter at the left of the photograph, and the two children at the back (fig. 77). Inker Glen Whitmore colored Jon Bogdanove's pencil drawings of these six figures in more vivid hues than the nearly monochrome masses in the background, who are uniformly shown in deep blues and grays. Bogdanove singles out all four of the children and the mothers who accompany them, as well as two of the soldiers at the far right. Four Stroop photograph figures are given voices; the mother at the far left reassures her daughter: "It's all right, honey. We're just being relocated out of Warsaw." The older boy has been given the name Avram, the name of the first Jew. Avram counters: "It's a lie! We're all going to be killed, gunned down or gassed like rats!" The Warsaw Ghetto boy's mother exhorts Avram to hush, concerned about what "the children" may overhear. A lone soldier, also colored as if he were true to life, warns: "No talking, or I'll shoot you where you stand!"

Bogdanove researched this story arc extensively, aided by an associate at the United States Holocaust Memorial Museum. He purposely quoted some of "the more moving images that really stuck with me, like the boy's photograph," and Bogdanove, as clearly demonstrated, is not alone in his attraction to this photograph. Understanding Superman as Siegel and Shuster's wish fulfillment, Bogdanove contends that the first superhero was born of "an adolescent impulse and power fantasy.

Superman was very much shaped by two Jewish boys powerless to help their people in eastern Europe. After thousands of years and then current goings-on in Europe, here were two Jewish kids tired of waiting to be free."[57] Bogdanove engages in his own wish fulfillment in this issue, easily allowed by the very nature of comics and by most who know of the Holocaust and its tragic history. The Warsaw Ghetto boy and his companions have been liberated from the black and white—given color and temporarily brought to life with their own voices, even if those voices register fear.

The plight of children in Nazi-dominated Europe and the ruthlessness of the Nazis pervade "Superman in the Ghetto!" and "Superman Breaks the Wall!" In the former, after Superman arrives in Poland, he passes through a decimated shtetl where he sees a distraught father clutching his dead son. Two soldiers loom over the heartbroken man, and one mockingly says: "Why the tears? Is it not an honor to visit your old hometown, to bury your own dead?" In a speech bubble with jagged edges to emphasize his pain, the father cries, "But—this—is my son!" (7). A second smiling soldier replies, "Well, you no longer have to worry about what sort of man he will grow to become!" The soldier unceremoniously shoots the father and kicks him and the son into a deep mass grave. In another episode, a scrawny child realizes that her brother is the baby now dead in the arms of her mother, and the mother can offer no comforting words: "Hush, child, I can no longer feed him. All we can do now is let him sleep" (9). In "Superman Breaks the Wall!," a smaller panel underneath the *Stroop Report* imitation pictures a figure begging a gun-wielding soldier to spare the children (5). On the adjacent page, a sadistic Nazi catches a mother clutching her infant to her breast. Wrapped in purple, the baby melds into its mother, who wears a purple top, each an extension of the other. Wielding a pipe that he intends to smash over the mother's head, the soldier taunts her as he prepares to beat her: "You cry so bitterly—after such a bit of fun! If life is so terrible for you, little mother—I can solve your problems!" (6).

The story reaches a crescendo in the final issue's last panel depicting the Warsaw Ghetto, before Superman and Lois Lane return to Metropolis (fig. 78). Superman, with Lois Lane at his side, marches out of the ghetto with dozens of dazed Jews behind him. He cradles a sleeping rescued child in his arms, flanked on his left by Moishe and Baruch and on his right by Lois Lane. Completing the front of the pyramidal grouping, the mother who was viciously beaten carries her infant wrapped in purple. These central figures, along with Moishe and Baruch's grandfather and a middle-aged man with a child riding on his shoulders, are colored in various hues, whereas the masses behind this group are shaded a monotonous blue, suggesting their anonymity in the eyes of Nazis (a ploy used by Bak when portraying the Warsaw Ghetto boy as multiple wooden cutouts). This kind of outsider rescue

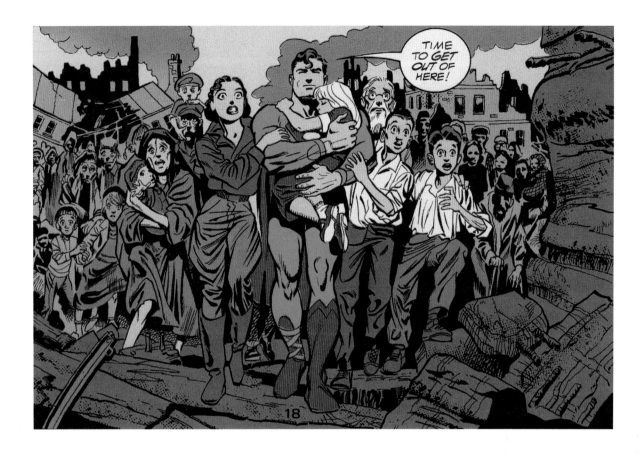

differs from the many cultural representations and reportorial examples already examined. Having an outsider swoop in, literally, to save Jews, who are placed in the victim role, undermines the common standard in ghetto representations and historical constructions of Jews fighting for themselves. When director and Holocaust survivor Roman Polanski decided to address the Holocaust, he opted for a story not about the concentration camps (his mother died in Auschwitz) or militancy but about one man's survival story in the festering, oppressed Warsaw Ghetto. Polanski's movie adaptation of Władysław Szpilman's memoir surely conveys how the pianist's wits, and a great deal of luck, ensured his survival, but his ultimate savior was a German soldier. In one of the best-known of these alternate narratives, *Schindler's List,* another outsider, Oskar Schindler, "swoops in" as a savior to rescue more than one thousand Jews who work in his factory.

An interesting parallel exists between this three-quarter-page panel of "Superman Breaks the Wall!" and a popular American painting by George Caleb Bingham, *Daniel Boone Escorting Settlers Through the Cumberland Gap* (1851–52; fig. 79). Bingham's scene of westward expansion in the 1770s has Daniel Boone leading

Fig. 78 Jon Bogdanove, "Superman Breaks the Wall!," from *Superman: The Man of Steel* 1, no. 82, 1998. Reproduced with permission of Jon Bogdanove. All characters © DC Comics.

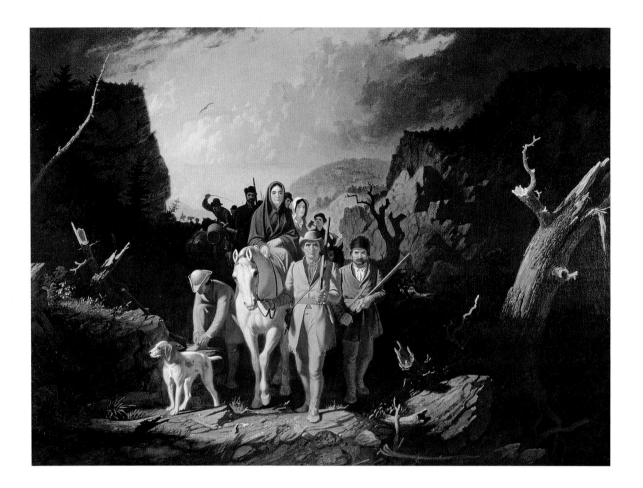

Fig. 79 George Caleb
Bingham, *Daniel Boone
Escorting Settlers Through
the Cumberland Gap,*
1851–52. Oil on canvas,
36 ½ × 50 ¼ in. Mildred
Lane Kemper Art Museum,
Washington University in
St. Louis. Gift of Nathaniel
Philips, 1890, WU 2171.

a group of settlers toward the unknown frontier. This band intrepidly traverses the dangerous terrain, with broken trees and the unrestrained wilderness surrounding them. Scholars by turns interpret the painting as a play on the Flight into Egypt, as recounted in the gospel of Matthew, or Boone as an allegorical Moses figure leading his people toward the Promised Land, as per the book of Exodus. Left unsaid is that Boone's journey was not one of righteousness but was propelled by the prevalent belief in Manifest Destiny—the mistaken belief that white Christian men, because of their superiority, had a God-given right to expropriate land from Native Americans. Convinced that his mission was noble and justified, as was Hitler, Boone and his compatriots wreaked havoc as they unilaterally took away Native Americans' freedoms and homes and in the process created a population of fearful Others—like the Jews in Nazi Europe. Nonetheless, Boone serves as a folk hero in American culture, much like Superman. With Charlton Heston's Moses from Cecil B. DeMille's *Ten Commandments* (1956) firmly in mind, and Bingham's canvas playing on the

periphery, Bogdanove understands his hero solely from a Jewish perspective, not a Christian one, thus interpreting Superman as a Moses figure. Unlike Boone, a frontiersman guiding his people to a life as oppressors in Kentucky's rural wilderness, Superman escorts the Jews of Warsaw from their oppressive urban nightmare to a place of safety.

Bogdanove's quotation of Bingham has Superman striding forward, leading the Jews away from the ruined ghetto in the same formation as Boone and his followers. Smoke from the destroyed ghetto mimics the clouds suffusing the background of Bingham's canvas. A rifle rests on Boone's left shoulder, and a child on Superman's. The broken wall on the right side of the comic panel takes on a rounded form, a most unnatural manmade structure of tyranny, as opposed to the similarly formed unbridled land in Bingham's painting. Particularly striking is a visual analogue near the lower right corner of both images, which speaks to what man is capable of in the name of religion. In the rubble of the ghetto wall, a rocklike, discarded Torah lies on the ground. Representative of the destruction of the Jewish people inside the ghetto, the holy scroll offers a "Jewish" interpretation and response to the broken tree branch, a symbolic cross, on the right of Bingham's painting.

In this late twentieth-century retelling of the ghetto's story, survivors do not find refuge in Palestine, as they wished in earlier ghetto representations like H. Leivick's play and Leon Uris's novel, but in the imaginary American city of Metropolis. The issue's cover shows Superman standing on two sides of the broken ghetto wall, with one foot in Warsaw and the other in Metropolis. He exhorts the few, exhausted survivors: "Just a few feet *more* and you'll be *safe!*" Here, and in most other instances discussed in this chapter, when comics mix with the Warsaw Ghetto, by the end they reveal something about wishful thinking in a most Jewish sense. These endeavors intersect with an outlandish hope for rescue deeply ingrained in the Jewish psyche—traditionally the arrival of a golem, and in the modern era a caped crusader with preternatural powers.

The ghetto child took hold in American culture, particularly in pop culture, from the end of the uprising to the current time—and especially from the seventies onward, when the ghetto no longer *needed* to be a place of armed resistance. The Six-Day War, Israel's other celebrated victories, and the mythic status of the Mossad began to erase the slur of the soft, inferior Jew, replaced with the opposite: the forceful Jewish warrior. Take the cover of *Life* magazine from June 23, 1967, featuring a tanned, handsome Israeli soldier cooling off in the Suez Canal, holding his large assault rifle up to the sky in victory, the same direction in which he gazes (fig. 80). This new Jew, pictured in brilliant color on the oversized cover of one of America's most widely read

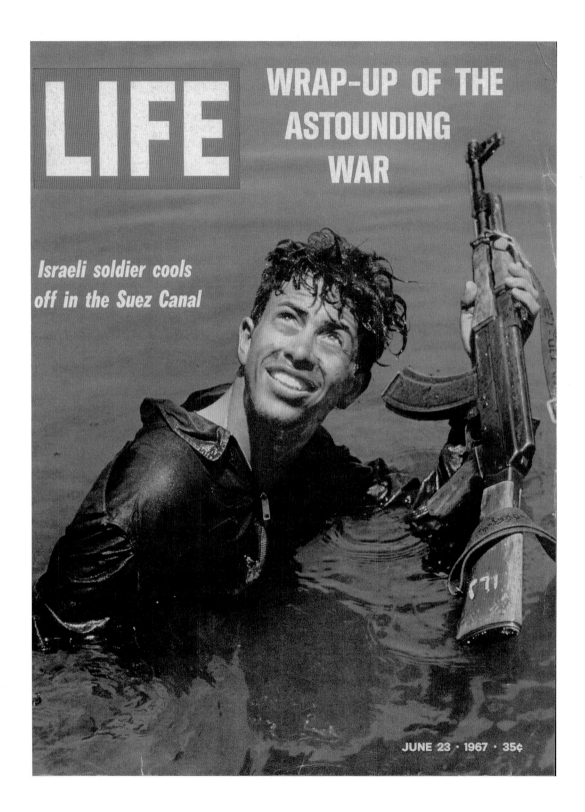

LIFE

WRAP-UP OF THE ASTOUNDING WAR

Israeli soldier cools off in the Suez Canal

JUNE 23 · 1967 · 35¢

magazines, conjures Leon Uris's fictional super-Jews—one cannot help but wonder if the iconic freedom fighter on the cover of *Exodus* inspired the *Life* photographer. With the muscular Jew gaining true currency in America and abroad, the place of the Warsaw Ghetto evolved; it was no longer singularly necessary as a symbol of Jewish strength. The fight adds a dramatic backdrop to some of the works described in this chapter, like Kubert's *Yossel,* whereas for Uris the fight is the raison d'être, and life in the ghetto the backdrop. With abuse, indignities, and persecution mostly in the past, and with the Jew remade, different leitmotifs of the Holocaust and the Warsaw Ghetto could be explored—influenced not only by the time a given work was conceived but dependent on the artist and medium as well. The children of the Holocaust were the lifeblood and future, and their memory and suffering insistently loom in art and history. No, art cannot heal, nor can art, depicting children or otherwise, assuage the trauma of the Holocaust. But it is still worth exploring how and why children's suffering and senseless deaths manifest across media for artists responding to the drumming pain of their stories and the outrage at their stolen lives.

Fig. 80 *Life* magazine cover, June 23, 1967. LIFE logo and cover design © Time Inc. LIFE and the LIFE logo are registered trademarks of Time Inc. used under license. Original photo by Denis Cameron.

I do not ask for any thanks, for any memorial, for any praise. I only wish to be remembered. . . . I wish my wife to be remembered, Gele Sekstein. . . . I wish my little daughter to be remembered. Margalit is 20 months old today. . . . I don't lament my own life or that of my wife. I pity only this little nice and talented girl. She too deserves to be remembered.

—Israel Lichtenstein's last testament, August 4, 1942, discovered in the Oneg Shabbos archive

It was always death that was at stake, not life. . . . All it was about, finally, was that we not just let them slaughter us when our turn came. It was only a choice as to the manner of dying.

—Marek Edelman (1919–2009), member of the Jewish Combat Organization, 1986

Epilogue: "Will the World Know of Us? Will the World Know?"

The Warsaw Ghetto in the United States Holocaust Memorial Museum

On the surface, the reasons that Americans, Jewish and otherwise, cannot resist the resistance are fairly clear. For many, this seminal event—and the uprising can indeed be so characterized, even as overdetermined as it has become—offers a glimpse of hope, misguided as it may be, amid a torrent of despair and horror. Namely, the various repetitions of the uprising, in its purest form of physical, heroic resistance, satisfies a desire, for those who were not there in the abyss, to grasp on to something less horrific than systematic deprivation, torture, and genocide. Those repetitions, though, hold important nuance in their retrospective deployment by cultural producers, politicians, lobbying groups, and others, thereby taking diverse forms and with varying goals.

The uprising engenders feelings of honor, pride, and dignity that go hand in glove with a desperate yearning for the Holocaust to have a different ending. And this explains why children come at the end of my book: not only because, chronologically, the anchoring works of art in the final two chapters fall near the end of the twentieth century but because, logically, the rebels fought in great part for the

children. Surely they fought not only for their own lives but also for the lives of the young innocents and the looming depletion of their future. As Israel Lichtenstein, who helped hide the Oneg Shabbos archive, puts it in the epigraph that begins this chapter: He accepts his own fate but bewails the death that awaits his child, who will never enjoy those experiences of life to which we should all be entitled. Instead she will have those experiences stripped away by unfounded prejudice, scapegoating, and hate rather than a natural death. Some so vehemently desire a different ending within the Holocaust's desolate landscape that the worst parts of the ghetto's insurrection receive airbrushing or are glossed over completely. The rebellion was brutal, fiery, and ultimately deadly for most, but these details are often obscured in the service of heroism and Jewish self-empowerment.

Nonetheless, my book has been about much more than a heroic but futile Spartacan revolt. Representations of the Warsaw Ghetto have been as various as the media in which they have appeared. There have been dozens of "other" Warsaw Ghettos: the pitiable ghetto of smuggling children broken in half by ruthless men, of beaten and humiliated elderly; the ghetto that slowly discloses the bureaucracy of degradation, where walls are first built, then prayer forbidden, and finally deportation instituted. The ghetto has been a conflicted place that permits Jews to behave badly and Nazis to be sympathetic, and a teeming, festering place where starvation and disease run rampant. But then again, the humanity of the ghetto found pride of place in many portrayals; despite punishment by death, the study of Torah continued and was introduced to the children. A good number of the populace participated in self-help organizations and attempted to create beauty through art, music, and other cultural pursuits. Families, by lineage or by circumstance, loved and quarreled, sometimes more deeply and bitterly in light of their dire situation, but in the most sanguine of accounts they remained families to the end.

This is the ghetto's universe, so very distinct from the death camps, and its use in art as a vehicle to uplift, persuade, educate, remember, and even entertain—both in its reality and in its exaggerations—has formed the core of this study. A living community attempting to survive together, not a protracted interment and death, the occupied ghetto tenders a complex environment with greater gradations than the camps and with a varied cast of characters, both true to life—like Mordecai Anielewicz, Adam Czerniakow, and Antek Zuckerman—and imaginary, the surrogates for these figures in fictional re-creations. The ghetto's denizens still *lived* in their confined city, knowing that they might die, while those in the camps accepted imminent death as almost a foregone conclusion. The ghetto's fleshed-out personalities provide an opportunity to mourn individuals and the loss of ordinary life, a scenario so much more relatable for the average American than the atrocity of

the camps and their relative anonymity—and audience identification has played an important role in the reception, positive or negative, of some of the creative works described above.

In part, I have contended that the Warsaw Ghetto's meaning in American culture, revealed in how its story has been told and retold, is indicative of Jewish American identity, aspirations, and needs at a particular time and place. Such shape-shifting comports with James Young's astute observation: "Memory is never shaped in a vacuum, and the motives of memory are never pure."[1] Indeed, by taking one event in human history and looking at its impact across creative pursuits, this book has demonstrated that the Warsaw Ghetto possesses many faces in America, enabling different artists' purposes and media, depending on the climate in which attendant cultural representations were made. Even amid these differing ghettos, certain referents persist and resonate. The Warsaw Ghetto boy comes to mind most readily, but also the smuggling child, as well as the parent and child holding hands in a vain attempt at protection and reassurance. Across media, the exhausted and resigned trudging crowd moves into the ghetto or leaves for the *Umschlagplatz*. There is the friction between the pious Torah Jew and the secular fighter, often a Zionist—also divided, typically, as the older generation versus the younger one. At times this older-younger generation juxtaposition takes the form of the compliant Jew versus the defiant Jew—that is, the Adam Czerniakow type versus the Mordecai Anielewicz type. On occasion, a tangible symbol of defiance, in the form of a partisan flag, appears among the ruins of the ghetto. That tattered flag, perhaps emblazoned with a Star of David, is a fleeting assertion of strength before the Nazi juggernaut quashes the uprising. And if a maker perceives the importance of animating a ghetto account with a hopeful sign, he or she may introduce the problematic saving remnant: a child who survives to bring forth a nation nearly destroyed.

A vocabulary of Holocaust iconography, as per the visual, or motifs, as per literature and other media, has been identified by past scholars, but that vocabulary is primarily one of the camps, in particular that of Auschwitz: cattle cars, the *Arbeit Macht Frei* gate, barbed wire, railroad tracks, piles of shoes, tattooed arms, and the crematorium chimney.[2] Oren Stier has usefully coined the term "icons of memory" to identify symbols and objects familiar to viewers because of their frequent association with the Holocaust, and is especially concerned with the afterlife and sacralization of related material objects in museums.[3] Barbie Zelizer terms so-called iconic images "signposts" that "help stabilize and anchor collective memory's transient and fluctuating nature in art, cinema, television, and photography, aiding recall to the extent that images often become an event's primary markers."[4] I find both of these considerations valuable but prefer to designate the recurring symbols in my study

referents, as I have done above, rather than icons or signposts, because I believe they retain a referential status specific to the Warsaw Ghetto. In other words, Stier's and Zelizer's "icons" and "signposts," respectively, more often stand for the atrocity of the death camps, which, while powerful and very relevant, do not exemplify the full range of the Holocaust. This project has more specifically identified the recognizable referents of the Warsaw Ghetto and looked at their deployment in American culture. Sometimes such referents do become shorthand, or signposts, for the major themes of ghetto life, distilled to their essence as heroism, hope, despair, family, squalor, tyranny, cruelty, and humanity. Stier's icons primarily denote objects (save for Anne Frank) or an idea (the number six million), whereas in the ghetto, which allows for the introduction of a vital human element, referents—in my formulation—comprise emotions, people, and actions as well. A share of the Warsaw Ghetto's referents, as discussed in the cultural productions in this book, can be found in the United States Holocaust Memorial Museum's permanent exhibition. I now want to look briefly at how the museum converses with the Warsaw Ghetto as already examined in these pages. In many respects, the museum's core exhibition serves as the culmination and institutionalization of the threads that run through my book—but it also subverts them.

The United States Holocaust Memorial Museum's presentation of the Warsaw Ghetto and its rebellion to a vast audience reveals the importance of the ghetto in its American conception, confirmed by the many creative incursions detailed in these pages. As explained in chapter 4, museum visitors enter the building into the four-story Hall of Witness, and the permanent exhibition occupies three floors: on the fourth level, "Nazi Assault: 1933–1939"; the middle level, "The 'Final Solution': 1940–1945"; and the second level, "Last Chapter." Most relevant for this analysis is the third floor, "The 'Final Solution': 1940–1945." Recounting the establishment and subsequent experience of ghetto life and the evolution of the concentration camps through artifacts, photographs, film, and audio, this middle level—in addition to other areas of the museum—pays disproportionate attention to the Warsaw Ghetto and its resistance efforts (I write this as a matter of fact, without any judgment). The museum's website describes the floor in a telling summary statement: "Highlights include efforts to preserve the evidence of Jewish life under Nazi rule, armed resistance in the Warsaw ghetto uprising, and the legacy of Anne Frank."[5] The Warsaw Ghetto's resistance effort has offered a "highlight" since 1943, as this study has established. And the story of Anne Frank has loomed large in American consciousness, beginning around the time that filmic and theatrical adaptations were being produced from her diary.

Entering the third floor, visitors first encounter a small presentation about Anne Frank's life (as detailed in chapter 4). The floor's central exhibition begins

Fig. 81 United States Holocaust Memorial Museum, third floor. Photo: Edward Owen.

after emerging from that nook, whereupon the visitors find underfoot cobblestones that once paved the Warsaw Ghetto. Next comes a narrow, claustrophobic bridge of wooden planks, bordered on each side by wall-sized photographs of groups of Jews in the crowded ghetto, augmenting the sense that the museum visitor has been transported to the moment (fig. 81). A photograph on the left side depicts masses of the Warsaw Ghetto's residents, and on the right, the Lodz Ghetto's inhabitants. Flanked by these photographs, one heads directly toward a glass enclosure behind which stands an eight-foot-tall, thirty-five-foot-long cast of the Warsaw Ghetto's largest remaining wall. Within the enclosure, positioned in front of the wall, sits a milk can once used to house part of the Oneg Shabbos archive (fig. 82), which, as already noted, serves as an authoritative source of information about the ghetto and affords one of its most lasting legacies.

Jeshajahu Weinberg, the museum's founding director, characterizes the milk can, recovered in the 1950 excavation, as "perhaps the Museum's most important historical artifact," and the manner in which it is displayed confirms this perception.[6] Lit from above, the rusted, corroded can, treated to retain the mud caking it upon discovery, seems to glow in its exhibition case. Set against a portion of the dark-red brick wall, accentuating its false golden hue, the vertical can rises upward, dominating the

Fig. 82 United States
Holocaust Memorial
Museum, third floor. Photo:
Ben Aderson.

space, and takes on the power of a relic and talisman—a gift unearthed from the
rubble to preserve something of the Warsaw Ghetto's destroyed lives. Supplementing
this installation, a handful of paper artifacts lie on either side of the milk can: a pho-
tograph of Ringelblum with his son, samples of documents from the archive, and
related ephemera. As an object, the milk can carries such power that on April 17,
1990, near the uprising's forty-seventh anniversary, two milk cans containing a scroll
signed by Holocaust survivors were symbolically buried under the museum's Hall of
Remembrance. Recall, too, that the play commissioned by the museum in honor of
the tenth anniversary of its opening, also the sixtieth anniversary of the rebellion,
featured the milk can and its contents. This object-based installation contrasts with
a strongly information-grounded narrative to the right, parallel to the cast brick
(fig. 83). Visitors learn about the miserable conditions and oppression of ghetto life
first in Warsaw, then in Lodz and other ghettos, in part from television monitors
hanging from the ceiling that show films and photographs, mostly taken by the
German perpetrators. Large wall labels do not shy away from disturbing particulars.

Fig. 83 United States Holocaust Memorial Museum, third floor. Photo: Edward Owen.

The untenable position of the Jewish Councils receives special attention, with the Warsaw Ghetto's Judenrat, including Czerniakow, specifically singled out.

On the opposite side of this floor a large installation focuses solely on the uprising, the first of several times the fight is invoked. Covering most of the display's back wall, a three-dimensional map of the ghetto demarcates its limits in 1940 and 1942, as well as the partisans' bunkers (fig. 84). Photographs of the battle's principal figures, including Zuckerman, Lubetkin, and Edelman, complement the map. Anielewicz receives pride of place atop two rows of four, stressing his role as the uprising's leader and his signification as the quintessence of heroism—the most valuable player— not only of the insurrection but of resistance in the Holocaust as a whole (fig. 85). Beneath this "hall of fame" arrangement of major players from the uprising appear a few artifacts, notably survivor Vladka Meed's false identity card, and photographs of the ghetto. Deliberately underscored by strong light, a glass case holds the remnants of a rifle and two artillery shells discovered in the decimated ghetto. A television screen above the display flashes dozens of photographs from the walled city on a loop. One of these is a photograph of Anielewicz, appearing on the monitor every three minutes or so, on which are overlaid his famous words, written in his final letter to Antek Zuckerman, on April 23: "Self-defense in the ghetto has become reality.

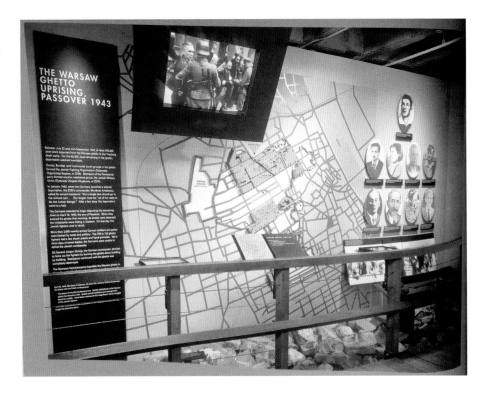

Jewish armed resistance and revenge are facts." To stress the theme of resistance, heroic at that, a panel explaining the uprising characterizes the insurrection, in all capital letters, as "A REVOLUTION IN JEWISH HISTORY." The same panel reproduces Anielewicz's celebrated description of the uprising at greater length, which further extols "the magnificent, heroic struggle of the Jewish fighters."

It is in this recurrent discourse about the resistance, which continues as visitors wind their way through the exhibition, that the uprising finds itself transformed and revealed as an idol, not an icon, as per Oren Stier's articulation: "The icon becomes instrumentalized, idolized, made into a false god. Idol making shows a misplaced (or displaced) impatience for redemption, and easy redemption, especially in the case of the Holocaust, is an impossible desire, an ever deferred wish."[7] The personage of Anielewicz and the act of the uprising offer museum visitors a superheroic act led by a Jewish Superman: Anielewicz, the leader of the uprising, brave and wise enough to die on his own terms, a great redeemer leading the great redemption—the man who has provided, at the least, a Band-Aid for the Holocaust's gaping wound. To be sure, the museum has in every way transformed the uprising, Anielewicz, and his words into idols. I am not saying that some cultural productions already explored did not take a similar tack, but doing so in the most public and visited venue

devoted to the Holocaust in the United States reveals something critical about how the Holocaust is remembered in its most permanent and visible form—and as conceptualized by those most informed about the Nazi genocide. In framing the uprising as such, the museum caters to the expectations of an American audience but at the same time falls into something of a trap. Anielewicz and the uprising lose nuance and become a false God because, in the end, as ghetto fighter Marek Edelman put it, the uprising was about death. Death on one's own terms, undeniably a noble goal, but still the death of nearly all the Warsaw Ghetto's final residents and the death of eastern European Jewry. In this instance, the museum's narrative construct diverges from most scholarly perspectives on the Holocaust, which eschew redemptive takes, and instead aligns with those more readily found in popular culture.

Turning the corner from the uprising's presentation, and at the end of a long hallway conveying information about

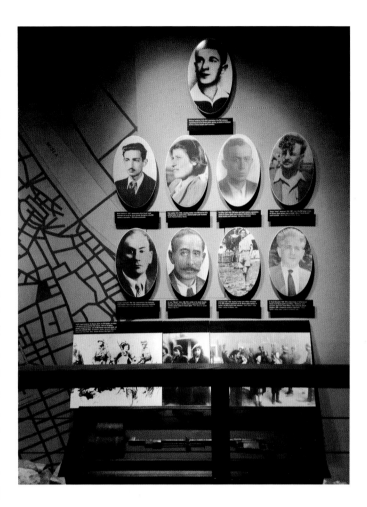

Fig. 85 United States Holocaust Memorial Museum, third floor. Photo: Samantha Baskind.

deportations, visitors reach a manhole cover, yet another key marker of the ghetto. As described on several occasions, some attempted escape by crawling through the sewers, the best known being those who lived through the uprising and subsequently found their way to the Polish side. Just to the right of the sewer cover, one finds a workbench that concealed a hiding place for a family of Polish Jews in a Warsaw suburb. These artifacts sit close to a handcart from Theresienstadt and the museum's railcar. As opposed to Anielewicz, the uprising, and the milk can, the sewer cover, because of its matter-of-fact presentation without fanfare or an excessive narrative loaded with superlatives, provides (as does the workbench) a less invested signifier: not an idol, but an icon. These two objects effectively mediate memory by functioning as "disengaged symbol[s]" rather than "overengaged idol[s]," to adopt Stier's phraseology.[8] On the other hand, the milk can, literally, and Anielewicz, symbolically, each sit on a pedestal—in the latter case, atop a hall-of-fame arrangement in the museum,

as well as in some of the accounts already detailed, especially Andrei Androfski, the surrogate Anielewicz in Uris's *Mila 18,* but also the various "Mordecais" in comics, the Mordecai in Kubert's graphic novel *Yossel,* and the actual Mordecais re-created in the miniseries *Holocaust* and *Uprising.* Particularly conspicuous and available to a wide audience is the Anielewicz played by Hank Azaria in *Uprising,* frequently in a tank top with glistening muscles and holding a gun—a matinee idol playing a Holocaust idol fearlessly leading his legions.

Space constraints do not allow me to describe all facets of the museum's permanent exhibition, but suffice it to say that more objects relate to the Warsaw Ghetto than any other ghetto, thereby emphasizing its importance—in reality and otherwise. While no additional artifacts from the ghetto appear in the remainder of the exhibition, the museum's second floor, although primarily detailing the Holocaust's aftermath, still returns to its central years. Even if not taking on the "last chapter" of the Holocaust, the exhibition revisits resistance, including, of course, the Warsaw Ghetto uprising, and introduces the theme of rescue. Resistance efforts and rescue, though, are part of the last chapter of a Holocaust narrative that—especially in its American context—*needs* to end on a more positive and uplifting note than it did in actuality. Likewise, at the exhibition's end, the documentary film *Testimony,* featuring interviews with survivors, emphasizes resistance and rescue. To appeal to the American desire for redemption and present the Nazi genocide in a way that will resonate in the American psyche, as well as not plunge visitors too deeply into an emotional abyss that would keep them from the museum, Alvin Rosenfeld observes, the Holocaust "had to enter American consciousness . . . in ways that Americans could readily understand on their own terms. These are terms that promote a tendency to individualize, heroize, moralize, idealize, and universalize."[9] The Warsaw Ghetto uprising suits just this kind of account, only rivaled by two other recurring "success" stories—those of rescuers and above all survivors. Details about Raoul Wallenberg's, the lauded Swede who saved tens of thousands of Hungarian Jews in his capacity as a diplomat with access to protection services, appear on the final floor, and, not coincidentally, the street on which the museum sits was renamed Raoul Wallenberg Place. (A playground on New York City's Upper West Side is also named for Wallenberg, thereby connecting rescue efforts with children and publicly declaring the premium put on the survival of the youngest generation.)

Project director Michael Berenbaum condones the Americanization of the Holocaust as "an honorable task provided that the story told is faithful to the historical event," a conclusion intertwined with another sharp observation: "Americans tend to be optimistic; the national ethos avoids the tragic or searches for a silver lining

behind dark clouds. This hopeful tendency has reflected itself in the ways Americans deal with the Holocaust intellectually. Popularizers of the Holocaust have tended to look for cheap grace, for easy sources of consolation."[10] The museum's retelling of the uprising, insofar as it follows this latter course, cuts against the grain of what the uprising was about, as has been told more realistically in some less authoritative episodes investigated in this book. However, it must be pointed out that the limitations of what a museum can do factor into the exhibition's narrative. By virtue of genre, some creative pursuits inherently enable a closer look at the subtleties and complications of the ghetto (e.g., Serling's *In the Presence of Mine Enemies,* Hersey's *The Wall,* and Lampell's *The Wall*), in part by conveying relationships and the human element, whereas constraints imposed by the museum setting force a narrative that must fall back, to a degree, on certain truisms in lieu of teasing out the Warsaw Ghetto's many meanings. Nevertheless, the majority of museumgoers still need cheap grace / silver linings / signposts / easily recognized referents, Zelizer contends, to direct "people who remember to preferred meaning by the fastest route."[11] This is not to say that the museum seeks to minimize atrocity. Some of the artifacts alone defy that assessment—a cast of a crematorium oven from Mauthausen, five thousand shoes once belonging to the senselessly slaughtered, barracks from Birkenau, the railcar, and a dissecting table—as do the narratives that accompany these objects, which do not evade the Holocaust's brutal realities. But amid that horror one finds a small antidote: a milk can containing an unprecedented archive, a sewer cover that set free those otherwise sentenced to death, an uprising against all odds, and Anielewicz, a Jewish Superman. These are the Warsaw Ghetto's referents that enable a fast track not only to a preferred meaning but to a mythologized one.

In 1995 the museum established the Miles Lerman Center for the Study of Jewish Resistance. Chairman of the United States Memorial Council from 1993 to 1995, Lerman, a survivor and active resister, led a partisan group in Poland against the German occupation. Part of the impetus for the center came from the Holocaust's scholarly historiography. Raul Hilberg, in his early and formative study *The Destruction of the European Jews* (1961), takes a documentary and empirical approach, focusing on Nazi perpetrators and the logistics of their crimes. By purposefully concentrating on how the Nazi genocide occurred, Hilberg paid scant attention to Jewish perspectives and went out of his way to downplay resistance: "The reaction pattern of the Jews is characterized by almost complete lack of resistance. In marked contrast to German propaganda, the documentary evidence of Jewish resistance, overt or submerged, is very slight."[12] Yehuda Bauer and others, though, trained their eyes on Jewish resistance, opening up the field to alternate perspectives, especially the importance of passive resistance along with active resistance.[13]

Founded to ensure that resistance would be studied, the Lerman Center funds fellowships for scholars working on the subject, publishes occasional papers, and has put together a working bibliography on resistance efforts. Notably, the center receives a prominent visual presence in the museum. The impact of this prominence cannot be underestimated—as museum visitors exit the dark and challenging core exhibition, immediately after visiting the Hall of Remembrance, they come upon the final presentation, about resistance, sponsored by the center. The exhibition has logically ended, and there should be time to reflect further after emerging from the quiet, symbolic, hexagonal Hall of Remembrance, shaped to evoke a Star of David as well as the six million slaughtered Jews. But no—visitors are confronted, perhaps some surprised, by yet another stop.

Eleven flags flank a descriptive wall label titled "Jewish Resistance," imparting further information to take in after the transitional space provided by the hall. Attached to the wall label, a glass case holds an example of a medal awarded by the center over a period of years (1995–2003) in recognition of Jewish bravery during the Holocaust. Predictably, the very first year recognized Anielewicz and the Warsaw Ghetto uprising along with Leon "Leibl" Feldhendler and Aleksandr "Sasha" Aronovich Perchersky of the Sobibór uprising. Later, among others, four participants in the Auschwitz Revolt received medals, as did Tuvia Bielski, representing partisans in eastern Europe. A porcelain enamel plaque marks each award, with details about the act of resistance it commemorates. Behind these plaques, the flags acknowledge the native countries of the camp's liberators save two: those of the Jewish Brigade, an all-Jewish military unit within the British Army, and the flag of the Warsaw Ghetto Resistance Organization (WAGRO), a survivor group established twenty years after the uprising. To be exact: the *final* object related to survivors of the Nazi genocide of eastern European Jewry that museum visitors see before returning to the Hall of Witness at the street level—the museum's entrance and exit—is a postwar flag commemorating the Warsaw Ghetto's insurrection.

Here and throughout, the museum favors the revolt. Whether or not by necessity, to manage visitors' expectations, the museum takes an approach less mediated than some of the cultural incursions with which the body of this book is occupied. I have chosen to explore at the finale the imprint of the Warsaw Ghetto in a very public and influential institution, the United States Holocaust Memorial Museum, to demonstrate how the memory of the sealed city within a city has been borrowed and transformed, and reenacted and shaped, by conflicting desires and goals born of the social, aesthetic, and political concerns of one time and place. Crucially, in no way am I disparaging the museum's exemplary exhibition. The museum effectively and remarkably answers young Zelbel's question, posed in Irving Ravetch's early radio

play *The Second Battle of the Warsaw Ghetto,* which aired just two months after the uprising and served as the first cultural representation discussed in this book: "Will the world know of us? Will the world know?"[14]

Notes

Introduction

The first epigraph to this chapter is drawn from Mordecai Anielewicz to Antek Zuckerman, reprinted in Yitzhak Arad, Israel Gutman, and Abraham Margaliot, eds., *Documents on the Holocaust: Selected Sources on the Destruction of the Jews of Germany and Austria, Poland, and the Soviet Union*, 8th ed. (Lincoln: University of Nebraska Press; Jerusalem: Yad Vashem, 1999), 315; emphasis in original. At Adolf Eichmann's 1961 trial in Jerusalem, Antek Zuckerman read this letter to the court.

The second epigraph derives from Claude Lanzmann, *Shoah: An Oral History of the Holocaust; The Complete Text of the Film* (New York: Pantheon Books, 1985), 196, and *Shoah*, directed by Claude Lanzmann (1985; New York: Criterion Collection, 2013), DVD. A few ghetto partisans wrote memoirs of the uprising and their experience in the ghetto. See Marek Edelman, *The Ghetto Fights: Warsaw 1941–43* (1946; repr., London: Bookmarks, 1990); Vladka Meed, *On Both Sides of the Wall: Memoirs from the Warsaw Ghetto*, trans. Steven Meed (New York: Holocaust Library, 1979); Simha Rotem, *Kazik: Memoirs of a Warsaw Ghetto Fighter*, trans. Barbara Harshav (1994; repr., New Haven: Yale University Press, 2002); and Yitzhak Zuckerman, *A Surplus of Memory: Chronicle of the Warsaw Ghetto Uprising*, trans. Barbara Harshav (Berkeley: University of California Press, 1993).

1. On the ghetto's history, I have particularly relied on Barbara Engelking and Jacek Leociak's encyclopedic *Warsaw Ghetto: A Guide to the Perished City* (New Haven: Yale University Press, 2009) and Israel Gutman, *The Jews of Warsaw, 1939–1943: Ghetto, Underground, Revolt*, trans.

Ina Friedman (Bloomington: Indiana University Press, 1982).

2. Statistics from Robert Chazan and Marc Lee Raphael, eds., *Modern Jewish History: A Source Reader* (New York: Schocken Books, 1974), 283.

3. Engelking and Leociak, *Warsaw Ghetto*, xiv.

4. On Holocaust resistance more broadly, see Nechama Tec's excellent study *Resistance: Jews and Christians Who Defied the Nazi Terror* (New York: Oxford University Press, 2013).

5. Harry Schneiderman and Morris T. Fine, eds., *The American Jewish Yearbook*, vol. 45, *5704* (Philadelphia: Jewish Publication Society of America, 1943), 310, 309.

6. Dorothy Thompson, "Homage to the Christian Poles and the Maccabean Jews of Warsaw!," *Washington Evening Star*, June 2, 1943; emphasis in original.

7. Ibid., reprinted in *Menorah Journal* 31, no. 2 (July–September 1943): unpaged prefatory material.

8. "The Battle of the Ghetto," *New York Times*, April 21, 1944, 18.

9. See especially Saul Friedlander, ed., *Probing the Limits of Representation: Nazism and the "Final Solution"* (Cambridge: Harvard University Press, 1992), the fundamental volume on this topic; Ernst van Alphen, *Caught by History: Holocaust Effects in Contemporary Art, Literature, and Theory* (Stanford: Stanford University Press, 1997), esp. 16–20 and 26–30; and Stephen C. Feinstein, introduction to *Absence/Presence: Critical Essays on the Artistic Memory of the Holocaust*, ed. Stephen C. Feinstein (Syracuse: Syracuse University Press, 2005), xxii–xxvi. Also worthy of note is a highly

controversial exhibition at the Jewish Museum in New York, *Mirroring Evil* (2001), which engaged work by an international cadre of artists interested in the perpetrators of the Holocaust rather than their victims. By not presenting "typical" Holocaust art—cathartic, memorializing, or redemptive—this show's defiance of so-called decorum, for better or for worse, traversing limits or not, broke barriers. Norman L. Kleeblatt, ed., *Mirroring Evil: Nazi Imagery / Recent Art* (New Brunswick: Rutgers University Press, 2001).

10. Theodor W. Adorno, "Cultural Criticism and Society," in *The Adorno Reader,* ed. Brian O'Connor (Oxford: Blackwell, 2000), 210. For a useful analysis and discussion of the afterlife of Adorno's observations, see Michael Rothberg, *Traumatic Realism: The Demands of Holocaust Representation* (Minneapolis: University of Minnesota Press, 2000), 25–58.

11. Theodor W. Adorno, "Meditations on Metaphysics: After Auschwitz," in *The Adorno Reader,* 86.

12. George Steiner, *Language and Silence: Essays on Language, Literature, and the Inhuman* (New York: Atheneum, 1967), 123, and Elie Wiesel, "Trivializing Memory," in *From the Kingdom of Memory: Reminiscences* (New York: Summit Books, 1990), 166.

13. Friedlander, *Probing the Limits of Representation,* 3; emphasis in original.

14. Marianne Hirsch, *Family Frames: Photography, Narrative, and Postmemory* (Cambridge: Harvard University Press, 1997), 40.

15. Hilene Flanzbaum, introduction to *The Americanization of the Holocaust,* ed. Hilene Flanzbaum (Baltimore: Johns Hopkins University Press, 1999), 8. See also Alvin H. Rosenfeld, "The Americanization of the Holocaust," in *Thinking About the Holocaust After Half a Century,* ed. Alvin H. Rosenfeld (Bloomington: Indiana University Press, 1997), 119–50, and Alan Mintz, *Popular Culture and the Shaping of Holocaust Memory in America* (Seattle: University of Washington Press, 2001). To name but a few studies on American cultural representations of the Holocaust, sometimes involving the Warsaw Ghetto but conceptualized broadly about diverse experiences (e.g., ghetto, camp, secondary witnessing, and so on) and frequently confined to one artistic medium: Matthew Baigell, *Jewish-American Artists and the Holocaust* (New Brunswick: Rutgers University Press, 1997); Judith E. Doneson, *The Holocaust in American Film,* 2nd ed. (Syracuse: Syracuse University Press, 2002); and Jeffrey Shandler, *While America Watches: Televising the Holocaust* (New York: Oxford University Press, 1999).

16. See https://www.washingtonpost.com/ politics/carson-suggests-that-gun-rights-might -have-prevented-the-holocaust/2015/10/08/99a8 2d9e-6df2–11e5–9bfe-e59f5e244f92_story .html and https://www.washingtonpost .com/news/post-politics/wp/2015/10/09/ ben-carson-jewish-group-talking-foolishness -on-holocaust/, accessed October 10, 2015.

17. See http://thepeoplescube.com/ current-truth/historians-warsaw-ghetto-uprisin g-was-overreaction-t797.html, accessed December 4, 2010.

18. *Notes from the Warsaw Ghetto: The Journal of Emmanuel Ringelblum,* trans. and ed. Jacob Sloan (1958; New York: Schocken Books, 1974). On Ringelblum and this remarkable, unprecedented record, see Samuel D. Kassow, *Who Will Write Our History? Emanuel Ringelblum, the Warsaw Ghetto, and the Oyneg Shabes Archive* (Bloomington: Indiana University Press, 2007).

19. For a critical discussion of these kinds of primary sources, see James E. Young, "Interpreting Literary Testimony: A Preface to Rereading Holocaust Diaries and Memoirs," *New Literary History* 18 (Winter 1986–87): 403–23.

20. See http://unitedwithisrael.org/ jews-commemorate-the-warsaw-ghetto-uprising, accessed May 25, 2013.

21. Quoted in Hasia R. Diner, *The Jews of the United States, 1654 to 2000* (Berkeley: University of California Press, 2004), 262. Diner's book *We Remember with Reverence and Love: American Jews and the Myth of Silence After the Holocaust, 1945–1962* (New York: New York University Press, 2009) thoroughly chronicles how Americans remembered the Holocaust from 1945 to 1962, upsetting previous assumptions about reticence during the immediate postwar period. Particularly disputing the definitive account before her publication, Peter Novick's *Holocaust in American Life* (Boston: Houghton Mifflin, 1999), Diner evaluates this commemorative impulse by uncovering myriad sources ranging from liturgy to summer-camp projects. As Novick writes: "Between the end of the war and

the 1960s, as anyone who has lived through those years can testify, the Holocaust made scarcely any appearance in American public discourse, and hardly more in Jewish public discourse—especially discourse directed to gentiles." Diner occasionally touches on cultural representations, but she does not analyze them thoroughly, and not at all after the early 1960s. A small portion of her crucial study does look at how the Warsaw Ghetto manifests in American remembrance (25–32, 66–77), and that material offered a crucial starting point for my book.

22. Rick Lyman, "Watching Movies with Harvey Weinstein, Memory's Independent Streak: 40 Years Tarnish an Epic's Luster," *New York Times,* April 27, 2001, 1, 20.

Chapter 1

The first epigraph to this chapter is drawn from Chaim A. Kaplan, *Scroll of Agony: The Warsaw Diary of Chaim A. Kaplan,* trans. and ed. Abraham I. Katsh (1965; repr., Bloomington: Indiana University Press, 1999), 394. A month earlier, on June 25, 1942, Kaplan employed this nomenclature, writing in the first line of that day's entry: "Every day Polish Jewry is brought to slaughter" (359).

The second epigraph derives from Mordecai Anielewicz to Antek Zuckerman, reprinted in Arad, Gutman, and Margaliot, *Documents on the Holocaust,* 315–16.

1. Two writings from the Bible supplied this offensive description. First, Isaiah 53:7: "He was oppressed, though he humbled himself and opened not his mouth; as a lamb that is led to the slaughter, and as a sheep that before her shearers is dumb; yea, he opened not his mouth" (from the Mechon Mamre Hebrew Bible, http://www.mechon-mamre.org/p/pt/pto.htm, as are all further biblical quotes unless otherwise indicated). In Psalms 44:22 readers encounter a comparable characterization: "Nay, but for Thy sake are we killed all the day; we are accounted as sheep for the slaughter." The phrase became more than a figure of speech, taking on literal meaning as Jews, after being herded away in "cattle cars," were literally sheared, their heads shaved, once they reached the death camps.

2. Call to resistance reprinted in Arad, Gutman, and Margaliot, *Documents on the Holocaust,* 302.

3. Ringelblum, *Notes from the Warsaw Ghetto,* 326.

4. Arch Oboler and Stephen Longstreet, eds., *Free World Theatre: Nineteen New Radio Plays* (New York: Random House, 1944), v.

5. Ibid., xiii.

6. *Tomorrow,* written by Budd Schulberg and Jerome Lawrence, includes a sly discussion between two soldiers on the front, one of whom, Steve, is reading a book by Mann. At one point the main character, Jack, leafs through the book's pages and says, "The way this book looks I'd still have to pay somebody ten bucks to understand it for me. Like it says here: 'Hitler is an anachronism.'" Ibid., 26–27. In short, *Tomorrow* is about a soldier named Jack, who returns to the United States somewhat traumatized, and his connection to a dead soldier from his hometown. The final play in *The Free World Series, V Day,* was based on a statement by Franklin Roosevelt and written by Arch Oboler, the editor of the published compilation of the scripts and a noted writer and director.

7. Ibid., x, xi.

8. Ibid., 221. Further quotations from *The Second Battle of the Warsaw Ghetto* are cited by page number parenthetically in the text.

9. In a monologue a few lines earlier Zelbel also asks, *"Will the world know?"* These words are italicized in the script for emphasis. Midway through the play, as the family muses whether they should fight or not, Leah similarly asks: "Will the world hear our lesson, Zaida? They don't see how we spill our lives here. . . . They don't know—or they will not know" (229; ellipsis in original).

10. Leon Uris, *Mila 18* (Garden City, N.Y.: Doubleday, 1961), 299, 346.

11. "The Battle of the Warsaw Ghetto," American Jewish Committee Archives, New York. Wishengrad's script has been reprinted in two different anthologies, both published close to the war's end, with very minor and occasional variations of word choice or word order: Eric Barnouw, ed., *Radio Drama in Action: Twenty-Five Plays of a Changing World*

(New York: Farrar & Rinehart, 1945), 34–45, and Morton Wishengrad, *The Eternal Light* (New York: Crown Publishers, 1947), 33–45. Here I use pagination from Wishengrad's book, noted parenthetically in the text.

12. Wishengrad quoted in Barnouw, *Radio Drama in Action,* 32–33.

13. The April 9 broadcast appears to be an early commemoration of the uprising, considering the next week's broadcast, on April 16, was dedicated to the thirteenth anniversary of Israel's independence. A list of broadcasts can be found at http://www.audio-classics.com/audio-classics/TheEternalLight.html, accessed January 14, 2013. On the history and aims of *The Eternal Light* in both its radio and televised incarnations, see Jeffrey Shandler and Elihu Katz, "Broadcasting American Judaism: The Radio and Television Department of the Jewish Theological Seminary," in *Tradition Renewed: A History of the Jewish Theological Seminary of America,* ed. Jack Wertheimer (New York: Jewish Theological Seminary of America, 1997), 2:363–401. Almost 1,900 radio shows were produced during *The Eternal Light*'s four and a half decades on the air (ibid., 372).

14. Barnouw, *Radio Drama in Action,* 33; Wishengrad, *Eternal Light,* 32.

15. See http://www.blogtalkradio.com/don canaan/2013/04/21/the-chosen-1the-battle-of-the-warsaw-ghetto, accessed May 1, 2013. These accurate statistics differ from those uttered at the start of the play, which was written so close to the uprising that many numbers were still unclear and had to be estimated.

16. This character is named Teacher 1 in Barnouw's reproduced script but only "voice" in Wishengrad's book.

17. Barnouw, *Radio Drama in Action,* 33.

18. William Gropper Papers, roll 3502, frame 6, Archives of American Art, Smithsonian Institution, Washington, D.C. Original clipping, Emery Grossman, "A Visit with William Gropper," *Temple Israel Light* 8 (March 1962).

19. William Shirer, "John Hersey's Superb Novel of the Agony of Warsaw," *New York Herald Tribune Book Review,* February 26, 1950, 1.

20. Howard Fast and William Gropper, *Never to Forget: The Battle of the Warsaw Ghetto* (New York: Book League of Jewish Peoples Fraternal Order, 1946), unpaged.

21. August L. Freundlich, *William Gropper: Retrospective* (Los Angeles: Ward Ritchie Press, in conjunction with the Joe and Emily Lowe Art Gallery of the University of Miami, 1968), plate 100 (p. 125).

22. Quoted in *Ben Wilson: The Margin as Center* (Wayne, N.J.: William Patterson University, 2008), unpaged.

23. Shlomo Mendelsohn, "The Battle of the Warsaw Ghetto," *Menorah Journal* 32, no. 1 (April–June 1944): 5–25.

24. Max Weinreich, preface to Shlomo Mendelsohn, *The Battle of the Warsaw Ghetto* (New York: Yiddish Scientific Institute, 1944), 4.

25. Mendelsohn, *The Battle of the Warsaw Ghetto,* 28.

26. H. Leyvik, "Der Nes in Geto," trans. Motl Didner (unpublished manuscript), 24, 25. By permission of the Institute for Jewish Research, YIVO, New York. I am deeply grateful to Motl Didner for sharing his unpublished translation with me.

27. Sam Zolotow, "Warsaw Play to Open," *New York Times,* October 10, 1944, 26. Kondell stage designs at the New York Public Library—three designs in box number 3, subseries 2, "Stage Designs" (folder 9).

28. For a description of what the stage should look like, see the Jacob Mestel Papers, box 23, folder 308, YIVO Archives, New York (1-page document). For the original script of the play, see the Jacob Mestel Papers, box 13, folder 176, YIVO Archives. Three pages of notes accompany the script.

29. Leyvik, "Der Nes in Geto," 9.

30. Ibid., 45, 46, 51.

31. Ibid., 65, 66.

32. Ibid., 86.

33. Herbert Whittaker, "'Warsaw Ghetto' Highly Dramatic," *Montreal Gazette,* February 7, 1945, 3. A *Gazette* advertisement for the play, which showed three times in Montreal, characterizes the production as an "original New York production of H. Leivick's heroic drama . . . with a cast of forty." Ibid., 3. Notice the use of the word "heroic."

34. S[amuel] Margoshes, News and Views, *The Day,* May 12, 1943, 1, cited in Haskel Lookstein, *Were We Our Brothers' Keepers? The Public Response of American Jews to the Holocaust, 1938–1944* (New York: Vintage Books, 1988), 154.

35. Hanna Krall, *Shielding the Flame: An Intimate Conversation with Dr. Marek Edelman, the Last Surviving Leader of the Warsaw Ghetto Uprising,* trans. Joanna Stasinska and Lawrence Weschler (New York: Henry Holt, 1986), 3.

36. "World Jewish Congress Sends Cultural Delegation to Jews in Displaced Camps in Germany," *Jewish Telegraphic Agency,* December 28, 1945. See http://archive.jta.org/article/1945/12/28/2869174/world-jewish-congress-sends-cultural-delegation-to-jews-in-displaced-camps-in-germany, accessed February 12, 2013.

37. On Trumpeldor's words, apocryphal or not, see Aviel Roshwald, *The Endurance of Nationalism: Ancient Roots and Modern Dilemmas* (Cambridge: Cambridge University Press, 2006), 148.

38. I am indebted to Joseph P. Ansell's meticulous work on the artist in "Arthur Szyk's Depiction of the 'New Jew': Art as a Weapon in the Campaign for an American Response to the Holocaust," *American Jewish History* 89, no. 1 (March 2001): 123–34. See also Ansell's full-length study *Arthur Szyk: Artist, Jew, Pole* (Portland, Ore.: Littman Library of Jewish Civilization, 2004). A helpful list of Szyk's published political cartoons from 1939 to 1950 appears in *Arthur Szyk,* 295–306. For excellent images, see Steven Luckert, *The Art and Politics of Arthur Szyk* (Washington, D.C.: United States Holocaust Memorial Museum, 2003).

39. Ansell, "Arthur Szyk's Depiction of the 'New Jew,'" 127. Long before the war, Szyk depicted resistance. He painted bellicose Jews attacking Persians with bloodied swords in *Jewish Resistance to Haman's Plan* (1925), published in Paris as *Le livre d' Esther.* A second version of Szyk's *Book of Esther,* posthumously published in Israel in 1974, includes an illumination of Haman marked with swastikas, thus connecting this earlier, biblical attempt at annihilation with Hitler and the Holocaust.

40. Rufus Learsi, *The Jew in Battle* (New York: American Zionist Youth Commission, 1944), 2, 3.

41. In 1949 an Israeli postage stamp was issued with another image by Szyk of Moses, Aaron, and Hur, here with Moses's arms fully aloft in victory, although he is much older and has a long white beard. Moses appeared several times in Szyk's *Haggadah,* a point worthy of note,

considering that he receives little attention in more traditional Haggadot and that no mention of him occurs in the haggadic text, despite his centrality in the biblical book of Exodus. A customary interpretation of Moses's omission is that the Seder reminds Jews that God, not Moses, freed them from Egyptian oppression. Exodus 12:12 reads: "For I will go through the land of Egypt in that night, and will smite all the first-born in the land of Egypt, both man and beast; and against all the gods of Egypt I will execute judgments: I am the Lord." In the *Haggadah* Szyk includes a full-page illumination of a determined, youthful Moses killing an Egyptian as retribution for the taskmaster's mistreatment of a Jewish slave. Moses appears in a customary guise—as an older, bearded leader with rays of light emanating from his head—in two contemporaneous publications: Szyk's illustrations for Mortimer J. Cohen's *Pathways Through the Bible* (Philadelphia: Jewish Publication Society of America, 1946), before page 68 and after page 100, as well as on the cover and two opening pages of Szyk's *Ten Commandments* (Philadelphia: John C. Winston, 1947), a book composed solely of his art.

42. Gershom Scholem, "The Star of David: History of a Symbol," in *The Messianic Idea in Judaism and Other Essays on Jewish Spirituality* (New York: Schocken Books, 1971), 259, 280–81.

43. Ithamar Gruenwald, "Midrash and the 'Midrashic Condition': Preliminary Considerations," in *The Midrashic Imagination: Jewish Exegesis, Thought, and History,* ed. Michael Fishbane (Albany: State University of New York Press, 1993), 9; emphasis in original. For an in-depth exploration of the influence of midrash on Jewish American artists, see Samantha Baskind, *Jewish Artists and the Bible in Twentieth-Century America* (University Park: Pennsylvania State University Press, 2014).

44. David G. Roskies, *Against the Apocalypse: Responses to Catastrophe in Modern Jewish Culture* (Cambridge: Harvard University Press, 1984), 13.

45. Ibid., 16.

46. Ibid., 20.

47. After the war, Szyk adopted the figures of Moses, Aaron, and Hur more than once to make a point. At the base of his highly ornate lithograph *Declaration of Independence for the State of Israel* (1948), Szyk pictures the trio,

returned to their ancient origins, along the border with other biblical figures (e.g., David and Ezekiel) and Zionist symbols (e.g., a sowing pioneer farmer), all in service of the fulfillment of the Zionist battle for a homeland. Rendered much like his *Haggadah* illustrations—strong on color and miniature detailing, akin to medieval manuscript illumination—the declaration also revisits Hillel's maxim, described earlier in Szyk's "Tel Hai" image. According to his wife, the day after Israel was declared independent, Szyk began working on the proclamation. Irvin Ungar, *Justice Illuminated: The Art of Arthur Szyk* (Berkeley, Calif.: Frog; Burlingame, Calif.: Historicana, 1999), 19.

48. For a compilation of some of the strongest editorial cartooning from the war, see André Schiffrin, *Dr. Seuss and Co. Go to War: The World War II Editorial Cartoons of America's Leading Comic Artists* (New York: New Press, 2009). Among the cartoonists featured are the Jewish artists Mischa Richter, Saul Steinberg, and Carl Rose, of *New Yorker* fame. None of the artists consistently made as searing and Jewish-oriented imagery as Szyk.

49. Struthers Burt, introduction to Arthur Szyk, *Ink and Blood: A Book of Drawings* (New York: Heritage Press, 1946), 3.

50. Irvin Ungar, insert included with copies of book.

51. Leyvik, "Der Nes in Geto," 94, 95.

52. Flavius Josephus, *The Jewish War,* trans. G. A. Williamson, rev. ed. by E. Mary Smallwood (London: Penguin Books, 1981), 398, 403.

53. Arad, Gutman, and Margaliot, *Documents on the Holocaust,* 302.

54. For a parsing of the history of Masada from Josephus to the current time, especially in relation to Israel's national identity but also carefully noting when the facts of the siege are uncertain, see Nachman Ben-Yehuda, *The Masada Myth: Collective Memory and Mythmaking in Israel* (Madison: University of Wisconsin Press, 1995).

55. David G. Roskies, ed., *The Literature of Destruction: Jewish Responses to Catastrophe* (Philadelphia: Jewish Publication Society, 1988), 358.

56. Two books have strongly impressed my thinking on the subject of Jews in relation to nonviolence and aggressive manliness: Paul Breines's important study *Tough Jews: Political Fantasies and the Moral Dilemma of American Jewry* (New York: Basic Books, 1990) and Warren Rosenberg's *Legacy of Rage: Jewish Masculinity, Violence, and Culture* (Amherst: University of Massachusetts Press, 2001). Rosenberg connects Jewish ambivalence to violence with biblical heroes like Samson, Joshua, Moses, and David, the last of whom is not permitted to build the Temple because he killed and went to war (55–67). Daniel Boyarin offers a rejoinder to Breines and other research on the New Jew. Examining written and visual texts, he contends that premodern, traditional Jews were offended by values associated with the fighting Jew, did not see themselves as weak, and instead prized a gentle and intellectual essence. He views later masculinization, instigated by the modern Jewish experience, as less traditionally "Jewish" than that of the more common "rabbinic," bookish male. See Daniel Boyarin, *Unheroic Conduct: The Rise of Heterosexuality and the Invention of the Jewish Man* (Berkeley: University of California Press, 1997).

57. Hayyim Bialik, "In the City of Slaughter," in *Complete Poetic Works of Hayyim Nahman Bialik,* ed. Israel Efros, vol. 1 (New York: Histadruth Ivrith of America, 1948), 133–34; emphasis in original. A month after the Kishinev pogrom and right before his visit, Bialik wrote "On the Slaughter" ("Al ha-Shehitah"). While the bibliography on Bialik in Hebrew is voluminous—the Bialik Museum in Tel Aviv estimated more than thirty thousand citations in 1988—the English-language literature on this foremost Hebrew poet is unfortunately sparse. On Bialik in English, with a summary of some key literature about his background and influences, see David Aberbach, *Bialik* (New York: Grove Press, 1988). For the statistic on Bialik's extensive bibliography, see ibid., 17.

58. Max Nordau, "Jewry of Muscle," in *The Jew in the Modern World: A Documentary History,* ed. Paul Mendes-Flohr and Jehuda Reinharz, 2nd ed. (New York: Oxford University Press, 1995), 547.

59. On Nordau, see George L. Mosse, "Max Nordau, Liberalism and the New Jew," *Journal of Contemporary History* 27, no. 4 (October 1992): 565–81. Michael Berkowitz observes that the gyms "constituted a significant means of displaying a new Jewish male type. . . . Exhibitions of the [gymnastic clubs demonstrated] ostensible

signs of Zionism's manliness, strength, and vigor." Michael Berkowitz, *Zionist Culture and West European Jewry Before the First World War* (Cambridge: Cambridge University Press, 1993), 99. For a more recent take on the effects of sports and masculinity on perceptions of modern Jews, see Michael Brenner and Gideon Reuveni, eds., *Emancipation Through Muscles: Jews and Sports in Europe* (Lincoln: University of Nebraska Press, 2006). In America, Jews similarly turned to sports to counter fallacies about physical ineptitude. See Peter Levine, *Ellis Island to Ebbets Field: Sport and the American Jewish Experience* (New York: Oxford University Press, 1992), which offers evidence challenging the notion that Jews are "people of the book rather than . . . people of the hook, right cross, or home run" (4).

60. Nordau, "Jewry of Muscle," 547.

61. Richard G. Marks, *The Image of Bar Kokhba in Traditional Jewish Literature: False Messiah and National Hero* (University Park: Pennsylvania State University Press, 1994).

62. *The Answer,* July 5, 1943, 3, as discussed and cited in Ansell, "Arthur Szyk's Depiction," 129.

63. *Jewish Examiner,* September 11, 1942, 1, as quoted in Ansell, "Arthur Szyk's Depiction," 130.

64. These details appear in Szyk's biography at the end of the journal issue: "Arthur Szyk," *Menorah Journal* 30, no. 2 (July–September 1942): 228.

65. On Lazarus, see, for example, Esther H. Schor, *Emma Lazarus* (New York: Schocken, 2006). While Jewish manhood in Europe has often been parsed, negative portrayals of American Jewish masculinity have received less attention. Most illuminating on this topic is Beth S. Wenger, "Constructing Manhood in American Jewish Culture," in *Gender and Jewish History,* ed. Marion A. Kaplan and Deborah Dash Moore (Bloomington: Indiana University Press, 2011), 350–66.

66. Zinaida Ragozin, "Russian Jews and Gentiles: From a Russian Point of View," *Century Magazine* 23, no. 6 (April 1882): 919.

67. Emma Lazarus, *An Epistle to the Hebrews* (New York: Jewish Historical Society of New York, 1987), 19, 8.

68. Ibid., 19.

69. Ibid., 30–31.

70. Ibid., 20.

71. Ibid., 24, 25, 25–26, 31.

72. As quoted in Cary Goodman, *Choosing Sides: Playground and Street Life on the Lower East Side* (New York: Schocken Books, 1979), 38–39.

73. Stanley B. Frank, *The Jew in Sports* (New York: Miles Publishing, 1936), unpaged prefatory material.

74. *Menorah Journal* 33, no. 1 (April–June 1945): 132.

75. See https://www.kirkusreviews.com/book-reviews/ralph-nunberg/the-fighting-jew/#review, accessed March 13, 2012.

76. Curt Reiss, introduction to *The Fighting Jew,* by Ralph Nunberg (New York: Creative Age Press, 1945), viii, x–xi, viii.

77. James M. Curley, introduction to *Jews Fight Too!,* by Mac Davis (New York: Hebrew Publishing, 1945), 7–10.

78. Davis, *Jews Fight Too!,* 13. Even before the uprising, the children's magazine *World Over* touted Jewish military accomplishments during the war. In the lead article of the final issue of 1942, titled "The Fighting Jews," the author asserts that although "Jews are called 'The People of the Book.' . . . Jews in the past and today, have known how to fight, when a cause is right and just." "The Fighting Jews," *World Over* 4, no. 5 (December 25, 1942): 2. The unnamed author offers the typical facts: "Today . . . Jews are fighting bravely under the flag to which they owe allegiance. . . . In the last World War over a million Jews fought in the Allied armies. In the United States there were nearly 250,000 Jews in the armed forces. There were ten thousand Jewish commissioned officers. The Distinguished Service Cross was awarded to nearly two hundred Jews. . . . Jews have fought in every American war for freedom, starting with the Revolution itself. There were Jewish heroes in the Civil War, in the Spanish American War, and in the First World War. Now once again by the tens of thousands Jews are fighting for American freedom, fighting to defend the country which they helped to build up" (2).

79. Davis, *Jews Fight Too!,* 145, 152.

80. Because *The Fighting Jew* went so quickly to print, some details are incorrect. The author erroneously writes that Eck Rubenstein ran the Jewish orphanage, not Janusz Korczak (12), and attributes leadership of the uprising to Michael Klepfisz, one of the fighters but not a leader, rather than Anielewicz and Zuckerman (13–21).

259

81. Ibid., 281.

82. Davis, *Jews Fight Too!,* 18, 22.

83. "First Anniversary of Battle of Warsaw Ghetto Commemorated; State Dept. Lauds Heroes." *Jewish Telegraphic Agency,* April 13, 1944, http://www.jta.org/1944/04/13/archive/first-anniversary-of-battle-of-warsaw-ghetto-commemorated-state-dept-lauds-heroes, accessed May 1, 2013.

84. Board of the Association of Jewish Refugees and Immigrants from Poland to the Jewish Labor Committee, April 5, 1944, United States Holocaust Memorial Museum, RG 67.001M, "Jewish Labor Committee records, 1934–47" (hereafter Jewish Labor Committee records), reel 32, frame 166.

85. Jacob Pat to Frank F. Hopper (director of the New York Public Library), April 15, 1944, Jewish Labor Committee records, reel 32, frame 171.

86. "April 19, 1944—First Anniversary of the Revolt of the Ghettos" (title in bold capitals on the leaflet), Jewish Labor Committee records, reel 32, frame 183.

87. See, for example, Jewish Labor Committee records, reel 32, frames 321–25, with the release on April 19 noting atop in capital letters: "Distinguished Array of Speakers to Address Opening."

88. Jewish Labor Committee records, reel 32, frame 167.

89. Nahum Goldmann, as quoted in "Jews Here Acclaim Heroes of Warsaw," *New York Times,* April 20, 1944, 10.

90. Ibid.

91. Synopsis of the exhibition, Jewish Labor Committee records, reel 32, frame 320.

92. *Martyrs and Heroes of the Ghettos* (New York: Jewish Labor Committee, 1945), Jewish Labor Committee records, reel 161 (the reel is unframed and the catalogue is unpaged).

93. Synopsis of the exhibition, Jewish Labor Committee records, reel 32, unframed page following frame 320 and before frame 321.

94. Jewish Labor Committee records, reel 161.

95. *Never Again Starts Here,* trifold brochure (Washington, D.C.: United States Holocaust Memorial Museum, n.d.), from the author's collection.

96. Jewish Labor Committee records, reel 32, frame 311.

97. Ibid., frames 338–39. Muni's support of the Jews was ongoing. In 1946 he appeared as a Holocaust survivor who was interned at Treblinka in the play *A Flag Is Born,* which briefly ran on Broadway and then traveled through the United States. Written by Ben Hecht, with music by Kurt Weill, and produced by Hillel Kook's / Peter Bergson's American League for a Free Palestine, *A Flag Is Born* promoted the creation of a Jewish state in Israel. Muni also performed for *The Eternal Light.*

98. *New York Times,* June 4, 1943, and *Jewish Telegraph Agency,* June 3, 1943. Translation from Jacob Glatstein, Israel Knox, and Samuel Margoshes, eds., *Anthology of Holocaust Literature* (Philadelphia: Jewish Publication Society of America, 1969), 329–31. *Time* magazine profiled Zygelbaum on May 31, 1943 (p. 24). On May 22, the *New York Times* covered his death (p. 4). The wording that Muni used varies slightly from that in the text here, due to translation differences.

99. "Pole's Suicide Note Pleads for Jews," *New York Times,* June 4, 1943, 7.

100. Jewish Labor Committee records, reel 161.

101. Ibid.

102. *Saturday Review of Literature* review, clipping pasted into the copy of *The Black Book* at the Cleveland Public Library. *The Black Book: The Nazi Crime Against the Jewish People* (New York: Jewish Black Book Committee, 1946).

103. *Black Book,* 214–34. The book ends with a larger entreaty for tolerance of Jews and a statement of hope that Jews will never suffer from anti-Semitism or genocide again: "In the name of the vast majority of the Jewish people, scattered over the face of the earth, we call upon the leaders of the world to effect a solution to the so-called Jewish problem, which is that of the non-Jew. . . . Now is the time to act, the time for governments of the nations to outlaw anti-Semitism within their countries and as an instrument of foreign policy" (467, 468).

104. Ibid., 3, 7.

105. Ibid., 51.

106. Ibid., 4.

107. Ibid., 5.

108. Ibid., 432.

109. Ibid., 442, 443. Pages 436–44 focus on the uprising.

110. For more on this never-erected memorial, including proposed designs, see James Young's field-defining study *The Texture of Memory: Holocaust Memorials and Meaning* (New Haven: Yale University Press, 1993), 288–92.

111. See Diner, *We Remember with Reverence and Love.*

Chapter 2

The first epigraph to this chapter is drawn from Rod Serling to Mrs. Thomas P. Richardson, June 22, 1960, box 13, folder 1, Rod Serling Papers, U.S. MSS 43AN, Wisconsin Center for Film and Theater Research (hereafter Serling Papers). Serling was responding to her request to write about the persecution of the German people of Yugoslavia.

The second epigraph derives from Millard Lampell, "Bringing 'The Wall' to the Stage," *Midstream* 6 (Autumn 1960): 14–15.

1. Anne Serling, *As I Knew Him: My Dad, Rod Serling* (New York: Citadel Press, 2013), 30, 31.

2. Ibid., 70.

3. Ibid., 31.

4. Ibid., 12.

5. Ibid., 42.

6. Ibid., 113.

7. Joel Engel, *Rod Serling: The Dreams and Nightmares of Life in the Twilight Zone; A Biography* (Chicago: Contemporary Books, 1989), 144. Engel's often-informative book is marred by a lack of citations and a rigid attempt to paint Serling as a victim of his early success, self-doubt, and personal insecurities. Gordon Sander's follow-up biography of Serling, written a few years later, rehashes the same material with a similar thesis. Gordon F. Sander, *Serling: The Rise and Twilight of Television's Last Angry Man* (1992; repr., Ithaca: Cornell University Press, 2011). More objective is a small catalogue for a 1984 retrospective exhibition about Serling at the Museum of Broadcasting. See Ron Simon, ed., *Rod Serling: Dimensions of Imagination* (New York: Museum of Broadcasting, 1984).

8. Rod Serling, *Patterns: Four Television Plays with the Author's Personal Commentaries* (New York: Simon & Schuster, 1957), 22. This volume includes an extended first chapter on the challenges of writing for television, followed by four reproduced scripts augmented by Serling's analyses and criticisms of his writing and the plays' structures, among other issues; the book includes the scripts for *Patterns, The Rack, Old MacDonald Had a Curve,* and *Requiem for a Heavyweight.* In a different discussion, of *Noon on Doomsday,* Serling explains that the U.S. Steel Company received protesting letters and telegrams after which "down went the flag and the biggest corporation in the world put on its own private Appomattox. The script was gone over with a fine-tooth comb." See Rod Serling, "Author's Comment: *Noon on Doomsday,*" in *Television Plays for Writers: Eight Television Plays with Comment and Analysis by the Authors,* ed. A. S. Burack (Boston: The Writer, 1957), 355. This volume reproduces the script of *Noon on Doomsday,* followed by a short author's comment, which repeats some of the material in *Patterns.*

9. Serling, "Author's Comment," 353, 357.

10. Serling, *Patterns,* 20.

11. Ibid., 23.

12. "Tale of a Script," *Time* 71, no. 6 (June 30, 1958): 38. For a review of the play, which lauds the network for airing it, see Jack Gould, "Prejudice Dissected: Rod Serling's 'A Town Has Turned to Dust' Offered on 'Playhouse 90,'" *New York Times,* June 20, 1958, 47.

13. Engel, *Rod Serling,* 195.

14. Dave Jampel, "With Rod and Reel: A Serling Safari Through Far East," *Variety* 232, no. 13 (November 20, 1963): 48.

15. See Rod Serling, "TV's Sacred Cows," *Writer's Digest Magazine* 36, no. 8 (July 1955), reproduced in *Legends of Literature: The Best Articles, Interviews, and Essays from the Archives of "Writer's Digest" Magazine,* ed. Phillip Sexton (Cincinnati, Ohio: Writer's Digest Books, 2007): 173, 174.

16. Indispensable to any discussion of *The Twilight Zone* is Martin Grams's comprehensive book *The Twilight Zone: Unlocking the Doors to a Television Classic* (Churchville, Md.: OTR Publishing, 2008), which covers the history of the show and provides an episode guide

along with some illuminating archival materials. Equally invaluable is Marc Scott Zicree's *Twilight Zone Companion,* 2nd ed. (Los Angeles: Silman-James Press, 1989). Serling's original ninety-two scripts for *The Twilight Zone* have been published in ten volumes edited by Tony Albarella and collectively titled *As Timeless as Infinity: The Complete Twilight Zone Scripts of Rod Serling* (Colorado Springs: Gauntlet Publications, 2004–13). Enriching the volumes are Albarella's commentaries on the episodes, some early drafts with handwritten notes, appreciations and interviews with colleagues, production photographs, correspondence, and music cue sheets.

17. Albarella, *As Timeless as Infinity,* 4:93.

18. Clipping reprinted in ibid., 107.

19. *In the Presence of Mine Enemies,* directed by Fielder Cook (1960, CBS), collection of the Paley Center for Media, New York (hereafter Paley Center files). *Playhouse 90* episodes are notoriously difficult to view; the Paley Center is one of the few venues to hold a copy of *In the Presence of Mine Enemies.* All unattributed quotes in the text are from the *Playhouse 90* episode unless otherwise specified. For the sole past discussion of the teleplay, see Shandler, *While America Watches,* 56–60.

20. Serling, *Patterns,* 16.

21. Rod Serling quoted in Gary Gerani with Paul H. Schulman, *Fantastic Television* (New York: Harmony Books, 1977), 38.

22. Serling, *Patterns,* 17.

23. Ibid., 17, 18.

24. Stan and Sue Goldberg to Rod Serling, May 19, 1960, box 12, folder 3, Serling Papers.

25. "Rod Serling's 'In the Presence of Mine Enemies' to be Presented in May on 'Playhouse 90,'" CBS advance press release, February 7, 1960, Rod Serling files of the Paley Center files.

26. "Charles Laughton to Star as Rabbi in Rod Serling Teleplay, 'In the Presence of Mine Enemies,' 'Playhouse 90' Special," CBS press release, April 25, 1960, Paley Center files.

27. "Charles Laughton (as a Rabbi) Welcomes Chance to Portray Man Who Has Both Feet on the Ground," May 4, 1960, Paley Center files.

28. "Playhouse 90-Drama," *TV Guide* (1960), A57, Paley Center files.

29. John Hersey, *The Wall* (New York: Alfred A. Knopf, 1950), 369.

30. Jack Gould, "TV: Ghetto Tragedy, Rod Serling's 'In the Presence of Mine Enemies' on 'Playhouse 90,'" *New York Times,* May 19, 1960, 75.

31. Sigmund Freud, *The Future of an Illusion,* trans. and ed. James Strachey (New York: Norton, 1975).

32. "In the Presence of Mine Enemies," revised draft (Serling's term for the second draft), March 19, 1960, box 56, folder 3, Serling Papers. In the first draft (November 6, 1959, box 56, folder 2), Heller kills Paul on the staircase of the apartment building. The third draft, labeled "final revised," is dated April 26, 1960 (box 56, folder 4).

33. When Alan Pakula, the director of *Sophie's Choice,* was raising money to make the film version of Styron's story, it was suggested that he give the story a happy ending, which he refused to do. See Janet Maslin, "Bringing 'Sophie's Choice' to the Screen," *New York Times,* May 9, 1982, 15.

34. This later production accurately notes in a written epilogue that the story takes place in January 1943, with the smaller, initial revolt occurring from January 18 to January 22.

35. *Daily Variety Review,* May 23, 1960, Paley Center files.

36. *Weekly Variety Review,* May 25, 1960, Paley Center files.

37. Brett Willis, "In the Presence of Mine Enemies," *Christian Spotlight on Entertainment,* http://www.christiananswers.net/spotlight/movies/2001/inthepresenceofmineenemies.html, accessed June 26, 2014.

38. "In the Presence of Mine Enemies," *New York Times,* April 18, 1997, 18.

39. Howard Rosenberg, "'Enemies' Remake: New Cast, Familiar Theme," *Los Angeles Times,* April 19, 1997, 14.

40. Rod Serling to Joseph Schildkraut, September 29, 1959, box 23, folder 3, Serling Papers.

41. Rod Serling to Bob (no last name), May 13, 1960, box 24, folder 2, Serling Papers.

42. Rod Serling to Ben Irwin, June 1, 1960, box 24, folder 2, Serling Papers. Ben Irwin said he was "tremendously moved" by the play and felt that it was effective within the framework of what television permits. Ben Irwin to Rod Serling, May 24, 1960, box 24, folder 2, Serling Papers. Comments on the poor casting of

Laughton also appear in Serling's letter to Batya Bauman, July 13, 1960, among other correspondence. Box 13, folder 3, Serling Papers.

43. John Crosby, "Distinguished Failure," *New York Herald Tribune,* May 29, 1960, 9, Paley Center files. "In the Presence of Mine Enemies," *Weekly Variety Review,* Paley Center files.

44. Rod Serling to Julius and Rho Galden, June 1, 1960, box 24, folder 2, Serling Papers.

45. A few years before *In the Presence of Mine Enemies* aired, Leon Uris delivered a lecture as part of a series at the University of Southern California's School of Library Science. There he complimented Serling: "Rod Serling, a very talented TV writer once said that no matter how glamorous a writer's office is, when he puts the seat of the pants to the seat of the chair it becomes a small dark room. And that is how I learned to write." Leon Uris, "About 'Exodus,'" in *The Quest for Truth,* ed. Martha Boaz (New York: Scarecrow Press, 1961), 126.

46. As quoted in Sander, *Serling,* 156.

47. William Zuckerman, "A Zionist Protest," *Jewish Newsletter* 16, no. 12 (June 13, 1960): 4, box 24, folder 2, Serling Papers.

48. Ann Landers to Rod Serling, May 27, 1960, box 24, folder 2, Serling Papers.

49. See letters from Rod Serling to Leon Uris, June 17, 1960; Uris to Serling, June 25, 1960; Serling to Uris, July 6, 1960; box 13, folder 1, Serling Papers.

50. Chaim Mosheh Bookson, "Warsaw Ghetto T.V. Drama Assailed," *Jewish Press,* July 1, 1960, clipping in box 13, folder 3, Serling Papers.

51. The "1939" Club to Frank Stanton, June 11, 1960, box 13, folder 3, Serling Papers.

52. Dorit B. Whiteman to Rod Serling, May 1960, box 12, folder 2, Serling Papers.

53. Helen Buck to Rod Serling, May 20, 1960, box 12, folder 3, Serling Papers.

54. Art Barron to Rod Serling, June 30, 1960, box 13, folder 2, Serling Papers.

55. Shirley Simpson to Rod Serling, May 19, 1960, box 12, folder 3, Serling Papers.

56. J. Rosenblum to Rod Serling, May 18, 1960, box 12, folder 3, Serling Papers.

57. Lil Garrison to Rod Serling, May 18, 1960, box 12, folder 3, Serling Papers.

58. See Hans Robert Jauss, "Literary History as a Challenge to Literary Theory," in *Toward an Aesthetic of Reception,* trans. Timothy Bahti (Minneapolis: University of Minnesota Press, 1982), 3–45. As Jauss establishes in several instances: "The new literary work is received and judged against the background of other works of art as well as against the background of the everyday experience of life" (41).

59. On the original production and responses to it, see Edna Nahshon, "Anne Frank from Page to Stage," in *Anne Frank Unbound: Media, Imagination, Memory,* ed. Barbara Kirshenblatt-Gimblett and Jeffrey Shandler (Bloomington: Indiana University Press, 2012), 59–92.

60. Shirer, "John Hersey's Superb Novel," 1, with Gropper's print from *Your Brother's Blood Cries Out* and *Never to Forget: The Battle of the Warsaw Ghetto* accompanying the article.

61. For an excellent discussion of the Americanization of Anne Frank, see Judith E. Doneson, "The American History of Anne Frank's Diary," *Holocaust and Genocide Studies* 2, no. 1 (1987): 149–60.

62. Frances Goodrich and Albert Hackett, *The Diary of Anne Frank* (New York: Random House, 1956), 168. A passage from the April 11, 1944, diary entry is particularized: "Who has inflicted this on us? Who has set us apart from all the rest? Who has put us through such suffering? It's God who has made us the way we are, but it's also God who will lift us up again. In the eyes of the world, we're doomed, but if, after all this suffering, there are still Jews left, the Jewish people will be held up as an example. Who knows, maybe our religion will teach the world and all the people in it about goodness, and that's the reason, the only reason, we have to suffer now. We can never be just Dutch, or just English, or whatever, we will always be Jews as well. And we'll have to keep on being Jews, but then, we'll want to be." Anne Frank, *The Diary of a Young Girl,* ed. Otto H. Frank and Mirjam Pressler, trans. Susan Massotty (New York: Doubleday, 1995), 261.

63. Nancy Sinkoff, "Fiction's Archive: Authenticity, Ethnography, and Philosemitism in John Hersey's *The Wall,*" *Jewish Social Studies: History, Culture, Society* 17, no. 2 (Winter 2011): 48–79.

64. John P. Shanley, "Nuremberg Judgment," *New York Times,* April 17, 1959, 53.

65. Bosley Crowther, "The Screen: The Stranger," *New York Times,* July 11, 1946, 18. For an overview of Holocaust film in this earlier

period, see Lawrence Baron, *Projecting the Holocaust into the Present: The Changing Focus of Contemporary Holocaust Cinema* (Lanham, Md.: Rowman & Littlefield, 2005), 23–42.

66. Anne Frank's diary aside, in this early period some nonfiction accounts looked at the efforts of gentiles to save Jews. Aage Bertelsen's *October '43* (1954) describes the successful effort of Nazi-occupied Denmark to smuggle almost the entirety of the country's six thousand Jews to safety in Sweden. See also Philip Friedman's *Their Brothers' Keepers* (New York: Crown Publishers, 1957). Friedman, who survived the war in hiding outside the Lodz Ghetto and testified at the Nuremberg trials, edited an early volume comprising primary documents about the Warsaw Ghetto (*Martyrs and Fighters: The Epic of the Warsaw Ghetto* [New York: Frederick A. Praeger, 1954]) three years before his account of Christian rescuers. These books, though, did not garner as large an audience as *In the Presence of Mine Enemies* and more often than not drew readers already prepared for what was inside the covers. Further, these books do not feature so-called "good" Nazis.

67. Rod Serling to Norman Krasner, July 13, 1960, box 13, folder 3, Serling Papers.

68. Jauss, "Literary History," 20.

69. Edith Leonard to Rod Serling, May 18, 1960, box 12, folder 3, Serling Papers.

70. Freda Katz to Rod Serling, May 18, 1960, box 12, folder 3, Serling Papers.

71. Rod Serling to Raymond E. Weston, June 1, 1960, box 24, folder 2, Serling Papers.

72. Warren Franklin, "Serling," May 15, 1960, UPI teletype of an article that appeared in various U.S. newspapers over the next few days, box 12, folder 2, Serling Papers.

73. See, for example, Rod Serling to John F. Hatchett, June 22, 1960, box 13, folder 1, Serling Papers.

74. Donald N. Schorr to Rod Serling, April 22, 1960, box 12, folder 2, Serling Papers. In response to another letter on the same subject, Serling reminded the writer that he did in fact write two *Playhouse 90* scripts on Communist themes and that *Playhouse 90* presented two other shows about Communism. Rod Serling to Margaret A. Prendergast, June 16, 1960, box 12, folder 7, Serling Papers.

75. Rod Serling to Donald N. Schorr, May 5, 1960, box 12, folder 2, Serling Papers.

76. Betty F. Sturm to Rod Serling, May 18, 1960, box 12, folder 3, Serling Papers.

77. Maxine Jackson to Rod Serling, May 19, 1960, box 12, folder 3, Serling Papers.

78. Albarella, *As Timeless as Infinity,* 3:221–22.

79. Ibid., 242.

80. Mark Kneece, *Rod Serling's The Twilight Zone: Deaths-Head Revisited,* ill. by Chris Lie (New York: Walker, 2009). Other *Twilight Zone* adaptations into graphic novels include *The Monsters Are Due on Maple Street* and *Will the Real Martian Please Stand Up.*

81. For a copy of this script, see Albarella, *As Timeless as Infinity,* 6:255–318. The quote in the text was transcribed from the episode as broadcast.

82. "Hitler" also appears in a *Twilight Zone* episode five months after *In the Presence of Mine Enemies.* Titled "The Man in the Bottle" (October 7, 1960), the story revolves around a genie in a bottle who grants an upstanding couple four wishes. The husband requests to be the leader of a modern formidable country that cannot remove him from office. In a signature surprise, the man is transformed into Hitler and finds himself hiding in a German bunker near the end of World War II, preparing to ingest a fatal dose of cyanide. Six months later, Hitler is alluded to in "The Mind and the Matter" (May 12, 1961). A misanthropic man learns how to concentrate so deeply that he can eliminate people with his thoughts. After his first success, eradicating his landlady, the man paraphrases Hitler: "Today the landlady, tomorrow the world!" As Hitler said: "Today Germany, tomorrow the world." A twentieth-century time traveler hopes to change some of the most awful moments in history, including World War II, in "No Time Like the Past" (March 7, 1963). After warning an official in Hiroshima about the atomic bomb, to no avail, he unsuccessfully attempts to assassinate Hitler in August 1939, one month before the start of World War II. Peering out of the Berlin hotel window, with actual film footage of Hitler leading a rally, the time traveler has Hitler in the crosshairs of his rifle—but the weapon fails to discharge.

83. Albarella, *As Timeless as Infinity,* 6:318.

84. Rod Serling to Chaim Mosheh Bookson, August 30, 1960, box 13, folder 6, Serling Papers.

85. On *Night Gallery,* see Scott Skelton and Jim Benson, *Rod Serling's Night Gallery: An After-Hours Tour* (Syracuse: Syracuse University Press, 1999).

86. Rod Serling, *The Season to Be Wary* (Boston: Little, Brown, 1967). Serling dedicated *The Season to Be Wary* to Davis: "For Sammy Davis, Jr., my friend. He has probably gotten just about everything possible out of life except a book dedicated to him . . . until now." Not only was the story condensed, but other small details were changed; Bluem, for example, was named Zamorski in the novella. Quotations from *The Season to Be Wary* are cited by page number parenthetically in the text.

87. One script by Serling, *Requiem for a Heavyweight,* reached Broadway on February 28, starring John Lithgow and George Segal, but its short run comprised eight previews and three performances.

88. Very little has been written about Lampell's version of *The Wall* or even about Lampell himself. For the only past contributions to this conversation, see Robert Franciosi, "Bringing *The Wall* to Broadway." *Journal of American Drama and Theatre* 16, no. 2 (2004): 88–97, and Lawrence L. Langer, "The Americanization of the Holocaust on Stage and Screen," in *From Hester Street to Hollywood: The Jewish-American Stage and Screen,* ed. Sarah Blacher Cohen (Bloomington: Indiana University Press, 1983), 217–20.

89. Alice Payne Hackett and James Henry Burke, *80 Years of Best Sellers, 1895–1975* (New York: R. R. Bowker, 1977), 152, 153. Of late there has been an upsurge of scholarly discussion about Hersey's *The Wall.* In "An Entirely Different Culture: English as Translation in John Hersey's *The Wall,*" in *Sounds of Defiance: The Holocaust, Multilingualism, and the Problem of English* (Lincoln: University of Nebraska Press, 2005), 34–49, Alan Rosen examines the role of language in the novel. See also Daniel R. Schwartz, *Imagining the Holocaust* (New York: St. Martin's Press, 1999), 143–59, and the aforementioned Sinkoff, "Fiction's Archive." For a discussion of the book's artistic program, see Robert Franciosi, "Designing John Hersey's *The Wall*: W. A. Dwiggins, George Salter, and the Challenges of American Holocaust Memory," *Book History* 11 (2008): 245–74.

90. John Hersey, "A Short Wait," *New Yorker* 23, no. 17 (June 14, 1947): 27–29.

91. John Hersey, *The Wall,* ill. by William Sharp (New York: Marchbanks Press, 1957).

92. John Hersey, "The Last Days of the Ghetto," *World Over* 11, no. 13 (April 21, 1950): 8–9.

93. John Hersey, "The Mechanics of a Novel," *Yale University Library Gazette* 27 (July 1952): 5.

94. Hersey, *The Wall* (1950).

95. For example, Millard Lampell to Lucy Kroll (agent), April 3, 1959, box 7, folder 1, Millard Lampell Papers, U.S. MSS 103AN, Wisconsin Center for Film and Theater Research (hereafter Lampell Papers).

96. *The Wall: A Play in Two Acts by Millard Lampell* (New York: Alfred A. Knopf, 1961), 30–31. The script was published with an introduction, a slightly modified version of the essay that had previously appeared in the autumn 1960 issue of *Midstream.*

97. On the Almanac Singers, see Richard A. Reuss with JoAnne C. Reuss, "The Almanac Singers: Proletarian 'Folk' Culture in Microcosm," in *American Folk Music and Left-Wing Politics, 1927–1957* (Lanham, Md.: Scarecrow Press, 2000), 147–78. For a short but informative interview with Lampell, see Paul Buhle, "Millard Lampell," in *Tender Comrades: A Backstory of the Hollywood Blacklist,* ed. Patrick McGilligan and Paul Buhle (New York: St. Martin's Press, 1997), 389–403.

98. Mike Landon [Millard Lampell], "Is There a Führer in the House," *New Republic* 9 (August 12, 1940): 212–13.

99. Lampell, "Bringing 'The Wall' to the Stage," 15.

100. Ibid., 14.

101. Ibid., 17.

102. Ibid., 19.

103. Walter Kerr, "First Night Report: *The Wall,*" *New York Herald Tribune,* October 12, 1960, clipping in box 9, folder 4, Lampell Papers.

104. Robert Coleman, "Robert Coleman's Theatre: 'Wall' Lacking in Emotional Punch," *New York Mirror,* October 12, 1960, clipping in box 9, folder 4, Lampell Papers.

105. John McClain, "'The Wall': Major Novel, Minor Play," *New York Journal American,* October 12, 1960, 23, clipping in box 9, folder 4, Lampell Papers. George M. Ross, of *Commentary* magazine, felt that Scott played Berson as flat

and too schematized. See Ross, "'The Wall' on Broadway," *Commentary* 31, no. 1 (January 1, 1961): 68.

106. Millard Lampell to Hiram Haydn, October 15, 1960, box 7, folder 1, Lampell Papers.

107. Notes on *The Wall*, box 9, folder 5, Lampell Papers.

108. Ibid.

109. Jay Carmody, "Arena Hits a Peak in Exciting 'Wall,'" *The Star,* January 30, 1964, 6, box 10, folder 7, Lampell Papers; Kathleen Carmody, "Another Wall," *Catholic Standard,* January 31, 1964, B6, box 10, folder 7, Lampell Papers.

110. Carmody, "Another Wall."

111. Richard D. Fletcher, "Arena Stage's 'Wall' Wins Highest Praise," *Christian Science Monitor,* February 19, 1964, clipping in box 10, folder 7, Lampell Papers.

112. Leo Sullivan, "Reconstructed Wall Proves Good Drama," *Washington Post,* January 31, 1964, 9.

113. Lampell, *The Wall: A Play in Two Acts,* 74–75.

114. Millard Lampell, *The Wall: A Drama in Three Acts* (New York: Samuel French, 1964), 56. Hersey's dialogue reads: "The Covenant . . . is in your heart. It's an inheritance in your fingertips and in the nerve behind your eyeball and in the drumstick of your ear and in the membranes of your nostrils—even if the Germans do not see anything Semitic about the outside of your nose. The heritage is in your heart, it is a glorious heritage, you should be proud of it" (188).

115. Lampell, *The Wall: A Play in Two Acts,* 83.

116. Ibid., 110.

117. Millard Lampell to (no first name) Taubman, October 23, 1960, box 7, folder 1, Lampell Papers.

118. Lampell, "Bringing 'The Wall' to the Stage," 16.

119. Ross, "'The Wall' on Broadway," 66, 68, 69.

120. S. Randolph Gaynes, "Despite Its Serious Theme, Play About Warsaw Ghetto Uprising Captures Audience," *Jewish Forum* 43, no. 11 (December 1960): 207, 208.

121. E.K., "The Wall," *Reconstructionist,* December 2, 1960, 5–6, box 9, folder 4, Lampell Papers.

122. David Boroff, "American Judaism Looks at the Living Arts," *American Judaism,* December 1960, 20, box 9, folder 4, Lampell Papers.

123. Ibid., 21.

124. Millard Lampell, "'The Wall': Its Message Is Life," *ADL Bulletin,* June 1961, 4–5, box 9, folder 5, Lampell Papers.

125. Eleanor Roosevelt, introduction to Anne Frank, *The Diary of a Young Girl,* trans. B. M. Mooyaart-Doubleday (Garden City, N.Y.: Doubleday, 1952), unpaged.

126. Goodrich and Hackett, *Diary of Anne Frank,* 168. At the end of the play the phrasing differs slightly: "In spite of everything, I still believe that people are really good at heart" (174).

127. Millard Lampell, introduction to *The Wall: A Play in Two Acts,* viii.

128. *The Wall,* directed by Robert Markowitz (1982; New York: HBO Home Video, 1996), VHS.

129. Lampell, "Bringing 'The Wall' to the Stage," 14.

Chapter 3

The first epigraph to this chapter is drawn from Uris, "About 'Exodus,'" 126–27; ellipsis in original. Uris delivered the lecture that included this quote as part of a series at the University of Southern California's School of Library Science. All invitees were charged to speak about their personal connection to their writing. Other notable lecturers included William Saroyan and Leonard Wibberley.

The second epigraph derives from Uris, *Mila 18* (1961), 410. Further quotations from *Mila 18* are taken from this edition and are cited by page number parenthetically in the text.

1. Leon Uris, *Exodus* (1958; repr., New York: Bantam Books, 1989), 131.

2. Uris, "About 'Exodus,'" 126. Uris wrote *Exodus* in 1957; the original manuscript was 1,500,000 words, cut down to 250,000 words for publication. Ibid., 130.

3. Ibid., 127.

4. Ibid.

5. M. M. Silver, *Our Exodus: Leon Uris and the Americanization of Israel's Founding Story* (Detroit: Wayne State University Press, 2010), 5. Silver's volume is an excellent full-length study of Uris's novel. For a broad overview of Uris's oeuvre, including a chapter discussing each of his novels through 1988's *Mitla Pass,* see Kathleen Shine Cain, *Leon Uris: A Critical Companion* (Westport, Conn.: Greenwood Press, 1998). See also Ira B. Nadel's in-depth study *Leon Uris: Life of a Best Seller* (Austin: University of Texas Press, 2010).

6. "Back to the Wall," review of *Mila 18, Time,* June 2, 1961, 94.

7. Ibid.

8. Uris, *Exodus,* 357.

9. Ibid., 578.

10. Uris, *Mila 18* (1961), back flap.

11. "Israel Blumenfeld, a Jewish Leader, 46," *New York Times,* March 29, 1962, 33.

12. Leon Uris to Tim Seldes, November 13, 1959, box 135, folder 7, Leon Uris Papers, Harry Ransom Center, University of Texas at Austin (hereafter Uris Papers).

13. Jewish-book-fairs speech (p. 5), box 181, folder 7, Uris Papers. This speech begins with Uris saying, "I was asked what I intended to speak about and I said I just wanted to chat with my people about writers and writing and being a Jew" (3).

14. Oversize folder 6, Uris Papers. Three of the chronologies appear on cardboard stock paper, 24 × 20 inches; the fourth is smaller, at 11 × 20 inches. In *Mila 18* the battle rages for forty-two days instead of the actual twenty-eight, an unnecessary ploy on Uris's part, it seems, to magnify even further the uprising's significance, and an example of how Uris was willing to distort the historical record for his narrative interests even as he worked diligently toward historical correctness. Similarly, in his fictionalization of the Oneg Shabbos group, Uris exaggerates the number of milk cans buried in the ghetto.

15. Leon Uris to William Uris, June 20, 1957, box 137, folder 8, Uris Papers.

16. George (first name unclear) J. Jaffe to Leon Uris, July 5, 1961, box 139, folder 2, Uris Papers.

17. "Mila 18," *Kirkus,* June 1, 1961, 370.

18. Quentin Reynolds, "In the Ghetto a Battle for the Conscience of the World," *New York Times Book Review,* June 4, 1961, 5. A full-page ad for *Mila 18,* with the book jacket prominently reproduced, appeared in the *New York Times* the next day (p. 29), with Reynolds's laudatory review partially reprinted. Atop the longer quotation, his comment that *Mila 18* "surpasses *Exodus* in every respect" was written in a bold, oversized font.

19. Orville Prescott, Books of the Times, *New York Times,* June 2, 1961, 29. Rose Feld also felt that *The Wall* had more to offer as a crafted novel: "On a literary level [*Mila 18*] falls short of the excellence of 'The Wall.' Hersey is a master of polished prose; Uris is not." Rose Feld, "Once More the Tragedy of Warsaw," *Herald Tribune Book Review,* June 4, 1961, 28.

20. George Adelman, review of *Mila 18, Library Journal,* June 15, 1961, 2339. Uris had Israeli relatives that survived the camps, including an uncle who published more than one memoir about the Holocaust, although this fact was not known until later. See, for example, Eliezer Yerushalmi, *Pinkas Shavli: Yoman mi-geto Lita'i, 1941–1944* (Jerusalem: Yad Vashem, 1958), in Hebrew.

21. Leon Uris to Tim Seldes, April 30, 1959, box 135, folder 7, Uris Papers.

22. Lanzmann, *Shoah,* 177.

23. Hackett and Burke, *80 Years of Best Sellers,* 160. *Mila 18* sold 134,397 copies in the first year. Ibid., 184.

24. Leon Uris, *Battle Cry* (New York: G. P. Putnam's Sons, 1953), 443.

25. Patrick Cruttwell, "Synthetic Tragedy," *Guardian,* October 27, 1961, 7.

26. Leon Uris to William Uris, March 4, 1958, box 137, folder 8, Uris Papers.

27. Leon Uris to William Uris, December 22, 1964, box 137, folder 10, Uris Papers.

28. Benjamin Ward Richardson, *Diseases of Modern Life* (New York: Bermingham, 1882), 98. The author goes on to praise Jews for their unlikely survival despite such diminished capacity: "In the course of centuries the most powerful nations have died out, and empires of perfect physical beauty and chivalric fame have passed away. But through all these vicissitudes one race [Jews], cultivating none of the so-called athletic and heroic qualities, . . . has held its irrepressible own." Ibid.

29. Mark Twain, "Concerning the Jews," in *The Complete Essays of Mark Twain,* ed. Charles Neider (Garden City, N.J.: Doubleday, 1963), 240.

30. Mark Twain, "The Jew as Soldier," in *Complete Essays,* 250.

31. Simon Wolf, *The American Jew as Patriot, Soldier, and Citizen* (Philadelphia: Levytype, 1895), 10.

32. Roger Mitchell, "Recent Jewish Immigration to the United States," *Popular Science Monthly,* February 1903, 342, as cited in Robert Singerman, "The Jew as Racial Alien: The Genetic Component of American Anti-Semitism," in *Anti-Semitism in American History,* ed. David A. Gerber (Urbana: University of Illinois Press, 1986), 109.

33. Curt Reiss, introduction to *The Fighting Jew,* viii.

34. Davis, *Jews Fight Too!,* 13.

35. Learsi, *The Jew in Battle,* 60, 63. On Jews and the military, across continents and in conjunction with Jewish ideas about fighting, beginning with biblical and rabbinical commentary, see Derek J. Penslar, *Jews and the Military: A History* (Princeton: Princeton University Press, 2013).

36. "Fighting Jews," 2.

37. Yuri Suhl, introduction to *They Fought Back: The Story of Jewish Resistance in Nazi Europe,* ed. and trans. Yuri Suhl (New York: Crown Publishers, 1967), 3, and Ber Mark, "The Warsaw Ghetto Uprising," in ibid., 92–127.

38. Program, dated October 23, 1991, titled *Havdalah with the President: Celebrating the First Week of B'nai B'rith's 151st Year,* box 183, folder 2, pp. 7–8, Uris Papers. Clinton's address can be found on pp. 6–8.

39. Jewish-book-fairs speech, 9.

40. The entire original call to resistance can be found in Arad, Gutman, and Margaliot, *Documents on the Holocaust,* 301–2.

41. Uris also has a character admiringly refer to Steinbeck's *In Dubious Battle* in *Mitla Pass,* a novel with some autobiographical inflections, about a Jewish American writer who goes to Israel to find source material for a new book and fights in the 1956 Sinai War. Leon Uris, *Mitla Pass* (New York: Doubleday, 1988), 365. In various speeches Uris described Steinbeck as his "personal idol" and quoted him. See, for example, box 181, folder 7, Uris Papers. On April 10, 1962, Uris, in answer to a fan letter from Jane Pacht, wrote: "If there is one writer whom I would credit for having a tremendous influence on my career that would be the early works

of John Steinbeck." See box 139, folder 2, Uris Papers.

42. "The Last Battle in the Great Tragedy," reprinted in Arad, Gutman, and Margaliot, in *Documents on the Holocaust,* 320 (entire reprint on 319–20).

43. David Ben-Gurion, as quoted in Israel Gutman, *Resistance: The Warsaw Ghetto Uprising* (Boston: Houghton Mifflin, 1994), 257. Ben-Gurion made these remarks in February 1943, at a commemoration honoring the battle at Tel Hai (the original subject of Szyk's 1936 Zelig-like image, discussed in chapter 1). Preceding this statement was a nod toward the legacy of Tel Hai for the Warsaw Ghetto rebellion, quoted in further depth: "The death of the defenders of Tel Hai was not in vain. Six days ago news reached us that our comrades in Warsaw—the tiny remnant of Jews still there, decided to fight for their lives and organized small groups to rise up and defend themselves. . . . [The fighters in the Warsaw Ghetto] have learned the new lesson of death which the defenders of Tel Hai and Sedgera have bequeathed to us—the heroic death." Ibid.

44. On the latter miniseries, see Doneson, *Holocaust in American Film,* 144–96, and Shandler, *While America Watches,* 159–78.

45. Paula E. Hyman, *Gender and Assimilation in Modern Jewish History: The Roles and Representation of Women* (Seattle: University of Washington Press, 1995), 134. Daniel Boyarin offers a different view, for which see note 56 to chapter 1.

46. Sander L. Gilman, *Freud, Race, and Gender* (Princeton: Princeton University Press, 1993), 85. For a fascinating discussion of different views on Jewish circumcision, see especially chapter 2, "The Construction of the Male Jew," in ibid., 49–92. Also essential reading, and influential on my work, is Sander Gilman, *The Jew's Body* (London: Routledge, 1991).

47. Gilman, *Freud, Race, and Gender,* 39.

48. Sigmund Freud, "Leonardo Da Vinci and a Memory of His Childhood," in *The Standard Edition of the Complete Psychological Works of Sigmund Freud,* vol. 11, trans. and ed. James Strachey et al. (London: Hogarth Press, 1957), 95–96n3.

49. Sigmund Freud, "Analysis of a Phobia in a Five-Year-Old Boy," in *Standard Edition,* vol. 10 (1955), 36 n. 1.

50. Ibid., 36.

51. Gérard Genette, *Paratexts: Thresholds of Interpretation*, trans. Jane E. Lewin (Cambridge: Cambridge University Press, 1997), 2, 1; emphasis in original.

52. Ibid., 344.

53. Francis Whitaker, *Beautiful Iron: The Pursuit of Excellence* (self-published, ca. 1997), unpaged. The literature on Whitaker is scarce, comprising only a few self-published items. This is a shame, considering his mastery of iron and influence on subsequent blacksmiths. He founded two branches of the Francis Whitaker Blacksmith School, and the Smithsonian American Art Museum owns an example of his work. Among Whitaker's many objects and architectural designs are andirons, candlesticks, door hardware, and gates.

54. Breines, *Tough Jews,* 175. A bibliography of "tough Jewish novels," as Breines terms them, can be found in ibid., 265–67. This subgenre peaked in the early 1980s. Ibid., 236.

55. Although beyond the purview of this analysis, it is interesting to note that the end-paper design for *Exodus* also held significance: maps of Israel decorated these areas as a means to orient the reader. Maps are included at the outset of each of the five books of *Exodus*—an obvious reference to the Five Books of Moses that make up the Torah.

56. Uris, "About 'Exodus,'" 128.

57. Leon Uris to Tim Seldes, October 31, 1961, box 135, folder 7, Uris Papers.

58. *Mila 18,* final galley proof, galley files, Uris Papers.

59. Jacques Lipchitz with H. H. Arnason, *My Life in Sculpture* (New York: Viking Press, 1972), 131–32.

60. Hackett and Burke, *80 Years of Best Sellers,* 183.

61. Leon Uris to William Uris, June 15, 1962, box 137, folder 8, Uris Papers.

62. Leon Uris, *Mila 18* (New York: Bantam Books, 1962).

63. Phoebe Adams, "Warsaw Ghetto," *Atlantic Monthly,* August 1961, 94.

64. Leon Uris, "The Most Heroic Story of Our Century," *Coronet,* November 1960, 173.

65. Ibid., 174.

66. Ibid., 175, 177.

67. Leon Uris, "The Rising of the Warsaw Ghetto" (unpublished script), 1, box 181, folder 7, Uris Papers.

68. Ibid., 1. Brandel reports in his journal: "The Star of David flies over the Warsaw ghetto! A Jewish army controls the first autonomous piece of Jewish land in nearly two thousand years of our dispersal." Uris, *Mila 18* (1961), 429.

69. Uris, "Rising of the Warsaw Ghetto," 3.

70. Ibid., 5. Of interest, Uris added the word "redeemed" by hand in one draft, but it does not appear in others.

71. Speech to Jewish-studies departments, box 181, folder 7, Uris Papers.

72. The example here is cited from a speech given at Temple Beth Shalom, Jacksonville, Fla., April 14, 1991, box 183, folder 1, Uris Papers.

73. Speech in Riga, October 15, 1989, pp. 2 and 3, box 149, folder 6, Uris Papers.

74. Ibid., 2.

75. This version of his recollection comes from a speech delivered in Hartford, Connecticut, on October 6, 1991, pp. 19–20, box 183, folder 1, Uris Papers.

76. Uris, "About 'Exodus,'" 127.

77. Ibid.

78. Krall, *Shielding the Flame,* 5.

79. Box 58, folder 7, Uris Papers. The artist's name is challenging to make out, but his surname may be Lachur and the date 1952. A little-known or -documented Polish artist named Maciej Lachur lived from 1927 to 2008, and it would be reasonable to assume that he made the image, considering he engaged the subject of the Warsaw Ghetto on another occasion.

80. Box 58, folder 7, Uris Papers. Chapter 5 of this book revisits *Mila 18* to investigate Uris's auxiliary preoccupation with the ghetto's children and their fate.

81. Leon Uris to Tim Seldes, December 12, 1961, box 135, folder 7, Uris Papers.

82. Allan H. Caplan to Leon Uris, June 19, 1979, box 63, folder 1, Uris Papers.

83. Leon Uris to Allan H. Caplan, June 28, 1979, box 63, folder 1, Uris Papers.

84. Leon Uris quoted in Foster Hirsch, *Otto Preminger: The Man Who Would Be King* (New York: Alfred A. Knopf, 2007), 284.

85. Herbert Schlosberg to Gregg Abrams, April 5, 1989, box 158, folder 1, Uris Papers.

86. Ira Trattner to Herbert Schlosberg, February 4, 1991, box 158, folder 1, Uris Papers.

87. Fax from Ira Trattner to Leon Uris, February 27, 1992, box 62, folder 7, Uris Papers. For the role of Deborah Bronski, the actresses

Julia Roberts, Debra Winger, Cher, Susan Sarandon, and Barbra Streisand were among many proposed. Christopher de Monti's casting choice was equally diverse, with Liam Neeson again a prime candidate, along with William Hurt, Jeremy Irons, Daniel Day-Lewis, and Mikhail Baryshnikov, to name only some of the possibilities. All the names were subject to Uris's approval. A shooting schedule was also laid out, but the film never came to fruition.

88. Leon Uris and Dimitrios Harissiadis, *Exodus Revisited* (Garden City, N.Y.: Doubleday, 1960). References to this work are cited by page number parenthetically in the text.

89. Uris, "Rising of the Warsaw Ghetto," 5.

90. Leslie A. Fiedler, *The Jew in the American Novel,* Herzl Institute Pamphlet No. 10. (New York: Herzl Institute, 1959), 8; emphasis in original.

91. Bernard Malamud, *The Assistant* (1957; repr., New York: Farrar, Straus & Giroux, 2003), 86.

92. Leon Uris, interviewed by Joseph Wershiba, "Daily Closeup: Leon Uris, Author of 'Exodus,'" *New York Post,* July 2, 1959, 34.

93. Uris, *Exodus,* opening page.

94. Leon Uris to William Uris, June 25, 1956, box 137, folder 7, Uris Papers; ellipses in original.

95. Philip Roth, "The New Jewish Stereotypes," *American Judaism* 11 (Winter 1961): 10–11, 49–51, reproduced in Roth's *Reading Myself and Others* (New York: Farrar, Straus & Giroux, 1975), 137–47, with numerous word and editorial changes and revisions; a final paragraph does not appear in the revision. I quote the original here because it is the version from which Uris would have read and which the public would have seen in 1961.

96. Roth, "New Jewish Stereotypes," 10.

97. Ibid., 49.

98. On Israel in Roth's novels, see Andrew Furman, "A New 'Other' Emerges in American Jewish Literature: Philip Roth's Israel Fiction," *Contemporary Literature* 36 (1995): 633–53. Israel also features prominently, for example, in *Operation Shylock* (1993).

99. Philip Roth, *The Counterlife* (New York: Farrar Straus Giroux, 1986), 56, 57.

100. Ibid., 127; emphasis in original. A few years after, in a biography of his father in old age, Roth espouses a vastly different perspective—notably referring to himself, obviously a Diaspora Jew: "We're the sons appalled by violence, with no capacity for inflicting physical pain, useless at beating and clubbing, unfit to pulverize even the most deserving enemy. . . . When we lay waste, when we efface, it isn't with raging fists or ruthless schemes or insane sprawling violence but with our words, our brains, with mentality." *Patrimony: A True Story* (New York: Simon & Schuster, 1991), 159.

101. Roth, *Counterlife,* 180, 181; emphasis in original.

102. Philip Roth, *Portnoy's Complaint* (New York: Ballantine Books, 1985), 299.

103. Roth, "New Jewish Stereotypes," 11.

104. Uris, "About 'Exodus,'" 128.

105. Midge Decter, "Popular Jews," *Commentary* 32, no. 4 (October 1961): 358–59, reprinted in Decter's *Liberated Woman and Other Americans* (New York: Coward, McCann & Geoghegan, 1971), 117–18, 119.

106. Box 59, folder 1, Uris Papers. Someone sent Uris two copies of each column, which remained in sealed envelopes until his death.

107. "Random Notes in Washington: A Diagnosis by Dr. Stevenson," *New York Times,* October 23, 1961, 14.

108. Keith Hernandez quoted in George Vecsey, "Historian at First Base," *New York Times,* August 28, 1983, S3.

109. Lyman, "Watching Movies with Harvey Weinstein," 20.

110. Lawrence Van Gelder, "Arts Briefing," *New York Times,* February 3, 2004, E2.

111. Gerri Kalb to Leon Uris, September 28, 1961, box 139, folder 2, Uris Papers.

112. Letter with an illegible signature to Leon Uris, October 31, 1961, box 139, folder 3, Uris Papers.

113. Joel Carmichael, "The Phenomenal Leon Uris," *Midstream* 7 (Autumn 1961): 87, 88.

114. Ibid., 88.

115. Ibid., 88, 89.

116. See note 112 above.

117. Elie Wiesel, "Trivializing the Holocaust: Semi-fact and Semi-fiction," *New York Times,* April 16, 1978, 1.

118. Novick, *Holocaust in American Life,* 209. Judith Doneson estimates the viewership at 120 million, amounting to over 50 percent of the population. See Doneson, *Holocaust in American Film,* 189.

119. From an introduction to a larger body of writing in the Oneg Shabbos Archive, reprinted

in *To Live with Honor and Die with Honor! Selected Documents from the Warsaw Ghetto Underground Archives "O.S." ("Oneg Sabbath"),* ed. Joseph Kermish (Jerusalem: Yad Vashem, 1986), 24. The longer quote reads: "I consider it a sacred duty for everyone, whether capable or not, to write down everything he himself has seen, or heard from those that have seen, of the outrages committed by the barbarians in every Jewish town. It must all be recorded with not a single fact omitted. And when the time comes—as it surely will—let the world read and know what the murderers have done. This will be the mourner's richest material when he comes to write the elegy on present times. This [our archive] will be the avenger's strongest substance when he comes to settle accounts."

Chapter 4

The first epigraph to this chapter is quoted in Richard Raskin, *A Child at Gunpoint: A Case Study in the Life of a Photo* (Aarhus: Aarhus University Press, 2004), 154.

The second epigraph is quoted in Steiner, *Language and Silence,* 168.

1. Quoted in Gutman, *Resistance,* 136.
2. Debórah Dwork, *Children with a Star: Jewish Youth in Nazi Europe* (New Haven: Yale University Press, 1991), xi. For more on children's experiences during the war, Jewish and otherwise, see Nicholas Stargardt, *Witnesses of War: Children's Lives Under the Nazis* (New York: Alfred A. Knopf, 2005). Specifically looking at the ghetto, see Barbara Engelking-Boni, "Childhood in the Warsaw Ghetto," in *Children and the Holocaust: Symposium Presentations* (Washington, D.C.: Center for Advanced Holocaust Studies, United States Holocaust Memorial Museum, 2004), 33–42.
3. A prominent instance of the appeal of children to symbolize the cruelty of the Holocaust, although not about the Warsaw Ghetto, reached a vast audience more than forty years later when Steven Spielberg effectively employed a child in his commercially successful, Oscar-winning film *Schindler's List* (1993). In a medium different from Szyk's print, and generations removed from the war, the black-and-white film uses color for effect. Some of the most memorable scenes in *Schindler's List* are those where a little girl in a red coat aimlessly roams the Krakow Ghetto, evincing the bloodstained fate of the Jews. In Spielberg's telling, it was this very child who stirred Oskar Schindler's conscience and compelled him to save the Jews in his factory.

4. Lawrence L. Langer, *The Holocaust and the Literary Imagination* (New Haven: Yale University Press, 1975), 124.
5. Marianne Hirsch, *The Generation of Postmemory: Writing and Visual Culture After the Holocaust* (New York: Columbia University Press, 2012), 167.
6. Marianne Hirsch, "Projected Memory: Holocaust Photographs in Personal and Public Fantasy," in *Acts of Memory: Cultural Recall in the Present,* ed. Mieke Bal, Jonathan Crewe, and Leo Spitzer (Hanover: University Press of New England, 1999), 13. Hirsch repeats this observation in "Nazi Photographs in Post-Holocaust Art: Gender as an Idiom of Memorialization," in *Crimes of War: Guilt and Denial in the Twentieth Century,* ed. Omer Bartov, Atina Grossmann, and Mary Nolan (New York: New Press, 2002), 111.
7. Michael Berenbaum, *The World Must Know: The History of the Holocaust as Told in the United States Holocaust Memorial Museum* (Boston: Little, Brown, 1993), 2–3. Invaluable to any discussion of the museum is Edward T. Linenthal's study of its creation, *Preserving Memory: The Struggle to Create America's Holocaust Museum* (New York: Viking, 1995).
8. Suhl, *They Fought Back,* dedication page.
9. *Black Book,* 8.
10. Ibid., 9.
11. Ibid., 43–45.
12. Adolph Hitler, *Mein Kampf,* trans. Ralph Manheim (1943; repr., Boston: Houghton Mifflin, 1971), 325. Translated slightly differently, this passage is highlighted in *The Black Book* (49).
13. *Black Book,* 50.
14. "Allies Condemn Nazi Plan to Destroy Jews of Europe," *World Over* 4, no. 6 (January 8, 1943): 2.

15. "A Child's Song of Courage," *World Over* 4, no. 2 (November 13, 1942): 6.

16. Ibid.

17. "Risks His Life to Save Torahs," *World Over* 4, no. 5 (December 25, 1942): 5.

18. "Revolt of the Warsaw Ghetto," *World Over* 5, no. 1 (October 29, 1943): 8–9. Illustrations by E. Schloss.

19. Ibid., 9.

20. "The Jewish Underground Fighters," *World Over* 5, no. 13 (April 13, 1944): 2.

21. "Remember the Battle of the Warsaw Ghetto," *World Over* 5, no. 14 (April 28, 1943): 2.

22. Ibid. See chapter 1 for discussion of this statement with a little more context.

23. Hersey, "Last Days of the Ghetto."

24. Stephen Fein, "Hanukkah Light in Warsaw," and Elchanan Indelman, "Underground Brigade," both in *The World Over Story Book,* ed. Norton Belth (New York: Bloch Publishing, 1952), 108–13 and 113–37.

25. Mordecai H. Lewittes, *Highlights of Jewish History,* vol. 4, *From the Middle Ages to Modern Times,* ill. by Sam Nisenson (New York: Hebrew Publishing, 1957), 294.

26. Morris Epstein, *A Picture Parade of Jewish History,* ill. by Maurice del Bourgo and F. L. Blake (New York: Shengold Publishers, 1963), 110–11.

27. The boy's identity is unknown, although a handful of men have come forward claiming that they are he. Two books unsuccessfully try to identify the child: Dan Porat, *The Boy: A Holocaust Story* (New York: Hill & Wang, 2010), and Raskin, *A Child at Gunpoint.* We do know the identity of the soldier holding the machine gun, Josef Blosche, who made the following statement after his arrest: "The picture shows I, as member of the Gestapo office in the Warsaw Ghetto, together with a group of SS members, am driving a large number of Jewish citizens out from a house. The group of Jewish citizens is comprised predominantly of children, women and old people, driven out of a house through a gateway, with their arms raised. The Jewish citizens were then led to the so-called *Umschlagplatz,* from which they were transported to the extermination camp Treblinka." See http://www.holocaustresearchproject.org/nazioccupation/boy.html, accessed March 23, 2015. Executed in Leipzig in July 1969, Blosche was, appropriately, like those Jews he sent to death, buried in an unmarked grave. Franz Konrad may have taken the photograph. Raskin, *A Child at Gunpoint,* 32.

28. Jürgen Stroop, *The Stroop Report: The Jewish Quarter of Warsaw Is No More!,* trans. Sybil Milton (New York: Pantheon Books, 1979), unpaged.

29. Most past analyses of the series cursorily review the iconography or only touch on a painting or handful of paintings. In the most sustained look at the series, Danna Nolan Fewell and Gary A. Phillips broadly, but still valuably, describe dozens of the paintings. See their *Icon of Loss: The Haunting Child of Samuel Bak* (Boston: Pucker Art Publications, 2009). Ziva Amishai-Maisels offers a closer visual analysis of two early canvases in "Haunting the Empty Place," in Feinstein, *Absence/Presence,* 131–33.

30. For more on this series, see Lawrence L. Langer, *Landscapes of Jewish Experience: Paintings by Samuel Bak* (Boston: Brandeis University Press, 1997).

31. Bak, as quoted in *Between Worlds: The Paintings and Drawings of Samuel Bak from 1946 to 2001,* ed. Irene Tayler (Boston: Pucker Art Publications, 2002), 297.

32. Samuel Bak, *Painted in Words* (Bloomington: Indiana University Press, 2001), 306.

33. Ibid., 127, 342.

34. Ibid., 332.

35. Ibid., 299.

36. Ibid., 300–302.

37. Ibid., 306.

38. Ibid., 33.

39. Ibid., 435.

40. Written initially for a German radio show and reprinted in Paul T. Nagano and Samuel Bak, *Samuel Bak: The Past Continues* (Boston: David R. Godine, 1988), unpaged.

41. Bak, *Painted in Words,* 33.

42. Ibid., 306.

43. Cathy Caruth, ed., *Trauma: Explorations in Memory* (Baltimore: Johns Hopkins University Press, 1995), 4–5. The literature of trauma studies, and the use of trauma theory as a tool to flesh out the meaning of images—mostly in the literary and filmic realms—has grown exponentially since the mid-1990s. Space constraints do not allow me to explicate all of these conceptions, which mostly begin from a place of belatedness and aftermath, but I do not use the term blithely.

I adopt Caruth's conception because of its clarity, breadth (not limited to the Holocaust), and widespread and successful use in the humanities. For Caruth's book-length treatment on trauma, see *Unclaimed Experience: Trauma, Narrative, and History* (Baltimore: Johns Hopkins University Press, 1996). See Ruth Leys, *Trauma: A Genealogy* (Chicago: University of Chicago Press, 2000), for a critique of Caruth and a historiography of trauma. Pivotal to the field is Shoshana Felman and Dori Laub's foundational *Testimony: Crises of Witnessing in Literature, Psychoanalysis, and History* (New York: Routledge, 1992), which concentrates on survivor testimony but makes points with wider applicability. I also single out Dominick LaCapra, who deftly employs trauma theory and its insistence on repetition, tempered by an unfavorable take on the redemptive narrative, to work through the meanings in literature. See, for example, his *Representing the Holocaust: History, Theory, Trauma* (Ithaca: Cornell University Press, 1994). For the most sustained attempt to discuss trauma in the visual arts, see Lisa Saltzman and Eric M. Rosenberg, eds., *Trauma and Visuality in Modernity* (Hanover: Dartmouth College Press, 2006).

44. Bak, *Painted in Words,* 129.

45. Ibid., 478, 479, 480. Although not a survivor, American artist Abraham Rattner also eschewed abstraction after the war, describing his turn toward personal subjects and disavowal of modernist forms as a reaction to World War II: "Hitler's voice disturbed me. It disturbed me in what I wanted to do. And I knew I could not keep on with abstraction, I could not keep on with the intellectual searching after an aesthetic direction, that I had to do something about this emotional thing in me." Abraham Rattner, oral history interview with Colette Roberts, May 20 and June 21, 1968, p. 13, transcript in the Archives of American Art, Smithsonian Institution, Washington, D.C.

46. Bak, *Painted in Words,* 12.

47. Ziva Amishai-Maisels, "Ben Shahn and the Problem of Jewish Identity," *Jewish Art* 12–13 (1986–87): 306.

48. Jack Levine, conversation with the author, New York City, July 24, 2010.

49. Judy Chicago, *Holocaust Project: From Darkness into Light* (New York: Penguin Books, 1993), 88.

50. Ibid., 134–35.

51. Judy Chicago, e-mail correspondence with the author, March 27, 2015.

52. Alvin H. Rosenfeld, "The Americanization of the Holocaust," *Commentary* 99, no. 6 (June 1995): 35–37. Rosenfeld expands on his Americanization thesis in "The Americanization of the Holocaust" of 1997. There he does not brand *Holocaust Project* atrocious but does characterize Chicago's foray as a "seriously skewed version of the Holocaust" (135).

53. Lawrence L. Langer, *Preempting the Holocaust* (New Haven: Yale University Press, 1998), 12.

54. Audrey Flack, telephone conversation with the author, March 28, 2007, and Ziva Amishai-Maisels, *Depiction and Interpretation: The Influence of the Holocaust on the Visual Arts* (New York: Pergamon Press, 1993), 210.

55. Audrey Flack, telephone conversation with the author, May 15, 2016.

56. M. Hirsch, "Nazi Photographs in Post-Holocaust Art," 100.

57. See http://www.bundestag.de/kulturundgeschichte/geschichte/gastredner/wiesel/rede/247400, accessed May 26, 2014.

58. Betty Jean Lifton, *The King of Children: A Biography of Janusz Korczak* (New York: Farrar, Straus & Giroux, 1988), 355. The Janusz Korczak Association, dedicated to perpetuating Korczak's ideals and recognizing his legacy, has twenty-one branches across the globe, including ones in the United States, Argentina, Germany, and Japan.

59. David A. Adler, *Child of the Warsaw Ghetto,* ill. by Karen Ritz (New York: Holiday House, 1995), unpaged. For a different approach, see Tomek Bogacki, *The Champion of Children: The Story of Janusz Korczak* (New York: Farrar Straus Giroux, 2009). This picture book attends more broadly to Korczak's life path while still discussing the children's misery and procession to the train station.

60. Christa Laird, *Shadow of the Wall* (1990; repr., New York: Greenwillow Books, 1997), 139–43.

61. Baron, *Projecting the Holocaust,* 174. For more on this structure and children's films, see Ian Wojcik-Andrews, *Children's Films: History, Ideology, Pedagogy, Theory* (New York: Garland, 2000).

62. *The Diary of Mary Berg: Growing Up in the Warsaw Ghetto,* ed. S. L. Shneiderman, new

273

Notes to Pages 179–190

exp. ed., prepared by Susan Lee Pentlin (Oxford: Oneworld, 2007), 170.

63. Yehoshue Perle, *Tvishn Lebn un Toyt,* ed. B. Mark (Warsaw: Farlag "Yidish bukh," 1955), 120. I am grateful to Sean Martin for his translation.

Chapter 5

The first epigraph to this chapter is drawn from Joe Kubert, *Yossel: April 19, 1943* (2003; repr., New York: DC Comics, 2011), unpaged introduction.

The second epigraph derives from Jerry Siegel, press release from 1975, quoted in Thomas Andrae and Mel Gordon, *Siegel and Shuster's Funnyman: The First Jewish Superhero* (Port Townsend, Wash.: Feral House, 2010), 59.

1. The first thirty-eight stories featuring the Unknown Soldier in the *Star Spangled War Stories* (nos. 151–90, June 1970–June 1975), before the character received his own title, can be found collected in Joe Kubert et al., *Showcase Presents: The Unknown Soldier,* vol. 1 (New York: DC Comics, 2006).

2. Bob Haney (writer), Dick Ayers (penciler), and Gerry Talaoc (illustrator), "A Season in Hell!," *The Unknown Soldier* 30, no. 247 (January 1981): 1, DC Comics; emphasis in original. All further references to comics derive from original copies in the author's own collection and are cited parenthetically in the text.

3. Ringelblum, *Notes from the Warsaw Ghetto,* 233–34, entry dated November 14, 1941.

4. *The Warsaw Ghetto Memoirs of Janusz Korczak,* trans. E. P. Kulawiec (Washington, D.C.: University Press of America, 1978), 110–11. Korczak's diary chronicles a short period, May to August 1942, until four days before he went willingly to Treblinka with the children.

5. *Diary of Mary Berg,* 73.

6. Janina Bauman, *Winter in the Morning: A Young Girl's Life in the Warsaw Ghetto and Beyond, 1939–1945* (New York: Free Press, 1986), 80.

7. Yitzhak Katznelson, *Vittel Diary (22.5.43–12.9.43),* trans. Myer Cohen, 2nd ed. (Tel Aviv: Hakibbutz Hameuchad, 1972), 53.

8. Charles Reznikoff, *Holocaust* (Los Angeles: Black Sparrow Press, 1975), 28–29.

64. See http://pasyn.org/resources/sermons/warsaw-ghetto-uprising, accessed May 26, 2014.

65. Bak, *Painted in Words,* 220.

66. Ibid., 297, 298.

9. Anthony Hecht, *Selected Poems,* ed. J. D. McClatchy (New York: Alfred A. Knopf, 2011), 189–90.

10. Yala Korwin, *To Tell the Story: Poems of the Holocaust* (New York: Holocaust Library, 1987), 76.

11. Serling, *Season to Be Wary,* 84.

12. Kenneth Treister, *A Sculpture of Love and Anguish: The Holocaust Memorial, Miami Beach, Florida,* with a foreword by Elie Wiesel (New York: S.P.I. Books, 1993).

13. Katznelson, *Vittel Diary,* 53.

14. As quoted in Harry Brod, *Superman Is Jewish? How Comic Book Superheroes Came to Serve Truth, Justice, and the Jewish-American Way* (New York: Free Press, 2012), 131–32. Kubert's six-issue miniseries *The Prophecy* (March–August 2006), published in its entirety the next year as a stand-alone book, freely mentions and pictures the death camps. Joe Kubert, *Sgt. Rock: The Prophecy* (New York: DC Comics, 2006). The story centers on a young Orthodox rabbi from Vilna whose followers believe he is the Messiah (the eponymous Prophecy). Openly depicting Jewishness, Kubert devotes a one-third-page horizontal panel to the tearful Prophecy reciting the first four words of the Mourner's Kaddish (45). The platoon Easy Company has been enlisted to deliver the Prophecy from war-ravaged Europe to America, where he can tell the world about Hitler's plan and ask for help. Younger children figure into the story: The Prophecy rescues a baby girl; a mother pleads for her children in speech bubbles that adopt a Hebrew-looking font for this interlude, meant to call attention to the woman's use of Yiddish; and the Prophecy laments of Hitler's plan: "Millions will die. Innocent children in the arms of helpless parents. . . . They will all die" (127).

15. Robert Kanigher (writer) and Ric Estrada (penciller, illustrator), "Walls of Blood,"

Blitzkrieg, no. 2 (March–April 1976): 1–11, National Periodical Publications.

16. Elie Wiesel, *A Jew Today,* trans. Marion Wiesel (New York: Random House, 1978), 178–79.

17. Władysław Szpilman, *The Pianist: The Extraordinary True Story of One Man's Survival in Warsaw, 1939–1943,* trans. Anthea Bell (New York: Picador, 1999), 13.

18. Hersey, *The Wall* (1950), 97.

19. Korczak, *Warsaw Ghetto Memoirs,* 43.

20. Ibid., 88.

21. Indelman, "Underground Brigade," 115.

22. Uris, *Mila 18* (1961), 356.

23. *Holocaust: The Story of the Family Weiss,* directed by Marvin J. Chomsky (1978; Los Angeles: Paramount, 2008), DVD.

24. "In the Presence of Mine Enemies," final draft, April 26, 1960, box 56, folder 4, Serling Papers; emphasis in original.

25. Lawrence L. Langer, *Versions of Survival: The Holocaust and the Human Spirit* (Albany: State University of New York Press, 1982), 72.

26. Kubert's stories were later collected in *The Adventures of Yaakov and Isaac,* vol. 1 (Jerusalem: Mahrwood Press, 2004).

27. Ibid., 4.

28. An earlier comic in the Yaakov and Isaac series, "Into the Shadows" (1984), employs the Holocaust to narrate a message about pride in one's Jewish heritage even though it differs from the mainstream and so may invite danger. Here Kubert also treads delicately, eschewing much graphic material, although one panel portrays Jews in concentration-camp barracks (the first panel about the war provides a bird's-eye view of fearful Jews herded by Nazis, similar to that found in "An Act of Resistance"). All scenes from the war are drawn in black and white, contrasting sharply with color used for the present day.

29. Kubert, *Adventures of Yaakov and Isaac,* 21.

30. "Child's Song of Courage," 6.

31. Arad, Gutman, and Margaliot, *Documents on the Holocaust,* 302; emphasis in original.

32. Vladka Meed, "Jewish Resistance in the Warsaw Ghetto," in *Resisters, Rescuers, and Refugees: Historical and Ethical Issues,* ed. John J. Michalczyk (Kansas City, Mo.: Sheed & Ward, 1997), 107.

33. Ibid., 107, 109.

34. Arnold Drake (writer) and Frank Robbins (penciller, illustrator). "Colonel Clown Isn't Laughing Anymore!," *Weird War Tales,* no. 36 (April 1975): 51–56, National Periodical Publications.

35. Meed, 107–8.

36. Ibid., 114–15.

37. Kubert, introduction to *Yossel,* unpaged. Bill Schelly's *Man of Rock: A Biography of Joe Kubert* (Seattle: Fantagraphics Books, 2008) provides details about Kubert's life and work, at times mentioning Kubert's interest in Jewish themes. See also Schelly's monograph *The Art of Joe Kubert* (Seattle: Fantagraphics Books, 2011).

38. Kubert, introduction to *Yossel,* unpaged.

39. Brad Prager, "The Holocaust Without Ink: Absent Memory and Atrocity in Joe Kubert's Graphic Novel *Yossel: April 19, 1943,*" in *The Jewish Graphic Novel: Critical Approaches,* ed. Samantha Baskind and Ranen Omer-Sherman (New Brunswick: Rutgers University Press, 2008), 118.

40. Bak, *Painted in Words,* 28.

41. Ibid., 61.

42. Geoffrey H. Hartman, *The Longest Shadow: In the Aftermath of the Holocaust* (Bloomington: Indiana University Press, 1996), 152. See also Carolyn J. Dean, *The Fragility of Empathy After the Holocaust* (Ithaca: Cornell University Press, 2004).

43. Art Spiegelman, *Maus: A Survivor's Tale,* 2 vols. (New York: Pantheon, 1986 and 1991). On Jewish graphic narratives, see Baskind and Omer-Sherman, *Jewish Graphic Novel.*

44. M. Hirsch, *Family Frames,* 22.

45. Eva Hoffman, *After Such Knowledge: Memory, History, and the Legacy of the Holocaust* (New York: Public Affairs, 2004), xv.

46. Bernice Eisenstein, *I Was a Child of Holocaust Survivors* (New York: Riverhead Books, 2006).

47. Marianne Hirsch, "Surviving Images: Holocaust Photographs and the Work of Postmemory," in *Visual Culture and the Holocaust,* ed. Barbie Zelizer (New Brunswick: Rutgers University Press, 2001), 221.

48. Hartman, *Longest Shadow,* 8.

49. Gary Weissman, *Fantasies of Witnessing: Postwar Efforts to Witness the Holocaust* (Ithaca: Cornell University Press, 2004), 5, 19–20. In the only other extended discussion of *Yossel,* Brad Prager's insightful essay "The Holocaust Without

Ink," the author draws on Weissman's thoughts about nonwitnesses to somewhat different ends.

50. Weissman, *Fantasies of Witnessing,* 23.

51. Ibid., 13.

52. Chicago, *Holocaust Project,* 36.

53. Kenneth W. Prescott, *The Complete Graphic Works of Ben Shahn* (New York: Quadrangle, 1973), 51.

54. Amishai-Maisels, "Ben Shahn," 316.

55. Primo Levi, *The Drowned and the Saved,* trans. Raymond Rosenthal (1986; repr., New York: Vintage International, 1989), 23–24.

56. Jon Bogdanove (writer, penciller), Louise Simonson (writer), and Dennis Janke (illustrator), *Superman: The Man of Steel* 1, no. 82 (August 1998), DC Comics.

57. Jon Bogdanove, interview with the author, May 27, 2015.

Epilogue

The first epigraph to this chapter is drawn from Kassow, *Who Will Write Our History?,* 3–4. The second epigraph is quoted in Krall, *Shielding the Flame,* 6, 10.

1. Young, *Texture of Memory,* 2.

2. For the most comprehensive treatment, and one focused on visual manifestations of Holocaust iconography, see Amishai-Maisels, *Depiction and Interpretation.* Oren Baruch Stier's excellent study *Holocaust Icons: Symbolizing the Shoah in History and Memory* (New Brunswick: Rutgers University Press, 2015) concentrates on four symbols of the Holocaust from an interdisciplinary perspective.

3. Oren Baruch Stier, *Committed to Memory: Cultural Mediations of the Holocaust* (Amherst: University of Massachusetts Press, 2003).

4. Barbie Zelizer, *Remembering to Forget: Holocaust Memory Through the Camera's Eye* (Chicago: University of Chicago Press, 1998), 6, 7.

5. See http://www.ushmm.org/information/exhibitions/permanent/floor-3, accessed October 10, 2015.

6. Jeshajahu Weinberg and Rina Elieli, *The Holocaust Museum in Washington* (New York: Rizzoli, 1995), 109.

7. Stier, *Committed to Memory,* 33.

8. Ibid.

9. Rosenfeld, "The Americanization of the Holocaust" (1997), 123.

10. Michael Berenbaum, *After Tragedy and Triumph: Essays in Modern Jewish Thought and the American Experience* (Cambridge: Cambridge University Press, 1990), 20, 13.

11. Zelizer, *Remembering to Forget,* 7.

12. Raul Hilberg, *The Destruction of the European Jews,* 3rd ed. (New Haven: Yale University Press, 2003), 3:1104.

13. Yehuda Bauer, *Rethinking the Holocaust* (New Haven: Yale University Press, 2001), 119–66.

14. Oboler and Longstreet, *Free World Theatre,* 235.

Bibliography

Archives

American Jewish Committee
Archives of American Art
Harry Ransom Center
Institute for Jewish Research, YIVO

New York Public Library
Paley Center for Media
United States Holocaust Memorial Museum
Wisconsin Center for Film and Theater Research

Other Sources

Aberbach, David. *Bialik.* New York: Grove Press, 1988.

Adams, Phoebe. "Warsaw Ghetto." *Atlantic Monthly,* August 1961, 94.

Adelman, George. Review of *Mila 18. Library Journal,* June 15, 1961, 2339.

Adler, David A. *Child of the Warsaw Ghetto.* Illustrated by Karen Ritz. New York: Holiday House, 1995.

Adorno, Theodor W. "Cultural Criticism and Society." In *The Adorno Reader,* edited by Brian O'Connor, 195–210. Oxford: Blackwell, 2000.

———. "Meditations on Metaphysics: After Auschwitz." In *The Adorno Reader,* edited by Brian O'Connor, 84–88. Oxford: Blackwell, 2000.

Albarella, Tony, ed. *As Timeless as Infinity: The Complete Twilight Zone Scripts of Rod Serling.* 10 vols. Colorado Springs: Gauntlet Publications, 2004–13.

"Allies Condemn Nazi Plan to Destroy Jews of Europe." *World Over* 4, no. 6 (January 8, 1943): 2.

Alphen, Ernst van. *Caught by History: Holocaust Effects in Contemporary Art, Literature, and Theory.* Stanford: Stanford University Press, 1997.

Amishai-Maisels, Ziva. "Ben Shahn and the Problem of Jewish Identity." *Jewish Art* 12–13 (1986–87): 304–19.

———. *Depiction and Interpretation: The Influence of the Holocaust on the Visual Arts.* New York: Pergamon Press, 1993.

———. "Haunting the Empty Place." In *Absence/ Presence: Critical Essays on the Artistic Memory of the Holocaust,* edited by Stephen C. Feinstein, 123–50. Syracuse: Syracuse University Press, 2005.

Andrae, Thomas, and Mel Gordon. *Siegel and Shuster's Funnyman: The First Jewish Superhero.* Port Townsend, Wash.: Feral House, 2010.

Ansell, Joseph P. *Arthur Szyk: Artist, Jew, Pole.* Portland, Ore.: Littman Library of Jewish Civilization, 2004.

———. "Arthur Szyk's Depiction of the 'New Jew': Art as a Weapon in the Campaign for an American Response to the Holocaust." *American Jewish History* 89, no. 1 (March 2001): 123–34.

Arad, Yitzhak, Israel Gutman, and Abraham Margaliot, eds. *Documents on the Holocaust: Selected Sources on the Destruction of the Jews of Germany and Austria, Poland, and the Soviet Union.* 8th ed. Lincoln: University of Nebraska Press; Jerusalem: Yad Vashem, 1999.

"Arthur Szyk." *Menorah Journal* 30, no. 2 (July–September 1942): 228.

Baigell, Matthew. *Jewish-American Artists and the Holocaust.* New Brunswick: Rutgers University Press, 1997.

Bak, Samuel. *Painted in Words.* Bloomington: Indiana University Press, 2001.

Barnouw, Eric, ed. *Radio Drama in Action: Twenty-Five Plays of a Changing World.* New York: Farrar & Rinehart, 1945.

Baron, Lawrence. *Projecting the Holocaust into the Present: The Changing Focus of Contemporary Holocaust Cinema.* Lanham, Md.: Rowman & Littlefield, 2005.

Baskind, Samantha. *Jewish Artists and the Bible in Twentieth-Century America.* University Park: Pennsylvania State University Press, 2014.

Baskind, Samantha, and Ranen Omer-Sherman, eds. *The Jewish Graphic Novel: Critical Approaches.* New Brunswick: Rutgers University Press, 2008.

"The Battle of the Ghetto." *New York Times,* April 21, 1944, 18.

Bauer, Yehuda. *Rethinking the Holocaust.* New Haven: Yale University Press, 2001.

Bauman, Janina. *Winter in the Morning: A Young Girl's Life in the Warsaw Ghetto and Beyond, 1939–1945.* New York: Free Press, 1986.

Ben Wilson: The Margin as Center. Wayne, N.J.: William Patterson University, 2008. Exhibition catalogue.

Ben-Yehuda, Nachman. *The Masada Myth: Collective Memory and Mythmaking in Israel.* Madison: University of Wisconsin Press, 1995.

Berenbaum, Michael. *After Tragedy and Triumph: Essays in Modern Jewish Thought and the American Experience.* Cambridge: Cambridge University Press, 1990.

———. *The World Must Know: The History of the Holocaust as Told in the United States Holocaust Memorial Museum.* Boston: Little, Brown, 1993.

Berg, Mary. *The Diary of Mary Berg: Growing Up in the Warsaw Ghetto.* Edited by S. L. Shneiderman. New exp. ed., prepared by Susan Lee Pentlin. Oxford: Oneworld, 2007. (Originally published as *Warsaw Ghetto: A Diary* [New York: L. B. Fischer, 1945].)

Berkowitz, Michael. *Zionist Culture and West European Jewry Before the First World War.* Cambridge: Cambridge University Press, 1993.

Bialik, Hayyim Nahman. *Complete Poetic Works of Hayyim Nahman Bialik.* Vol. 1. Edited by Israel Efros. New York: Histadruth Ivrith of America, 1948.

The Black Book: The Nazi Crime Against the Jewish People. New York: Jewish Black Book Committee, 1946.

Bogacki, Tomek. *The Champion of Children: The Story of Janusz Korczak.* New York: Farrar Straus Giroux, 2009.

Bogdanove, Jon (w, p), Louise Simonson (w), and Dennis Janke (i). *Superman: The Man of Steel* 1, no. 82 (August 1998). DC Comics.

Boyarin, Daniel. *Unheroic Conduct: The Rise of Heterosexuality and the Invention of the Jewish Man.* Berkeley: University of California Press, 1997.

Breines, Paul. *Tough Jews: Political Fantasies and the Moral Dilemma of American Jewry.* New York: Basic Books, 1990.

Brenner, Michael, and Gideon Reuveni, eds. *Emancipation Through Muscles: Jews and Sports in Europe.* Lincoln: University of Nebraska Press, 2006.

Brod, Harry. *Superman Is Jewish? How Comic Book Superheroes Came to Serve Truth, Justice, and the Jewish-American Way.* New York: Free Press, 2012.

Buhle, Paul. "Millard Lampell." In *Tender Comrades: A Backstory of the Hollywood Blacklist,* edited by Patrick McGilligan and Paul Buhle, 389–403. New York: St. Martin's Press, 1997.

Cain, Kathleen Shine. *Leon Uris: A Critical Companion.* Westport, Conn.: Greenwood Press, 1998.

Carmichael, Joel. "The Phenomenal Leon Uris." *Midstream* 7 (Autumn 1961): 86–90.

Caruth, Cathy, ed. *Trauma: Explorations in Memory.* Baltimore: Johns Hopkins University Press, 1995.

———. *Unclaimed Experience: Trauma, Narrative, and History.* Baltimore: Johns Hopkins University Press, 1996.

Chazan, Robert, and Marc Lee Raphael, eds. *Modern Jewish History: A Source Reader.* New York: Schocken Books, 1974.

Chicago, Judy. *Holocaust Project: From Darkness into Light.* New York: Penguin Books, 1993.

"A Child's Song of Courage." *World Over* 4, no. 2 (November 13, 1942): 6.

Cohen, Mortimer J. *Pathways Through the Bible.* Illustrated by Arthur Szyk. Philadelphia: Jewish Publication Society of America, 1946.

Crowther, Bosley. "The Screen: The Stranger." *New York Times,* July 11, 1946, 18.

Cruttwell, Patrick. "Synthetic Tragedy." *Guardian,* October 27, 1961, 7.

Davis, Mac. *Jews Fight Too!* New York: Hebrew Publishing, 1945.

Dean, Carolyn J. *The Fragility of Empathy After the Holocaust.* Ithaca: Cornell University Press, 2004.

Decter, Midge. "Popular Jews." In *The Liberated Woman and Other Americans,* 117–20. New York: Coward, McCann & Geoghegan, 1971.

Diner, Hasia R. *The Jews of the United States, 1654 to 2000.* Berkeley: University of California Press, 2004.

———. *We Remember with Reverence and Love: American Jews and the Myth of Silence After the Holocaust, 1945–1962.* New York: New York University Press, 2009.

Doneson, Judith E. "The American History of Anne Frank's Diary." *Holocaust and Genocide Studies* 2, no. 1 (1987): 149–60.

———. *The Holocaust in American Film.* 2nd ed. Syracuse: Syracuse University Press, 2002.

Drake, Arnold (w), and Frank Robbins (p, i). "Colonel Clown Isn't Laughing Anymore!" *Weird War Tales,* no. 36 (April 1975): 51–56. National Periodical Publications.

Dwork, Debórah. *Children with a Star: Jewish Youth in Nazi Europe.* New Haven: Yale University Press, 1991.

Edelman, Marek. *The Ghetto Fights: Warsaw 1941–43.* 1946. Reprint, London: Bookmarks, 1990.

Eisenstein, Bernice. *I Was a Child of Holocaust Survivors.* New York: Riverhead Books, 2006.

Engel, Joel. *Rod Serling: The Dreams and Nightmares of Life in the Twilight Zone; A Biography.* Chicago: Contemporary Books, 1989.

Engelking, Barbara, and Jacek Leociak. *The Warsaw Ghetto: A Guide to the Perished City.* New Haven: Yale University Press, 2009.

Engelking-Boni, Barbara. "Childhood in the Warsaw Ghetto." In *Children and the Holocaust: Symposium Presentations,* 33–42. Washington, D.C.: Center for Advanced Holocaust Studies, United States Holocaust Memorial Museum, 2004.

Epstein, Morris. *A Picture Parade of Jewish History.* Illustrated by Maurice del Bourgo and F. L. Blake. New York: Shengold Publishers, 1963.

Fast, Howard, and William Gropper. *Never to Forget: The Battle of the Warsaw Ghetto.* New York: Book League of Jewish Peoples Fraternal Order, 1946.

Fein, Stephen. "Hanukkah Light in Warsaw." In *The World Over Story Book,* edited by Norton Belth, 108–13. New York: Bloch Publishing, 1952.

Feinstein, Stephen C. Introduction to *Absence/Presence: Critical Essays on the Artistic Memory of the Holocaust,* edited by Stephen C. Feinstein, xxi–xxxii. Syracuse: Syracuse University Press, 2005.

Feld, Rose. "Once More the Tragedy of Warsaw." *Herald Tribune Book Review,* June 4, 1961, 28.

Felman, Shoshana, and Dori Laub. *Testimony: Crises of Witnessing in Literature, Psychoanalysis, and History.* New York: Routledge, 1992.

Fewell, Danna Nolan, and Gary A. Phillips. *Icon of Loss: The Haunting Child of Samuel Bak.* Boston: Pucker Art Publications, 2009.

Fiedler, Leslie A. *The Jew in the American Novel.* Herzl Institute Pamphlet No. 10. New York: Herzl Institute, 1959.

"The Fighting Jews." *World Over* 4, no. 5 (December 25, 1942): 2–3.

"First Anniversary of Battle of Warsaw Ghetto Commemorated; State Dept. Lauds Heroes." *Jewish*

Telegraphic Agency, April 13, 1944.
http://www.jta.org/1944/04/13/
archive/first-anniversary-of-battl
e-of-warsaw-ghetto-commemo-
rated-state-dept-lauds-heroes.

Flanzbaum, Hilene, ed. *The Americanization
of the Holocaust.* Baltimore: Johns
Hopkins University Press, 1999.

Franciosi, Robert. "Bringing *The Wall* to
Broadway." *Journal of American Drama
and Theatre* 16, no. 2 (2004): 88–97.

———. "Designing John Hersey's *The Wall:*
W. A. Dwiggins, George Salter, and
the Challenges of American Holocaust
Memory." *Book History* 11 (2008):
245–74.

Frank, Anne. *The Diary of a Young Girl.* Edited
by Otto H. Frank and Mirjam Pressler.
Translated by Susan Massotty. New
York: Doubleday, 1995.

Frank, Stanley B. *The Jew in Sports.* New York:
Miles Publishing, 1936.

Freud, Sigmund. "Analysis of a Phobia in a
Five-Year-Old Boy." In *The Standard
Edition of the Complete Psychological
Works of Sigmund Freud,* vol. 10, trans-
lated and edited by James Strachey et al.,
3–149. London: Hogarth Press, 1955.

———. *The Future of an Illusion.* Translated and
edited by James Strachey. New York:
Norton, 1975.

———. "Leonardo Da Vinci and a Memory
of His Childhood." In *The Standard
Edition of the Complete Psychological
Works of Sigmund Freud,* vol. 11, trans-
lated and edited by James Strachey et al.,
63–137. London: Hogarth Press, 1957.

Freundlich, August L. *William Gropper:
Retrospective.* Los Angeles: Ward
Ritchie Press, in conjunction with the
Joe and Emily Lowe Art Gallery of the
University of Miami, 1968. Exhibition
catalogue.

Friedlander, Saul, ed. *Probing the Limits of
Representation: Nazism and the
"Final Solution."* Cambridge: Harvard
University Press, 1992.

Friedman, Philip, ed. *Martyrs and Fighters: The
Epic of the Warsaw Ghetto.* New York:
Frederick A. Praeger, 1954.

———. *Their Brothers' Keepers.* New York:
Crown Publishers, 1957.

Furman, Andrew. "A New 'Other' Emerges in
American Jewish Literature: Philip
Roth's Israel Fiction." *Contemporary
Literature* 36 (1995): 633–53.

Gaynes, S. Randolph. "Despite Its Serious
Theme, Play About Warsaw Ghetto
Uprising Captures Audience." *Jewish
Forum* 43, no. 11 (December 1960): 207,
208.

Gelder, Lawrence Van. "Arts Briefing." *New York
Times,* February 3, 2004, E2.

Genette, Gérard. *Paratexts: Thresholds of
Interpretation.* Translated by Jane
E. Lewin. Cambridge: Cambridge
University Press, 1997.

Gerani, Gary, with Paul H. Schulman. *Fantastic
Television.* New York: Harmony Books,
1977.

Gilman, Sander L. *Freud, Race, and Gender.*
Princeton: Princeton University Press,
1993.

———. *The Jew's Body.* London: Routledge, 1991.

Glatstein, Jacob, Israel Knox, and Samuel
Margoshes, eds. *Anthology of Holocaust
Literature.* Philadelphia: Jewish
Publication Society of America, 1969.

Goodman, Cary. *Choosing Sides: Playground and
Street Life on the Lower East Side.* New
York: Schocken Books, 1979.

Goodrich, Frances, and Albert Hackett. *The
Diary of Anne Frank.* New York:
Random House, 1956.

Gould, Jack. "Prejudice Dissected: Rod Serling's
'A Town Has Turned to Dust' Offered
on 'Playhouse 90.'" *New York Times,*
June 20, 1958, 47.

———. "TV: Ghetto Tragedy, Rod Serling's
'In the Presence of Mine Enemies' on
'Playhouse 90.'" *New York Times,* May
19, 1960, 75.

Grams, Martin. *The Twilight Zone: Unlocking
the Doors to a Television Classic.*
Churchville, Md.: OTR Publishing,
2008.

Gruenwald, Ithamar. "Midrash and the
'Midrashic Condition': Preliminary
Considerations." In *The Midrashic
Imagination: Jewish Exegesis, Thought,
and History,* edited by Michael
Fishbane, 6–22. Albany: State University
of New York Press, 1993.

Gutman, Israel. *The Jews of Warsaw, 1939–1943: Ghetto, Underground, Revolt.* Translated by Ina Friedman. Bloomington: Indiana University Press, 1982.

———. *Resistance: The Warsaw Ghetto Uprising.* Boston: Houghton Mifflin, 1994.

Hackett, Alice Payne, and James Henry Burke. *80 Years of Best Sellers, 1895–1975.* New York: R. R. Bowker, 1977.

Haney, Bob (w), Dick Ayers (p), and Gerry Talaoc (i). "A Season in Hell!" *The Unknown Soldier* no. 247 (January 1981): 1–17. DC Comics.

Hartman, Geoffrey H. *The Longest Shadow: In the Aftermath of the Holocaust.* Bloomington: Indiana University Press, 1996.

Hecht, Anthony. *Selected Poems.* Edited by J. D. McClatchy. New York: Alfred A. Knopf, 2011.

Hersey, John. "The Last Days of the Ghetto." *World Over* 11, no. 13 (April 21, 1950): 8–9.

———. "The Mechanics of a Novel." *Yale University Library Gazette* 27 (July 1952): 1–11.

———. "A Short Wait." *New Yorker* 23, no. 17 (June 14, 1947): 27–29.

———. *The Wall.* New York: Alfred A. Knopf, 1950.

———. *The Wall.* Illustrated by William Sharp. New York: Marchbanks Press, 1957.

Hilberg, Raul. *The Destruction of the European Jews.* 3rd ed. Vol. 3. New Haven: Yale University Press, 2003. (Originally printed in a single volume by Quadrangle Books, Chicago, 1961.)

Hirsch, Foster. *Otto Preminger: The Man Who Would Be King.* New York: Alfred A. Knopf, 2007.

Hirsch, Marianne. *Family Frames: Photography, Narrative, and Postmemory.* Cambridge: Harvard University Press, 1997.

———. *The Generation of Postmemory: Writing and Visual Culture After the Holocaust.* New York: Columbia University Press, 2012.

———. "Nazi Photographs in Post-Holocaust Art: Gender as an Idiom of Memorialization." In *Crimes of War: Guilt and Denial in the Twentieth Century,* edited by Omer Bartov, Atina Grossmann, and Mary Nolan, 100–120. New York: New Press, 2002.

———. "Projected Memory: Holocaust Photographs in Personal and Public Fantasy." In *Acts of Memory: Cultural Recall in the Present,* edited by Mieke Bal, Jonathan Crewe, and Leo Spitzer, 2–23. Hanover: University Press of New England, 1999.

———. "Surviving Images: Holocaust Photographs and the Work of Postmemory." In Zelizer, *Visual Culture and the Holocaust,* 214–46.

Hitler, Adolph. *Mein Kampf.* Translated by Ralph Manheim. 1943. Reprint, Boston: Houghton Mifflin, 1971.

Hoffman, Eva. *After Such Knowledge: Memory, History, and the Legacy of the Holocaust.* New York: Public Affairs, 2004.

Holocaust: The Story of the Family Weiss. Directed by Marvin J. Chomsky. 1978. Los Angeles: Paramount, 2008. DVD.

Huse, Nancy L. *The Survival Tales of John Hersey.* Troy, N.Y.: Whiston Publishing, 1983.

Hyman, Paula E. *Gender and Assimilation in Modern Jewish History: The Roles and Representation of Women.* Seattle: University of Washington Press, 1995.

Indelman, Elchanan. "Underground Brigade." In *The World Over Story Book,* edited by Norton Belth, 113–37. New York: Bloch Publishing, 1952.

"In the Presence of Mine Enemies." Directed by Fielder Cook. CBS. 1960.

"In the Presence of Mine Enemies." *New York Times,* April 18, 1997, 18.

"Israel Blumenfeld, a Jewish Leader, 46." *New York Times,* March 29, 1962, 33.

Jampel, Dave. "With Rod and Reel: A Serling Safari Through Far East." *Variety* 232, no. 13 (November 20, 1963): 39, 48.

Jauss, Hans Robert. "Literary History as a Challenge to Literary Theory." In *Toward an Aesthetic of Reception,* translated by Timothy Bahti, 3–45. Minneapolis: University of Minnesota Press, 1982.

"The Jewish Underground Fighters." *World Over* 5, no. 13 (April 13, 1944): 2.

"Jews Here Acclaim Heroes of Warsaw." *New York Times,* April 20, 1944, 10.

Josephus, Flavius. *The Jewish War*. Translated by G. A. Williamson. Revised ed. by E. Mary Smallwood. London: Penguin Books, 1981.

Kanigher, Robert (w), and Ric Estrada (p, i). "Walls of Blood." *Blitzkrieg*, no. 2 (March–April 1976): 1–11. National Periodical Publications.

Kaplan, Chaim A. *Scroll of Agony: The Warsaw Diary of Chaim A. Kaplan*. Translated and edited by Abraham I. Katsh. 1965. Reprint, Bloomington: Indiana University Press, 1999.

Kassow, Samuel D. *Who Will Write Our History? Emanuel Ringelblum, the Warsaw Ghetto, and the Oyneg Shabes Archive*. Bloomington: Indiana University Press, 2007.

Katznelson, Yitzhak. *Vittel Diary (22.5.43–12.9.43)*. Translated by Myer Cohen. 2nd ed. Tel Aviv: Hakibbutz Hameuchad, 1972.

Kermish, Joseph, ed. *To Live with Honor and Die with Honor! Selected Documents from the Warsaw Ghetto Underground Archives "O.S." ("Oneg Sabbath")*. Jerusalem: Yad Vashem, 1986.

Kleeblatt, Norman L., ed. *Mirroring Evil: Nazi Imagery / Recent Art*. New Brunswick: Rutgers University Press, 2001. Exhibition catalogue.

Kneece, Mark. *Rod Serling's The Twilight Zone: Deaths-Head Revisited*. Illustrated by Chris Lie. New York: Walker, 2009.

Korczak, Janusz. *The Warsaw Ghetto Memoirs of Janusz Korczak*. Translated by E. P. Kulawiec. Washington, D.C.: University Press of America, 1978.

Korwin, Yala. *To Tell the Story: Poems of the Holocaust*. New York: Holocaust Library, 1987.

Krall, Hanna. *Shielding the Flame: An Intimate Conversation with Dr. Marek Edelman, the Last Surviving Leader of the Warsaw Ghetto Uprising*. Translated by Joanna Stasinska and Lawrence Weschler. New York: Henry Holt, 1986.

Kubert, Joe. *The Adventures of Yaakov and Isaac*. Vol. 1. Jerusalem: Mahrwood Press, 2004.

———. *Sgt. Rock: The Prophecy*. New York: DC Comics, 2006.

———. *Yossel: April 19, 1943*. 2003. Reprint, New York: DC Comics, 2011.

Kubert, Joe, et al. *Showcase Presents: Unknown Soldier*. Vol. 1. New York: DC Comics, 2006.

LaCapra, Dominick. *Representing the Holocaust: History, Theory, Trauma*. Ithaca: Cornell University Press, 1994.

Laird, Christa. *Shadow of the Wall*. 1990. Reprint, New York: Greenwillow Books, 1997.

Lampell, Millard. "Bringing 'The Wall' to the Stage." *Midstream* 6 (Autumn 1960): 14–19.

———. *The Wall: A Drama in Three Acts*. New York: Samuel French, 1964.

———. *The Wall: A Play in Two Acts by Millard Lampell*. New York: Alfred A. Knopf, 1961.

Landon, Mike [Millard Lampell]. "Is There a Führer in the House?" *New Republic* 9 (August 12, 1940): 212–13.

Langer, Lawrence L. "The Americanization of the Holocaust on Stage and Screen." In *From Hester Street to Hollywood: The Jewish-American Stage and Screen*, edited by Sarah Blacher Cohen, 213–30. Bloomington: Indiana University Press, 1983.

———. *The Holocaust and the Literary Imagination*. New Haven: Yale University Press, 1975.

———. *Landscapes of Jewish Experience: Paintings by Samuel Bak*. Boston: Brandeis University Press, 1997.

———. *Preempting the Holocaust*. New Haven: Yale University Press, 1998.

———. *Versions of Survival: The Holocaust and the Human Spirit*. Albany: State University of New York Press, 1982.

Lanzmann, Claude. *Shoah: An Oral History of the Holocaust; The Complete Text of the Film*. New York: Pantheon Books, 1985.

Lazarus, Emma. *An Epistle to the Hebrews*. New York: Jewish Historical Society of New York, 1987.

Learsi, Rufus. *The Jew in Battle*. New York: American Zionist Youth Commission, 1944.

Levi, Primo. *The Drowned and the Saved*. Translated by Raymond Rosenthal. 1986. Reprint, New York: Vintage International, 1989.

Levine, Peter. *Ellis Island to Ebbets Field: Sport and the American Jewish Experience.* New York: Oxford University Press, 1992.

Lewittes, Mordecai H. *Highlights of Jewish History.* Vol. 4, *From the Middle Ages to Modern Times.* Illustrated by Sam Nisenson. New York: Hebrew Publishing, 1957.

Leys, Ruth. *Trauma: A Genealogy.* Chicago: University of Chicago Press, 2000.

Leyvik, H. "Der Nes in Geto." Translated by Motl Didner. Unpublished manuscript.

Lifton, Betty Jean. *The King of Children: A Biography of Janusz Korczak.* New York: Farrar, Straus & Giroux, 1988.

Linenthal, Edward T. *Preserving Memory: The Struggle to Create America's Holocaust Museum.* New York: Viking, 1995.

Lipchitz, Jacques, with H. H. Arnason. *My Life in Sculpture.* New York: Viking, 1972.

Lookstein, Haskel. *Were We Our Brothers' Keepers? The Public Response of American Jews to the Holocaust, 1938–1944.* New York: Vintage Books, 1988.

Luckert, Steven. *The Art and Politics of Arthur Szyk.* Washington, D.C.: United States Holocaust Memorial Museum, 2003.

Lyman, Rick. "Watching Movies with Harvey Weinstein, Memory's Independent Streak: 40 Years Tarnish an Epic's Luster." *New York Times,* April 27, 2001, 1, 20.

Malamud, Bernard. *The Assistant.* 1957. Reprint, New York: Farrar, Straus & Giroux, 2003.

Mark, Ber. "The Warsaw Ghetto Uprising." In Suhl, *They Fought Back,* 92–127.

Marks, Richard G. *The Image of Bar Kokhba in Traditional Jewish Literature: False Messiah and National Hero.* University Park: Pennsylvania State University Press, 1994.

Martyrs and Heroes of the Ghettos. New York: Jewish Labor Committee, 1945. Exhibition catalogue.

Maslin, Janet. "Bringing 'Sophie's Choice' to the Screen." *New York Times,* May 9, 1982, 1, 15.

Meed, Vladka. "Jewish Resistance in the Warsaw Ghetto." In *Resisters, Rescuers, and Refugees: Historical and Ethical Issues,* edited by John J. Michalczyk. Kansas City, Mo.: Sheed & Ward, 1997.

———. *On Both Sides of the Wall: Memoirs from the Warsaw Ghetto.* Translated by Steven Meed. New York: Holocaust Library, 1979.

Mendelsohn, Shlomo. "The Battle of the Warsaw Ghetto." *Menorah Journal* 32, no. 1 (April–June 1944): 5–25.

———. *The Battle of the Warsaw Ghetto.* New York: Yiddish Scientific Institute, 1944.

"Mila 18." *Kirkus,* June 1, 1961, 370.

Mintz, Alan. *Popular Culture and the Shaping of Holocaust Memory in America.* Seattle: University of Washington Press, 2001.

Mosse, George L. "Max Nordau, Liberalism and the New Jew." *Journal of Contemporary History* 27, no. 4 (October 1992): 565–81.

Nadel, Ira B. *Leon Uris: Life of a Best Seller.* Austin: University of Texas Press, 2010.

Nagano, Paul T., and Samuel Bak. *Samuel Bak: The Past Continues.* Boston: David R. Godine, 1988.

Nahshon, Edna. "Anne Frank from Page to Stage." In *Anne Frank Unbound: Media, Imagination, Memory,* edited by Barbara Kirshenblatt-Gimblett and Jeffrey Shandler, 59–92. Bloomington: Indiana University Press, 2012.

Nordau, Max. "Jewry of Muscle." In *The Jew in the Modern World: A Documentary History,* edited by Paul Mendes-Flohr and Jehuda Reinharz, 2nd ed., 547–48. New York: Oxford University Press, 1995.

Novick, Peter. *The Holocaust in American Life.* Boston: Houghton Mifflin, 1999.

Nunberg, Ralph. *The Fighting Jew.* New York: Creative Age Press, 1945.

Oboler, Arch, and Stephen Longstreet, eds. *Free World Theatre: Nineteen New Radio Plays.* New York: Random House, 1944.

Parker, James Edward. "Rod Serling's 'The Twilight Zone': A Critical Examination of Religious and Moralistic Themes and Motifs Presented in the *Film Noir* Style." Ph.D. diss., Ohio University, 1987.

Penslar, Derek J. *Jews and the Military: A History.* Princeton: Princeton University Press, 2013.

Perle, Yehoshue. *Tvishn Lebn un Toyt.* Edited by B. Mark. Warsaw: Farlag "Yidish bukh," 1955.

The Pianist. Directed by Roman Polanski 2002. Universal City, Calif.: Focus Features, 2003. DVD.

"Pole's Suicide Note Pleads for Jews." *New York Times,* June 4, 1943, 7.

Porat, Dan. *The Boy: A Holocaust Story.* New York: Hill & Wang, 2010.

Prager, Brad. "The Holocaust Without Ink: Absent Memory and Atrocity in Joe Kubert's Graphic Novel *Yossel: April 19, 1943.*" In Baskind and Omer-Sherman, *Jewish Graphic Novel,* 111–28.

Prescott, Kenneth W. *The Complete Graphic Works of Ben Shahn.* New York: Quadrangle, 1973.

Prescott, Orville. Books of the Times. *New York Times,* June 2, 1961, 29.

Ragozin, Zinaida. "Russian Jews and Gentiles: From a Russian Point of View." *Century Magazine* 23, no. 6 (April 1882): 905–20.

"Random Notes in Washington: A Diagnosis by Dr. Stevenson." *New York Times,* October 23, 1961, 14.

Raskin, Richard. *A Child at Gunpoint: A Case Study in the Life of a Photo.* Aarhus: Aarhus University Press, 2004.

Rattner, Abraham. Oral History Interview by Colette Roberts, May 20, 1968, and June 21, 1968. Archives of American Art. Smithsonian Institution, Washington, D.C.

"Remember the Battle of the Warsaw Ghetto." *World Over* 5, no. 14 (April 28, 1943): 2.

Reuss, Richard A., with JoAnne C. Reuss. *American Folk Music and Left-Wing Politics, 1927–1957.* Lanham, Md.: Scarecrow Press, 2000.

"Revolt of the Warsaw Ghetto." *World Over* 5, no. 1 (October 29, 1943): 8–9.

Reynolds, Quentin. "In the Ghetto a Battle for the Conscience of the World." *New York Times Book Review,* June 4, 1961, 5.

Reznikoff, Charles. *Holocaust.* Los Angeles: Black Sparrow Press, 1975.

Richardson, Benjamin Ward. *Diseases of Modern Life.* New York: Bermingham, 1882.

Ringelblum, Emmanuel. *Notes from the Warsaw Ghetto: The Journal of Emmanuel Ringelblum.* Translated and edited by Jacob Sloan. 1958. Reprint, New York: Schocken Books, 1974.

"Risks His Life to Save Torahs." *World Over* 4, no. 5 (December 25, 1942): 5.

Roosevelt, Eleanor. Introduction to *The Diary of a Young Girl,* by Anne Frank, translated by B. M. Mooyaart-Doubleday. Garden City, N.Y.: Doubleday, 1952.

Rosen, Alan. *Sounds of Defiance: The Holocaust, Multilingualism, and the Problem of English.* Lincoln: University of Nebraska Press, 2005.

Rosenberg, Howard. "'Enemies' Remake: New Cast, Familiar Theme." *Los Angeles Times,* April 19, 1997, 14.

Rosenberg, Warren. *Legacy of Rage: Jewish Masculinity, Violence, and Culture.* Amherst: University of Massachusetts Press, 2001.

Rosenfeld, Alvin H. "The Americanization of the Holocaust." *Commentary* 99, no. 6 (June 1995): 35–40.

———. "The Americanization of the Holocaust." In *Thinking About the Holocaust After Half a Century,* edited by Alvin H. Rosenfeld, 119–50. Bloomington: Indiana University Press, 1997.

Roshwald, Aviel. *The Endurance of Nationalism: Ancient Roots and Modern Dilemmas.* Cambridge: Cambridge University Press, 2006.

Roskies, David G. *Against the Apocalypse: Responses to Catastrophe in Modern Jewish Culture.* Cambridge: Harvard University Press, 1984.

———, ed. *The Literature of Destruction: Jewish Responses to Catastrophe.* Philadelphia: Jewish Publication Society, 1988.

Ross, George M. "'The Wall' on Broadway." *Commentary* 31, no. 1 (January 1, 1961): 66–69.

Rotem, Simha. *Kazik: Memoirs of a Warsaw Ghetto Fighter.* Translated by Barbara Harshav. 1994. Reprint, New Haven: Yale University Press, 2002.

Roth, Philip. *The Counterlife.* New York: Farrar Straus Giroux, 1986.

———. "The New Jewish Stereotypes." *American Judaism* 11 (Winter 1961): 10–11, 49–51.

———. *Patrimony: A True Story.* New York: Simon & Schuster, 1991.

———. *Portnoy's Complaint.* New York: Ballantine Books, 1985.

Rothberg, Michael. *Traumatic Realism: The Demands of Holocaust Representation.* Minneapolis: University of Minnesota Press, 2000.

Saltzman, Lisa, and Eric M. Rosenberg, eds. *Trauma and Visuality in Modernity.* Hanover: Dartmouth College Press, 2006.

Sander, Gordon F. *Serling: The Rise and Twilight of Television's Last Angry Man.* New York: Dutton, 1992. Reprint, Ithaca: Cornell University Press, 2011.

Sanders, David. *John Hersey Revisited.* Boston: Twayne Publishers, 1990.

Schelly, Bill. *The Art of Joe Kubert.* Seattle: Fantagraphics Books, 2011.

———. *Man of Rock: A Biography of Joe Kubert.* Seattle: Fantagraphics Books, 2008.

Schiffrin, André. *Dr. Seuss and Co. Go to War: The World War II Editorial Cartoons of America's Leading Comic Artists.* New York: New Press, 2009.

Schneiderman, Harry, and Morris T. Fine, eds. *The American Jewish Yearbook.* Vol. 45, *5704.* Philadelphia: Jewish Publication Society of America, 1943.

Scholem, Gershom. "The Star of David: History of a Symbol." In *The Messianic Idea in Judaism and Other Essays on Jewish Spirituality,* 257–81. New York: Schocken Books, 1971.

Schor, Esther H. *Emma Lazarus.* New York: Schocken, 2006.

Schwartz, Daniel R. *Imagining the Holocaust.* New York: St. Martin's Press, 1999.

Serling, Anne. *As I Knew Him: My Dad, Rod Serling.* New York: Citadel Press, 2013.

Serling, Rod. "Author's Comment: *Noon on Doomsday.*" In *Television Plays for Writers: Eight Television Plays with Comment and Analysis by the Authors,* edited by A. S. Burack, 353–59. Boston: The Writer, 1957.

———. "The Challenge of the Mass Media to the 20th-Century Writer." *Quarterly Journal of the Library of Congress* 25, no. 2 (April 1968): 130–33.

———. *Patterns: Four Television Plays with the Author's Personal Commentaries.* New York: Simon & Schuster, 1957.

———. *The Season to Be Wary.* Boston: Little, Brown, 1967.

———. "TV's Sacred Cows." In *Legends of Literature: The Best Articles, Interviews, and Essays from the Archives of "Writer's Digest" Magazine,* edited by Phillip Sexton, 173–78. Cincinnati, Ohio: Writer's Digest Books, 2007. (Originally published in *Writer's Digest Magazine* 36, no. 8 [July 1955].)

Shandler, Jeffrey. *While America Watches: Televising the Holocaust.* New York: Oxford University Press, 1999.

Shandler, Jeffrey, and Elihu Katz. "Broadcasting American Judaism: The Radio and Television Department of the Jewish Theological Seminary." In *Tradition Renewed: A History of the Jewish Theological Seminary of America,* edited by Jack Wertheimer, 2:363–401. New York: Jewish Theological Seminary of America, 1997.

Shanley, John P. "Nuremberg Judgment." *New York Times,* April 17, 1959, 53.

Shirer, William. "John Hersey's Superb Novel of the Agony of Warsaw." *New York Herald Tribune Book Review,* February 26, 1950, 1, 14.

Shoah. Directed by Claude Lanzmann. 1985. New York: Criterion Collection, 2013. DVD.

Silver, M. M. *Our Exodus: Leon Uris and the Americanization of Israel's Founding Story.* Detroit: Wayne State University Press, 2010.

Simon, Ron, ed. *Rod Serling: Dimensions of Imagination.* New York: Museum of Broadcasting, 1984. Exhibition catalogue.

Singerman, Robert. "The Jew as Racial Alien: The Genetic Component of American Anti-Semitism." In *Anti-Semitism in American History,* edited by David A. Gerber, 103–28. Urbana: University of Illinois Press, 1986.

Sinkoff, Nancy. "Fiction's Archive: Authenticity, Ethnography, and Philosemitism in John Hersey's *The Wall.*" *Jewish Social Studies: History, Culture, Society* 17, no. 2 (Winter 2011): 48–79.

Skelton, Scott, and Jim Benson. *Rod Serling's Night Gallery: An After-Hours Tour.*

Syracuse: Syracuse University Press, 1999.

Spiegelman, Art. *Maus: A Survivor's Tale.* 2 vols. New York: Pantheon, 1986 and 1991.

Stargardt, Nicholas. *Witnesses of War: Children's Lives Under the Nazis.* New York: Alfred A. Knopf, 2005.

Steiner, George. *Language and Silence: Essays on Language, Literature, and the Inhuman.* New York: Atheneum, 1970.

Stier, Oren Baruch. *Committed to Memory: Cultural Mediations of the Holocaust.* Amherst: University of Massachusetts Press, 2003.

———. *Holocaust Icons: Symbolizing the Shoah in History and Memory.* New Brunswick: Rutgers University Press, 2015.

Stroop, Jürgen. *The Stroop Report: The Jewish Quarter of Warsaw Is No More!* Translated by Sybil Milton. New York: Pantheon Books, 1979.

Suhl, Yuri, ed. and trans. *They Fought Back: The Story of Jewish Resistance in Nazi Europe.* New York: Crown Publishers, 1967.

Sullivan, Leo. "Reconstructed Wall Proves Good Drama." *Washington Post,* January 31, 1964, 9.

Szpilman, Władysław. *The Pianist: The Extraordinary True Story of One Man's Survival in Warsaw, 1939–1943.* Translated by Anthea Bell. New York: Picador, 1999.

Szyk, Arthur. *Ink and Blood: A Book of Drawings.* New York: Heritage Press, 1946.

———. *The Ten Commandments.* Philadelphia: John C. Winston, 1947.

"Tale of a Script." *Time* 71, no. 6 (June 30, 1958): 38.

Tayler, Irene, ed. *Between Worlds: The Paintings and Drawings of Samuel Bak from 1946 to 2001.* Boston: Pucker Art Publications, 2002.

Tec, Nechama. *Resistance: Jews and Christians Who Defied the Nazi Terror.* New York: Oxford University Press, 2013.

Thompson, Dorothy. "Homage to the Christian Poles and the Maccabean Jews of Warsaw!" *Menorah Journal* 31, no. 2 (July–September 1943): unpaged prefatory material. (Originally published

in the *Washington Evening Star,* June 2, 1943.)

Treister, Kenneth. *A Sculpture of Love and Anguish: The Holocaust Memorial, Miami Beach, Florida.* With a foreword by Elie Wiesel. New York: S.P.I. Books, 1993.

Twain, Mark. "Concerning the Jews." In *The Complete Essays of Mark Twain,* edited by Charles Neider, 235–50. Garden City, N.J.: Doubleday, 1963.

———. "The Jew as Soldier." Postscript to "Concerning the Jews." In *Complete Essays,* 250.

Ungar, Irvin. *Justice Illuminated: The Art of Arthur Szyk.* Berkeley, Calif.: Frog; Burlingame, Calif.: Historicana, 1999.

Uprising. Directed by Jon Avnet. NBC. 2001. Burbank: Warner Home Video, 2005. DVD.

Uris, Leon. "About 'Exodus.'" In *The Quest for Truth,* edited by Martha Boaz, 123–30. New York: Scarecrow Press, 1961.

———. *Battle Cry.* New York: G. P. Putnam's Sons, 1953.

———. *Exodus.* 1958. Reprint, New York: Bantam Books, 1989.

———. *Mila 18.* Garden City, N.Y.: Doubleday, 1961.

———. *Mila 18.* New York: Bantam Books, 1962.

———. *Mitla Pass.* New York: Doubleday, 1988.

———. "The Most Heroic Story of Our Century." *Coronet,* November 1960, 170–78.

Uris, Leon, and Dimitrios Harissiadis. *Exodus Revisited.* Garden City, N.Y.: Doubleday, 1960.

Vecsey, George. "Historian at First Base." *New York Times,* August 28, 1983, S3.

The Wall. Directed by Robert Markowitz. 1982. New York: HBO Home Video, 1996. VHS.

Weinberg, Jeshajahu, and Rina Elieli. *The Holocaust Museum in Washington.* New York: Rizzoli, 1995.

Weissman, Gary. *Fantasies of Witnessing: Postwar Efforts to Witness the Holocaust.* Ithaca: Cornell University Press, 2004.

Wenger, Beth S. "Constructing Manhood in American Jewish Culture." In *Gender and Jewish History,* edited by Marion A. Kaplan and Deborah Dash Moore,

350–66. Bloomington: Indiana University Press, 2011.

Wershiba, Joseph. "Daily Closeup: Leon Uris, Author of 'Exodus.'" *New York Post,* July 2, 1959, 34.

Whitaker, Francis. *Beautiful Iron: The Pursuit of Excellence.* Self-published, ca. 1997.

Whittaker, Herbert. "'Warsaw Ghetto' Highly Dramatic." *Montreal Gazette,* February 7, 1945, 3.

Wiesel, Elie. *A Jew Today.* Translated by Marion Wiesel. New York: Random House, 1978.

———. "Trivializing Memory." In *From the Kingdom of Memory: Reminiscences,* 165–72. New York: Summit Books, 1990.

———. "Trivializing the Holocaust: Semi-fact and Semi-fiction." *New York Times,* April 16, 1978, 1, 29.

Willis, Brett. "In the Presence of Mine Enemies." *Christian Spotlight on Entertainment.* http://www.christiananswers.net/spotlight/movies/2001/inthepresenceofmineenemies.html.

Wishengrad, Morton. *The Eternal Light.* New York: Crown Publishers, 1947.

Wojcik-Andrews, Ian. *Children's Films: History, Ideology, Pedagogy, Theory.* New York: Garland, 2000.

Wolf, Simon. *The American Jew as Patriot, Soldier, and Citizen.* Philadelphia: Levytype, 1895.

"World Jewish Congress Sends Cultural Delegation to Jews in Displaced Camps in Germany." *Jewish Telegraphic Agency,* December 28, 1945.

Yerushalmi, Eliezer. *Pinkas Shavli: Yoman mi-geto Lita'i, 1941–1944.* Jerusalem: Yad Vashem, 1958.

Young, James E. "Interpreting Literary Testimony: A Preface to Rereading Holocaust Diaries and Memoirs." *New Literary History,* no. 2 (Winter 1987): 403–23.

———. *The Texture of Memory: Holocaust Memorials and Meaning.* New Haven: Yale University Press, 1993.

———. *Writing and Rewriting the Holocaust: Narrative and the Consequences of Interpretation.* Bloomington: Indiana University Press, 1988.

Zelizer, Barbie. *Remembering to Forget: Holocaust Memory Through the Camera's Eye.* Chicago: University of Chicago Press, 1998.

———, ed. *Visual Culture and the Holocaust.* New Brunswick: Rutgers University Press, 2001.

Zicree, Marc Scott. *The Twilight Zone Companion.* 2nd ed. Los Angeles: Silman-James Press, 1989.

Zolotow, Sam. "Warsaw Play to Open." *New York Times,* October 10, 1944, 26.

Zuckerman, Yitzhak. *A Surplus of Memory: Chronicle of the Warsaw Ghetto Uprising.* Translated by Barbara Harshav. Berkeley: University of California Press, 1993.

Index

In a number of cases, the titles of cultural representations are the same. To avoid confusion, identifiers can be found in parentheses after the works in question. USHMM is the abbreviation for the United States Holocaust Memorial Museum and *IPOME* is the abbreviation for *In the Presence of Mine Enemies*. Page numbers in *italics* refer to illustrations.

292

Index

faith of, unmitigated: in *IPOME*, 68, 71, 75, 76–77, 85, 90, 102, 171; in *Mila 18*, 121, 122; in *The Wall* (Hersey), 77, 102–3, 171
 pro-resistance: in *The Miracle of the Warsaw Ghetto*, 28; in *Mila 18*, 122
Ragozin, Zinaida, 47
railcar, 255 n. 1
 as signifier of Holocaust, 241
 in *Superman: The Man of Steel* 1, #82, 231
 in USHMM, 247, 249
 in *Yossel*, 225
railroad tracks, as signifier of Holocaust, 241
Rainer, Louise, 54
Raoul Wallenberg Place, 248
Rapoport, Nathan
 Korczak's Last Walk (memorial), 191–92, *193*
 Mordecai Anielewicz, monument to, *126*, 140
 Warsaw Ghetto Monument, 126, 191; Uris's speech at, 136, 137, 209; visits by U.S. presidents to, 8
Rashi, 161
Rattner, Abraham, 273 n. 45
Ravetch, Irving. See *Second Battle of the Warsaw Ghetto, The*
Reconstructionist (magazine), 104
redemptive endings/narratives, to mitigate offensives of Holocaust
 Baron on, in film, 190
 Langer opposed to, 210
Redford, Robert, 68, 76
referents of Warsaw Ghetto and uprising, 241–42, 249
Rembrandt, *Moses with the Tablets of the Law* (art), 34, *36*
resistance, 48, 59–60. *See also* Warsaw Ghetto; Warsaw Ghetto uprising
 Auschwitz Revolt, 250
 Bielski brothers, 89, 250
 Defiance (film), 89
 downplayed in early scholarship, 249
 "The Jewish Underground Fighters," 163
 Miles Lerman Center for the Study of Jewish Resistance, 249, 250
 Sobibór uprising, 250
 in USHMM permanent exhibition, 248
revenge fantasies, in cultural representations of the Holocaust and Warsaw Ghetto
 "Deaths-Head Revisited," 88–89, *91*
 Inglourious Basterds, 88–89, 216
 The Shamir of Dachau, 93
 Weird War Tales #36, 215–16, *216*
 Yossel, 219
Reynolds, Burt, 65
Reznikoff, Charles, *Holocaust* (poem), 6, 200, 201, 224
 and Eichmann and Nuremberg trial transcripts, 200

Ringelblum, Emanuel. *See also* Oneg Shabbos archive
 creation of Oneg Shabbos archive, 10
 memorial to (Warsaw), 191
 in *Mila 18*, prototype for character, 19, 120
 Notes from the Warsaw Ghetto, 10, 142; on children, 159–60, 199, 220; influence on Hersey, 96; influence on Uris, 113; on resistance, 15–16
 photograph of, in USHMM, 244
 Time Capsule in a Milk Can (stage play about), 10, 244
 in *The Wall* (Hersey), prototype for character, 96
Rising of the Warsaw Ghetto, The. See Uris, Leon: works
Ritz, Karen, *Child of the Warsaw Ghetto* (children's picture book), 189, 190
Riverside Park memorial (New York), 60
Robards, Jason, 65
Robbins, Trina
 Wimmen's Comix (comics anthology), 210
 Zog nit keyn mol (The Partisans Song) (comic), 210–11, *211*
Robinson, Edward G., 95
Rodin, Auguste, *The Burghers of Calais* (sculpture), 226, *227*; compared to *Yossel*, 226
Roosevelt, Eleanor
 The Diary of Anne Frank, introduction to, 105
 on suffering of Holocaust's Jews, 55
Roosevelt, Franklin Delano, 16, 98, 255 n. 6
Rose, Reginald, *The Final Ingredient* (teleplay), 84
Rosenfeld, Alvin, 184, 248
Roskies, David, 37–38, 44–45
Roth, Philip
 The Counterlife (novel), 145
 "Defender of the Faith," (short story), 143, 144
 Goodbye Columbus (collected fiction), 143, 144
 "The New Jewish Stereotypes" (essay and speech), 144, 146, 147, 149
 Patrimony: A True Story (novel), 270 n. 100
 Portnoy's Complaint (novel), 145–46; protagonist in, compared to protagonist in *Mila 18*, 123
 and Uris, 144–45, 146
Rudahl, Sharon, *Zog nit keyn mol (The Partisans Song)* (comic), 210–11, *211*

Sakstier, Boris, *Janusz Korczak and the Children* (memorial), 191; as inspiration for *Korczak's Orphans*, 192
Salinger, J. D., *Franny and Zooey* (book), 132
Samson (biblical figure)
 as biblical precedent for Jewish fighting, 258 n. 56; in *Exodus Revisited*, 139
 in *Battle of the Warsaw Ghetto* (Szyk), 41, *42*

used to incur American support, 5, 20, 23, 34, 55, 57, 60, 61, 239

USHMM, represented in, 242, 245–48, *246*, *247*, 250–51

weapons, attempts to get and lack of, 1, 3, 8; in *The Battle of the Warsaw Ghetto* (Wishengrad), 22; in children's book, 189; in *Mila 18*, 120, 142; in *The Miracle of the Warsaw Ghetto*, 29, 31

Zog nit keyn mol (The Partisans' Song): comic structured around, 210–11, *211*; in *Warsaw Ghetto Boy* (Flack), 186, *188*, 211; at Yom Hashoah commemorations, 60, 211

Washington Post, 8, 101

Watchmen, The (Gibbons and Moore, comic book), 222

Weekly Variety Review, 79, 80

Weinberg, Jeshajahu, 243

Weinstein, Harvey
 on *Exodus* (film), 148
 Mila 18, proposed film adaptation of, 12, 147–48

Weird War Tales #36 (Drake and Robbins, comic book), 215–16, *216*

Weissman, Gary, 224

Welles, Orson, *The Stranger* (film), 85

"We Remember Our Heroes" (comic), 163–65, *164*

Westinghouse Desilu Playhouse (anthology series), 65

Whitaker, Francis, 125, 269 n. 53

Whitman, Walt, 16

Wiesel, Elie, 184
 on children's value in Judaism, 206
 on *Holocaust* (miniseries), 150
 on Holocaust's indescribability, 7
 Night (memoir), 171
 on Warsaw Ghetto boy, 188

Wilson, Ben
 Deportation (art), 26–27
 Flight (art), 26
 Uprising in the Polish Ghetto (art), 25–26, *26*, 180

Wise, Stephen, Rabbi, 53, 147

Wishengrad, Morton. See *Battle of the Warsaw Ghetto, The*

Wolf of Masada, The (Fredman, novel), cover of, 125, 125–26

Wolf, Simon, *The American Jew as Patriot, Soldier, and Citizen*, 118

Workmen's Circle, 52, 191

World Jewish Congress, 32, 53, 58

World Over, The (children's magazine), 161, 212
 excerpt from *The Wall* in, 96, 163
 Holocaust history in, 161–63, 190
 Jewish military accomplishments in, 119, 163, 259 n. 78
 Warsaw Ghetto articles and stories in: "A Child's Song of Courage," 162, 214; "Hanukkah Light in Warsaw," 163; "The Jewish Underground Fighters," 163;

"Remember the Battle of the Warsaw Ghetto," 162; "Revolt of the Warsaw Ghetto," 162; "Underground Brigade," 163, 208–9

Writer's Digest Magazine, 67

Yad Vashem
 Garden for Children Without a Childhood, 208
 Janusz Korczak and the Children, 191
 Janusz Korczak Square, 191
 name linked to heroism in Holocaust, 4
 Uris's research at, 113
 Warsaw Ghetto Square, 4

Yiddish Art Theatre, 28. See also *Miracle of the Warsaw Ghetto, The*

Yiddish Scientific Institute, 27

Yivo Bleter (journal), 27

Yom Hashoah
 in Israel, 4
 origins of, 4
 Uris at commemorations of, 135
 and USHMM, 157
 and Warsaw Ghetto and uprising, 4, 192, 211
 Zog nit keyn mol sung at, 211

Yossel: April 19, 1943. See Kubert, Joe: works

Young, James E., 241

Zelizer, Barbie, 241–42, 249

Zimler, Richard, *The Warsaw Anagrams* (novel), 11

Zinnemann, Fred, *The Seventh Cross* (film), 92

Zionism
 ideology of, 4
 Star of David, as symbol of, 36–37
 Uris, theme of in: *Exodus*, 110; *Exodus Revisited*, 139–41

Zionist flag. *See* flag, Zionist, as referent of Warsaw Ghetto uprising

Zog nit keyn mol (Glik, The Partisans' Song)
 Flack's *Warsaw Ghetto Boy* incorporating lyrics from, 186, *188*, 211
 Robbins and Rudahl's comic structured around lyrics of, 210–11, *211*
 sung at Yom Hashoah commemorations, 60, 211

Zuckerman, Antek, 3, 240
 on postwar anguish, xvi, 12
 Lampell and, 99–100
 letter from Anielewicz to, 14, 15, 18, 126, 245–46
 photographs of, 141, 245, *246*, *247*
 on spiritual resistance, 100
 survival of, 3, 12
 on uprising, 100, 141
 Uris and, 99–100, 112–13, 135, 141
 in USHMM, 245, *246*, *247*

Zwick, Edward, *Defiance* (film), 89

Zygelbaum, Samuel, suicide of, 56–57, 260 n. 98

Typeset by
Regina Starace

Printed and bound by
Asia Pacific Offset

Composed in
Minion, Unit Slab, and DIN Next

Printed on
Chen Ming FSC Matt

Bound in
JHT